Wild Seas

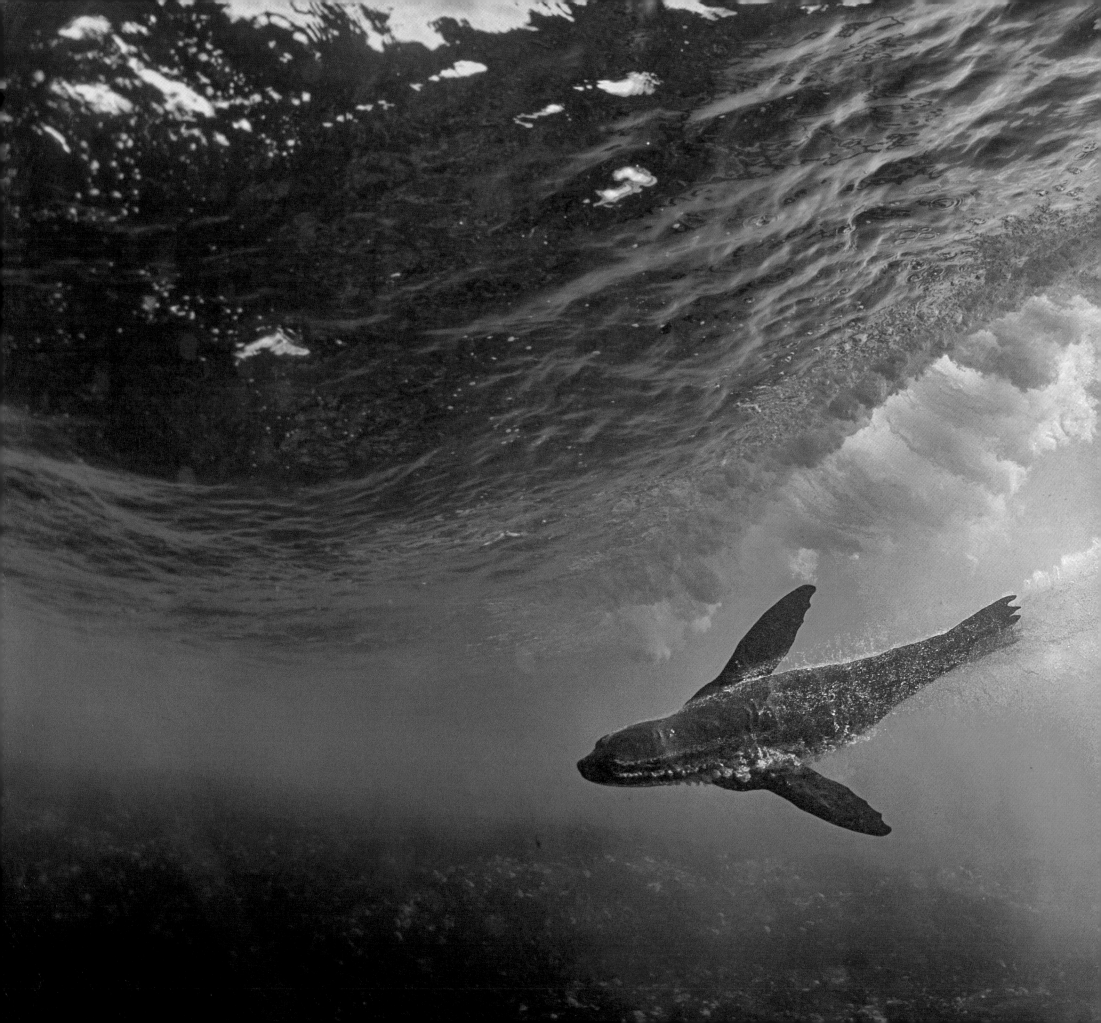

Wild Seas
Thomas Peschak

NATIONAL
GEOGRAPHIC
WASHINGTON, D.C.

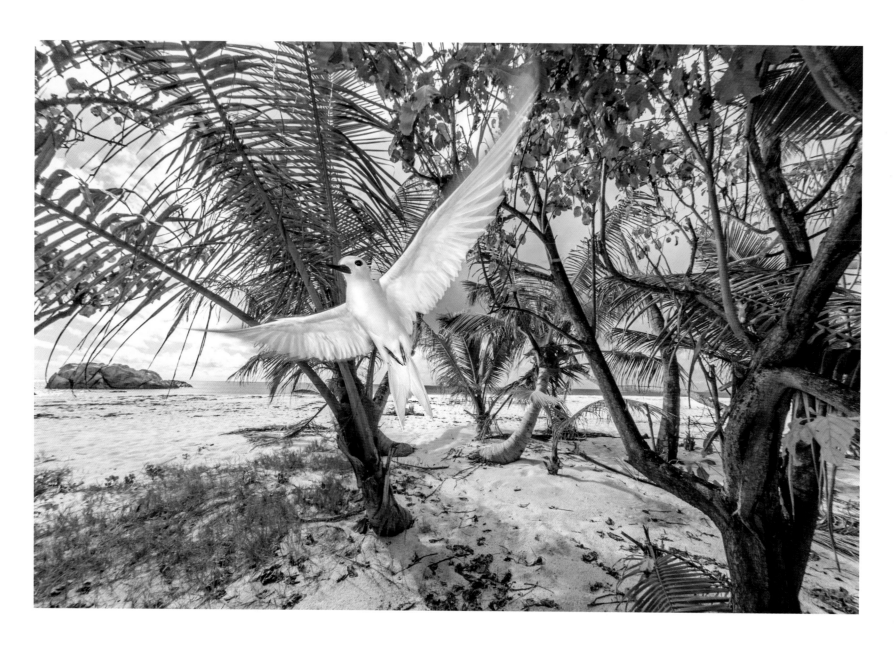

On the tiny Seychelles island of Cousine, a white tern hovers where the forest meets the Indian Ocean.

PREVIOUS PAGES: A Cape fur seal surfs giant Atlantic swells off the coast of Cape Town.

CONTENTS

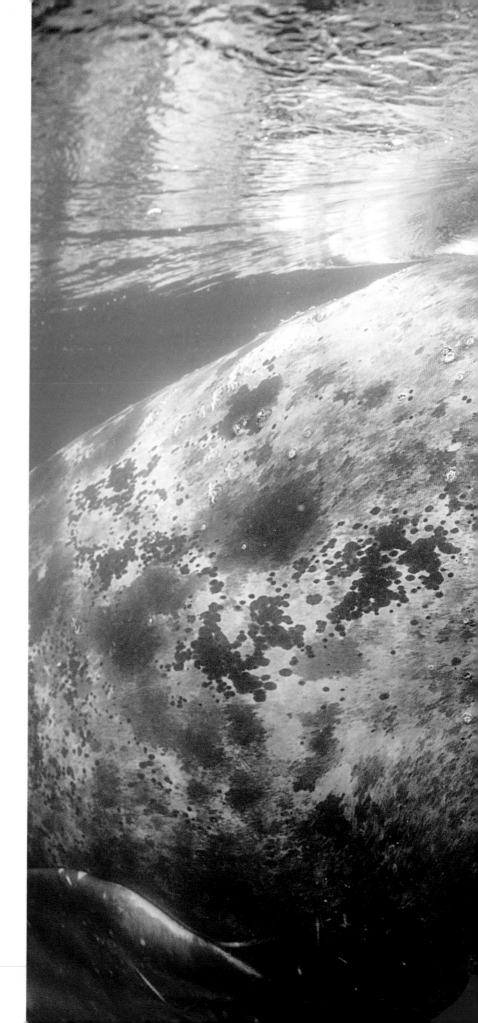

"You can't fall in love with something you don't know exists. As a photographer, I am a matchmaker. I introduce people to wildlife that lies hidden beneath the ocean's surface."

Close Contact • A tourist on a boat reaches into the water in the hopes of touching a gray whale. Baja California's San Ignacio Lagoon is one of the few places in the world where whales seek out physical contact with people. This unique culture has been passed down from mother to offspring for more than 40 years. Mexico, 2015

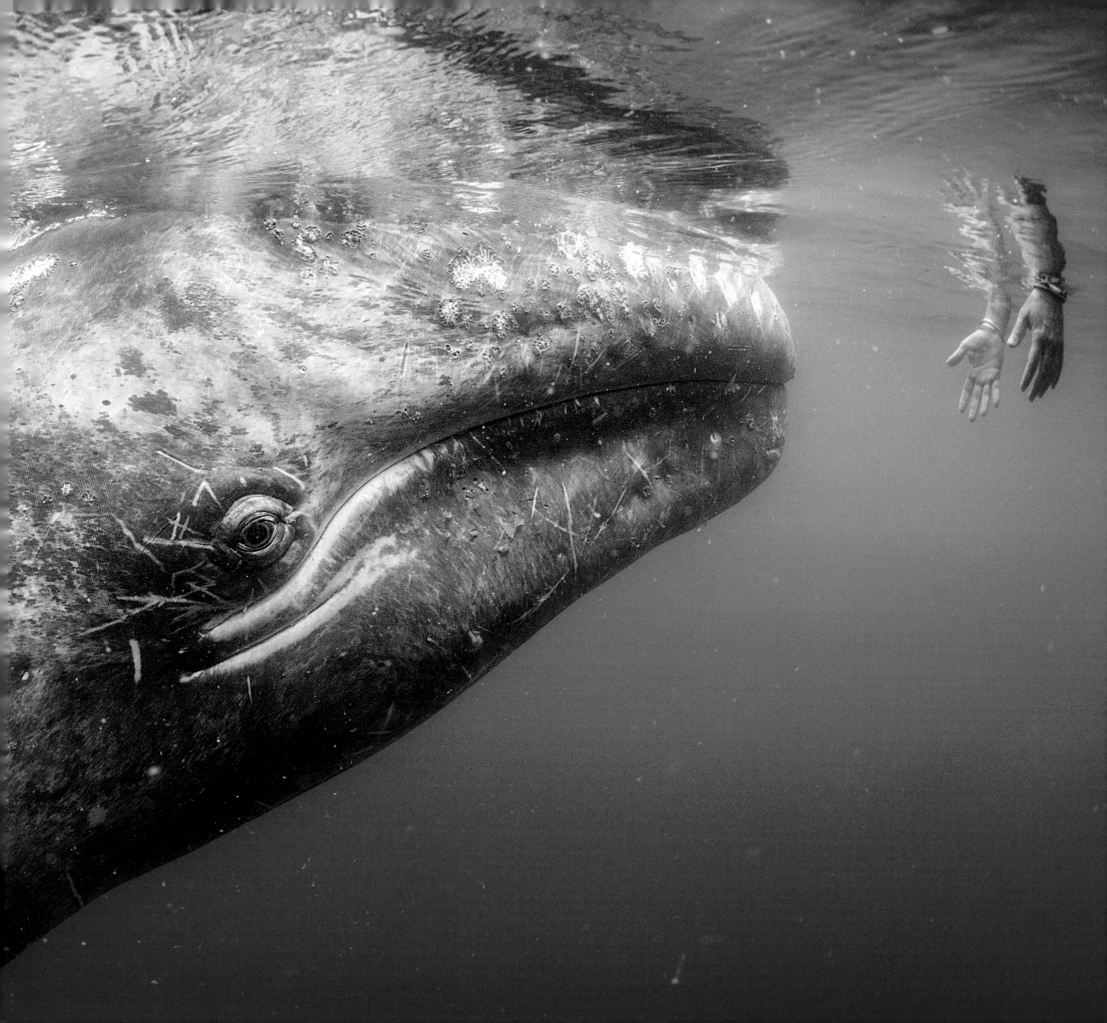

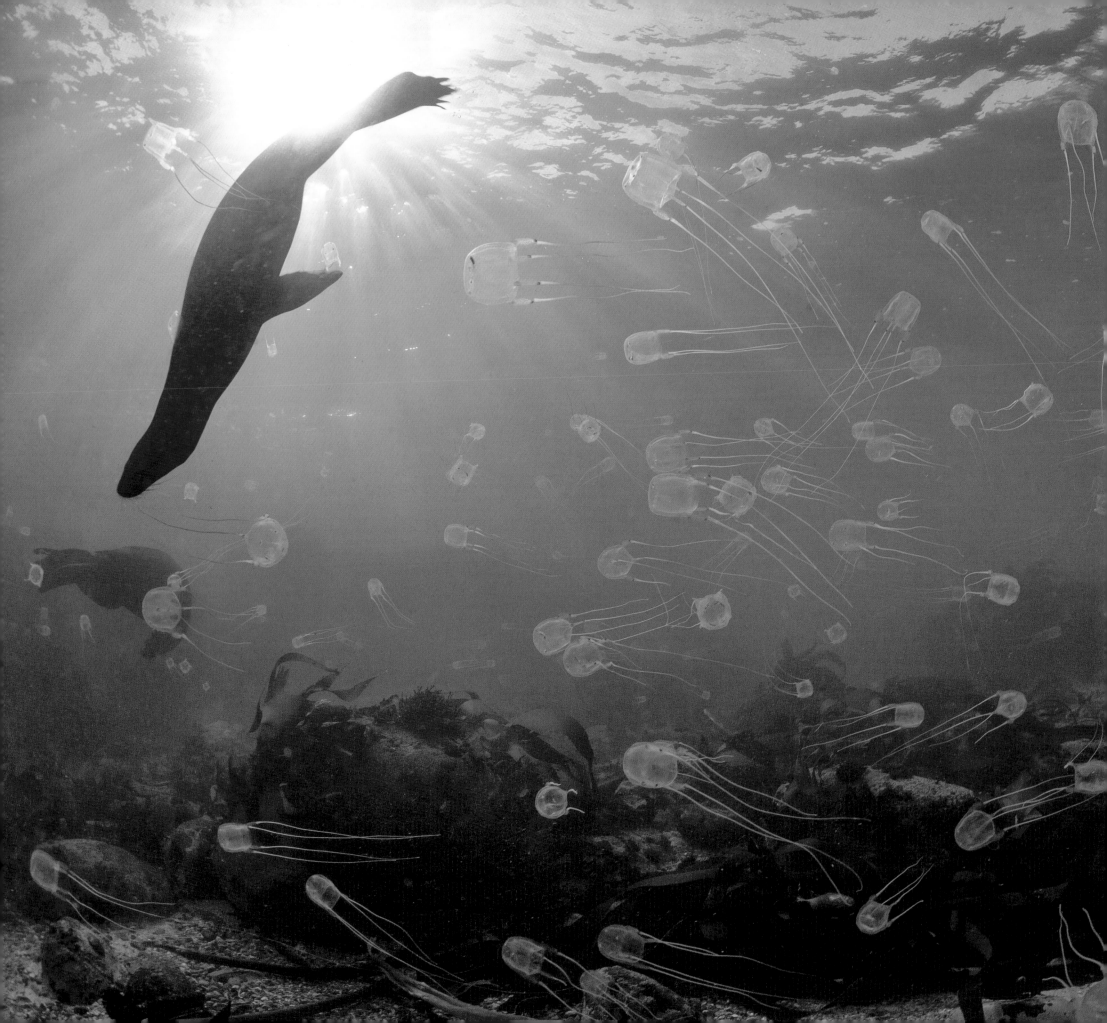

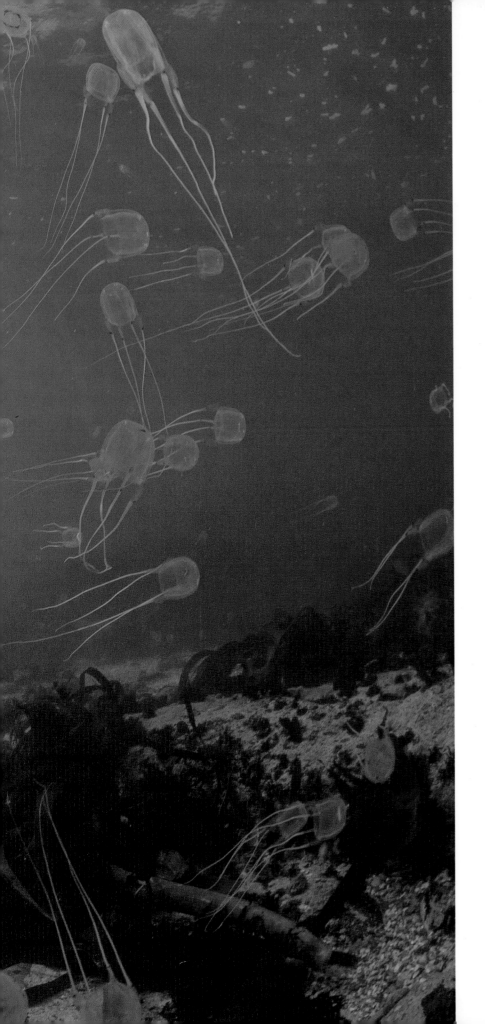

Sharing Space • Cape fur seals dive among a swarm of box jellyfish in the kelp-lined shallows of the Table Mountain National Park Marine Protected Area. This African variety of jellyfish is nowhere near as venomous as its infamous Australian relative. South Africa, 2012

Salmon Run • Hundreds of salmon back up in a pool at the base of a waterfall, waiting for the right moment to leap up the falls and continue their journey upriver to their spawning grounds. The Great Bear Rainforest is home to thousands of fragile watercourses, essential to ensuring the next generation of salmon. Canada, 2007

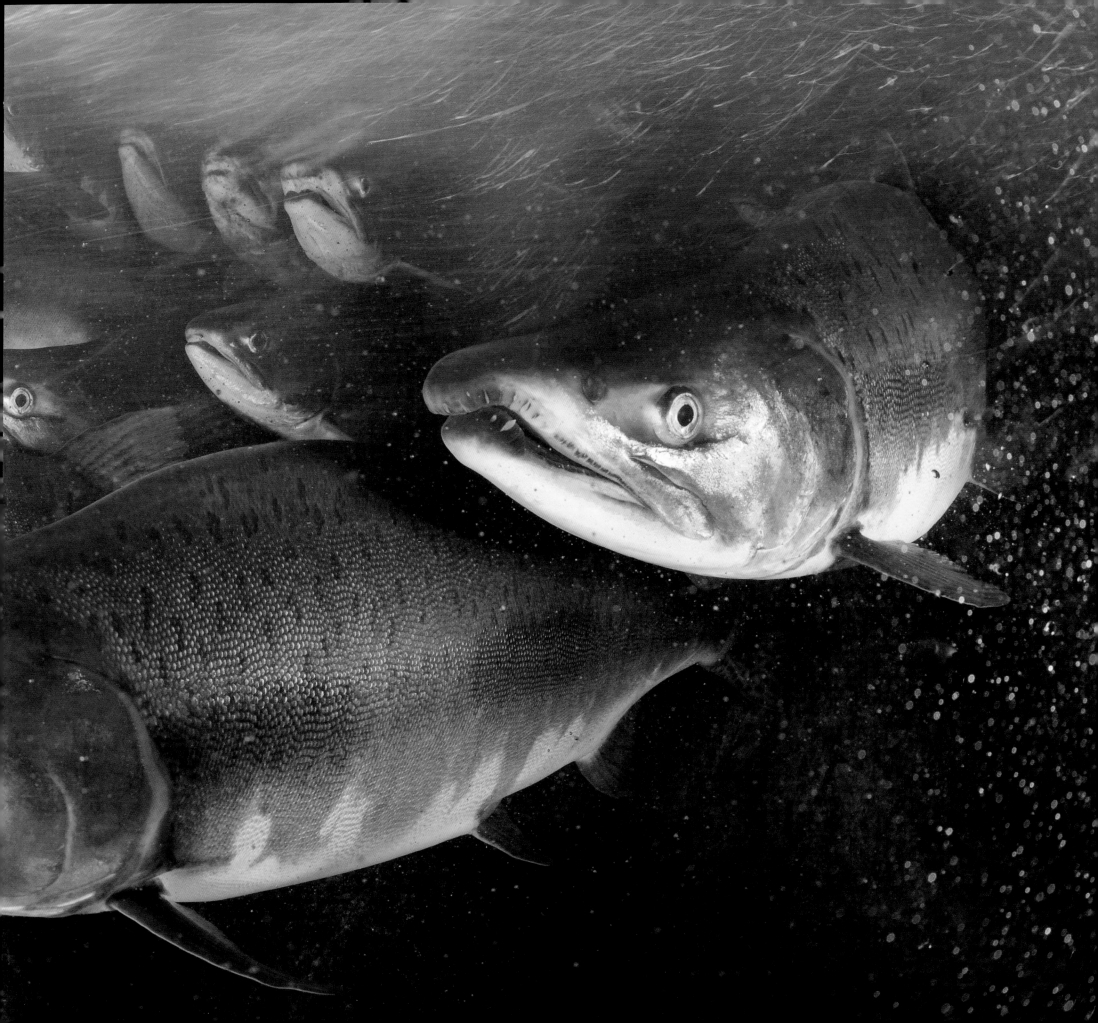

Back in Time • In a scene that could be 10,000 years old, giant tortoises rest in a mud pool in Volcán Alcedo's crater on Isla Isabela. The sound track to this primordial landscape includes earthquake-like rumblings and hissing sulfur plumes rocketing into the night sky. Galápagos, 2016

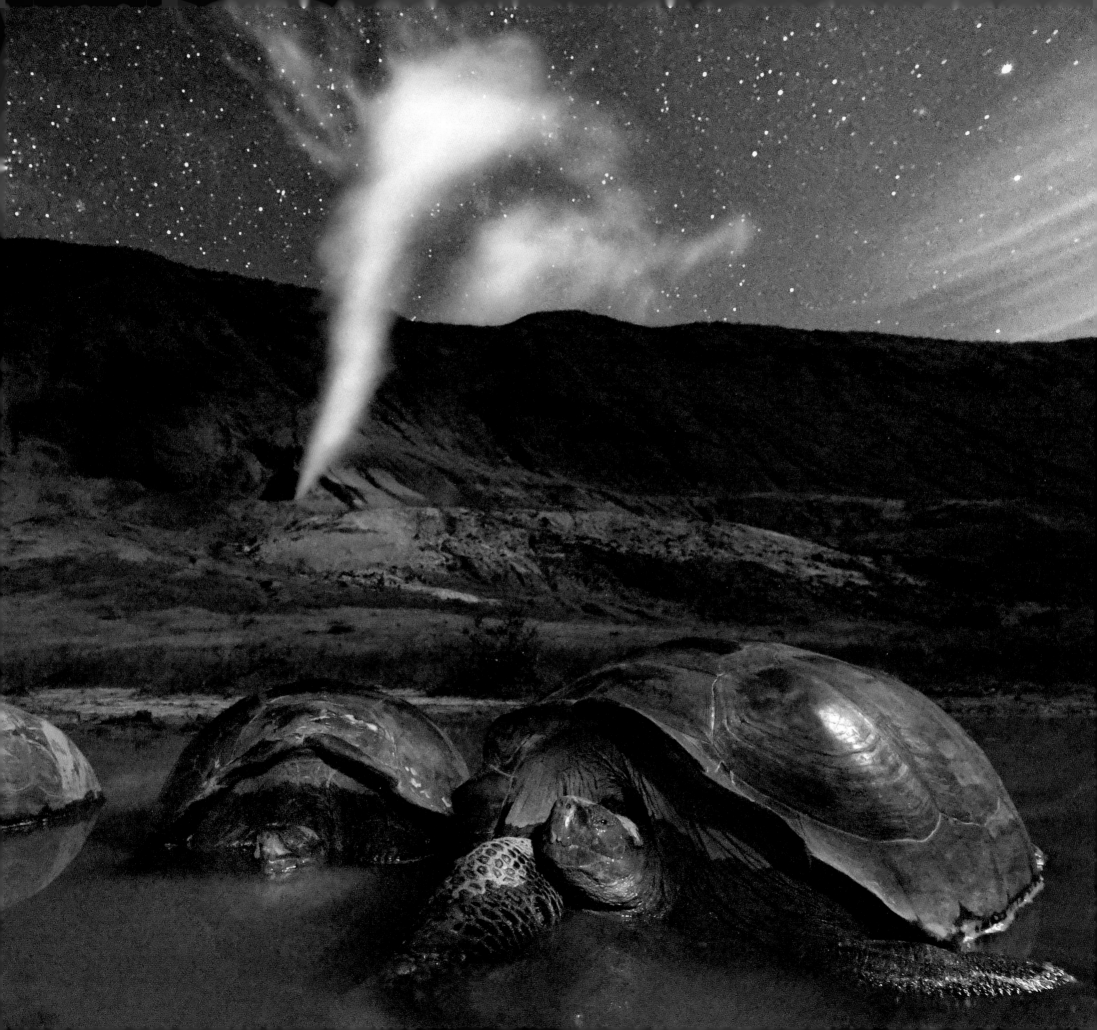

Crab Rock • Sally Lightfoot crabs cling to a tide-washed boulder in the productive intertidal zone on Isla Fernandina. Named for their effortless agility, the crabs eat a varied diet and keep the shores clean of organic debris. Galápagos, 2016

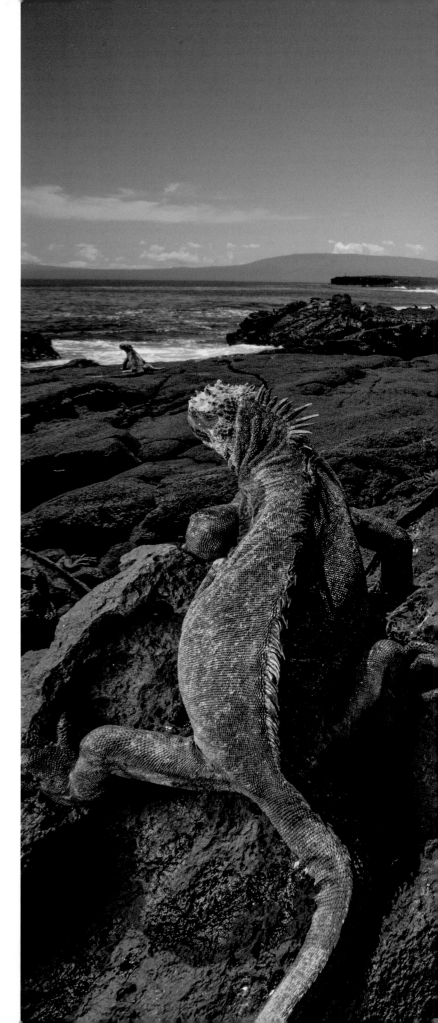

Lounging Lizards • After foraging for seaweed in the cold waters of the Pacific Ocean, marine iguanas bask on Isla Fernandina's shore. The black volcanic rock is an excellent sponge for heat, and by late morning these cold-blooded reptiles have warmed up. Galápagos, 2016

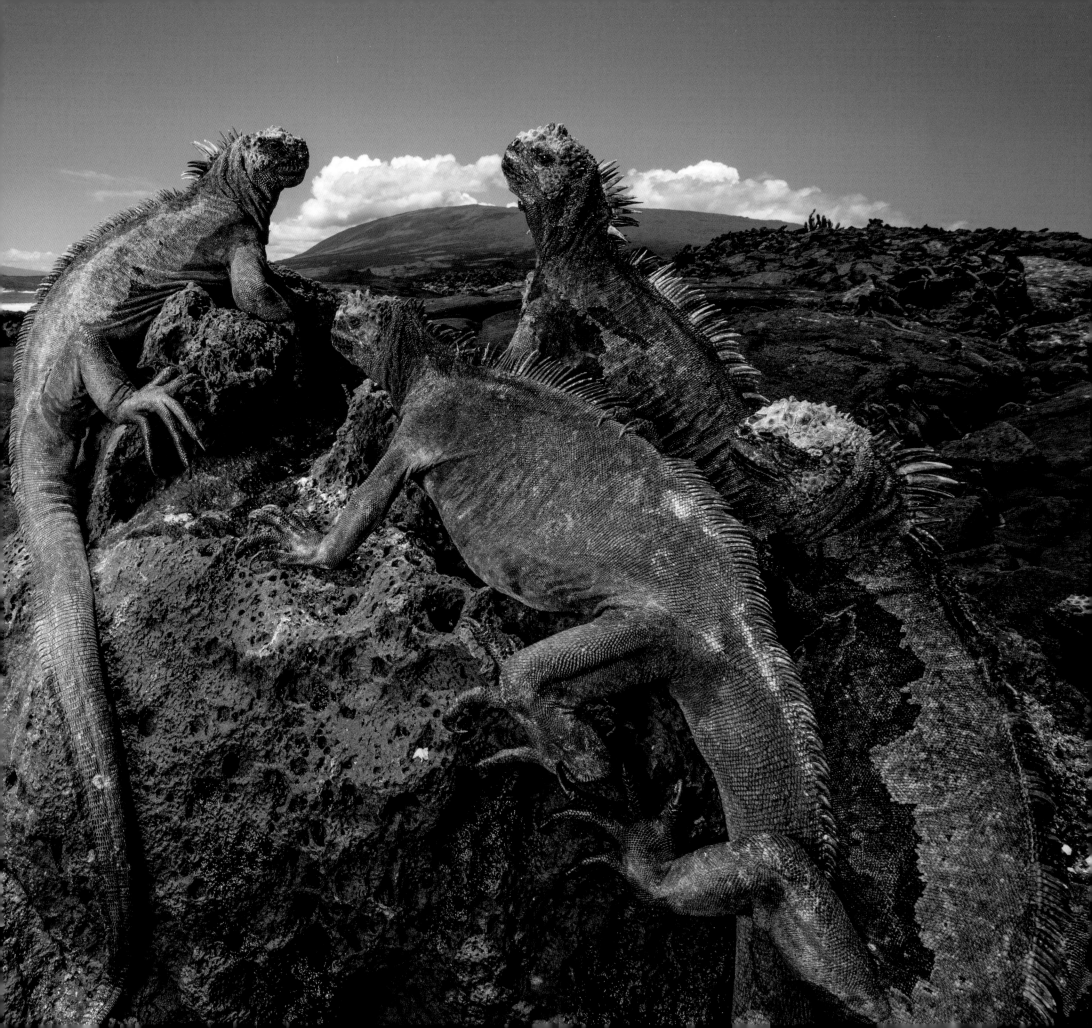

Border Crossing • A pod of Indo-Pacific bottlenose dolphins forages in the surf zone of Africa's first transfrontier marine protected area. It links Ponta do Ouro in Mozambique to South Africa's Kosi Bay, allowing these border-crossing animals to spend most of their lives in protected seas. Mozambique, 2012

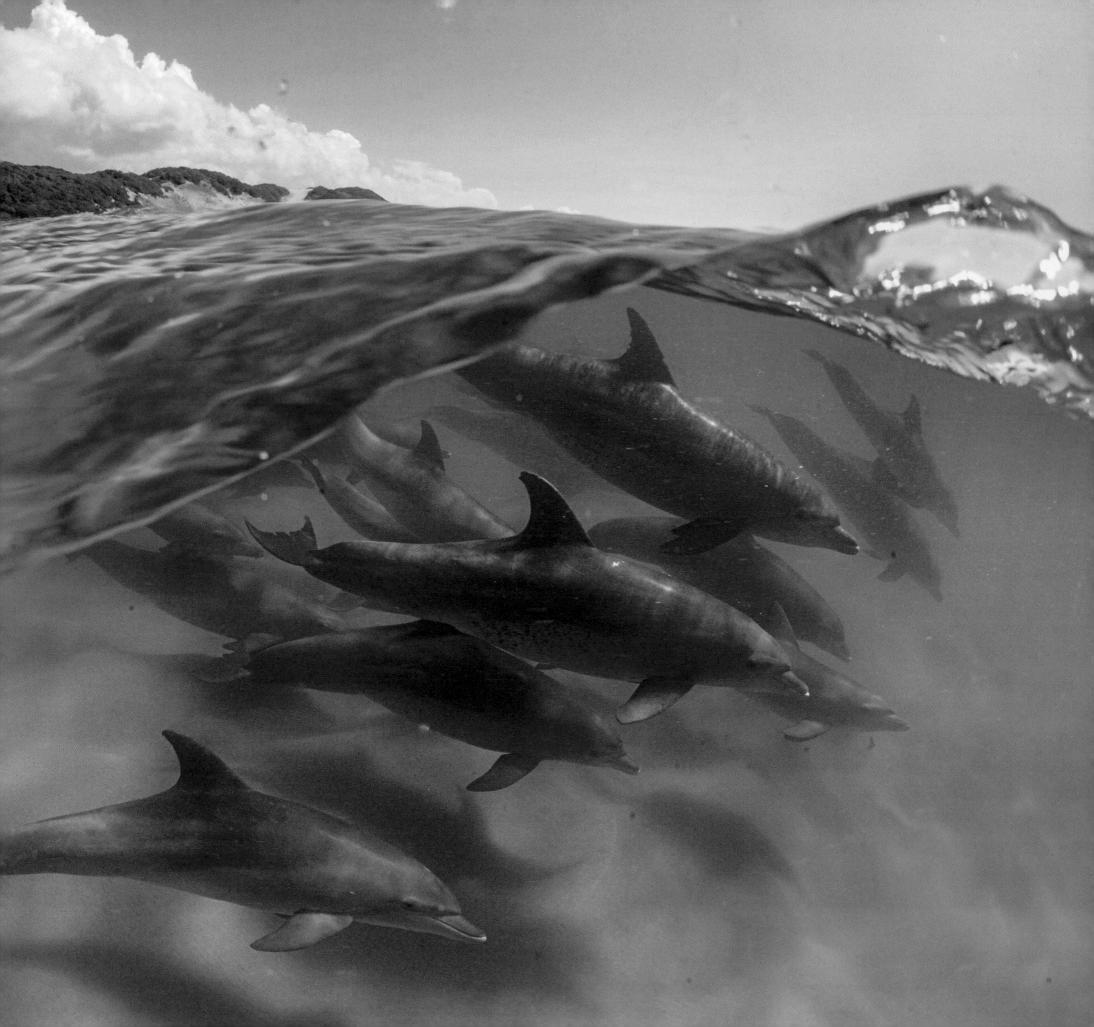

Brittle Star Express • A constellation of brittle stars hitchhikes on a jellyfish off the Bazaruto Archipelago. It appears that these opportunistic travelers not only get a free ride, but also actively "steal" planktonic food scraps from the jelly's tentacles.
Mozambique, 2006

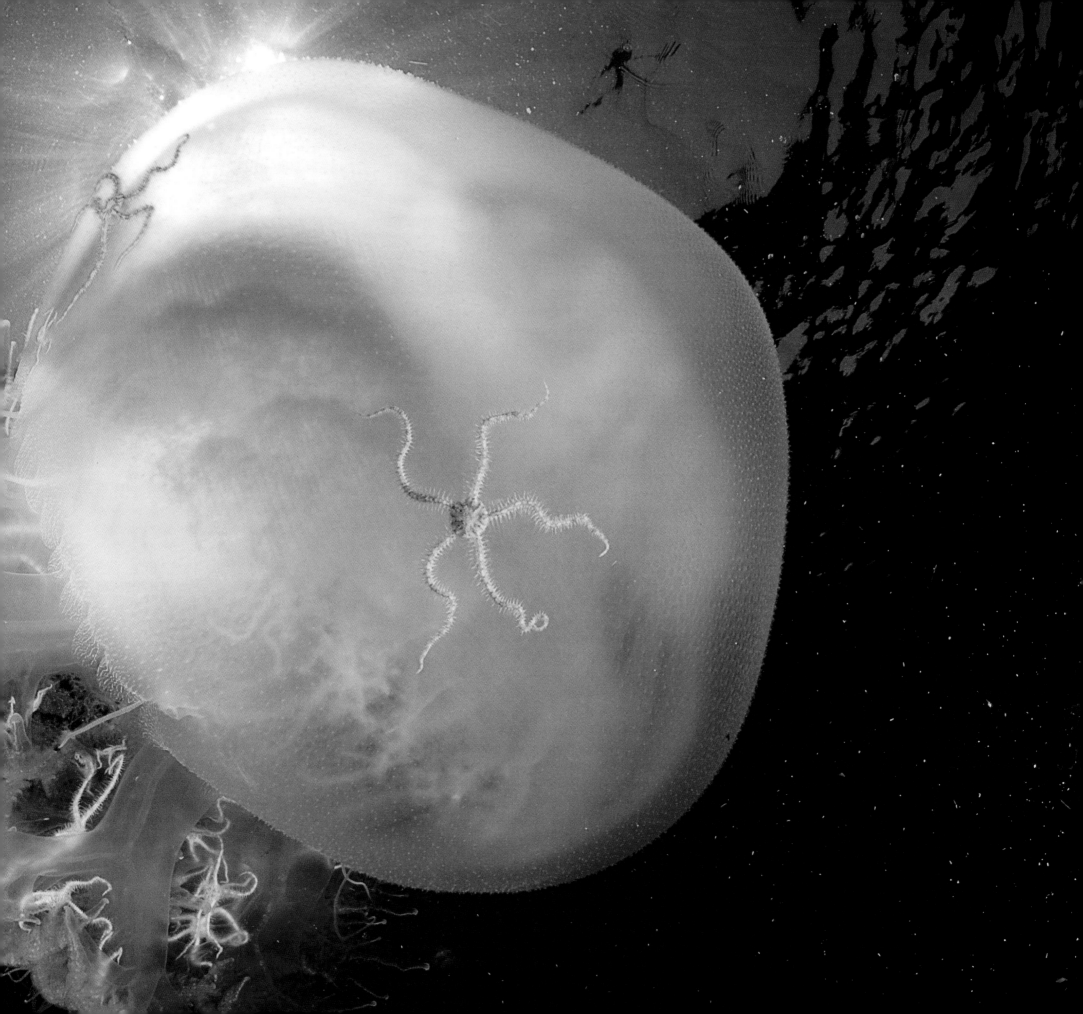

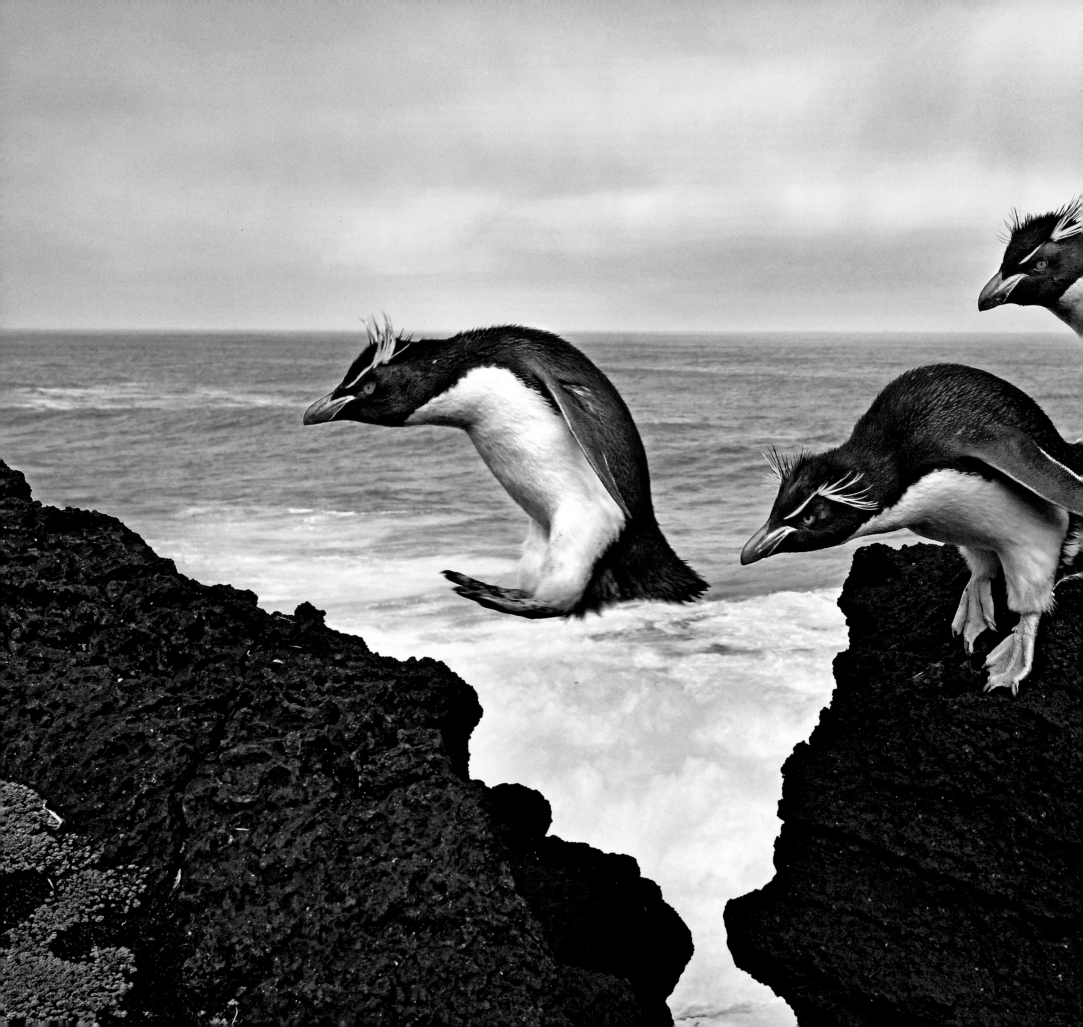

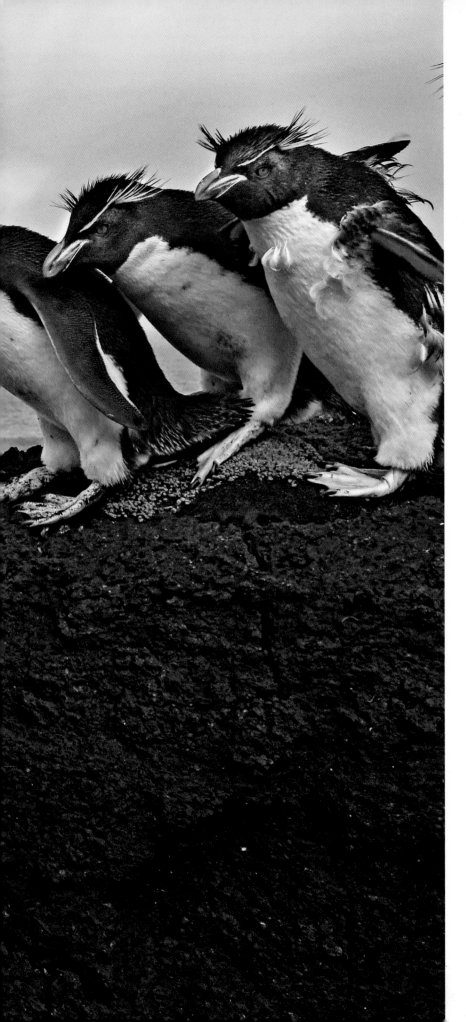

Rock Stars • Rockhopper penguins live up to their name as they leap from one rock to the next. With surprising grace and ease, they navigate the treacherous lava rock that blankets the steep western coastline of subantarctic Marion Island. South Africa, 2016

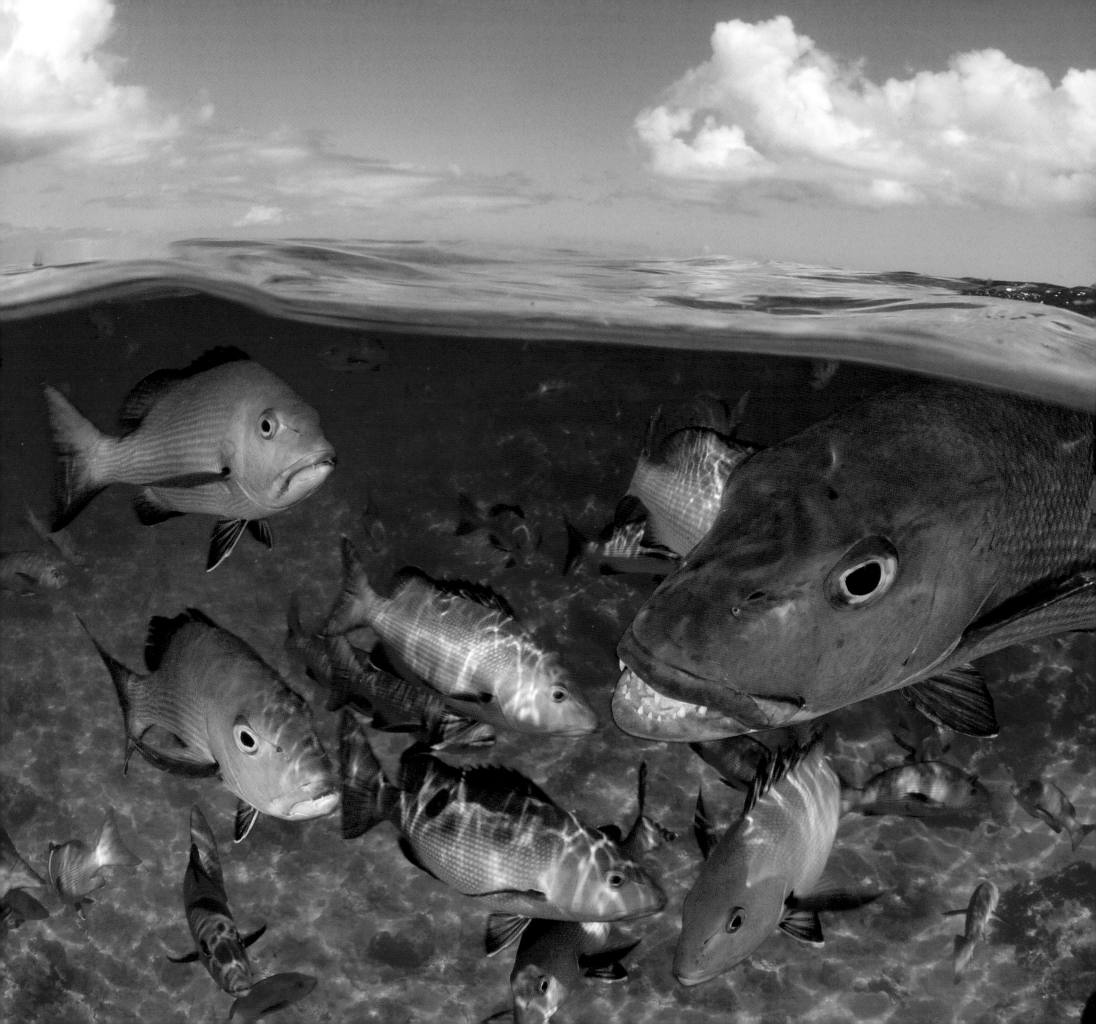

Meet the Snappers • Large schools of bohar snappers aggregate at the mouth of channels that funnel water in and out of Aldabra lagoon. They are among the atoll's top predators and have the chops to prove it. Seychelles, 2008

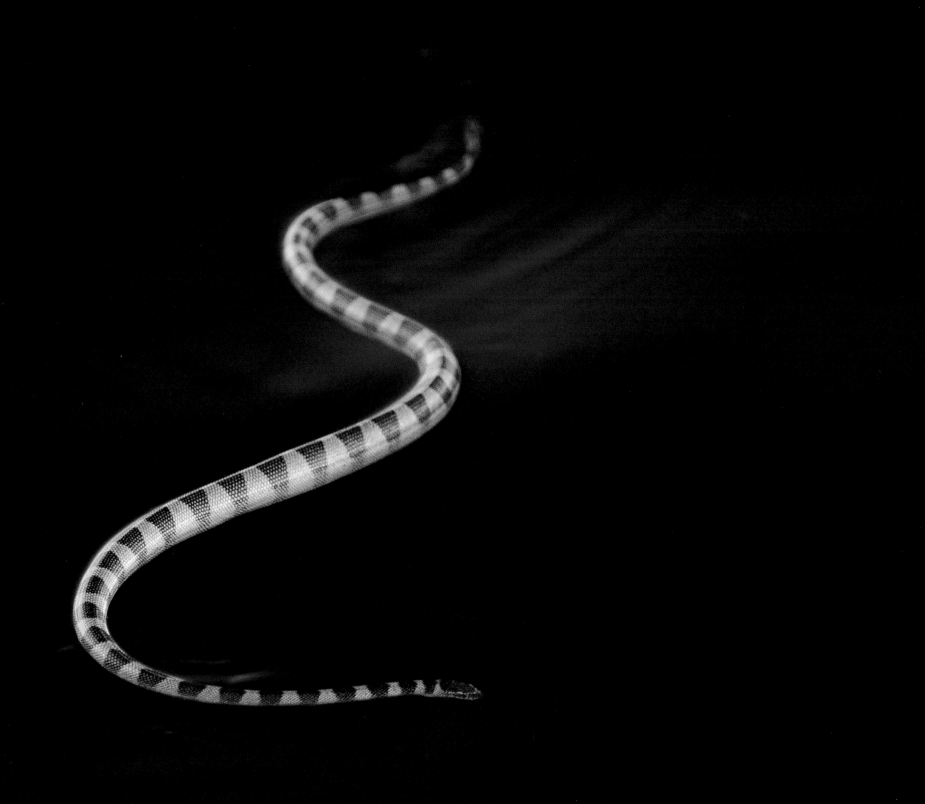

Sea Serpent • An Arabian sea snake surfaces to breathe after hunting small fish on the seabed. Though not aggressive to humans, these highly venomous animals are common in the shallow waters of the Persian Gulf. Oman, 2008

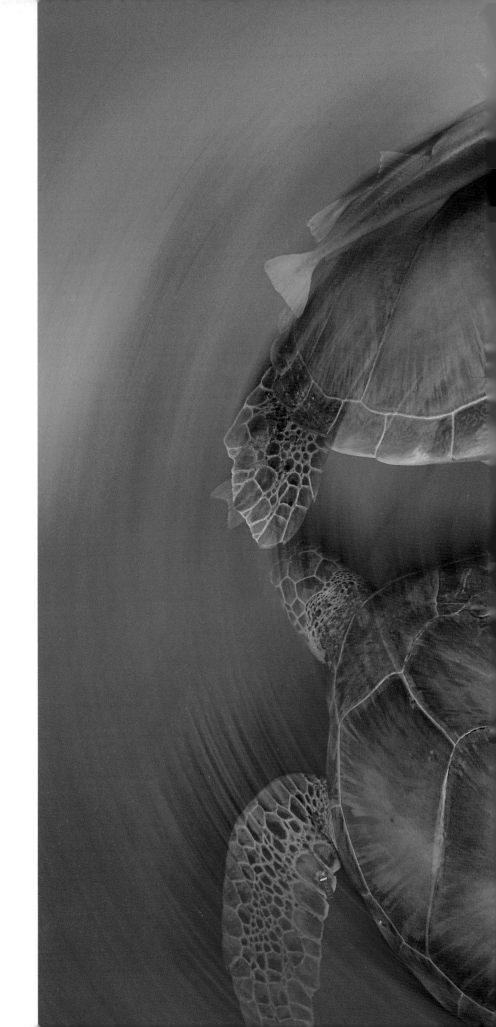

Turtle Trio • Three green turtles gather off the dock at Little Farmer's Cay. The shallow banks of the Bahamas are important foraging grounds for both juveniles and subadults. Bahamas, 2018

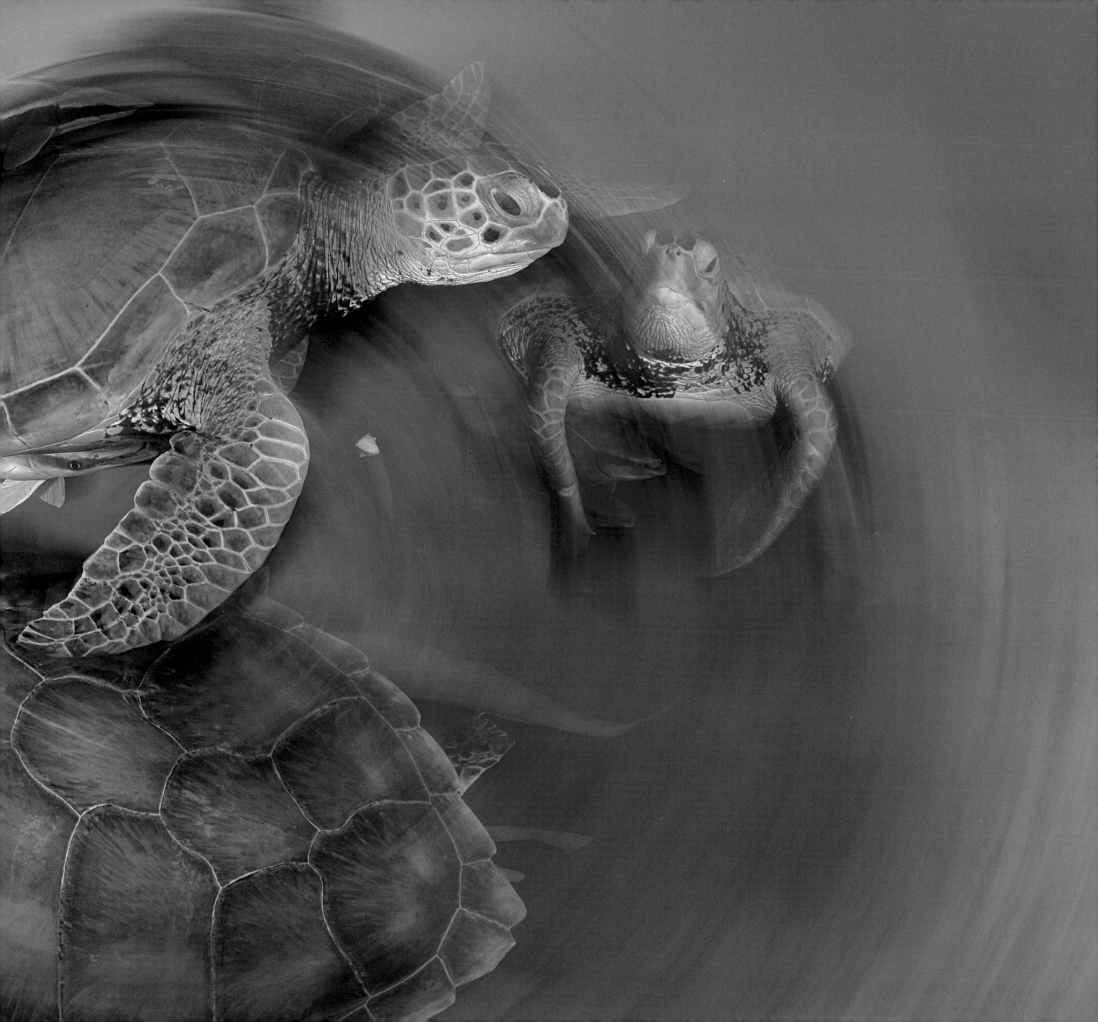

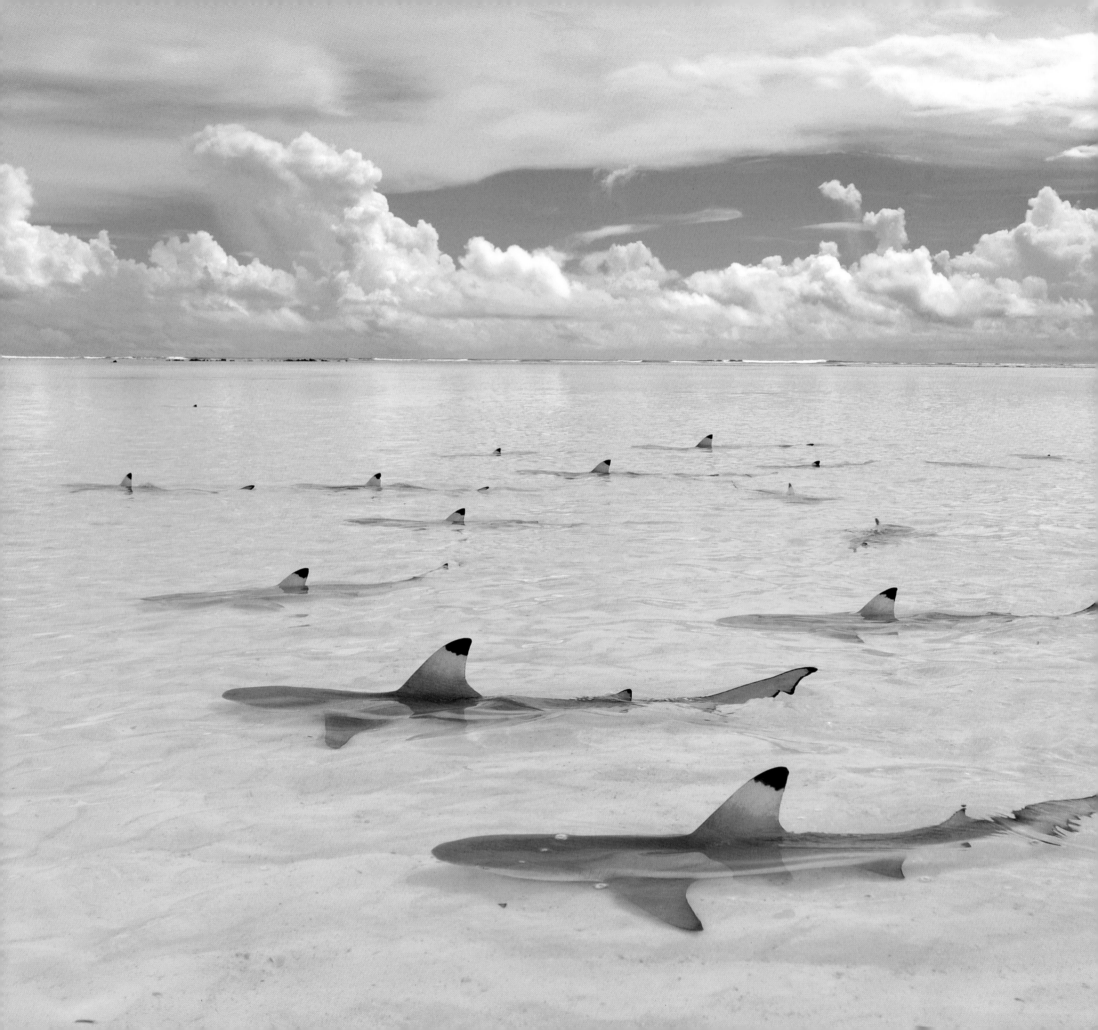

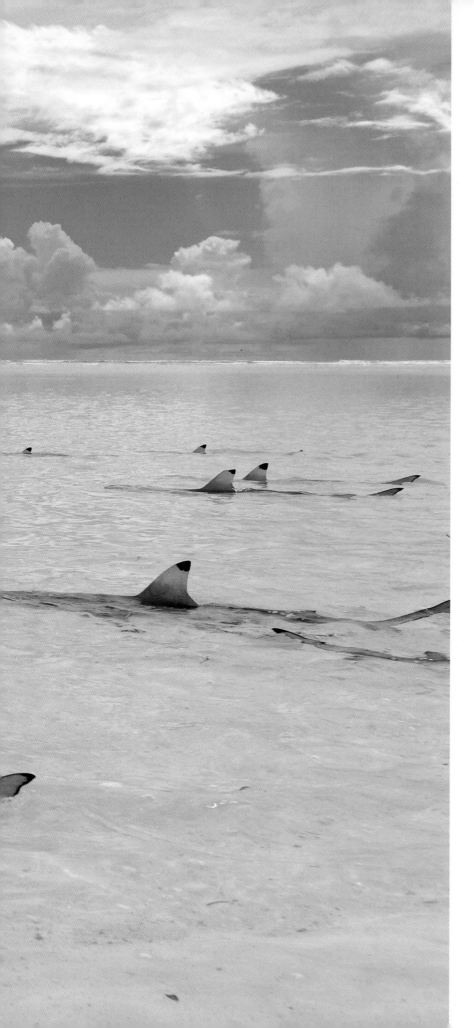

"I am inspired by love and fear—love for our planet's wild seas and fear that future generations will not get to experience them the way I have."

Blacktip Flotilla • Swimming in inches of warm water off Aldabra, blacktip reef sharks wait for the tide to refill the lagoon. With their bellies touching the sand, they point their snouts into the current to keep water flowing over their gills. Seychelles, 2008

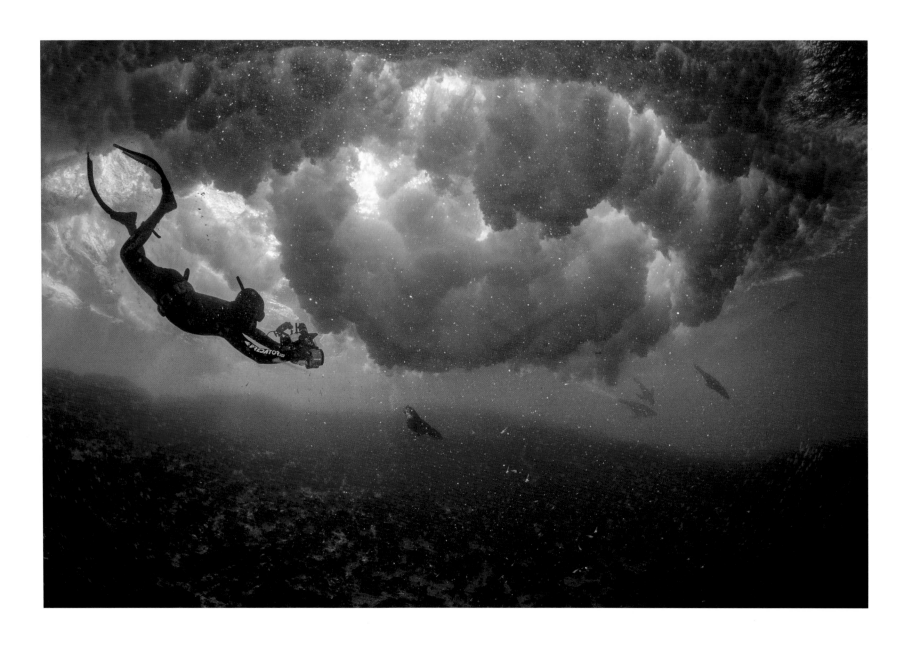

Beneath the Waves • Making photographs underwater is always more complicated than on dry land. It took imagination and years of planning before I finally found myself surfing alongside Cape fur seals to capture their playful antics.

Ocean Storyteller

THEY ARE ALL GONE. It can't be. Did I swim into the wrong bay by mistake?

No, of course I didn't. To my right is the cake-shaped boulder carpeted by purple sea urchins; to my left is the distinctive crack at the base of a rocky pinnacle, home to a curious octopus that loves to explore my fingertips with its tentacles. Just ahead is a cluster of swaying kelp that, with a little bit of imagination, looks like a herd of drunk giraffes. I am definitely in the right place.

I swim away into the swell rolling across the bay. But neither direction nor distance changes the fact that all my study animals—dinner plate–size sea snails called abalones—have disappeared overnight.

My confusion is soon replaced by despair, then anger, and then unedited rage; I actually scream four-letter expletives. The shock wave of insults cascading through my snorkel causes a nearby school of fish to scatter.

I pass through a narrow gap between two rocky pinnacles, not realizing, thanks to my inner turmoil, that something else is also trying to get through. My mask is knocked sideways,

my jaw aches, I swallow some seawater, and am enveloped in turbulent froth. When the water clears, I see the distinctive tail fin of a large sevengill shark speeding away.

Shaken, I try to piece together what happened. Swimming a search pattern across the crime scene, I soon find clues left by the perpetrators: a slime-covered bag entangled in the kelp canopy, a rusty screwdriver wedged between two holdfasts, and a cracked flashlight on the seabed. I then find one, then two, then dozens of abalone shells.

A wave carries me deep into a gully and my worst fears are realized. Behind a large outcrop lies a mountain of empty shells. Carnivorous whelks and a few small sharks are already scavenging on the entrails of the dead.

I turn over one of hundreds of shells. A blue plastic tag with the number 8 on it stares back at me. Then I uncover numbers 25, 53, 102, and more. As part of my research, I had spent weeks gluing these tags to their shells. Granted, they are not Jane Goodall's chimpanzees or Dian Fossey's gorillas. But these abalones are more than just numbers to me. After all, I had devoted so many months following their

every move. I watched them reach out with their muscular feet to snatch drifting kelp from the water, use their specialized zipperlike tongues to scrape algae, and vigorously twist their shells to deter predatory octopuses. Slowly, these abalones were revealing the ecological role they played in this kelp forest ecosystem.

That is, until a moonless night, when poachers stumbled across my research site and cut the conversation short. Only one abalone, number 82, survives; I don't know why. I can only imagine that the poachers must have been disturbed right before using a knife to violently separate 82's body from its shell, as they had done to the others.

I sigh through my snorkel and gently remove 82 from among its fallen comrades. I press its muscular foot to my palm until it securely takes hold. Hand in foot, we swim the few hundred feet back into the bay where I return it to its home on the rock flats. The act is more symbolic than anything else, for I knew that 82's number would come up sooner or later.

That day is the beginning of the end; the sun sets on me as an active research scientist. The dawn of reinventing myself as an ocean photographer and conservation storyteller is coming; I just don't know it yet.

It's 1999. I'm 24 years old and preparing for the next chapter of my life. I stuff all my possessions into two oversize backpacks and head to South Africa to begin my Ph.D. at the University of Cape Town. Somewhere over the Sahara, I pull out the inflight magazine and fatefully flip to an article titled "Abalone Wars: The Curse of the Sea Snail." My Ph.D. supervisor, George Branch, a legendary South African marine biologist, didn't inform me that I would be

stepping onto an ecological battlefield where violent showdowns between law enforcement and poachers are commonplace. I am only half joking when I ask him if my research budget has a line item for a bulletproof vest.

Across Asia, abalones are a delicacy. Their flesh can fetch over $200 a pound, making it one of the most expensive seafood items in the world. Despite the high price, the demand for "the truffle of the sea" is insatiable. Chinese criminal syndicates, also trading in shark fins, drive this black market trade and smuggle the dried abalone to Hong Kong. Local South African divers from impoverished fishing communities are taking the biggest risks. The gangs from Cape Town, who control the local drug markets, serve as middlemen between Chinese syndicates and local fishermen; abalone is often traded for methamphetamines, known locally as *tik*.

I had begun my research when rocky reefs the size of football fields were blanketed in abalones. But within a few years, sights like this had become relegated to the history books. I was vocal about the conservation carnage I witnessed. Serving as an expert government witness in abalone poaching court cases, I was not immune to the same threats and intimidation law enforcement received. I wrote endless reports and gave interviews to any media outlet interested in abalone poaching; once, I even gave a presentation to a visiting FBI delegation that was investigating links between abalone poaching syndicates and an international drug smuggling ring.

But no matter how important all of this felt, abalones were still being poached in record numbers: more than six million in 2002. My research supported a dismal truth: The species was quickly approaching extinction in the wild. Still, no

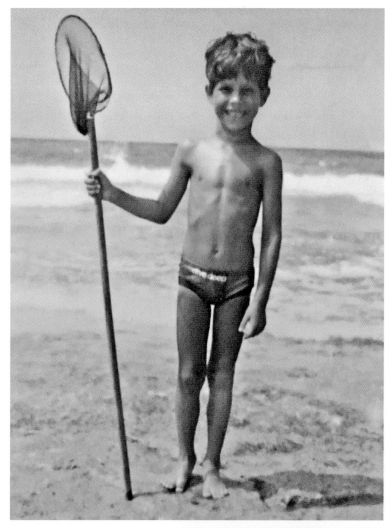

Born to Swim • I was 10 years old when I strapped on a mask and stuck my head underwater for the first time. I instantly fell in love with the ocean and its creatures. Inspired by books and films, I don't remember a time when I didn't want to be a marine biologist. For my Ph.D., I researched the impacts of marine poaching, but soon discovered I could be a more potent conservationist using photographs rather than statistics. The first step in my journey from scientist to photographer was living out of my Land Rover to document life in southern Africa's oceans.

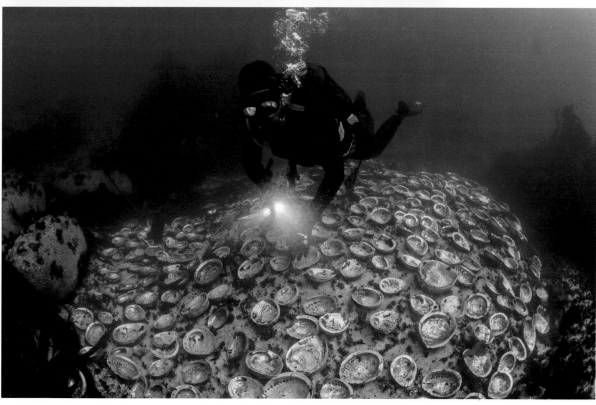

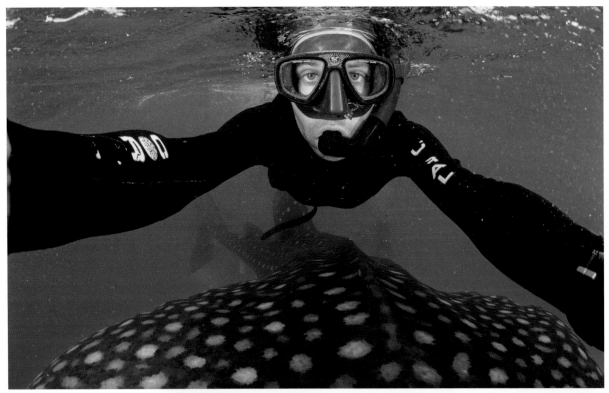

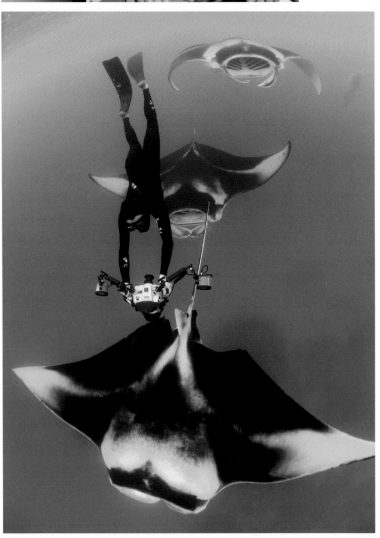

On Assignment • *National Geographic* assignments have taken me to some of the wildest seas and most remote islands on our planet; free diving with manta rays in the Maldives, shooting selfies with whale sharks off Djibouti, and having giant tortoises as roommates on Aldabra Atoll are just a few of the highlights. The life I have lived over the past 20 years is as close as possible to my childhood fantasy of becoming Jacques Cousteau.

matter how alarming my scientific data, all my warnings seemed to fall on deaf ears.

My reason for becoming a marine biologist was to make a difference in conservation. But as I watched abalone Armageddon unfold and failed miserably to stop it, I realized that I had to find a more compelling way to communicate and inspire change.

In tandem with collecting data, I had often made photographs to include in both scientific presentations and my Ph.D. thesis. Compared with the standards I use today, my early work was crude at best. But my access to the front lines of abalone poaching was unique, and so I was able to place my photographs in popular publications with ease.

At first it was just small local community newspapers, often with readerships of fewer than 50, most over the age of 80. Regional and national newspapers and magazines soon followed, and eventually my images and stories appeared internationally. The more I published, the more the authorities and people with influence took note; my images and tales from the front lines touched a nerve and inspired action. Extra resources and personnel for a dedicated marine antipoaching unit was enough to significantly curtail poaching at my research sites.

In a few short months, armed with just a handful of photographs, I accomplished what I had been unable to do with years of data. This was a game-changing moment: I realized I could achieve more through photographs than statistics. Although there wasn't a name for it yet, I had in essence become a conservation photographer. Googling this field at the turn of this century would have resulted in articles about the restoration of historical photographs. In 2020, the same search yields nearly 50 million hits about how photography can catalyze the conservation of animals, plants, and natural habitats.

Although the term "conservation photography" was only coined in 2005, the practice is deep rooted. In the 19th century, images by Carleton Watkins and William Henry Jackson helped gain protection for both Yosemite and Yellowstone, while Ansel Adams's iconic landscape photographs were instrumental in expanding the U.S. National Park System in the 20th century.

Around the same time I was wrestling with my Ph.D. in South Africa, something much bigger was afoot on the continent. Ecologist Mike Fay was conducting his 2,000-mile MegaTransect from the Congo rainforests to the coast of Gabon. Three articles about this iconic feat, photographed by Michael "Nick" Nichols, were published in *National Geographic* magazine in 2000 and 2001, and the ripple effects were astonishing: Thirteen new national parks and more than $50 million in funding to preserve the Congo Basin were the direct results of their work. Watching this global conservation milestone unfold, I began to understand the power of what I accidentally tapped into by trying to protect abalones.

Afraid to admit the truth to myself, I stuck with science for a few more years. But my love for research waned as my love for photography took hold. I went for many data-collection dives in the kelp forests, equipped with writing slates, measuring calipers, and my underwater camera. Instead of measuring the size distribution of juvenile abalones in cryptic habitats, I got lost in photographing the antics of a spotted gully shark or octopus, often misplacing my science tools in the process.

I was afraid my professors, parents, and colleagues would see a career in photography as a step down from my lofty scientific ambitions. I envisioned receiving a Ph.D. by 28, becoming the director of a major marine biology lab by 40, and sealing my global reputation as an expert with hundreds of scientific publications by 50. But after years of making excuses, missing deadlines, and downright lying about the progress in my research, I eventually decided to tell the truth.

It was tough bidding farewell to a career in science. Becoming a marine biologist was something I'd dreamed of since I was 10 years old; being a photographer was never really a consideration. My heroes were the marine scientists depicted at work in *National Geographic* magazine. I marveled at their adventures exploring underwater caves filled with sleeping bull sharks or diving with Weddell seals under Antarctic ice. Flashlight in hand, I spent many nights under my blanket reading fish ID books as if they were the *Harry Potter* series. (The scientific name of the sergeant major damselfish–*Abudefduf saxatilis*–could even pass for one of Hogwarts' spells.)

In 2005, I walked away from my Ph.D. to focus solely on photography, and spent the next two years exploring southern Africa's underwater realm. While most photographers in the region were making images of elephants, lions, and leopards, I focused on revealing the biodiversity of the region's oceans and coasts. I captured great white sharks feasting on whales, jackals hunting fur seal pups, and common dolphins herding sardines. I even watched a herd of antelope wade across the mouth of the Cunene River while green turtles and Nile crocodiles basked together on exposed sandbanks. Pliny the Elder put it best when he wrote, *"Ex Africa semper aliquid novi*–From Africa, always something new."

Being a photo nomad involved living in my Land Rover and subsisting on stale crackers, cans of expired corned beef, and *chakalaka* (African vegetable relish). These years were filled with adventure and excitement, but also heartbreak and fear. When I felt lonely and lost, my photographs were never good enough; doubt crept in like a draft. I often wondered if I'd made a huge mistake.

Today, with eight books, hundreds of articles, and more than 14 *National Geographic* magazine features under my belt, I am finally at peace with my decision. Every once in a while, when insecurity gets the better of me, I still wish I had become Dr. Peschak. But thank goodness, this desire is ephemeral. Although I have not written a scientific paper in ages, I will always be a marine biologist at heart. Science and conservation still underpin everything I do; the photographs I make have to tell a story that inspires real and measurable change.

Achieving that goal, as it turns out, involves quite a lot of work. For a single story, I often spend more than six months in the field, but the research period leading up to that trip takes much longer. I read hundreds of scientific papers, dozens of books, and consult with experts from around the world. This research helps me work out what photographs I need to tell a story effectively, as well as exactly where, when, and how to create them. Oceanography, animal behavior, climate, and so many other subjects factor into every image I make. Capturing the desired scene in my camera's viewfinder is just the final act, and often the easiest part of the process.

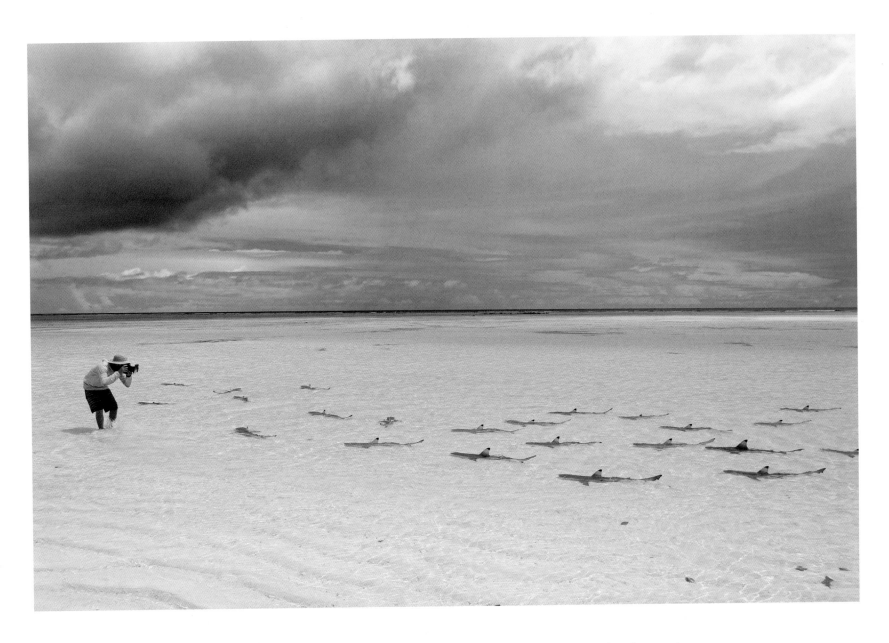

Into the Wild • I love being immersed in wild places; they inspire me to create images that I hope make a difference. But reaching them is never easy. Getting to Aldabra's shark-rich shallows took a week, two commercial flights, one $25,000 chartered propeller plane, and six hours on a small boat through rough seas.

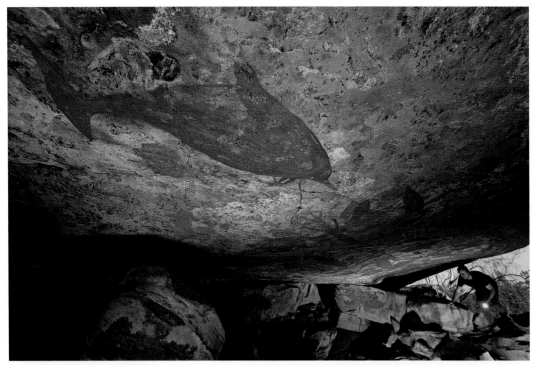

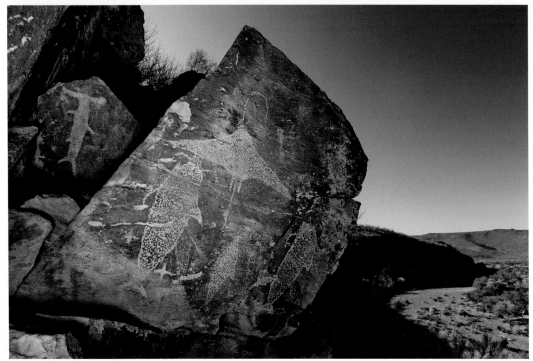

Ancient Artists • Ocean storytelling began long before the first underwater photo was taken in 1856. A mule-fueled journey through the remote mountains of Baja California Sur, Mexico, revealed 5,000-year-old rock art depicting manta rays, sharks, and tuna. Time spent with Aboriginal elders in Australia allowed me the privilege to photograph magnificent, ancient painted frescoes of dugongs, turtles, and dolphins in a cave on Groote Eylandt.

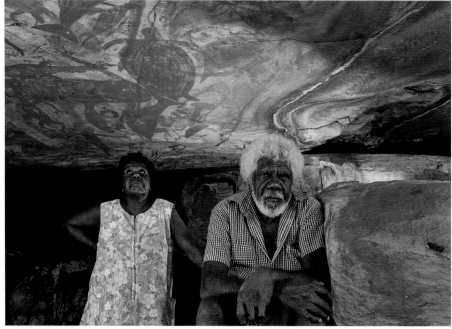

Needless to say, it's difficult to become a champion for something you don't know exists. So as a conservation photographer, I am a matchmaker: I introduce people to wildlife that lies hidden beneath the ocean. This is one of the superpowers of this field; it's all about finding the right balance between the carrot and stick.

To inspire people, I show them pristine marine habitats and magical creatures. But I also reveal the darker side of our relationship with the ocean, including pollution, climate change, and overfishing. I walk a fine line between inspiring and disturbing: Too much beauty results in complacency, while too much gore leads to hopelessness. I try my best to tell balanced stories that get people to think, act, and ultimately try to make a difference. An Indigenous North American proverb eloquently sums up this mission: "Tell me the facts and I'll learn. Tell me the truth and I'll believe. But tell me a story and it will live in my heart forever."

I HAVE ALWAYS BEEN CURIOUS about the history of ocean storytelling. When and how did humans begin to tell and depict tales of the sea and marine animals? William Thompson made the first underwater photograph in 1856, off the coast of Dorset, England. But the first images of ocean life are much more ancient. In 2015, I embarked on a series of expeditions to search for the works of the first artists and storytellers.

And that's how I find myself deep in the Sierra de San Francisco, a rugged mountain range in the center of Mexico's Baja California, riding a mule named Juanita. Minutes earlier she had walked too close to a candelabra cactus, and now my pants are down by my ankles. In my right hand I clutch the tweezers of my Swiss army knife; desperately, I twist and crane my neck to extract spines sharp as hypodermic needles now firmly lodged in my flesh. Earlier in the day, Juanita had pooped on one of my camera bags. We've only known each other for three days, but I get the feeling she doesn't like me very much. The two of us, along with two other mules, five humans, and four donkeys laden with camera gear, are about to descend into one of the world's most dramatic desert canyons.

Despite my terrestrial surroundings, I am in fact here to photograph manta rays—but not the kind you might imagine. A helpful goat rancher points my guides in the vague direction of a nearby hill; this will be my very first time climbing up, rather than diving down, to photograph sea creatures.

We arrive at the top and there they are: four large rays, finely drawn in red ocher. The artist painted them on an overhang, and it evokes the sense that the mantas are passing overhead. Did the artist observe them underwater? Why were these marine animals painted in a desert canyon? Are they a simple record of a favorite food item? Or was the artist trying to tell a story?

The answers are not immediately obvious; archaeologists estimate these murals to be five thousand years old, created by the Cochimí, an Indigenous people who were tragically decimated by disease at the beginning of the 20th century. Unfortunately, the link between the modern world and rock art is often lost; only later do I meet people who still have an ancestral connection to prehistoric images of marine wildlife.

Three years later, I find myself engaged in a similar journey. This time, I'm inside a cave on the vast sandstone plateau of Groote Eylandt, homeland of the Warnindhilyagwa people in Australia. Above me is a one-of-a-kind fresco, a gallery rich in marine megafauna with layer after layer of dugongs, dolphins, stingrays, and saltwater crocodiles. The art here is not a simple catalog of animals found in their waters; it's a representation of the totemic connections of Aboriginal culture to the seascape and the creatures with whom they share it.

I'm guided on this adventure by Ida Mamarika and Christopher Maminyamanja, two elders who tell me stories of totem animals forming the landscape during the creation of the world. Ida tells me that the green turtle is one of the totem animals of her clan, the Wurrakwakwa.

I crawl to the back of the cave until my headlamp illuminates a painting of a very large sea turtle. Dugout canoes paddled by hunters block its path, and two harpoons are embedded in the turtle's head and flipper. This is clearly a story, either a factual one showing a memorable hunt, or a work of fiction depicting a hunt the artist hopes to manifest.

Although our mediums may differ—sandstone versus digital photography—I realize that the two of us are both telling stories about the ocean and its creatures. And though we are separated by space and time, I feel deeply connected to this artist.

MY LIFE AS a *National Geographic* photographer has been socially isolating, emotionally exhausting, and physically demanding—but it is the most rewarding pursuit I can imagine. I have cried from loneliness, felt nauseous with fear, and cursed in frustration. But every time I thought I was at my limit, I discovered untapped reservoirs of strength, creativity, and passion. This is not just a job; it's a calling.

From the moment I first donned mask and snorkel as a 10-year-old, the oceans, coastlines, and remote islands of our planet have felt like home. Although they are places of inspiration and hope, they are also beset with challenges. But most important of all, they are a bottomless reservoir for photographs and stories. I will always have vivid memories of kayaking with great white sharks off South Africa, rubbing shoulders with king penguin chicks on Marion Island, dodging saltwater crocs on Cape York's beaches, and communing with thousands of jellyfish in the cold seas off Canada's Great Bear Rainforest.

The 200-plus images in this book are my favorites from more than a million I made between 2002 and 2019. They transport me back in time; each is a reminder of where, how, and why I made them. My photographs help me to recount the tale of a unique animal, a wild place, or a critical conservation threat; together, they tell the collective story of our planet's wild seas. But they also tell my own story.

Conservationist George Schaller observed that "Pen and camera are weapons against oblivion, they can raise awareness for that which may soon be lost forever." I hope this book will play a small part in ensuring that the beauty and life contained within it will not be lost forever.

This project was inspired by love and fear; love for the oceans and fear that future generations will not get to experience them the way I have. May they, too, feel the rush of swimming with sharks, be overwhelmed by the riotous sound of a penguin colony, and experience the rich bouquet of a gray whale's sneeze.

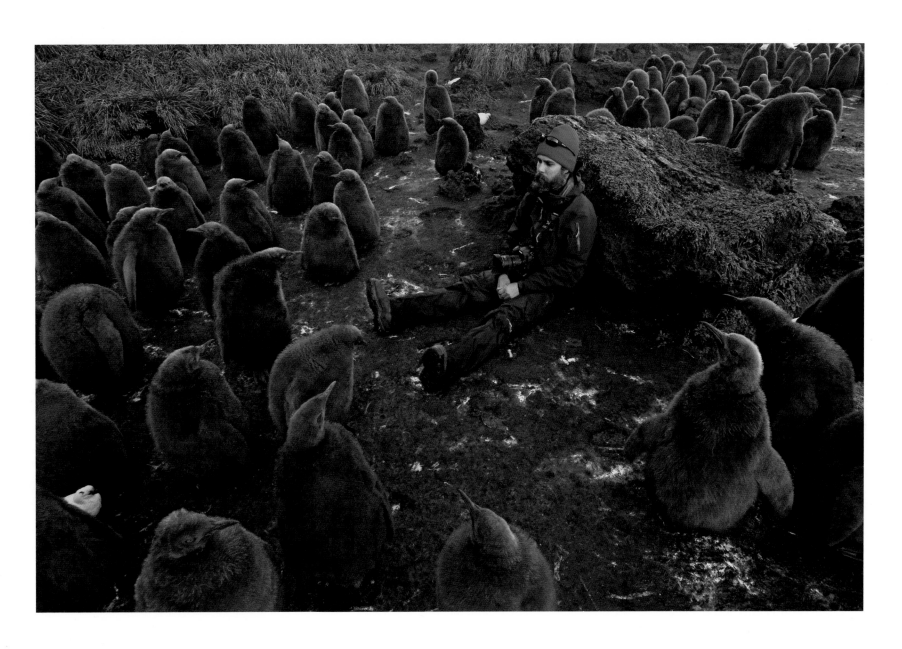

Laws of Attraction • Most of my life is lived behind the camera, and the only time I became a chick magnet on a *National Geographic* shoot was in a creche of king penguins. On subantarctic Marion Island, these young birds were instantly drawn to me; they could not stop staring at this strange bearded bird in a red hat.

Ancient Mariners

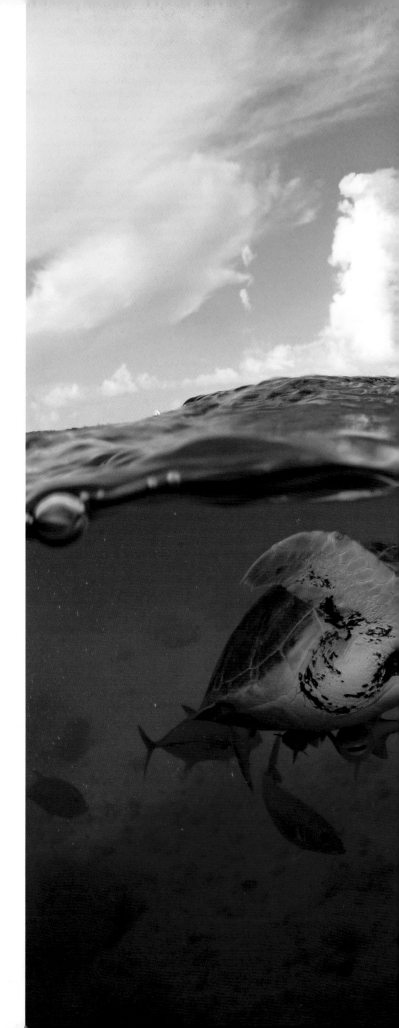

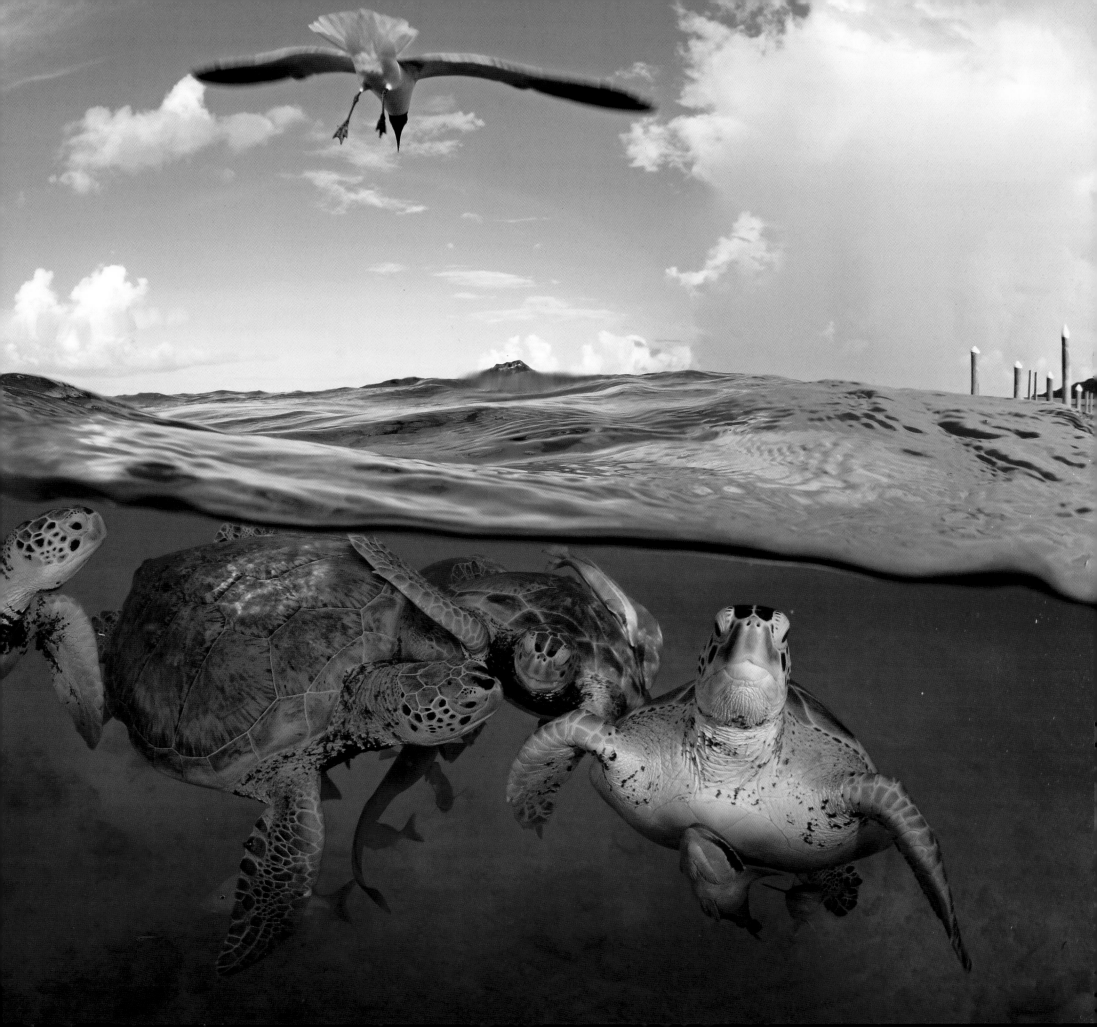

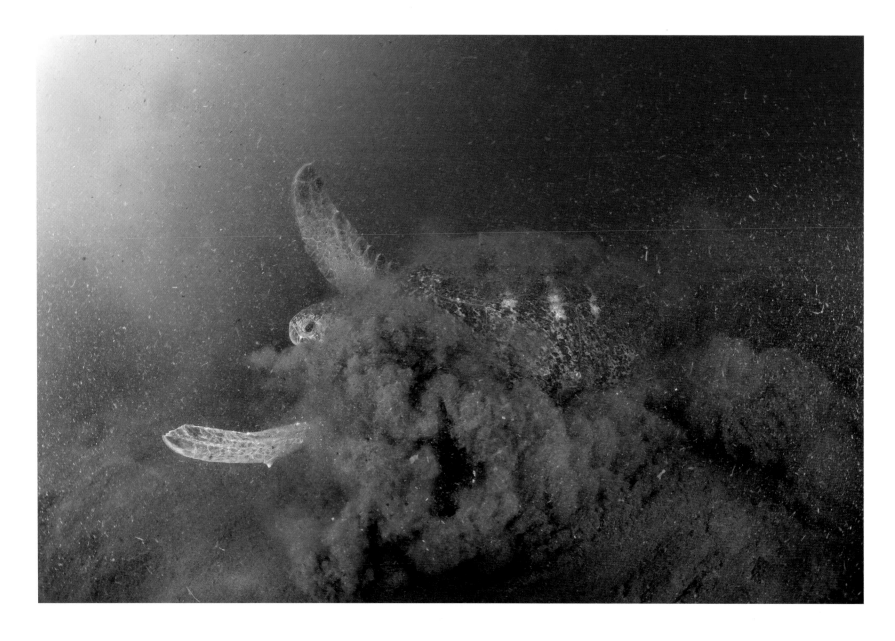

Mud Monster • A green sea turtle erupts from the muddy seabed along the east coast of Fernandina Island. Galápagos, 2017

PREVIOUS PAGES

Turtle Time Machine • Green turtles congregate near a dock at a fledgling ecotourism project at Little Farmer's Cay. Bahamas, 2018

"STOP SHAKING the damn ladder!" I yell into the tropical night. My photographs are a blurry mess. The ladder moves again, this time with such force that I almost fall off. I have been awake for more than 24 hours and am ready to strangle my assistant, Filipe, who is tasked with keeping the ladder steady.

I sweep the red light of my headlamp downward, but he is nowhere to be seen. In his place are two very determined olive ridley sea turtles, who are clearly trying to bulldoze my ladder out of their way. I had been so focused on the dozens of turtles scaling the beach in front of me that I had missed thousands on the move right behind me. Almost every inch of sand is covered in a moving puzzle of shells and flippers. During these mass nesting events, called *arribadas,* as many as half a million female turtles come ashore at Ostional along Costa Rica's Pacific coast. Over the course of five days, they collectively deposit 10 million eggs.

I finally spot Filipe down the beach, where he is hurriedly packing up my equipment before it is trampled or buried in the sand by the onslaught. Soon we are almost entirely surrounded. In the dim red light of our torches, it is hard to distinguish where beach ends and sea turtles begin. Ladder in hand for more than 20 minutes, we slalom walk between olive ridleys to navigate the half mile back to our vehicle.

Years ago, I learned that the distinction between a great picture and a *National Geographic* picture can often be a matter of centimeters. I now climb trees and buildings, tables and chairs in search of a more original perspective. But sometimes, as on a beach in Costa Rica, there just isn't anything to scale. For those moments, I always have a ladder on hand.

Although I have photographed nesting sea turtles on four continents, what I experienced that night was otherworldly. Normally I hike for hours on remote beaches, hiding in bushes to wait for a lone turtle to emerge from the surf. Until she lays her eggs and goes into a trancelike state, I remain perfectly still so as not to disturb her. But these olive ridley turtles were not at all secretive. They ran roughshod over my ladder, driftwood, and even one another.

Nesting numbers are so high in this area that turtles run out of space, sometimes inadvertently digging up previously laid eggs so that they might lay their own. To take advantage of this overcrowding issue, the local community in Ostional is allowed to collect eggs for the first 48 hours of the event. Funds from the sale of eggs go to community development and conservation projects, including employment of a biologist and round-the-clock turtle guards. After three decades of harvesting, the number of nesting olive ridleys at Ostional has remained stable.

Unfortunately, the same cannot be said for other species. Hawksbills and Kemp's ridley turtles are critically endangered on a global scale, and leatherback and loggerhead numbers are in steep decline in the western Pacific and northern Indian Ocean, respectively.

During Columbus's second Caribbean voyage in 1494, green sea turtles were said to be so numerous that his ships nearly ran aground on them; apparently, his crews could almost walk to shore on their backs. At that time, the green sea turtle population in the Caribbean was estimated to be as high as 660 million adults. Today, the species is endangered, with the global population hovering around 100,000 nesting females. Targeted fisheries, bycatch, and coastal development have taken a heavy toll.

With most green sea turtle populations mere remnants of past abundance, I was encouraged in visiting Little Farmer's Cay in the Bahamas. In the past, local fishermen regularly hunted these animals; now a younger generation realizes that they are worth more alive than dead.

Over decades, the green sea turtles of a local bay became habituated to the sound of fishermen cracking conch shells; the noise served as a signal for them to congregate and feed on conch fishery discards. Today, these turtles are fed more deliberately, but are still attracted to the dock by the sound of a hammer on a conch shell. Day-trippers from as far as Nassau travel here to swim with green sea turtles. If properly managed, the fledgling operation will benefit both the animals and locals.

Although I will never get to experience the number of turtles that roamed the Caribbean in 1494, the ones swirling around my head in this little corner of the Bahamas helped me imagine the wonder of our oceans' past.

Lit From Within • A rare trifecta of high tide, sunset light, and glassy calm seas in Aldabra lagoon reveals a green sea turtle grazing on sea grass. The atoll hosts one of the healthiest populations in the Indian Ocean. Seychelles, 2008

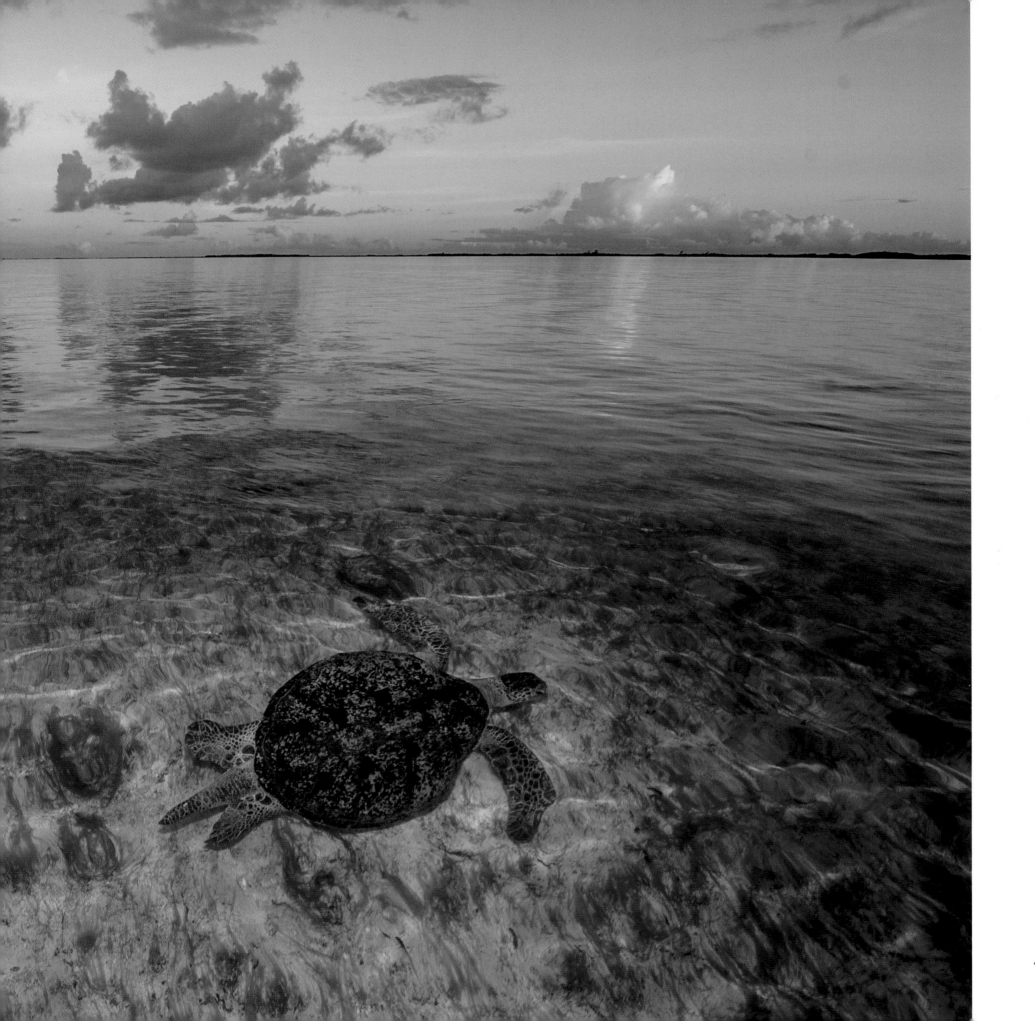

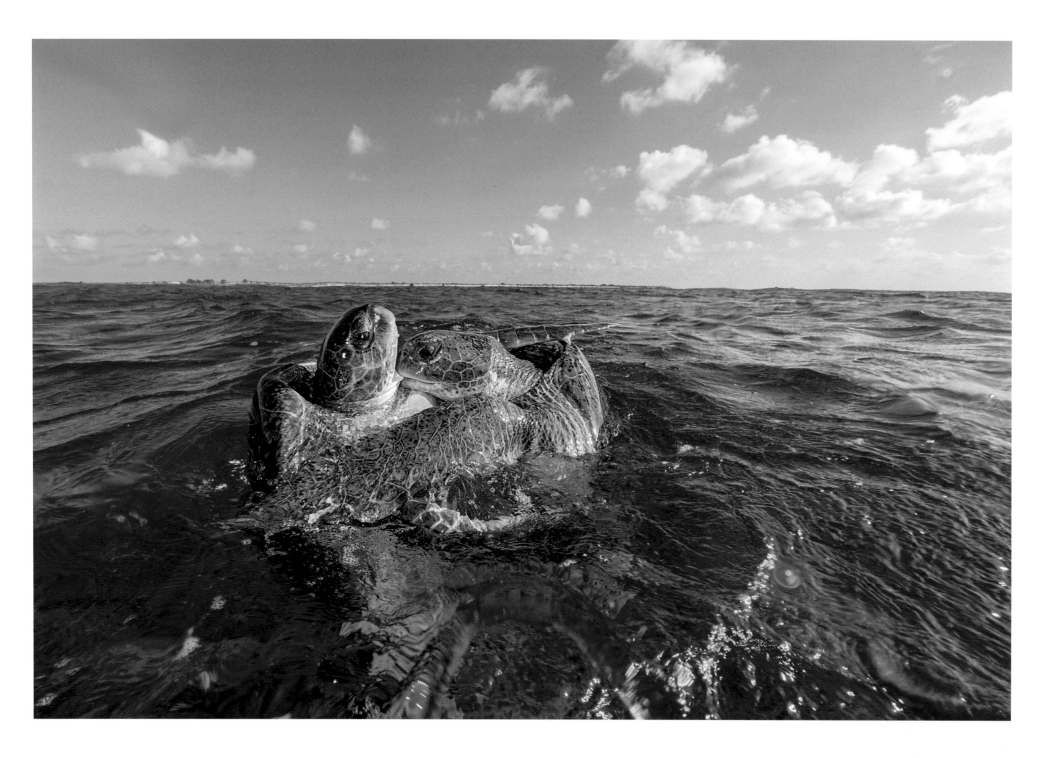

Love Bite • A male green sea turtle clings to a female off Europa Island. Getting into mating position can be tricky when bobbing like a cork on the surface. This struggling male latched onto the female's neck for additional leverage. Mozambique Channel, 2010

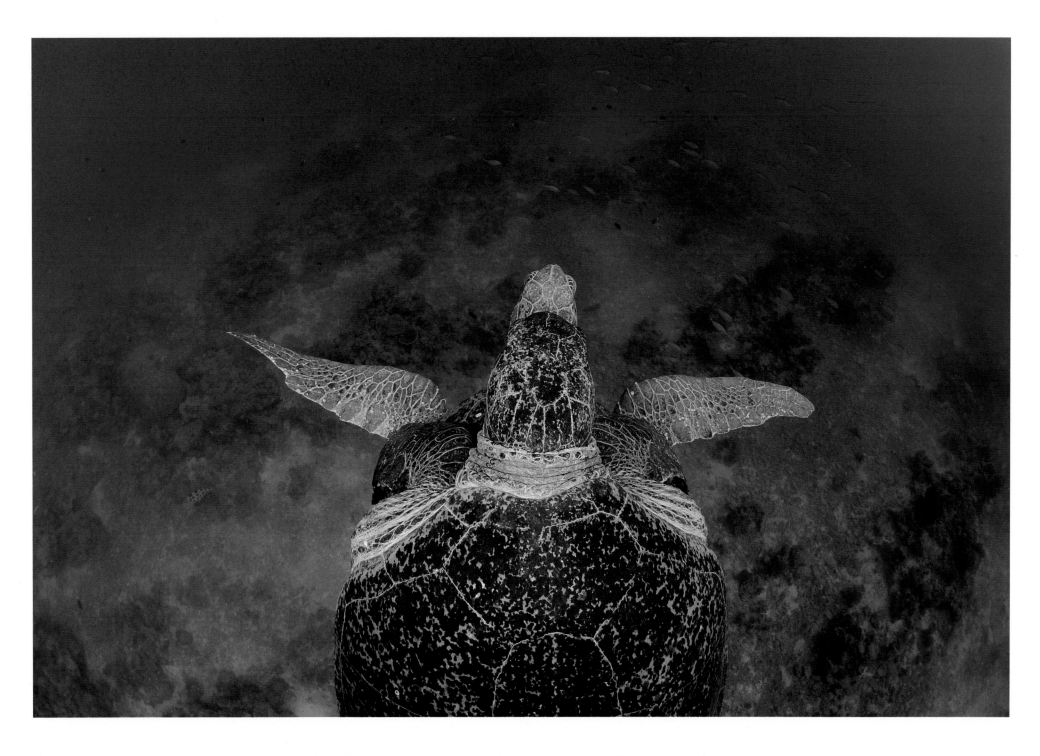

Along for the Ride • Sea turtles can remain in a mating embrace for hours. With the male on top, the female determines their journey as they sail through open water, along coral reefs, and across sea grass beds. Mozambique Channel, 2010

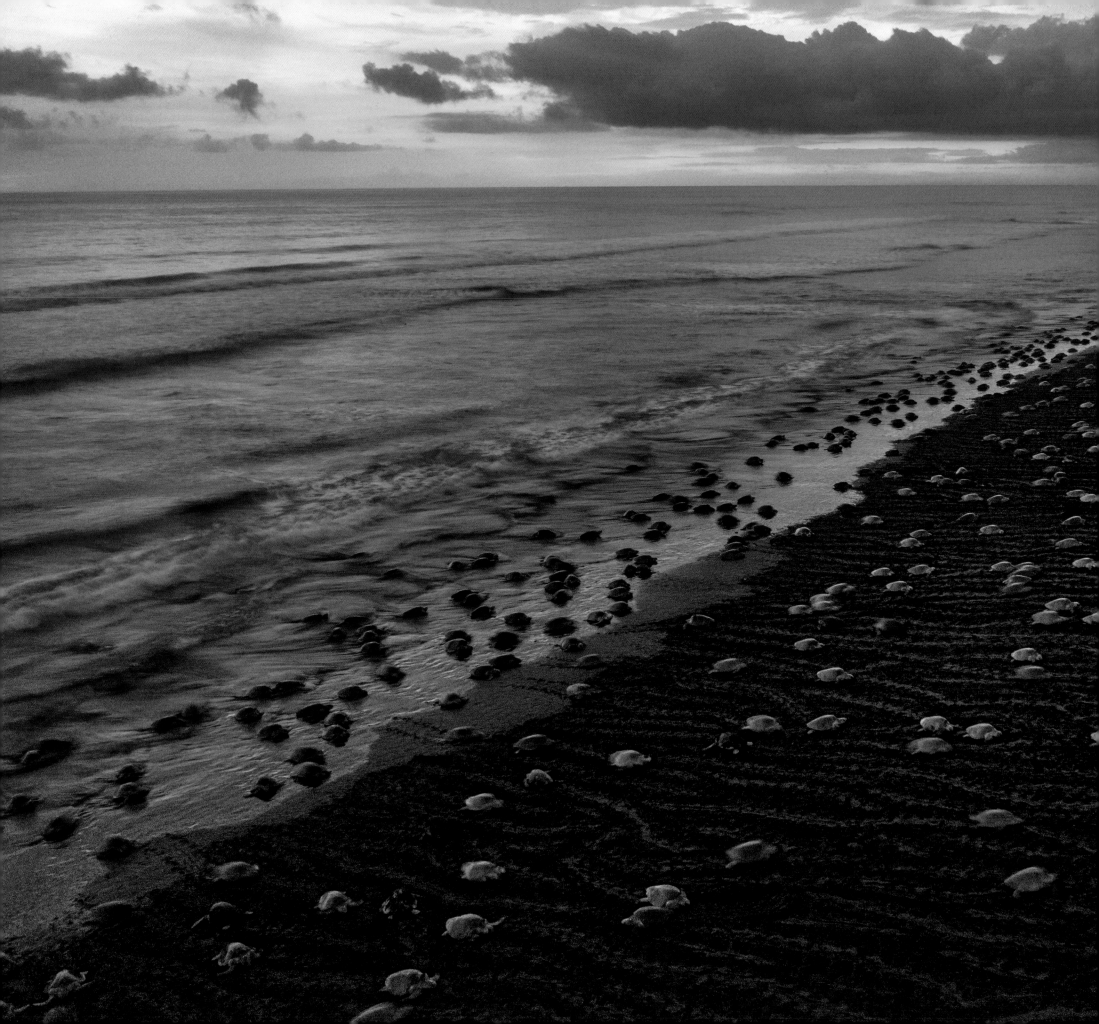

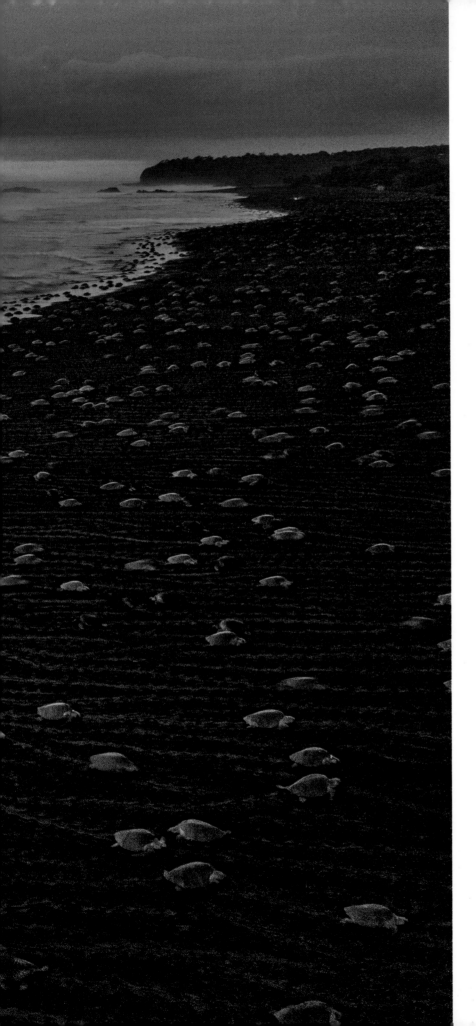

Drone's-Eye View • Though they appear as hatchlings from this drone image, these adult olive ridley turtles are three feet in length. Once or twice a month during the rainy season, mature female turtles come ashore at Ostional by the tens of thousands. Costa Rica, 2018

Outback Flatback • A flatback sea turtle kicks up sand while digging her nest on remote Crab Island, off the Cape York Peninsula. To monitor the flatbacks' most important nesting beach, Indigenous rangers with the Apudthama Land Trust brave saltwater crocodiles and merciless mosquitoes. Queensland, Australia, 2018

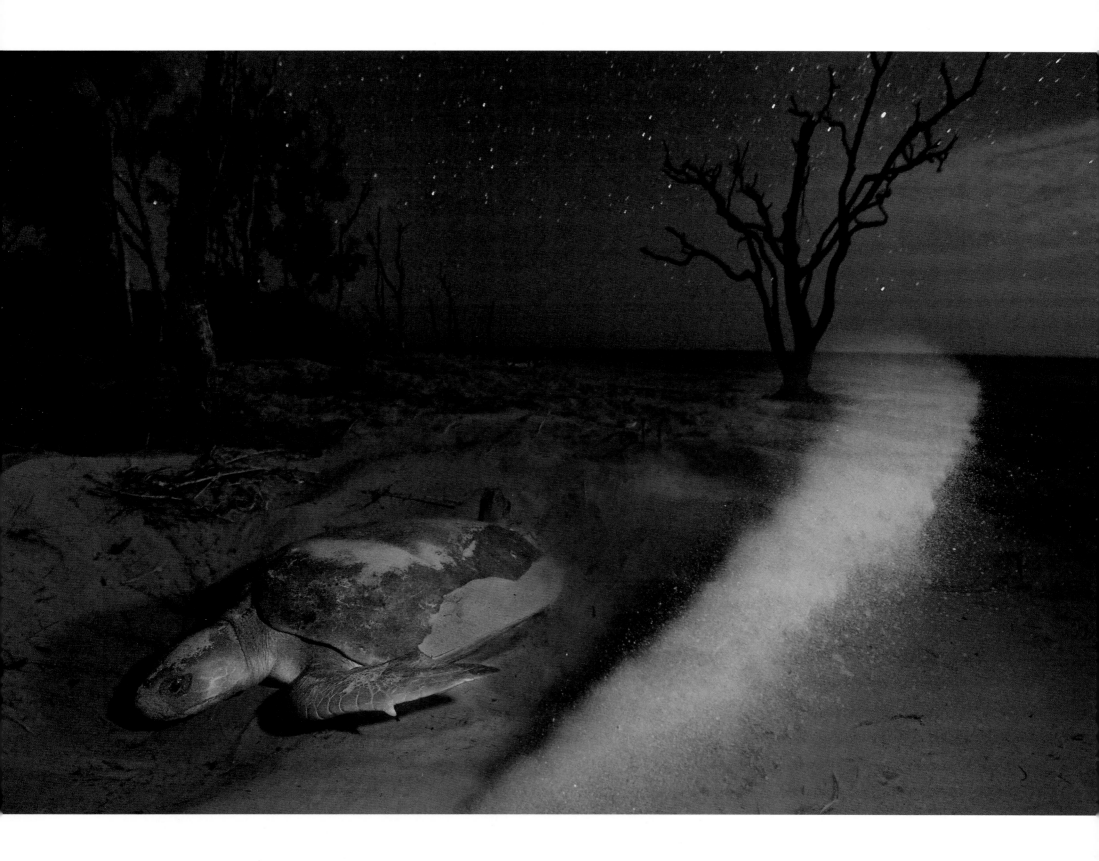

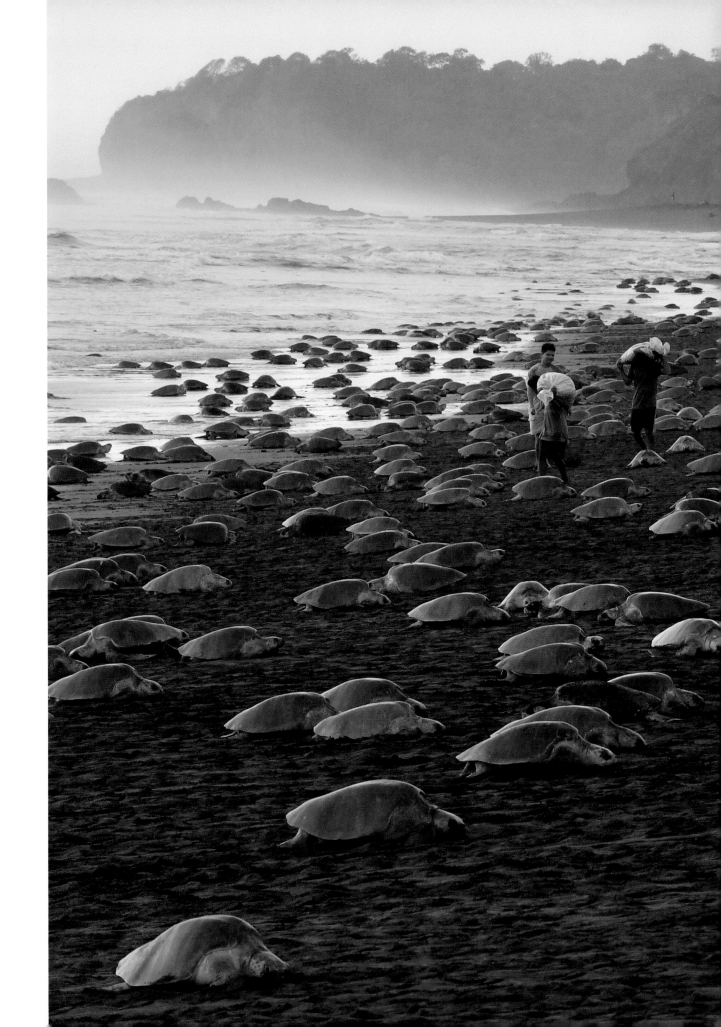

Nature's Egg Basket • At Ostional, olive ridley turtles nest so close together that they inadvertently crush one another's eggs. During this window of overcrowding, authorities allow residents to gather turtle eggs for consumption and domestic sale. Costa Rica, 2018

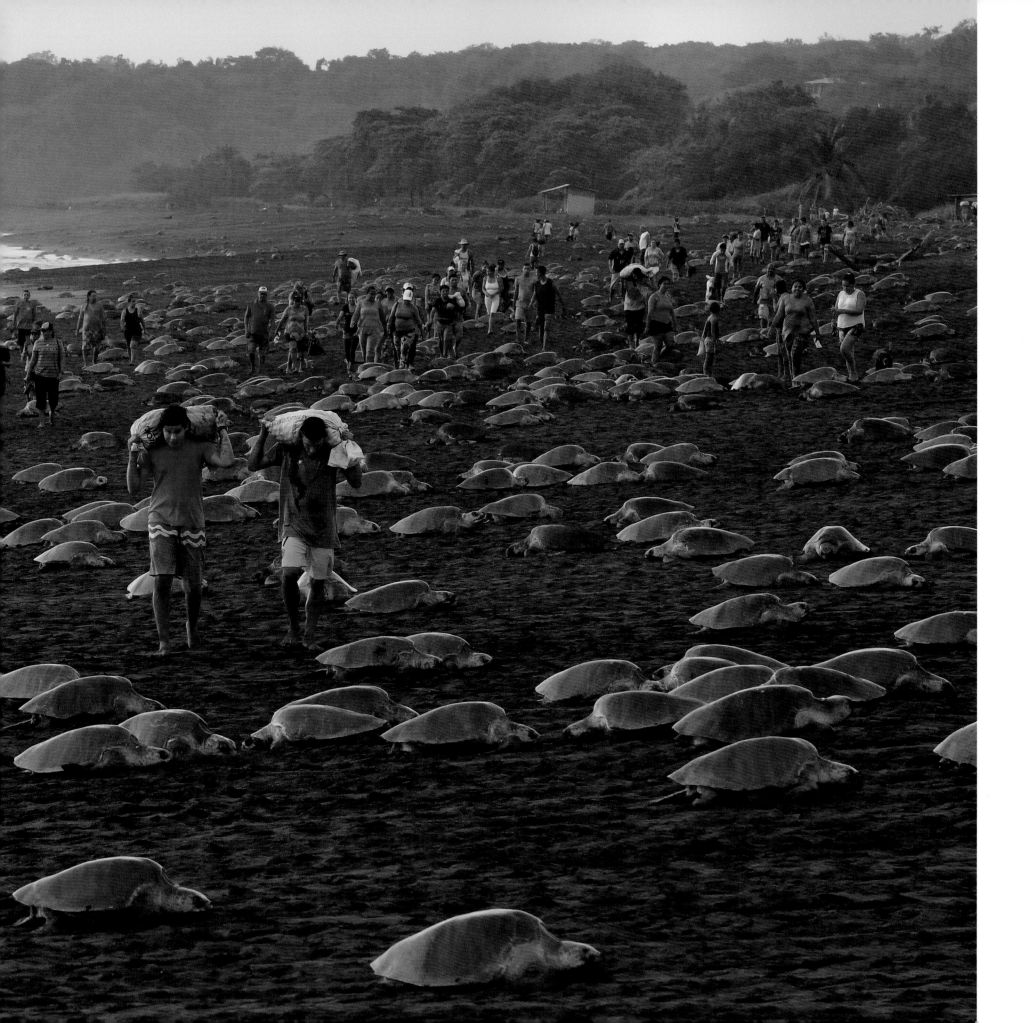

Poached Eggs • To find out if illegally collected eggs are "laundered" with the official Ostional harvest, the NGO Paso Pacifico developed 3D printed turtle eggs equipped with GPS trackers. The fake eggs are placed in turtle nests, and if poached, biologists track their journey. Costa Rica, 2018

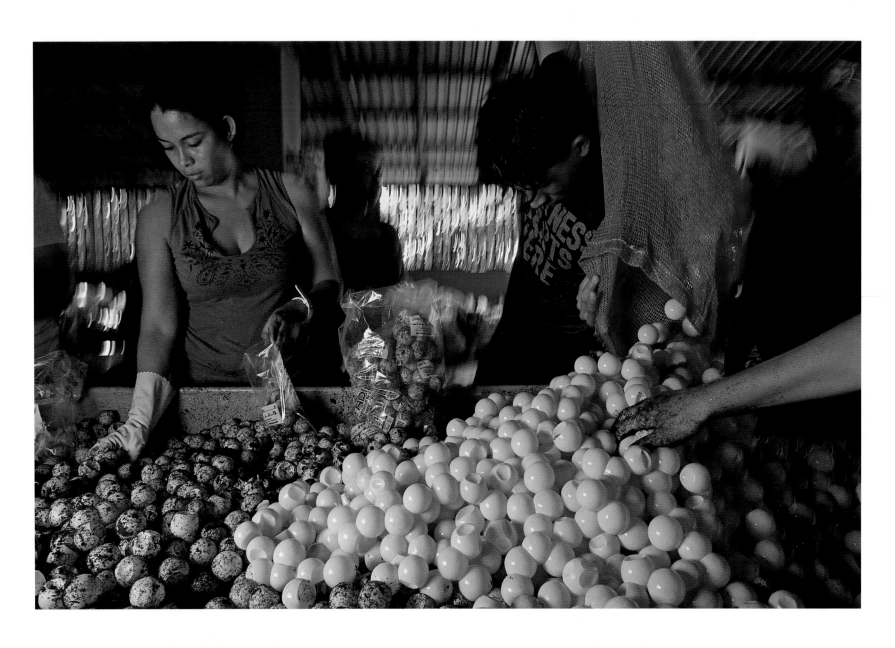

Bountiful Harvest • Olive ridley eggs are packed and shipped to restaurants and bars around the country. Out of the 10 million laid, approximately 15 percent are collected. The number of nesting turtles at Ostional has remained stable for the past 30 years. Costa Rica, 2018

Back to Sea • After completing her annual nesting, a barnacle-encrusted loggerhead turtle paddles into the surf of the Arabian Sea. Masirah Island is a globally important rookery for this critically endangered species, but nesting numbers have declined here by 70 percent over the past 20 years. Oman, 2012

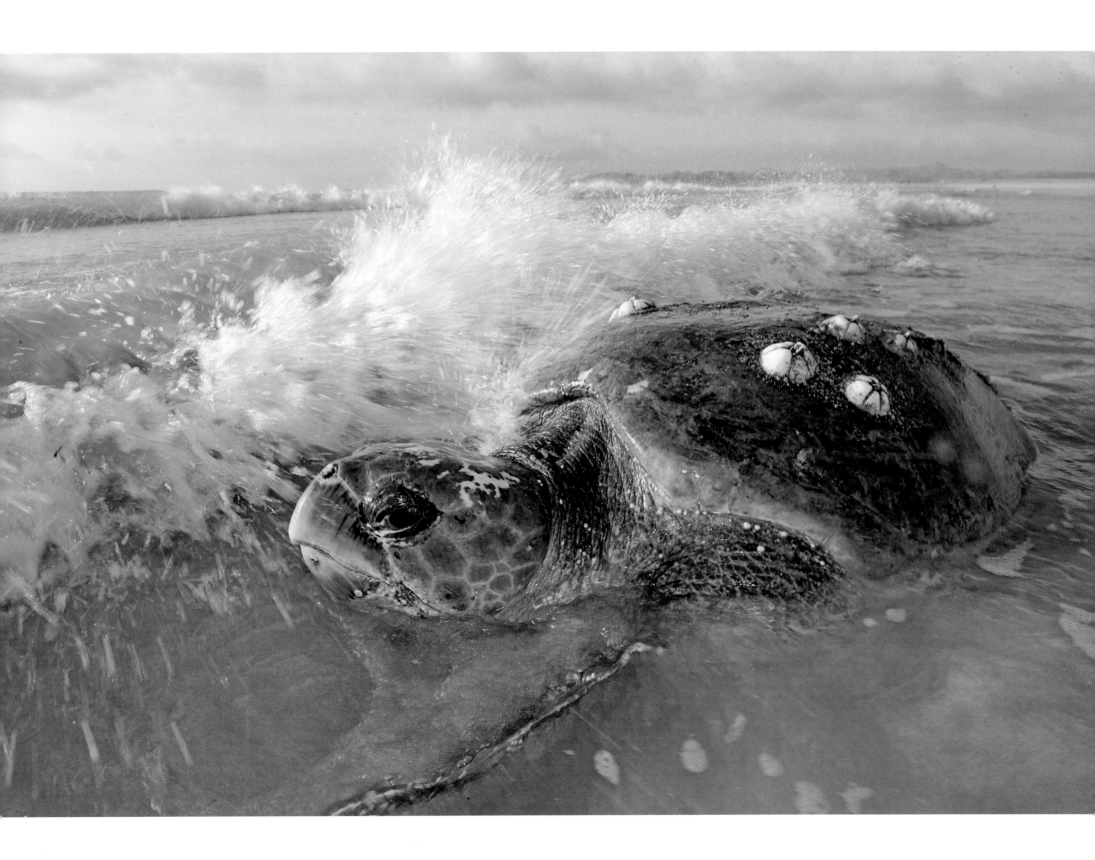

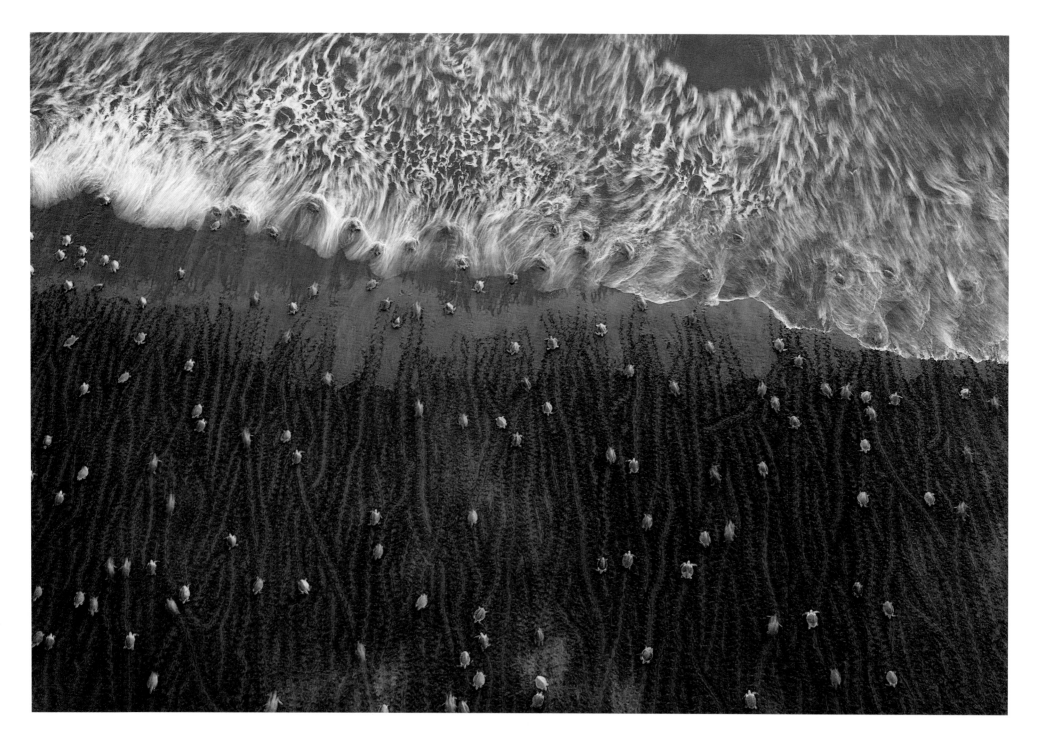

Strength in Numbers • Over the course of an *arribada,* up to 200,000 olive ridley turtles storm the beaches in synchronized mass nesting events. The exact reasons for this phenomenon are still being studied, but one theory is predator swamping. Costa Rica, 2018

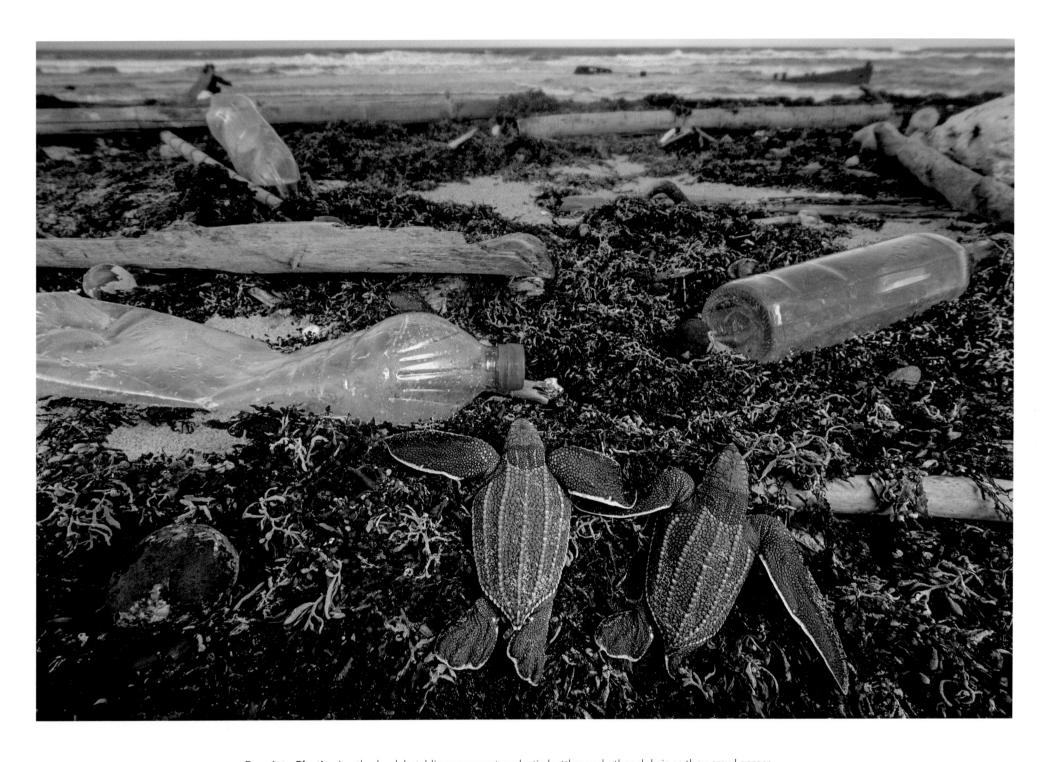

Born Into Plastic • Leatherback hatchlings encounter plastic bottles and other debris as they crawl across Matura Beach to reach the ocean. Nature Seekers, a local conservation group, organizes regular beach cleanups that have helped leatherbacks rebound at that beach. Trinidad, 2019

Blood in the Water • Each year Indigenous fishermen from the Kei Islands harvest roughly a hundred leatherback sea turtles. This western Pacific population has fewer than a thousand females, depleted primarily by climate change and fisheries bycatch. Indonesia, 2017

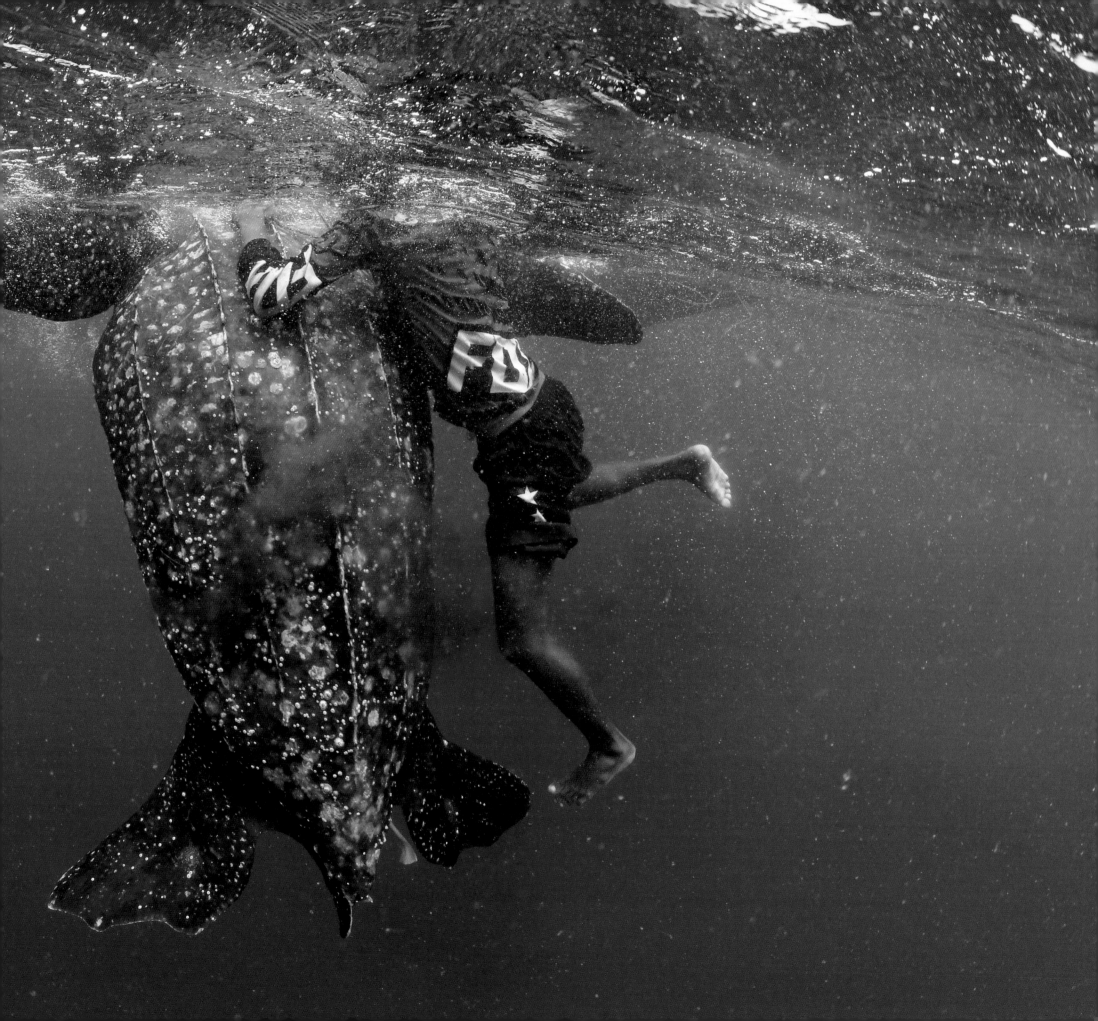

The End • A harpooned leatherback turtle is towed back to shore. This century-old harvest occurs between October and December, when the seas are calm enough for hunters to spot the turtles breathing at the surface. Indonesia, 2017

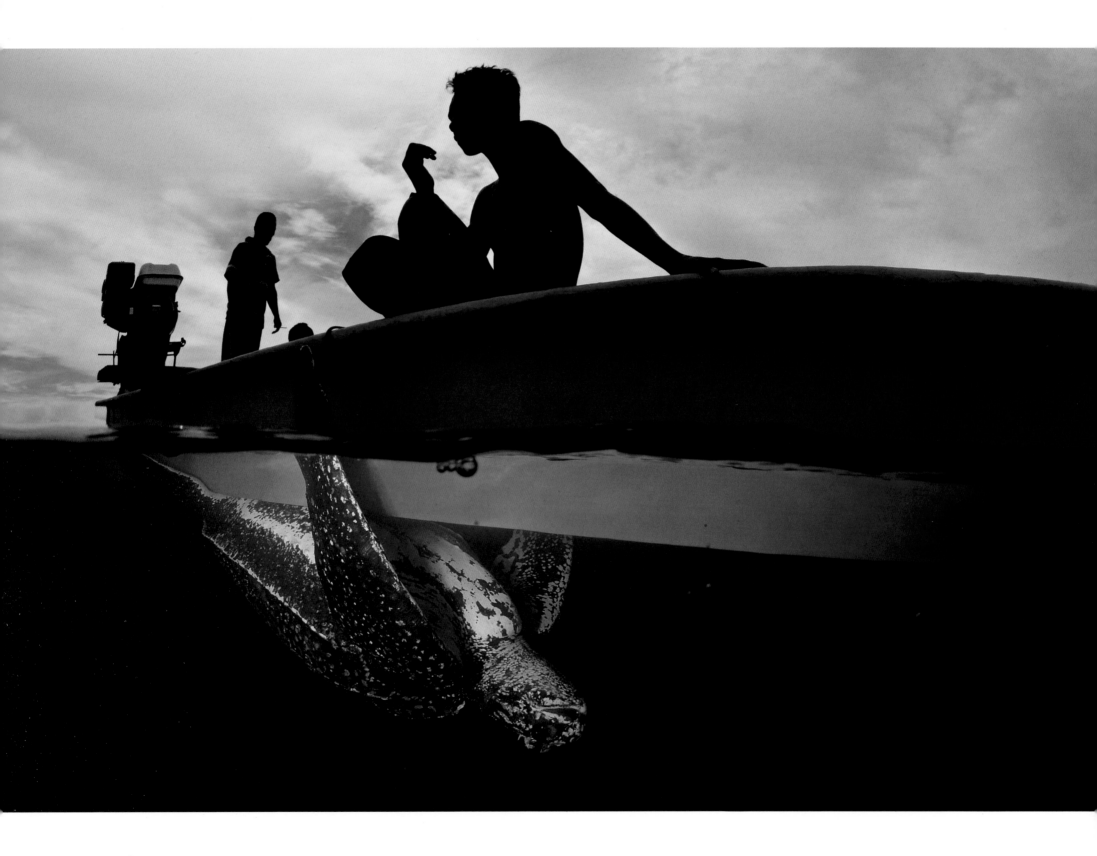

The Dark Side • A critically endangered hawksbill sea turtle nests on the Daymaniyat Islands while the city lights of Muscat shine bright in the distance. Turtles laid their eggs in large numbers on the mainland until coastal development and light pollution encroached on their habitat. Oman, 2012

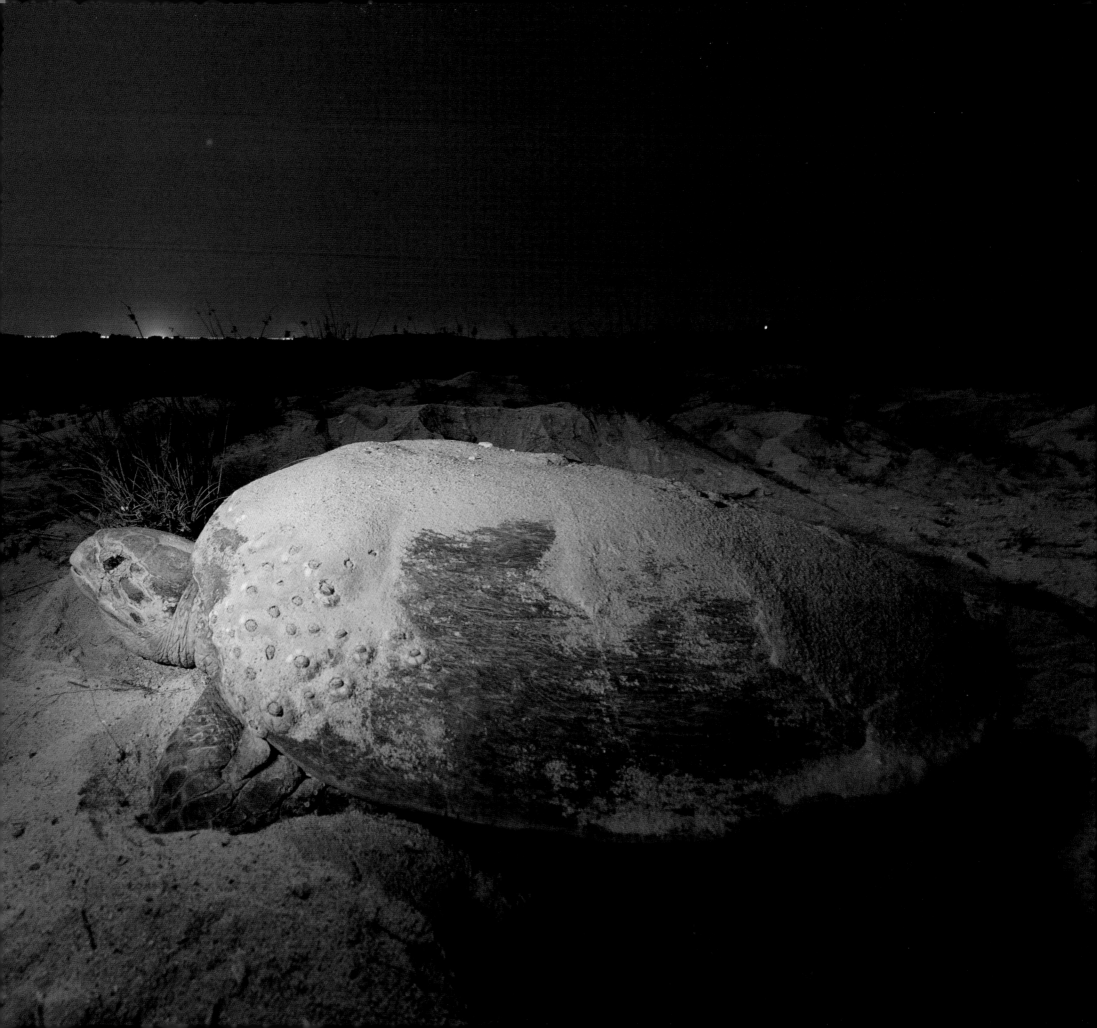

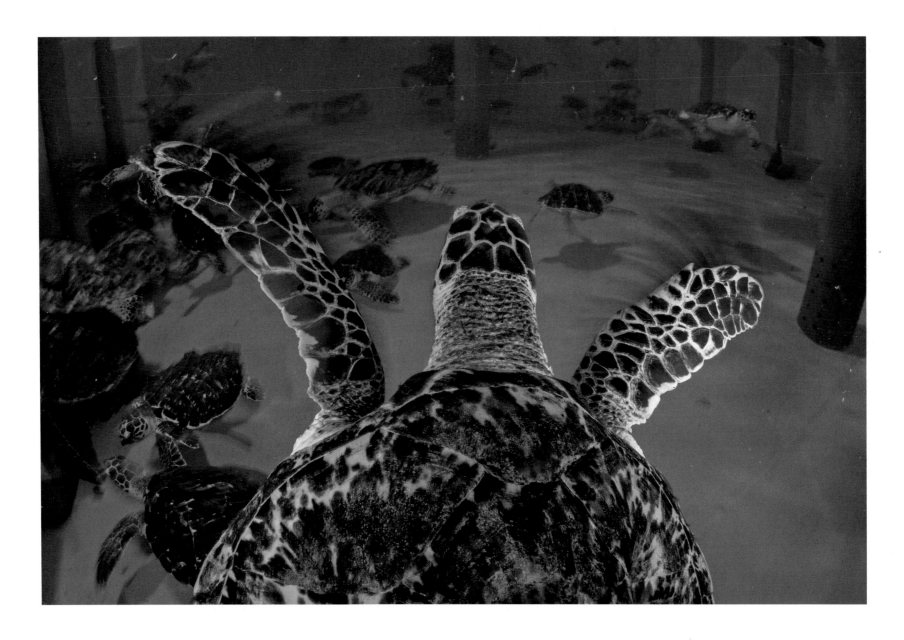

Rehab Deluxe • A sea turtle rehabilitation center operates from one of the world's most luxurious hotels, the Burj al Arab in Dubai. This rescue center has treated and released more than 1,600 sick and injured turtles in the past 15 years. U.A.E., 2011

OPPOSITE

Free at Last • More than 60 rehabilitated hawksbill and green sea turtles are released on Dubai's Jumeirah Beach. Satellite tags track the turtles' successful reintroduction into the wild, with some traveling over 5,000 miles from the release site. U.A.E., 2010

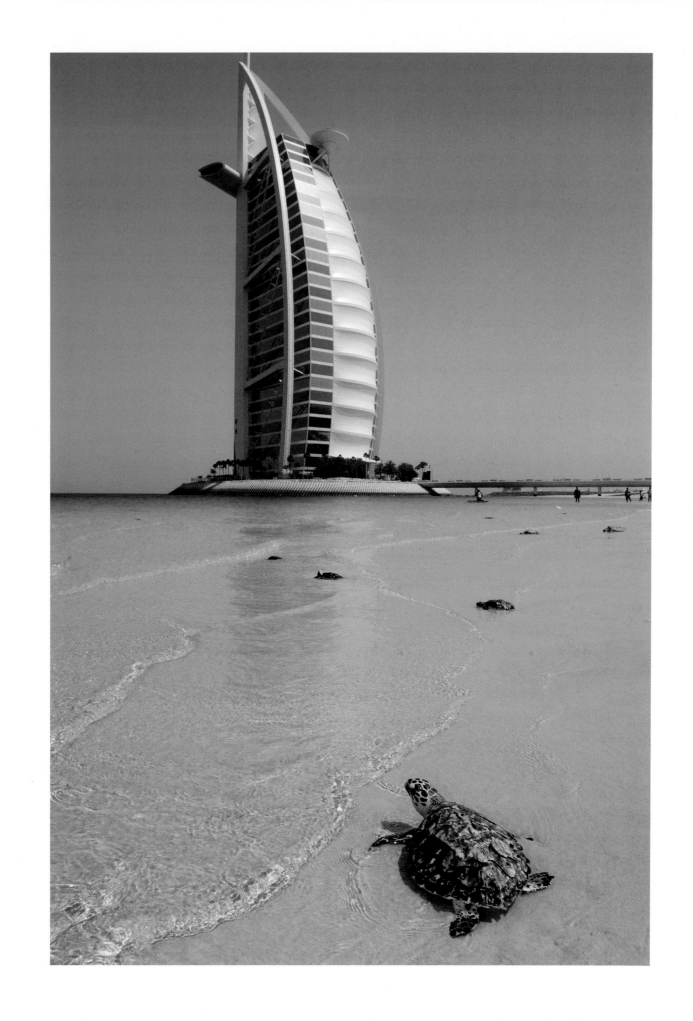

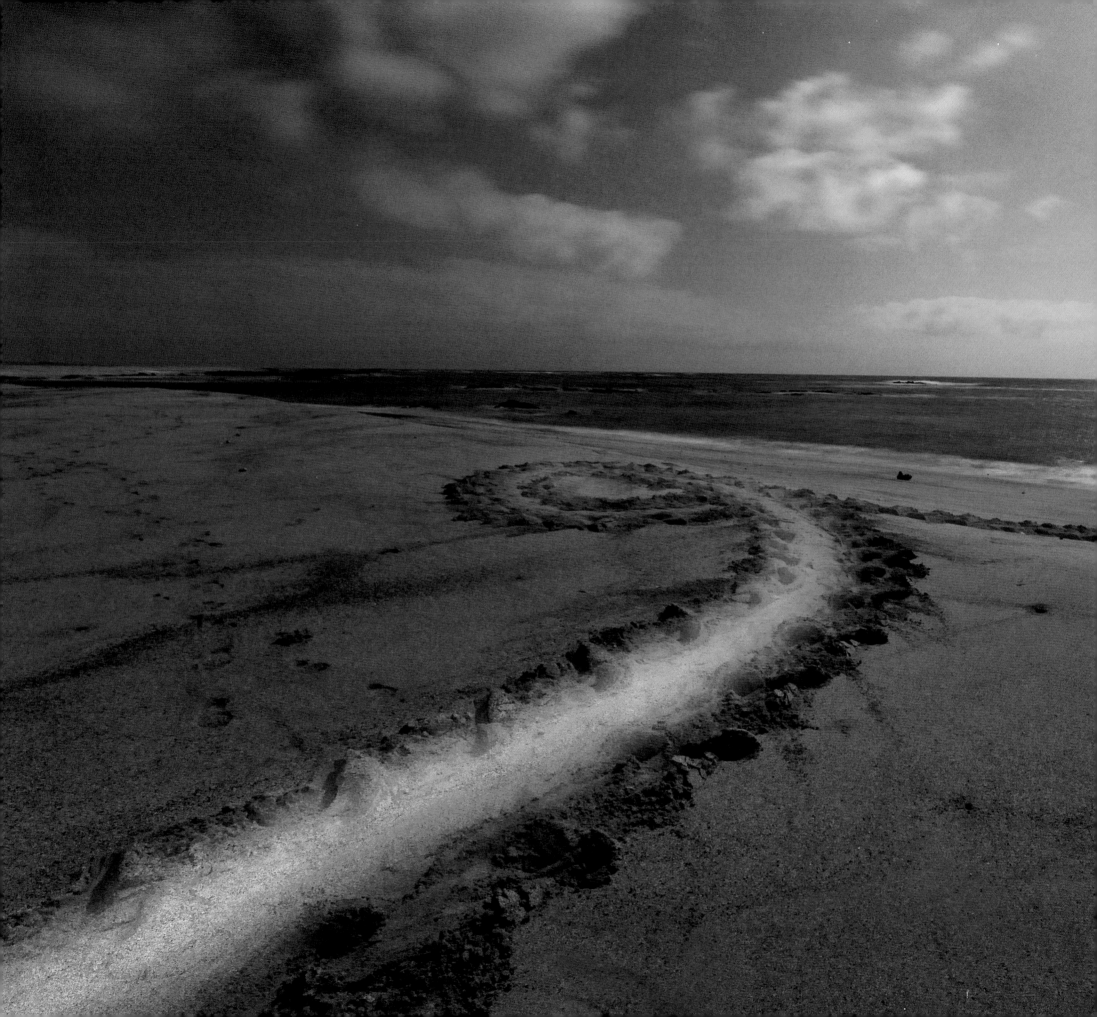

The Return • The track of a loggerhead lit by a flashlight. The track shows where a female turtle left the sea to nest on a remote beach on Masirah Island. Oman, 2012

The Cave

NOT MANY ECOSYSTEMS dominated by reptiles are left on Earth—especially not 100,000 of them, each weighing up to 550 pounds. I wanted to convey through my images of Aldabra giant tortoises what it is like to live with these modern-day dinosaurs in an otherworldly place.

Aldabra Atoll is one of the most inhospitable places on Earth—an exposed landscape of black, razor-sharp limestone and regular temperatures of 110°F. The hottest days on assignment for *National Geographic* in the Seychelles, I drank gallons of water and was constantly drenched in sweat.

Reptiles, on the other hand, cannot sweat, and during the dry season there is little water for them. If the tortoises don't get into the shade by late morning, they risk baking to death in their shells. The supply of shady places is low, and competition is fierce for the few stunted trees. Some tortoises have taken heat relief to the next level: They go underground.

To get to the cave, a small boat dropped off me, my team, 200 pounds of photo equipment, and a ranger in a mangrove swamp. Humility comes quick in a wild place like this; if you fall ill or injure yourself, you're in trouble, and if you don't drink enough water, you're done. The nearest medical facilities are over 700 miles away. This punishing climate wreaked havoc on both my gear and my mind.

I sat near the cave entrance, and when the mercury rose, the tortoise brigade arrived. They lined up single file and clumsily descended underground along a steep, well-worn path. The cave is about 16 feet deep and can fit more than 80 tortoises.

You can tell which animals utilize this shelter because their shells often have fresh scratches from rubbing against the ceiling; a bleached puzzle of tortoise bones at the entrance indicates that latecomers didn't fare well. The smell and sounds emanating from this place are a scarring sensory adventure. Imagine 80 giant tortoises farting and pooping all day in a crowded space.

Despite the assault on my senses, I was in awe. There's something humbling about being immersed in such a primordial landscape; the real world ceases to exist, and daily life is beautifully simplified.

Make pictures, hold your nose, try not to die.

Giant tortoises on Aldabra Atoll have found a unique way to keep cool:
They spend the hottest part of the day underground in seaside coral caves.

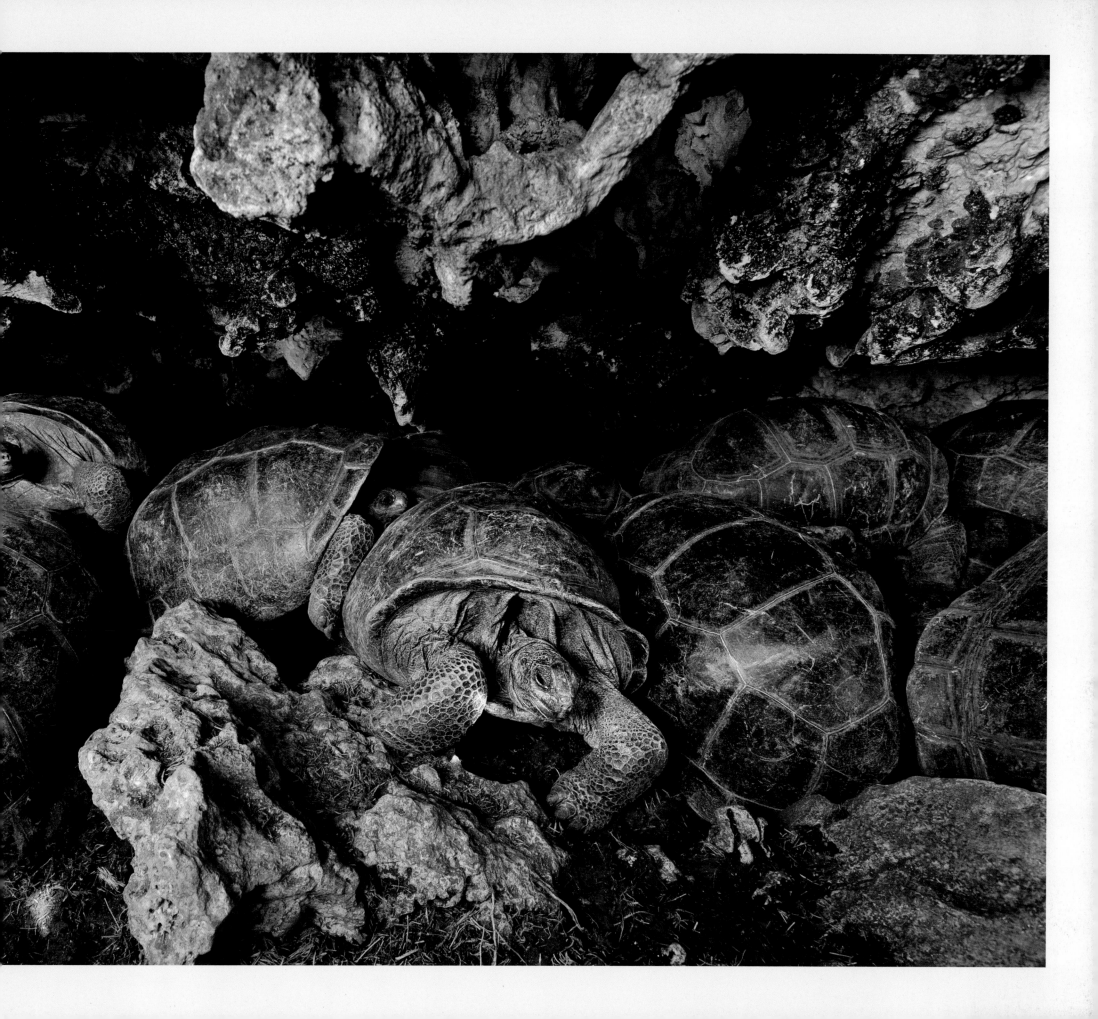

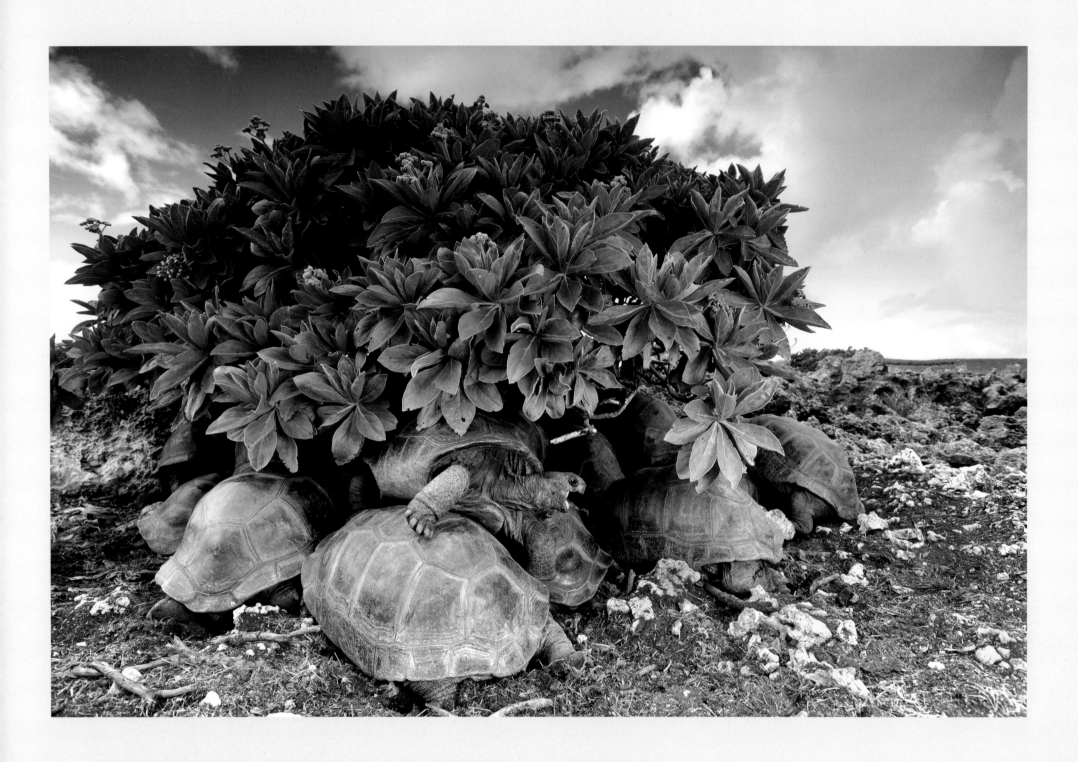

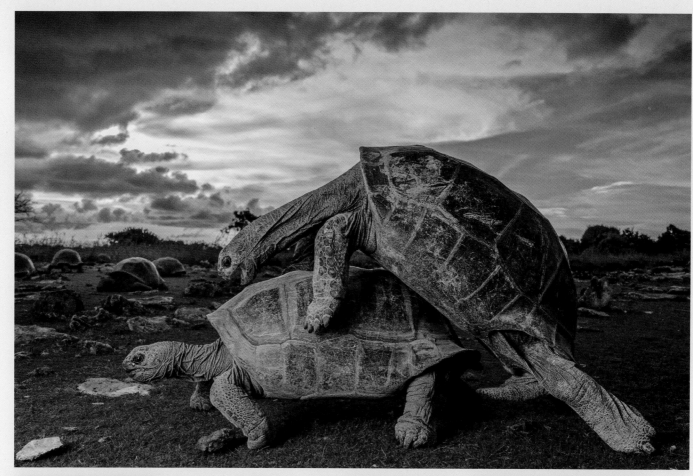

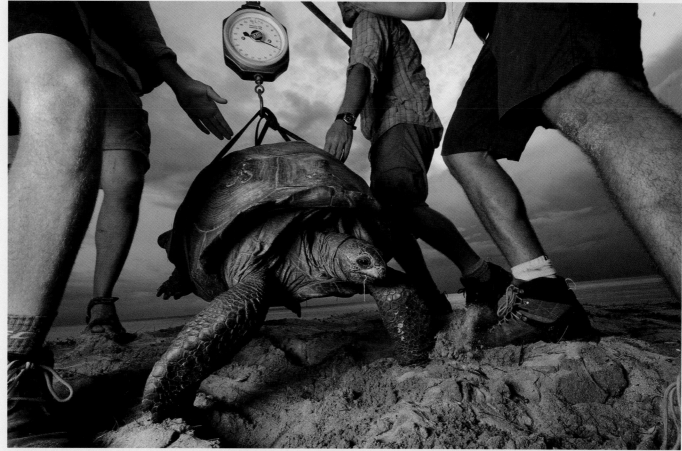

OPPOSITE: Giant tortoises fight for limited shade offered by a lone heliotrope tree. If they remain in direct sunlight after late morning, they risk baking to death in their shells.

RIGHT, TOP: Aldabra giant tortoises mate frequently; in the last century, the population has risen from a few thousand to over 100,000.

RIGHT, BOTTOM: Scientists from the University of Zurich weigh a giant tortoise as part of research efforts on the Aldabra population.

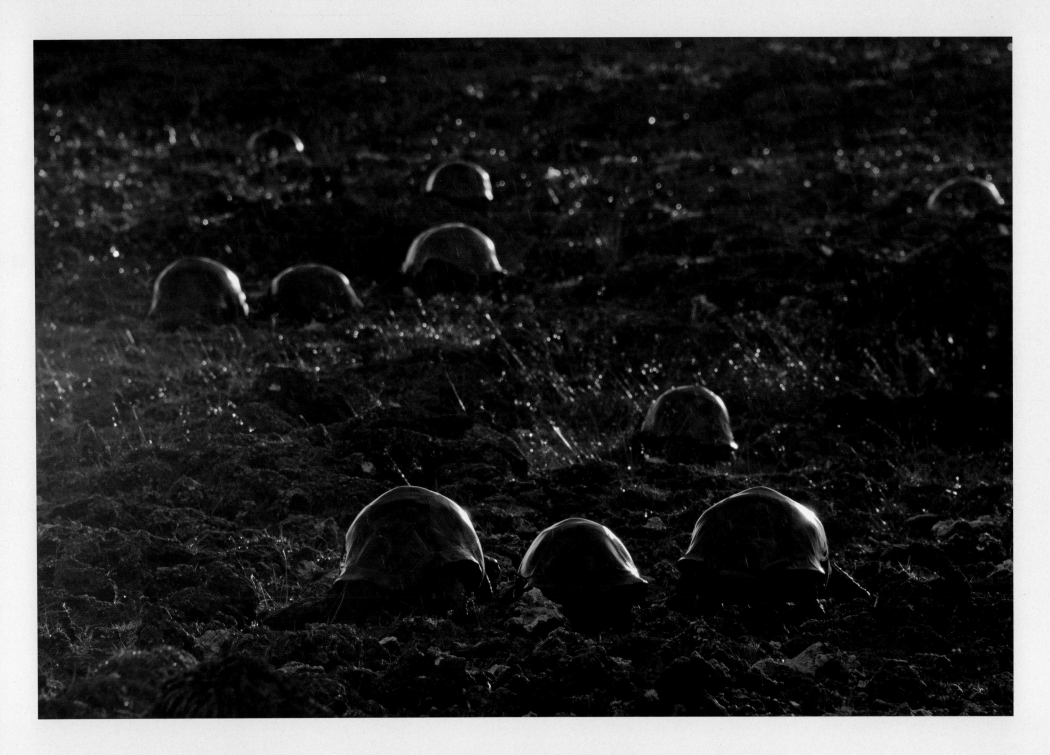

Giant tortoises graze at dusk on Grande Terre, one of the four major islands that make up Aldabra Atoll. Grande Terre has the largest tortoise population, but due to the harsh environment, these animals are half the size of those on adjacent islands.

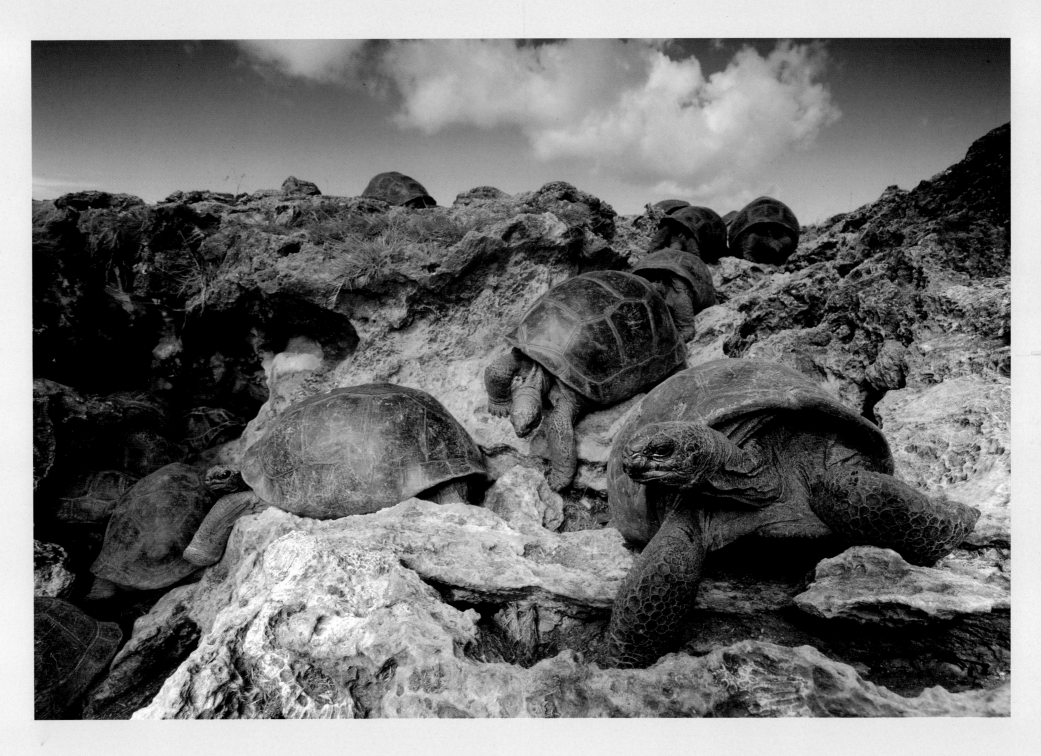

Like coal miners, Aldabra giant tortoises line up single file to go underground. They are not the most agile of climbers, and it can take over an hour for this cave to fill up with close to 100 individuals.

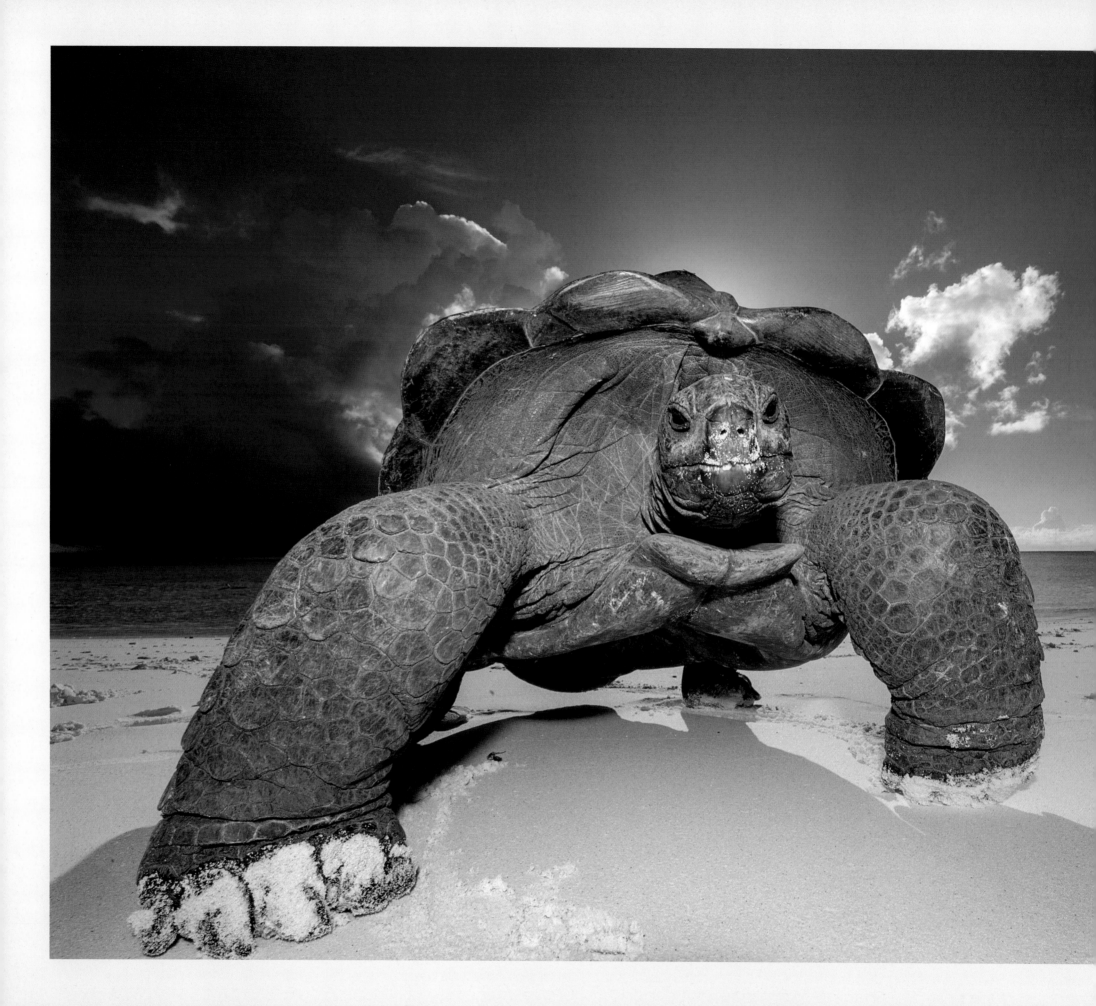

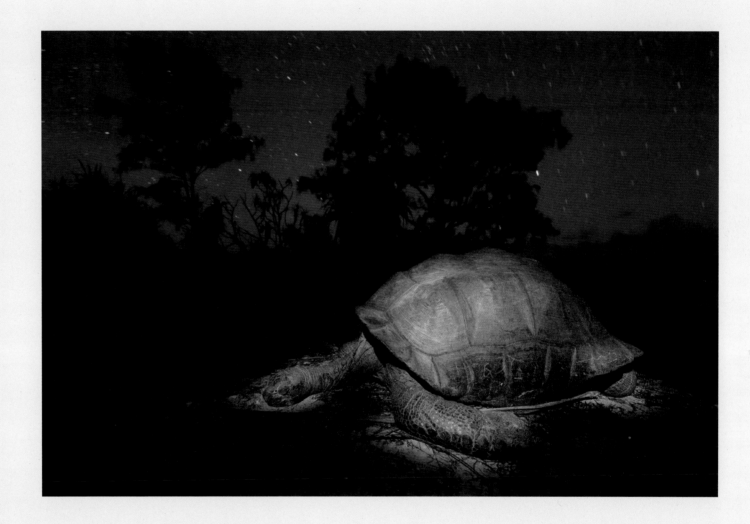

Giant tortoises can safely sleep with their heads and necks exposed on Aldabra Atoll. The island has no mammalian predators large enough to tackle an adult tortoise, which can weigh up to 672 pounds.

LEFT: Aldabra giant tortoises normally graze on "tortoise turf," a blend of herbs and grasses that grow close to the ground in response to being cropped. But this 100-year-old female regularly wanders onto the beach to eat washed-up seedpods.

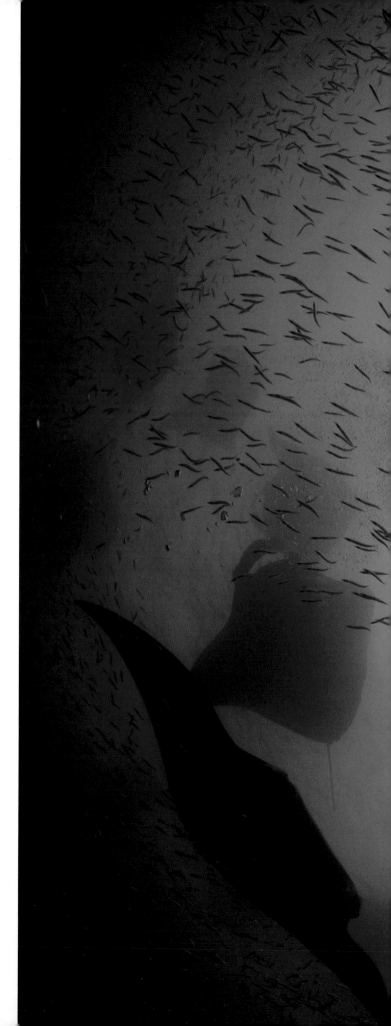

Gentle Giants

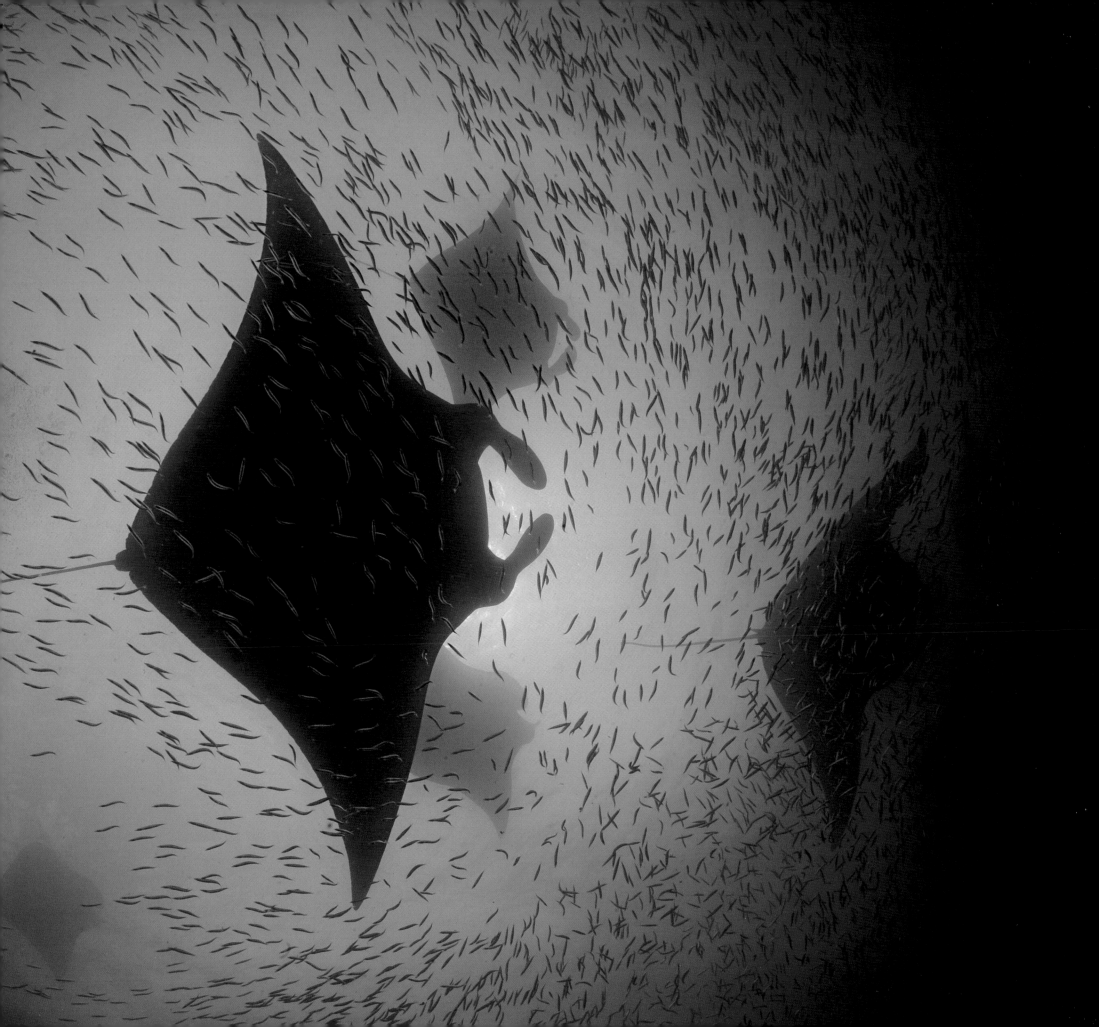

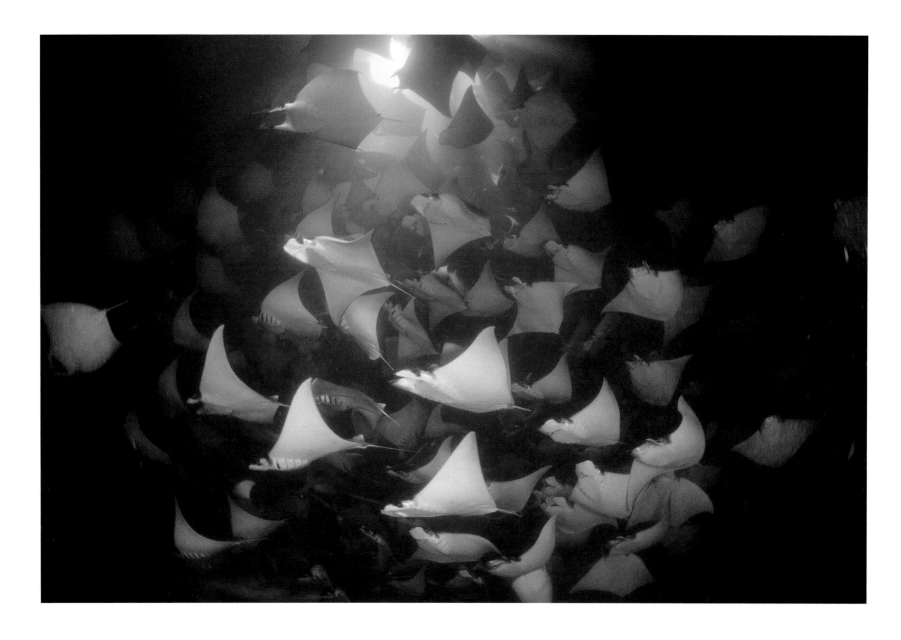

Band of Devils • Hundreds of Munk's pygmy devil rays feed on a dense swarm of zooplankton concentrated by lights off Baja California Sur. Mexico, 2015

PREVIOUS PAGES

Manta Batman • A giant diamond-shaped manta is silhouetted against the sun. It feeds through the water column, scattering a school of silversides. Maldives, 2008

I AM IN A GIANT VORTEX of hundreds of feeding manta rays. With nine-foot wingspans, these animals create their own current, delivering a bounty of zooplankton toward their gaping mouths. I am hypnotized by their beauty and gobsmacked by the scale.

As I prepare to make another photograph, intense spasms rattle my diaphragm. I've stayed down too long; the precious oxygen I hastily inhaled at the surface two minutes before is almost exhausted. My body gives a final warning to return to the surface or risk losing consciousness. As the level of carbon dioxide in my blood increases, my lungs burn as if lined with stinging nettles. But before I can take a breath, I have to ascend 50 feet to the surface through a shifting, Tetris-like puzzle of mantas.

Mantas are benign, but during a feeding frenzy they are oblivious to their surroundings. As I ascend, the rays crash into each other like 2,000-pound bumper cars. Eventually, I navigate through the gauntlet of wings, break the surface, and gasp in euphoric relief.

Those eventful minutes swimming in Maldivian manta soup would change my life. In 2008, some of the photographs from this free dive caught the eye of *National Geographic* magazine's senior photo editor, Kathy Moran. Ever since making the transition from marine biologist to photographer, my goal had been to be published within those famous yellow borders—and to my surprise, my first story, showcasing the manta ray feeding frenzy in Hanifaru, appeared there just a year later.

Since then, more than a decade has passed; I am on my 15th story assignment for *National Geographic*. So it seems that I have manta rays to thank for helping me realize my dream of becoming a *National Geographic* photographer.

In the Maldives, I'd heard rumors about foreign fishing boats catching mantas illegally and landing them at ports in neighboring Sri Lanka and India. So in 2009, I decided to go and see for myself.

It is 4:30 a.m. and the Negombo fish market is bustling. Boats off-load their catches, and traders eagerly inspect the landings. I weave through orderly piles of fish and rows of sharks on the weathered concrete floor. An emaciated stray dog becomes my shadow, frequently darting out from the safety of my legs to snatch a piece of fish.

I arrive just in time to watch a butcher separate a manta ray's giant pectoral fins from its body. The meat rarely fetches high prices, but another cut reveals something far more valuable: the manta's gill plates, buried within the chest cavity. These featherlike appendages are used to filter plankton from the water; fishermen sell them to traders who export them to markets throughout Asia.

I followed the trade all the way to the dried seafood markets of Hong Kong, where gill plates are sold alongside shark fins and seahorses. They are in high demand as an ingredient in a Chinese health tonic, touted to have anti-inflammatory and other healing properties. But no current scientific evidence supports these claims, and they are not mentioned in any of the Traditional Chinese Medicine texts.

Some of the photographs I made during this time are hard to look at; imagery of butchered mantas causes most people to quickly turn the page. For me, though, the challenge lies in how to create beautiful pictures from a haunting reality.

As a photojournalist, I strive to create balanced stories. The communities that catch manta rays are some of the most impoverished in the world; most live hand to mouth and see none of the extravagant profits made in Hong Kong. In fact, manta meat is some of the cheapest protein available in the region.

I am proud to say that in my own way, I have helped to give these animals a voice. *National Geographic* magazine has a readership of tens of millions; issues grace the coffee tables of almost every world leader, making it the ultimate influencer platform for a conservation photographer. So when a commercial development threatened to disrupt Hanifaru's manta feeding aggregation, my photographs helped turn the tide. A local grassroots campaign gained momentum, the nation's president vetoed new development, and the waters of Hanifaru were declared a marine protected area. Today, people from all over the world come here to snorkel with these incredible giants.

As I've learned firsthand, manta rays are a boon to tourism and are worth far more alive than dead. As a conservation photographer, I couldn't ask for anything more—and am grateful that my images can in some small way repay my debt to an animal that has done so much for me.

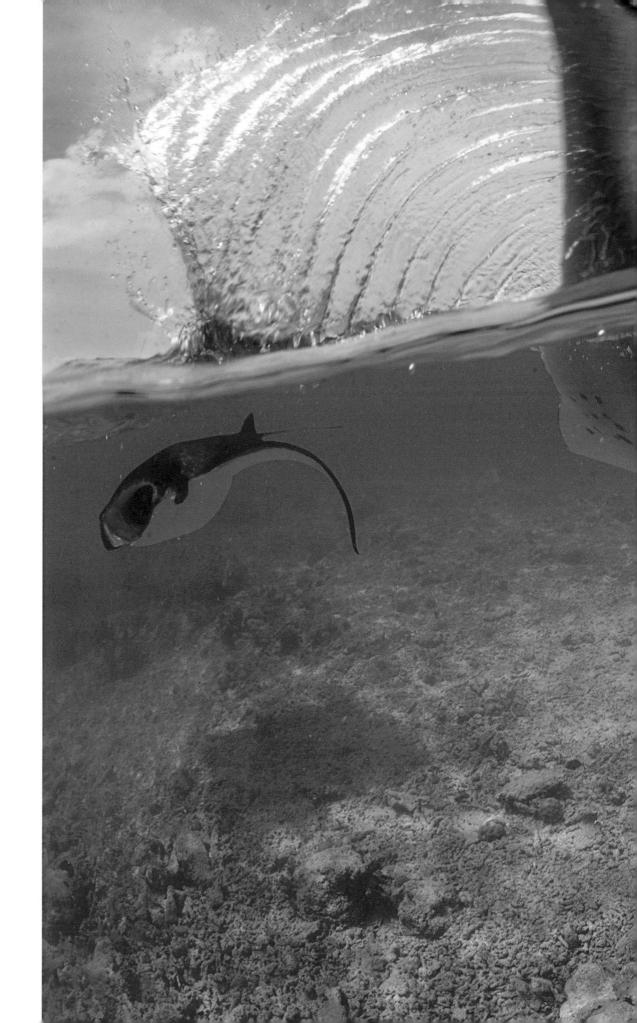

Current Events • Mantas are serene by nature but can use their powerful pectoral fins to surge quickly through the water. Even Hanifaru Bay's ferocious tidal currents are no match for them. Maldives, 2015

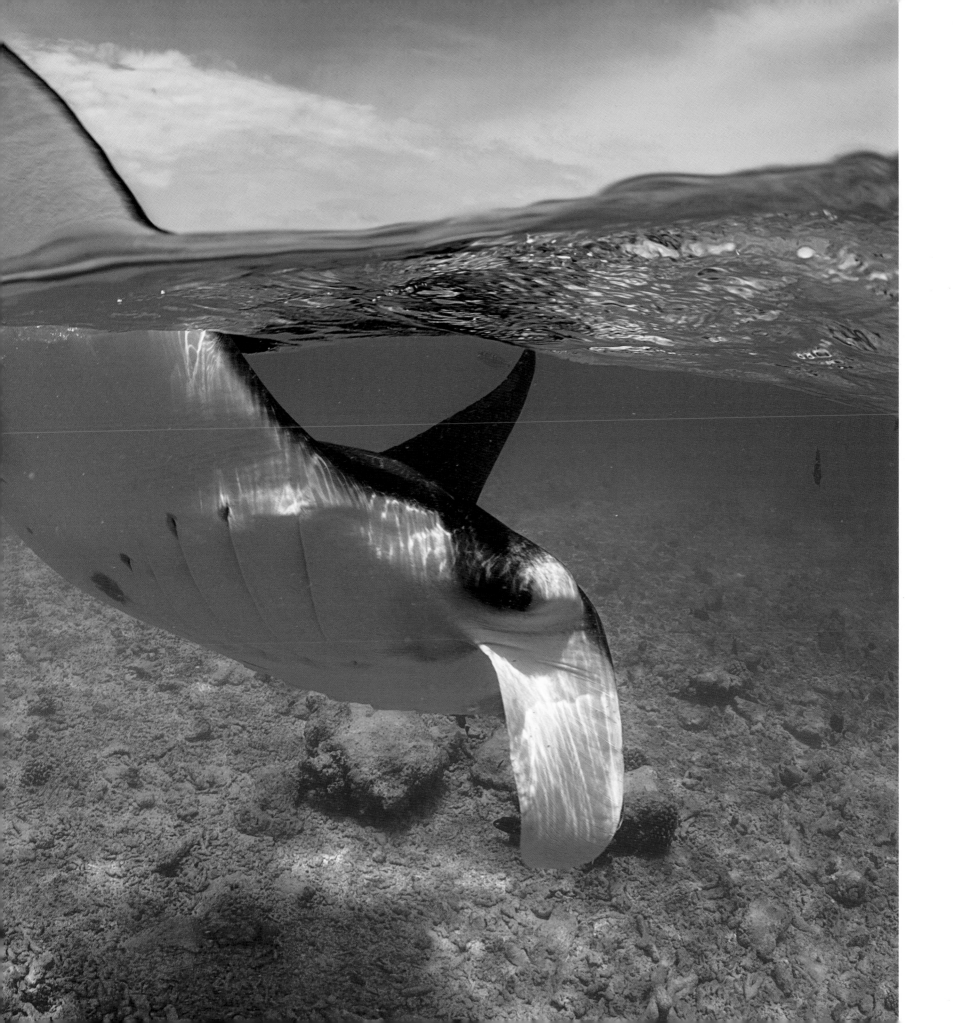

Open Wide • A reef manta gorges itself on tiny prey as it somersaults backward through the water. The cephalic fins held in front of the lower jaw funnel plankton-rich water into the mouth. Maldives, 2008

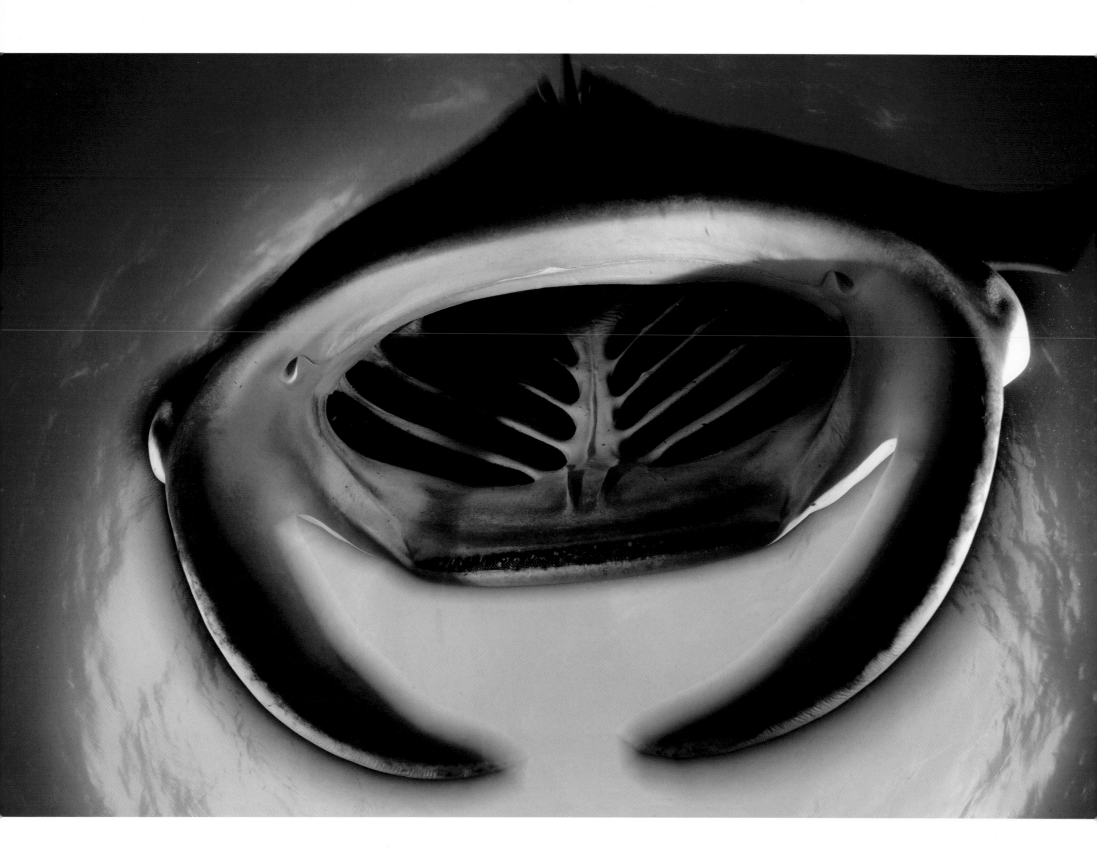

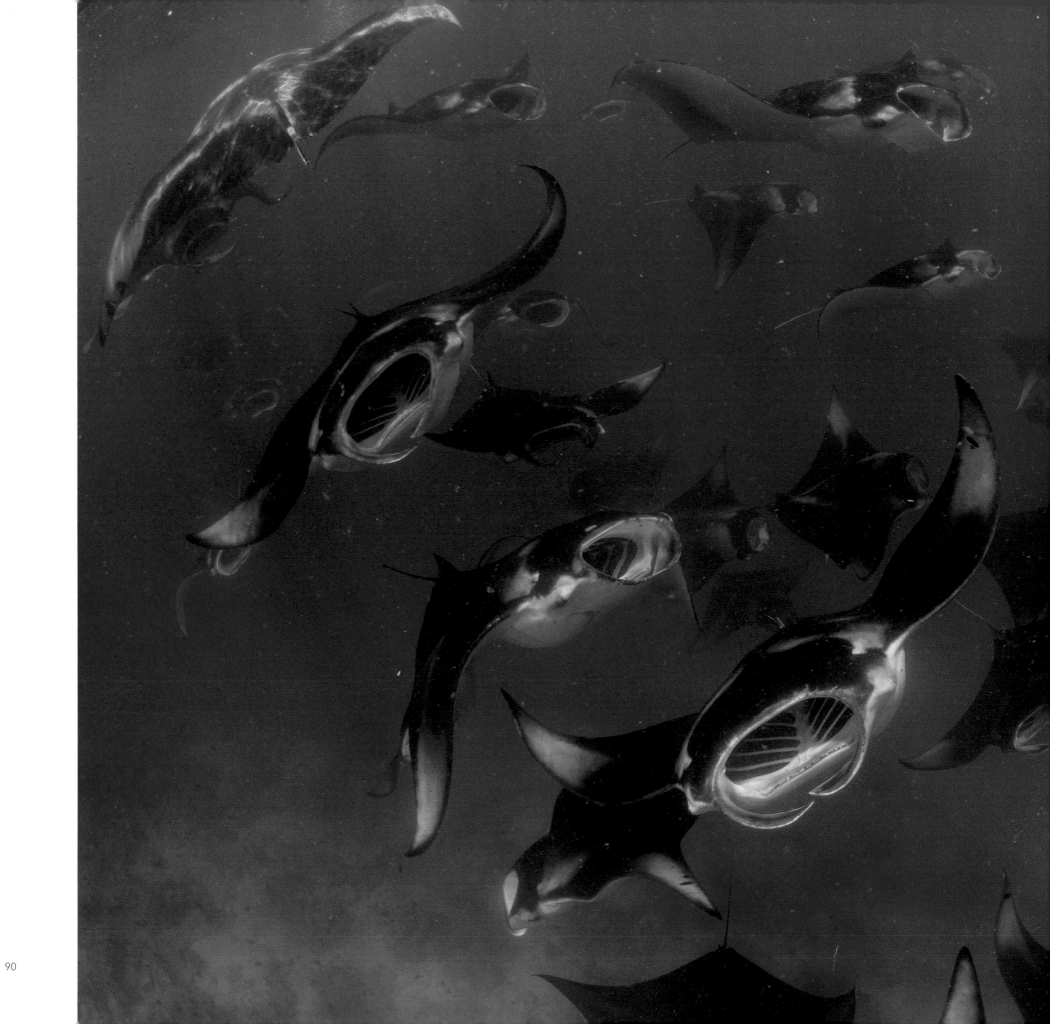

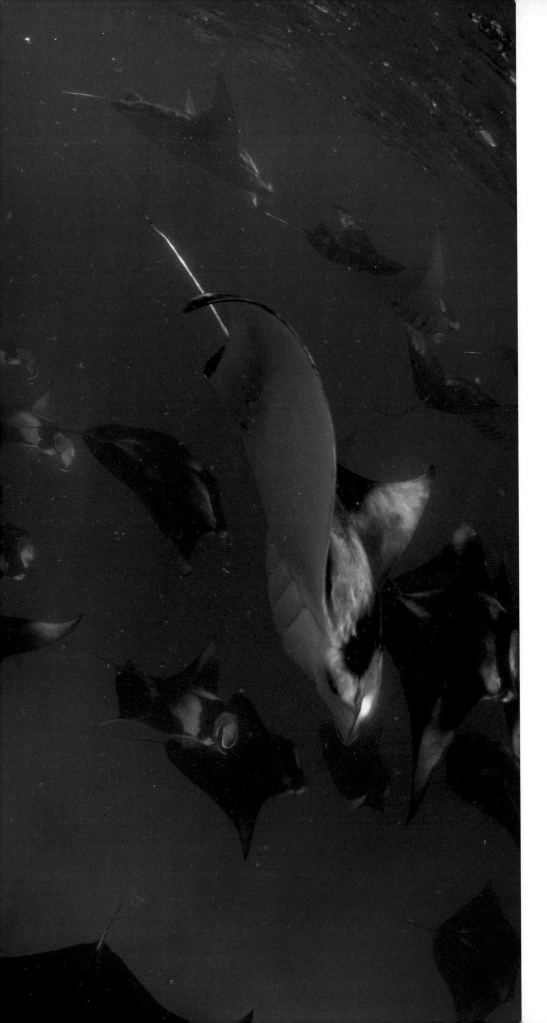

Feeding Frenzy • Spectacular mass feeding events occur about a dozen times a year in Hanifaru Bay. Cramming into a soccer field-size lagoon, as many as 250 mantas feed on dense patches of zooplankton. Maldives, 2008

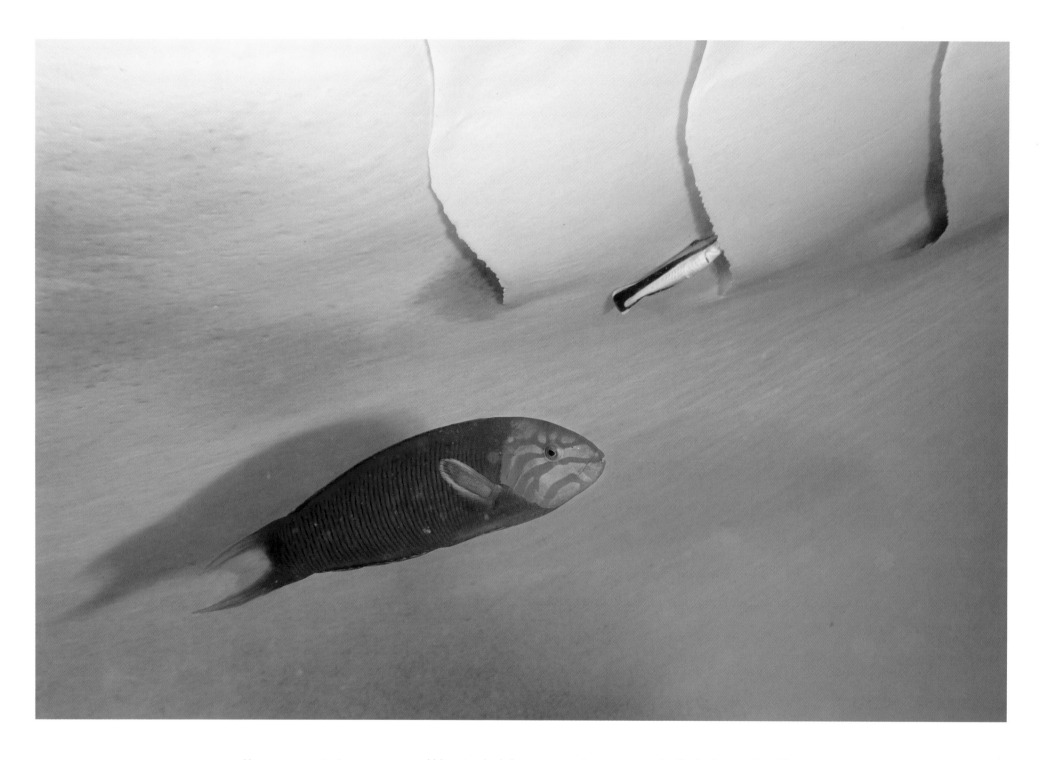

Ha-wrasse-ment • A green moon and blue-streaked cleaner wrasse inspect a manta's gill slits for parasites. The ocean is an itchy place, and these fish provide cleaning services in hard-to-reach areas. Maldives, 2009

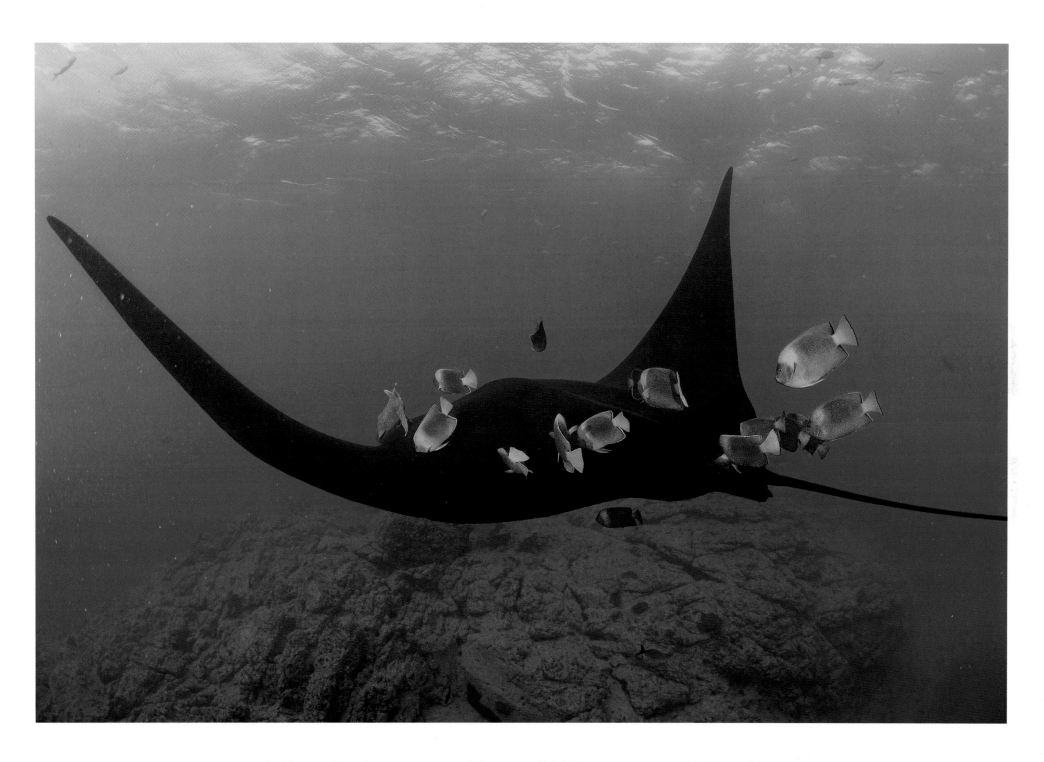

Touched by Angels • A cleaning entourage of Clarion angelfish follows a giant manta in the Islas Revillagigedo Biosphere Reserve. These animals feed on parasites, dead skin, and mucus from the manta's skin. Mexico, 2015

Manta Magnetism • A reef manta ray feeds on a dense patch of plankton while mesmerized tourists watch from above. Snorkeling or diving with manta rays generates $140 million annually around the globe via tourism. Maldives, 2008

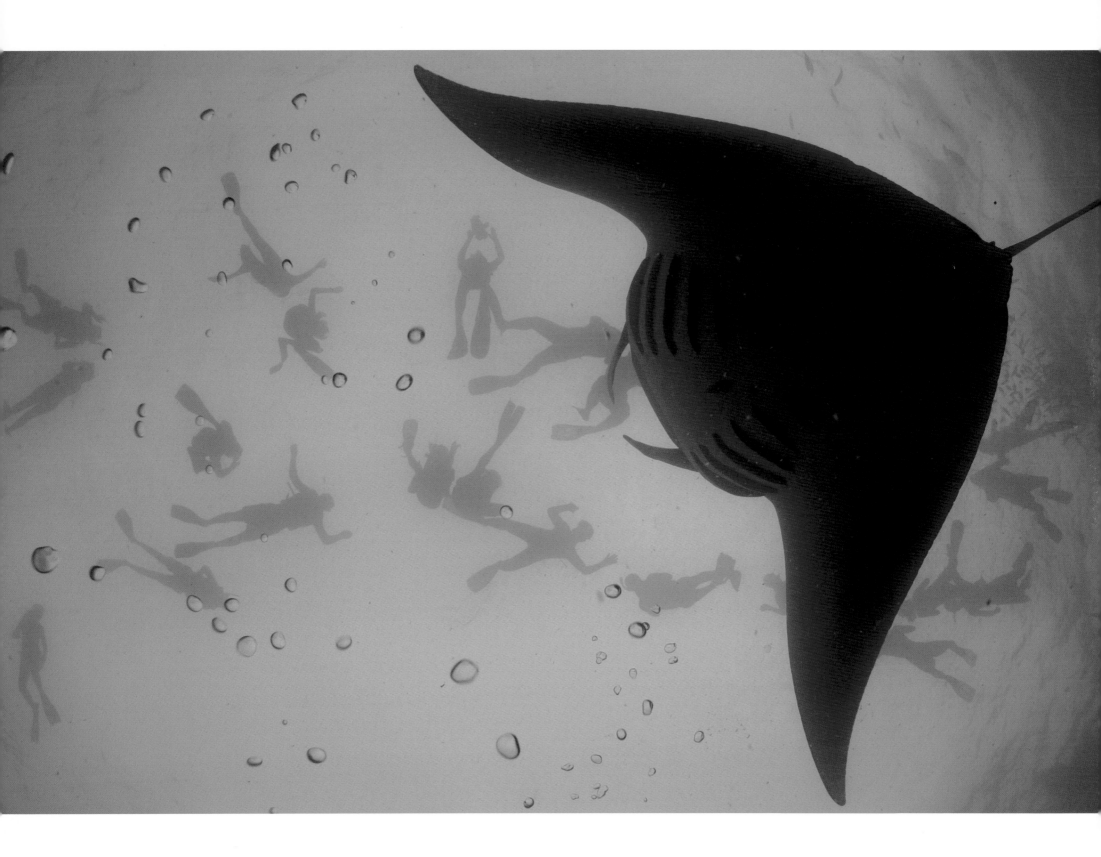

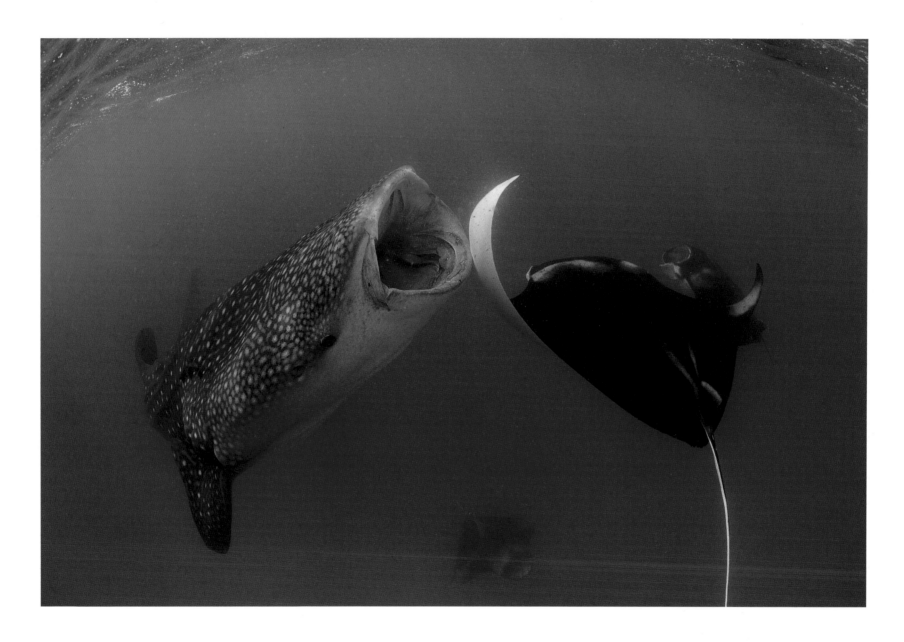

Collision Course • A reef manta and a whale shark collide as they feed alongside each other in Hanifaru Bay. This unusual behavior often occurs during the monsoon when the waters are rich with plankton. Maldives, 2008

OPPOSITE

Fin Prints • Whale sharks and manta rays have spot patterns unique to each individual, just like a human fingerprint. A manta's unique pattern of black ovals, spots, and mottles is found on its white belly. Maldives, 2008

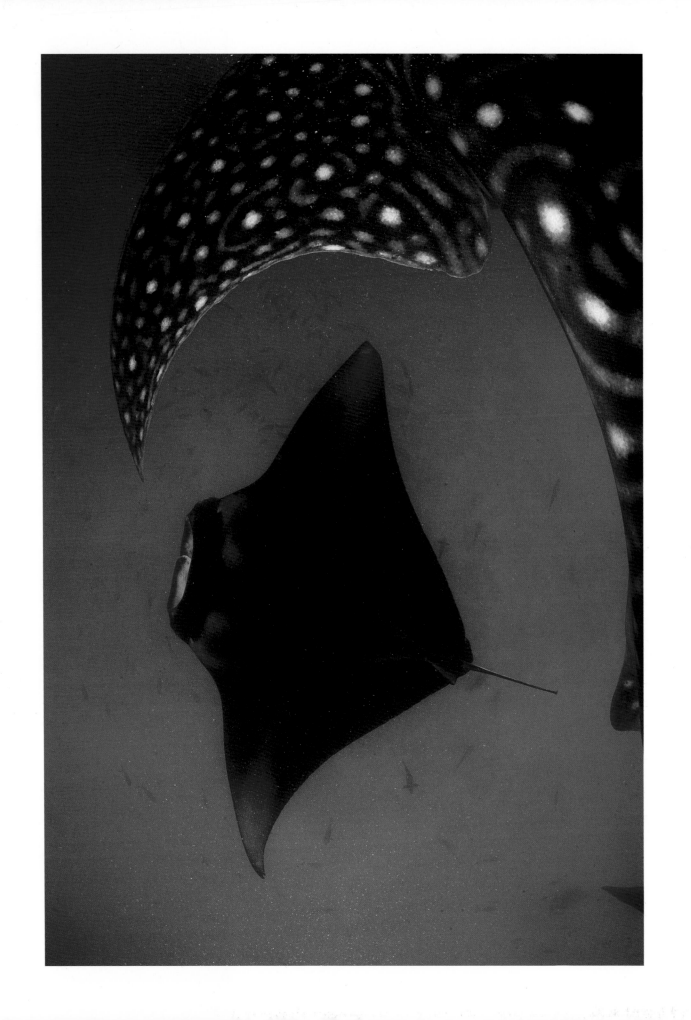

Light Buffet • A reef manta feeds on zooplankton attracted to the lights of a dive boat. Juveniles often seek refuge from predators in shallow lagoons, and some have learned to take advantage of the easy meal. Maldives, 2015

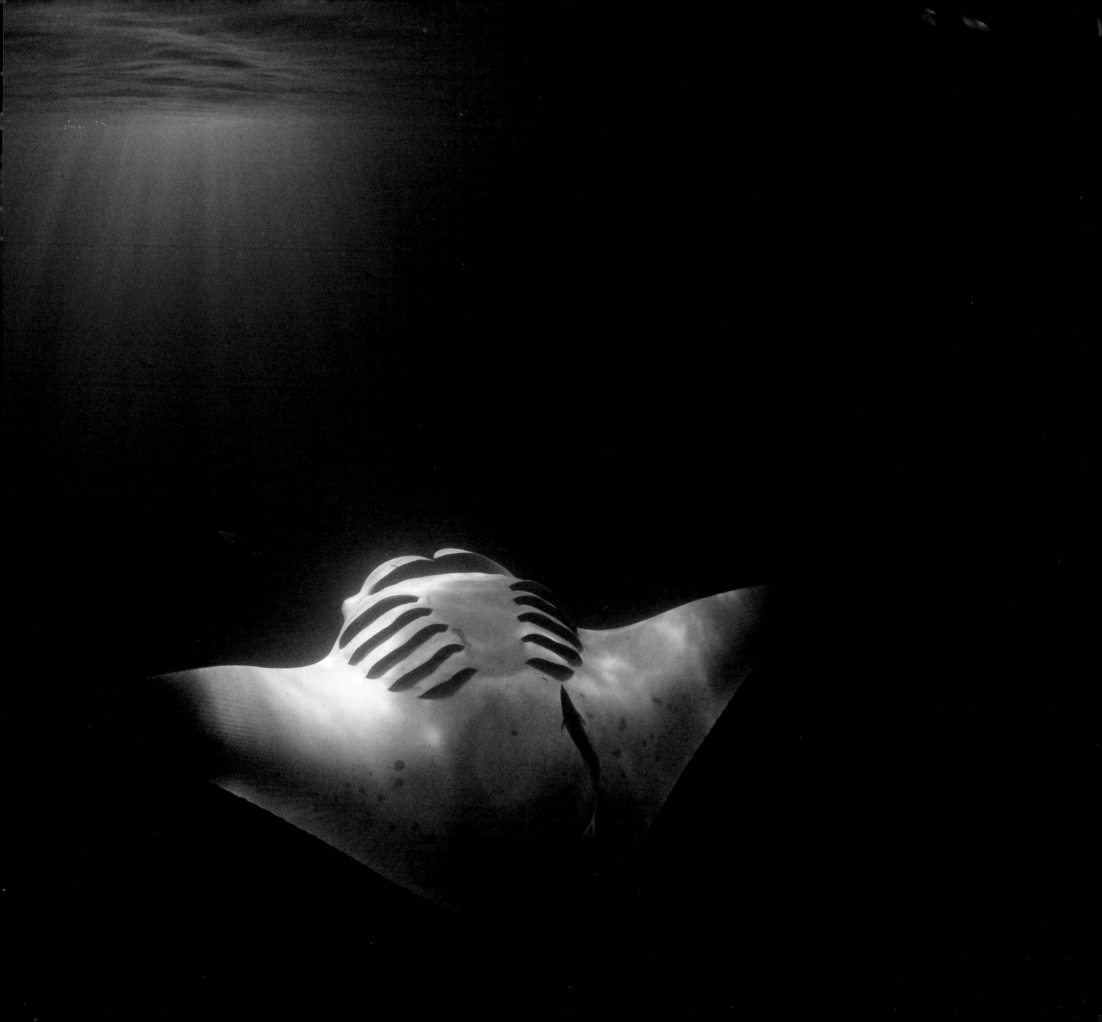

Ancient Rays • Four manta rays, finely drawn in red ocher, grace an overhang in Baja California's mountains. This rock art is estimated to be over 5,000 years old. We may never know exactly why the Cochimí people drew mantas in this remote desert canyon because they were tragically decimated by disease. Mexico, 2015

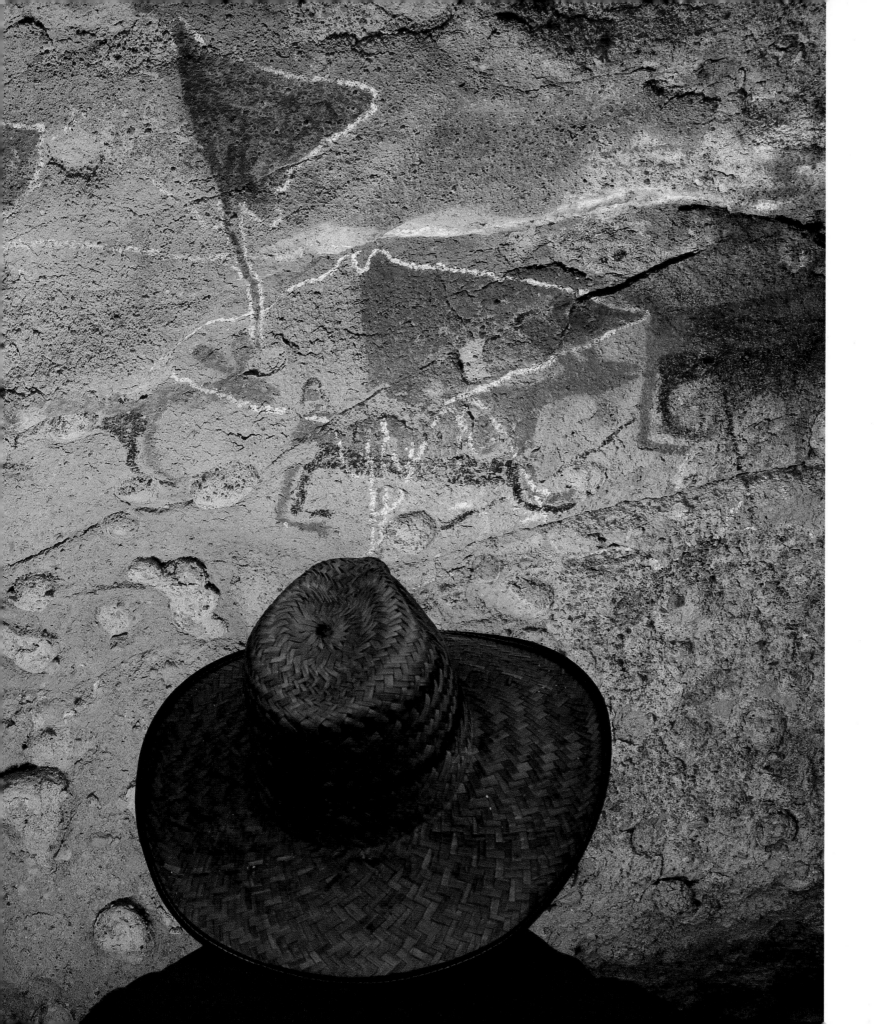

Bad Medicine • Manta ray gill plates have only recently entered into Asian folk medicines but are not featured in any official Traditional Chinese Medicine manuals. Their popularity appears to stem from media attention and marketing by retailers. Sri Lanka, 2009

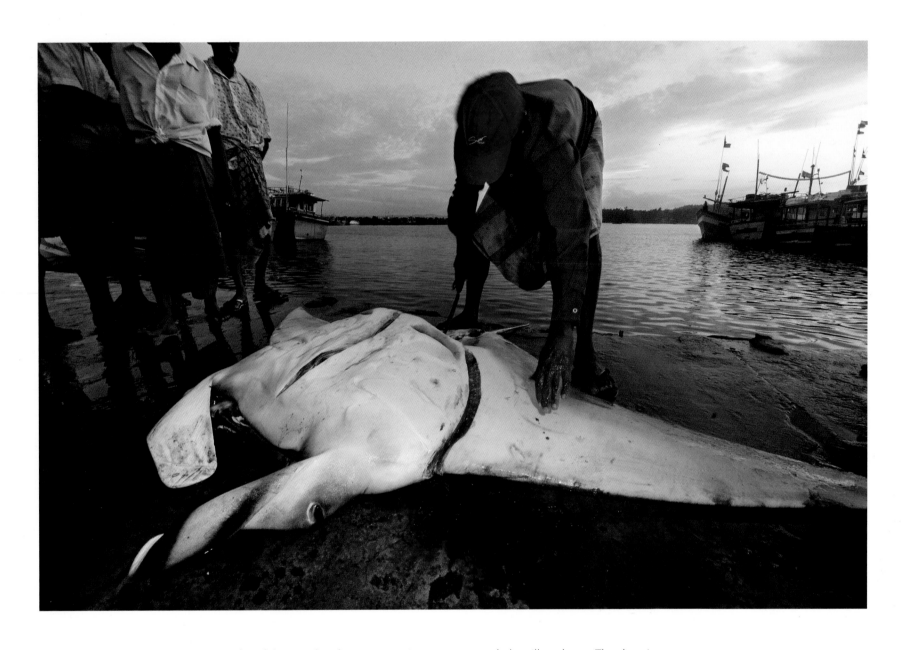

A Giant's End • A fisherman butchers an oceanic manta ray caught by gill net boats. The chest is cut open to extract the highly valued gill plates, which are sold to specialist dealers. Sri Lanka, 2009

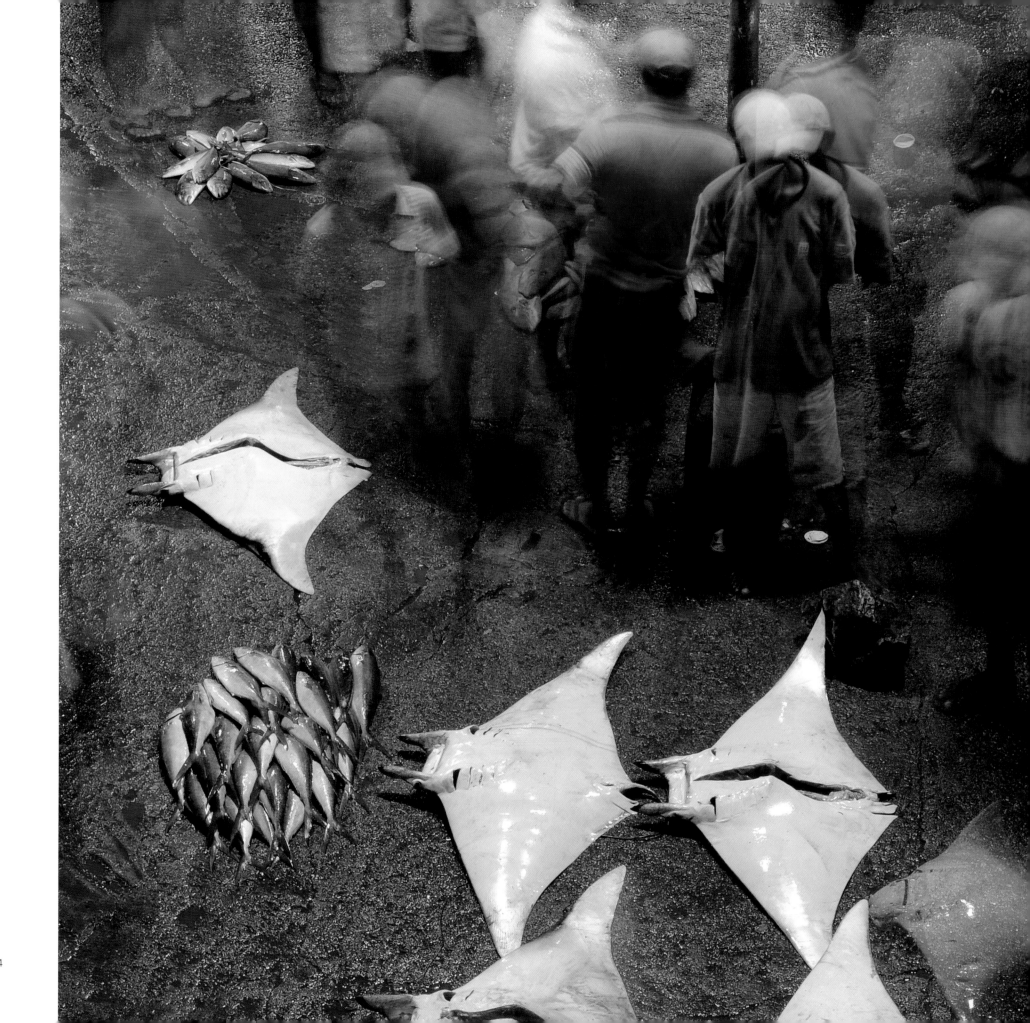

Death Rays • Fishermen and market traders wend their way through islands of dead fish. Not ideal for human consumption, manta and mobula meat is last to sell and is sometimes processed for animal feed. Sri Lanka, 2009

Manta Storm • A reef manta ray swims just beneath the surface as heavy monsoon rain pelts down from above. With an 11-foot wingspan, this graceful animal soars through the water like a giant underwater bird. Maldives, 2008

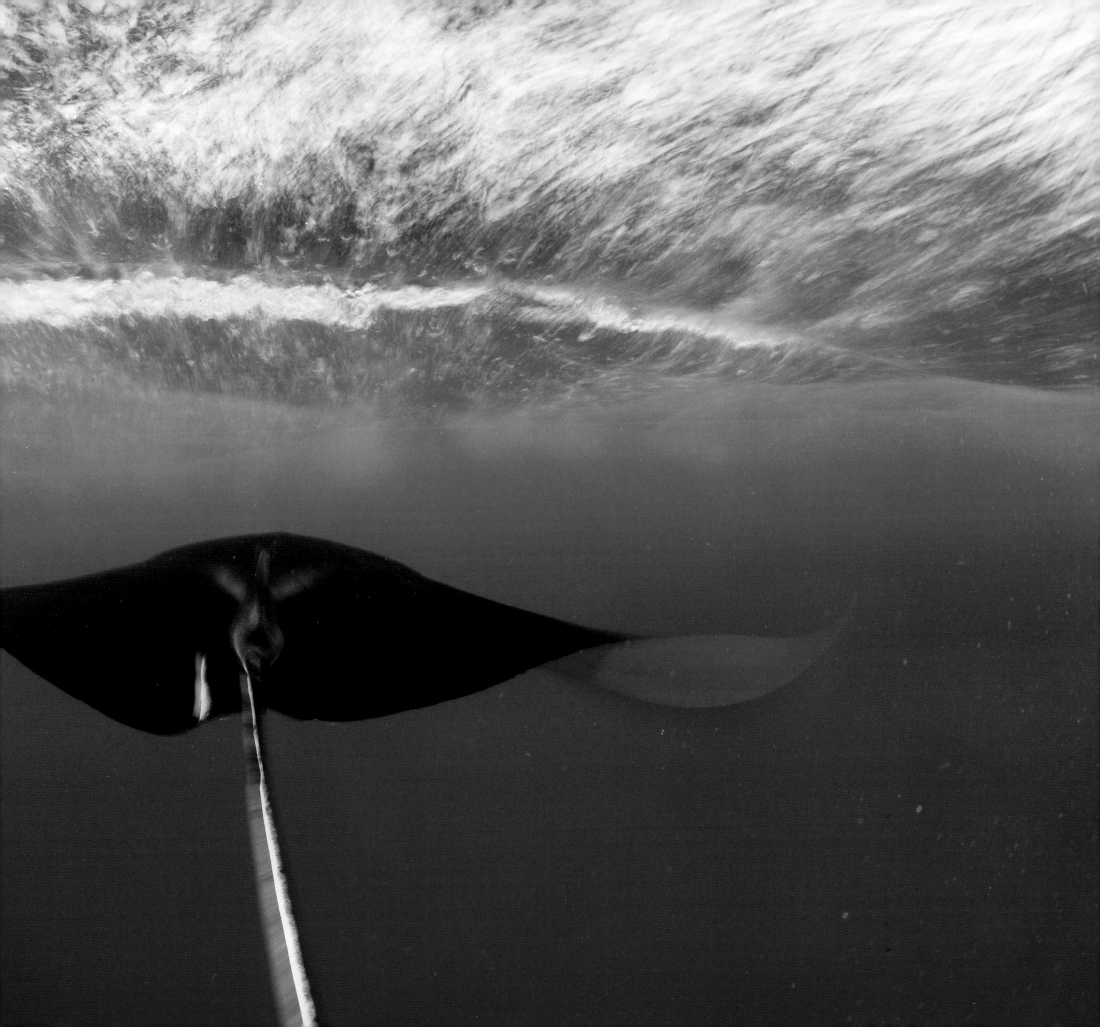

Brother Whale

THE MOTHER PUSHES her reluctant, rhino-size calf to the surface for a closer look. I lean over the side of our boat and lower my underwater camera. The youngster quickly gains confidence as his mother nudges him closer. Soon he eyeballs me from just a few feet away.

What happens next is still difficult to comprehend. The young whale lifts his head out of the water until we are eye to eye. All the while I furiously make images, not wanting to miss a moment. Then, I find my left hand reaching out, and suddenly I am touching a whale. Gingerly at first, but soon I am rubbing more vigorously. The calf clearly enjoys the interaction, swaying back and forth and eagerly pushing his two-ton body into my hand. After a few minutes, I stop, and the whale lifts his head high as if to say, "Is that it?"

As a rule, I do not touch wildlife. But here at San Ignacio Lagoon in Baja California, one must employ a willing suspension of disbelief. In the world we know, one rarely comes this close to whales. Here, it happens every day—and they are the ones to initiate contact.

This culture of mutual curiosity and physical contact between cetaceans and humans goes back to the 1970s, when a pioneering gray whale approached local fisherman Pachico Mayoral. The man eventually found the courage to touch the friendly animal, creating a foundation for 50 years of interspecies interactions to come.

This unique whale culture is passed down from mother to calf, as well as from parents to children in San Ignacio. Local families operate seasonal whale-watching operations, and people come from all over the world to participate. One of the whales' fiercest guardians, this community partnered with conservation organizations in the 1990s to defeat a salt mine that would have degraded the critical gray whale sanctuary.

Unfortunately, though, relations between gray whales and humans haven't always been so friendly; more than a hundred years ago, whalers killed more than 20,000 gray whales in the Pacific waters off Baja.

It's hard to imagine that the calf I played with on that magical day is a descendant of one of the few that survived the ravages of the whaling era.

In Mexico's San Ignacio Lagoon, a gray whale mother pushes her curious calf to the surface.

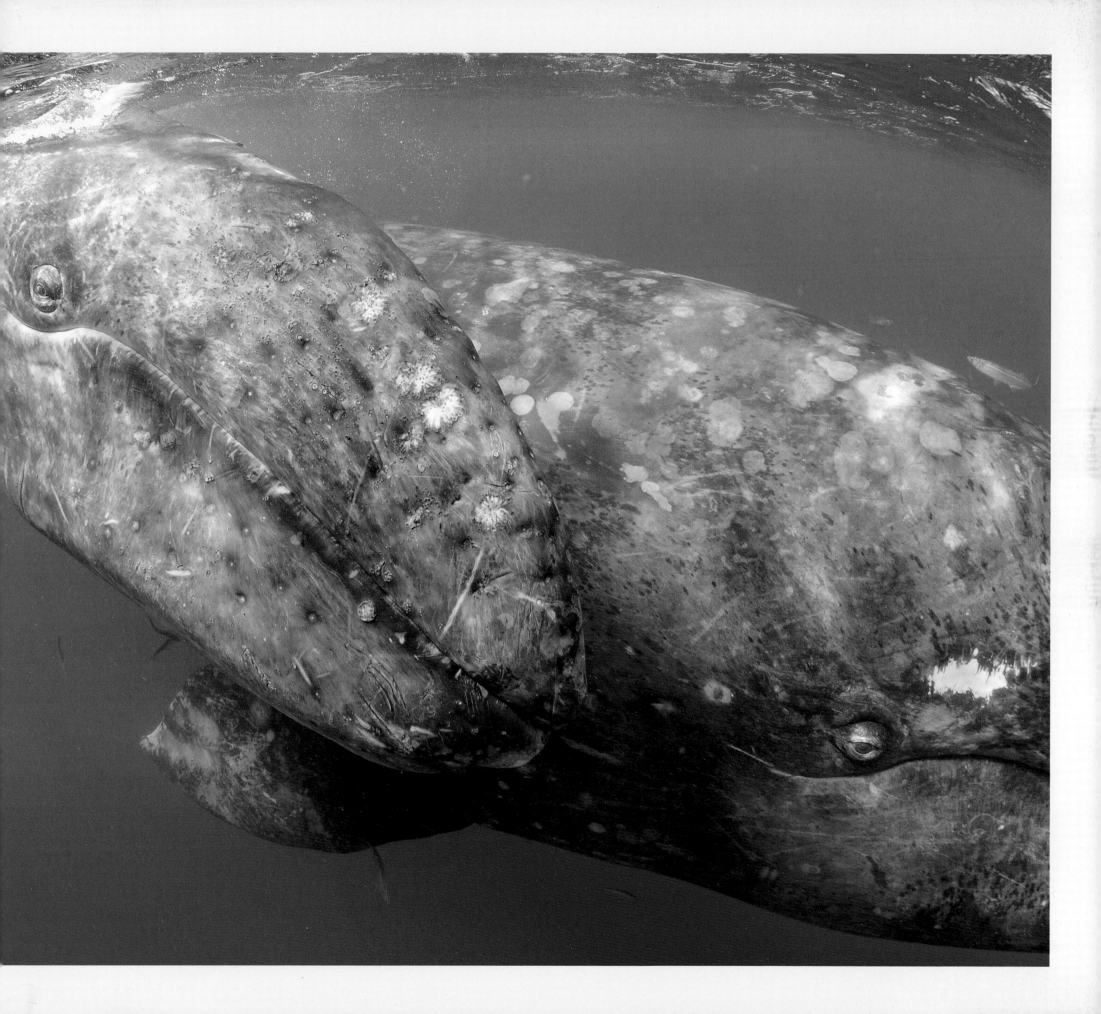

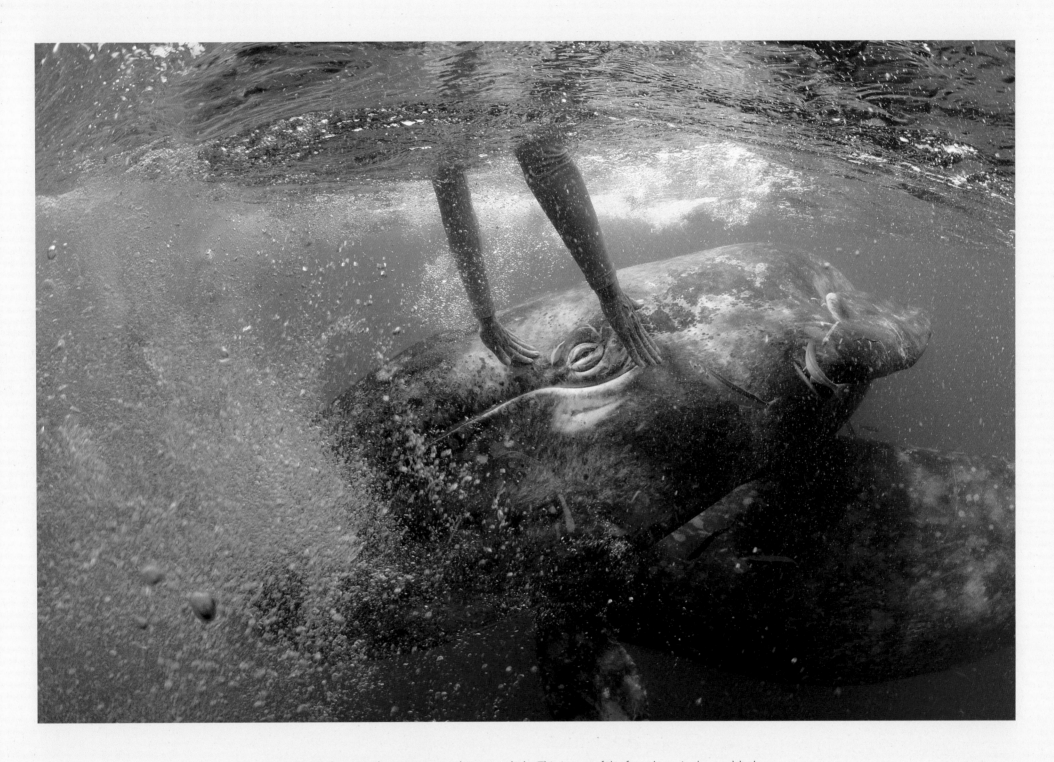

A tourist reaches into the water to touch a gray whale. This is one of the few places in the world where whales seek out physical contact with people.

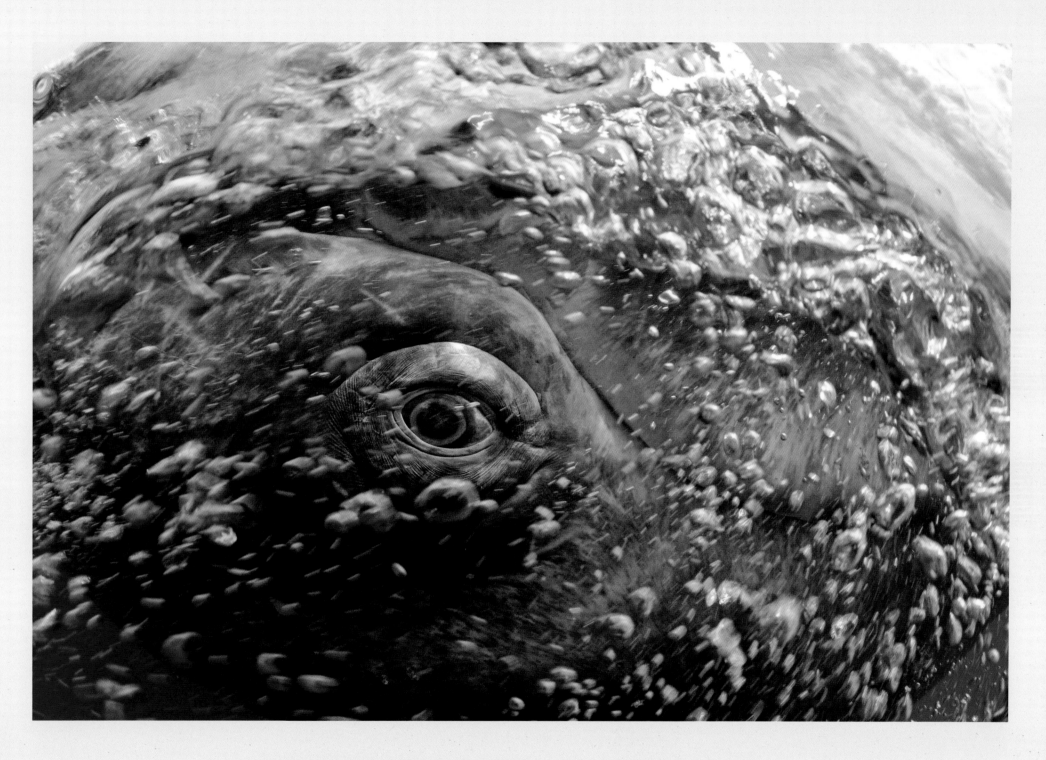

The eye of a curious gray whale calf stares into the camera. This unique culture of interacting with people has been passed down from mother to offspring for more than 40 years.

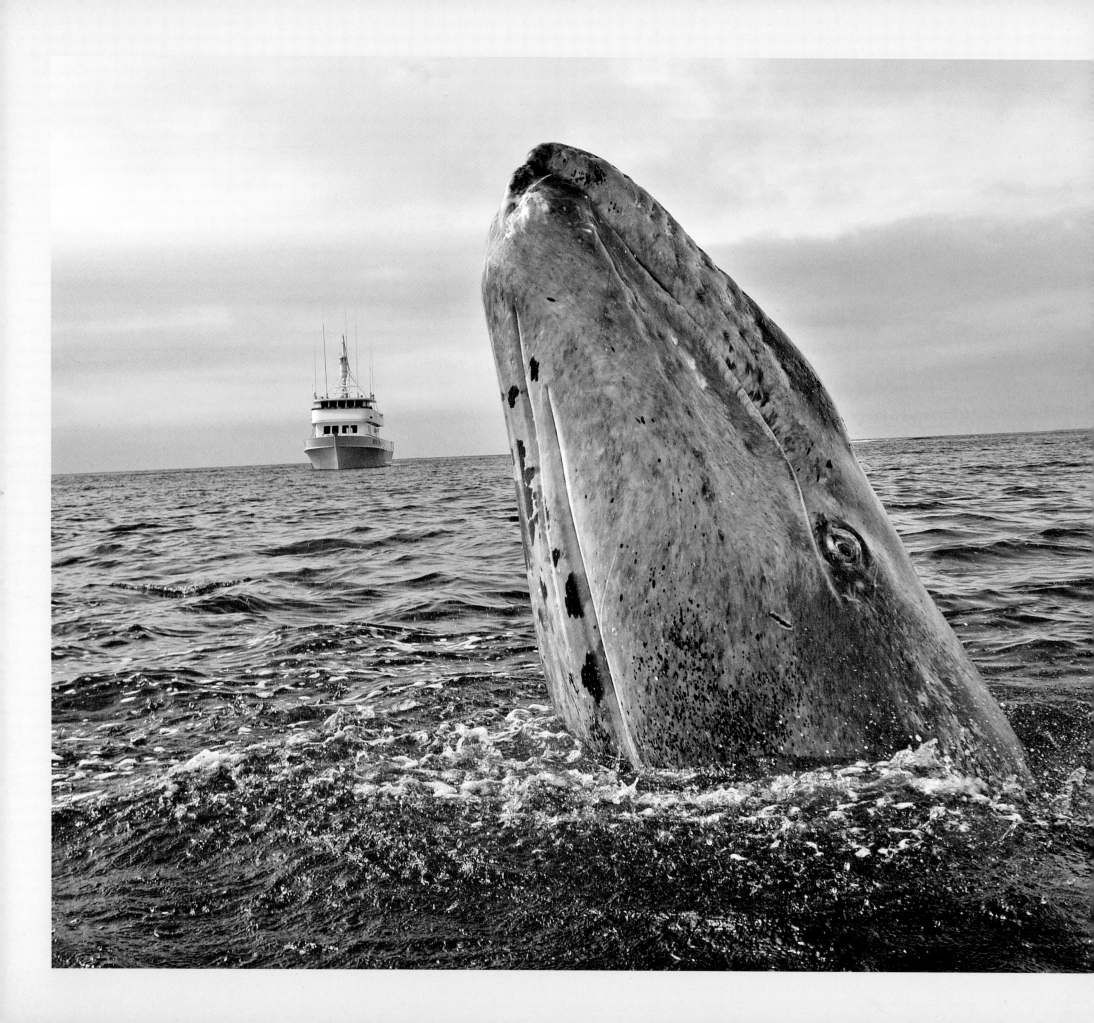

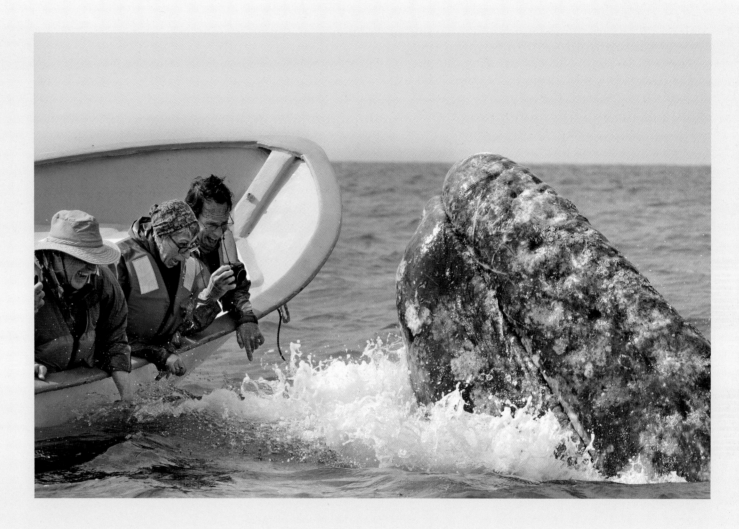

Tourists marvel at their close encounter with a gregarious gray whale. Local fishing families operate seasonal whale-watching expeditions and have become the whales' fiercest guardians.

LEFT: A gray whale spy-hops to get a better look. Nature-based marine tourism in Baja California Sur generates $300 million a year and supports more than 2,000 jobs.

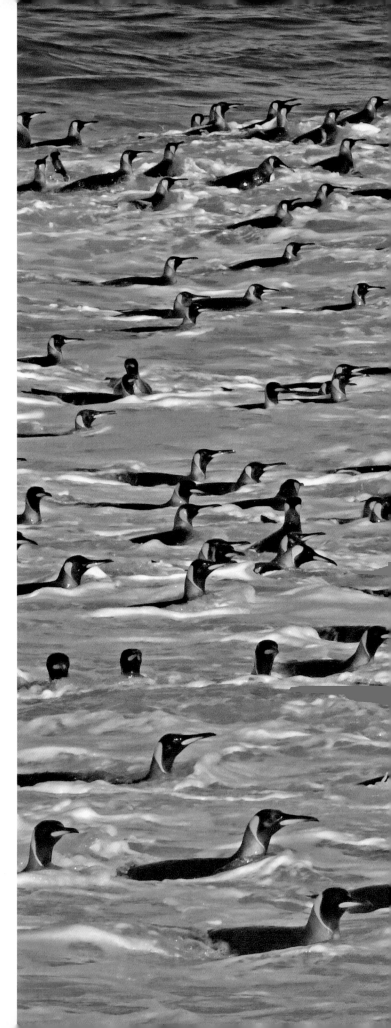

SEABIRDS

Ocean Spirits

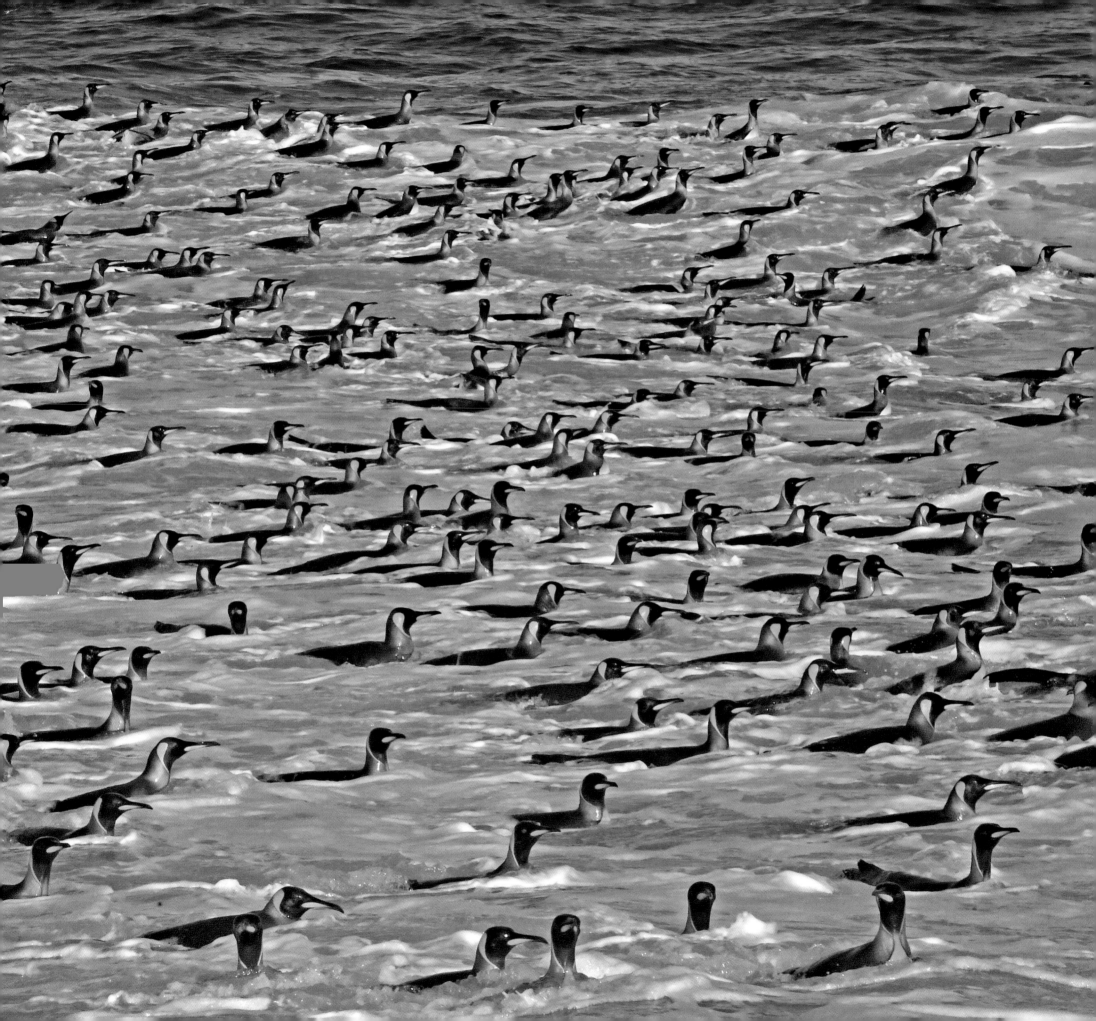

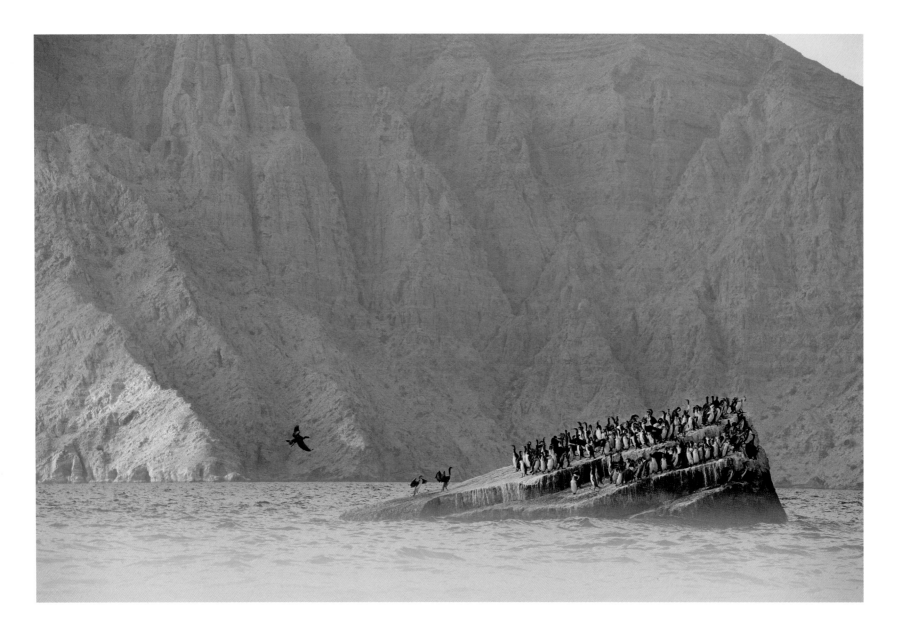

Birds of a Feather • Juvenile Socotra cormorants take advantage of a popular resting spot beneath the cliffs of the Musandam Peninsula. Oman, 2011

PREVIOUS PAGES

Sea Kings • After a day of hunting, king penguins congregate within the shore break of Kildalkey Bay. Marion Island, 2017

THEY SWOOP DOWN on me like pterodactyls, dive-bombing from every direction. They want what I have, but I will not surrender. As a hungry and determined six-year-old, I protect my french fries at all costs. These urban herring gulls are my first introduction to seabirds.

Even many years later, I remained painfully ignorant of the more than 360 species of seabirds, each seemingly armed with their own superpower. Some hunt for squid at depths of over 300 feet. Others make annual migrations of tens of thousands of miles. And some spend years at sea without ever setting foot on land. When a *National Geographic* assignment took me to a remote, subantarctic island, I humbly realized how much I'd underrated this incredible group of animals.

Few can locate Marion Island on a map, and even fewer have visited this remote outpost halfway between Africa and Antarctica, open only to scientists. It took a year of emails, phone calls, and meetings before I find myself on the icebreaker S.A. *Agulhas II* heading south through tempestuous waters.

After five days at sea, we arrive on Marion during a rare reprieve of calm. With no time to waste, my assistant Otto and I load our gear into the helicopter, which drops us on the remote west side of the island. Fortunately, Otto knows the terrain; he spent a year here studying penguins. Over the following three weeks, we trek across the island and document the albatrosses, petrels, and penguins that breed in this environment. We shelter a few days at a time in compact research huts peppered across the island.

Before setting off, I spend a few days photographing a terraced landscape called the Amphitheatre, which hosts a colony of 24,000 macaroni penguins. The weather is near tropical; I'm in a T-shirt and there isn't a breath of wind. For a moment I forget where I am.

Marion sits in the latitudes that mariners call the roaring forties. With no other landmasses to curb the wind, it has a legendary reputation when it comes to weather. Back-to-back low-pressure systems sow gale-force winds that carry snow, hail, or torrential rain.

It is so quiet on our first night that I can hear the wailing cries of petrels and the whooshing of their wings as they fly past the hut. And then, in the darkness of early morning, Marion shows her true colors. I awake disoriented, feeling I'm aboard a rolling sailboat caught in a hurricane. The howling winds force us inside for two days.

The moment the winds die down just enough to safely open up our steel door, I race back to the penguins with great anticipation. But instead of being greeted by their cacophony, I find the ledges of the Amphitheatre empty. The storms pushed the penguins back to sea, where they would feed for the following six months. I traveled over 600 miles and spent five days at sea for just three hours of photography.

Terrainwise, Marion Island is the illegitimate love child of a swamp and a volcano. On the coast, you have mires that threaten to suck you in at every step. They alternate with razor-sharp lava fields that seem to consume your boots as you traverse. Researchers with light daypacks cover the distance between huts in four to five hours, but with hundred-pound backpacks full of camera equipment, we take twice as long. Of the 38-day journey, only eight are spent making photographs. And within those days, we have just 25 hours of good light in which to create publishable images.

In the last 60 years, 230 million seabirds have vanished from our planet. This constitutes 70 percent of the global population. Fishing fleets overharvest their food, then hook and drown them as bycatch. They become coated in oil and entangled in plastics; climate change and invasive species degrade their breeding sites.

High up on a cliff, I come face-to-face with the gruesome evidence that remote Marion Island is not immune to these ravages. Before me is a mortally wounded albatross; the back of its head and neck have been eaten away. The culprits—foreign to this environment and weighing just 40 grams—are mice. Accidentally introduced to the island by sealers in the 1800s, they now number more than a million, and threaten to decimate this seabird stronghold.

Seabirds are the most endangered large group of birds in the world. Although the fates of rhinos and elephants always make headlines, seabirds remain largely forgotten. And they are as exciting as sharks and as iconic as panda bears. They are intelligent, majestic, vulnerable—and are as critical to the oceans as any whale or sea turtle.

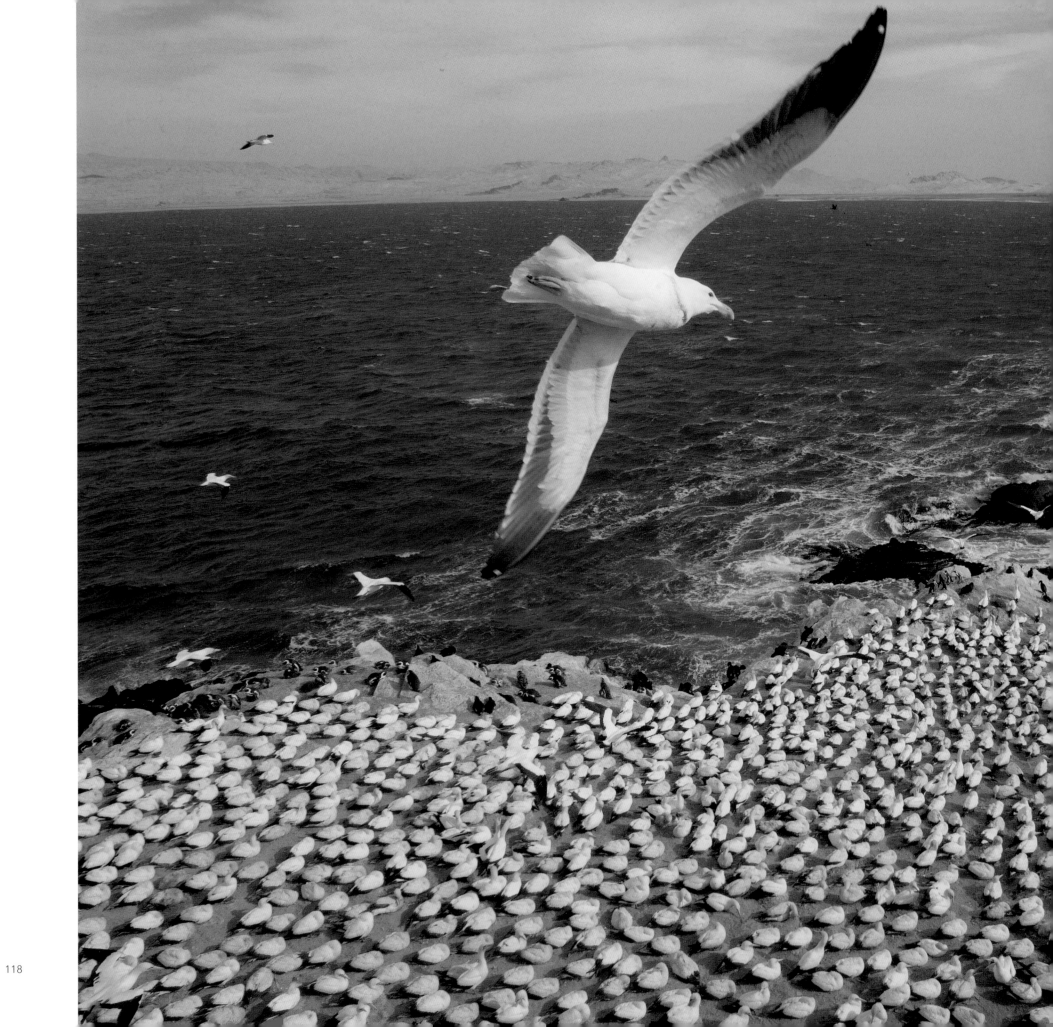

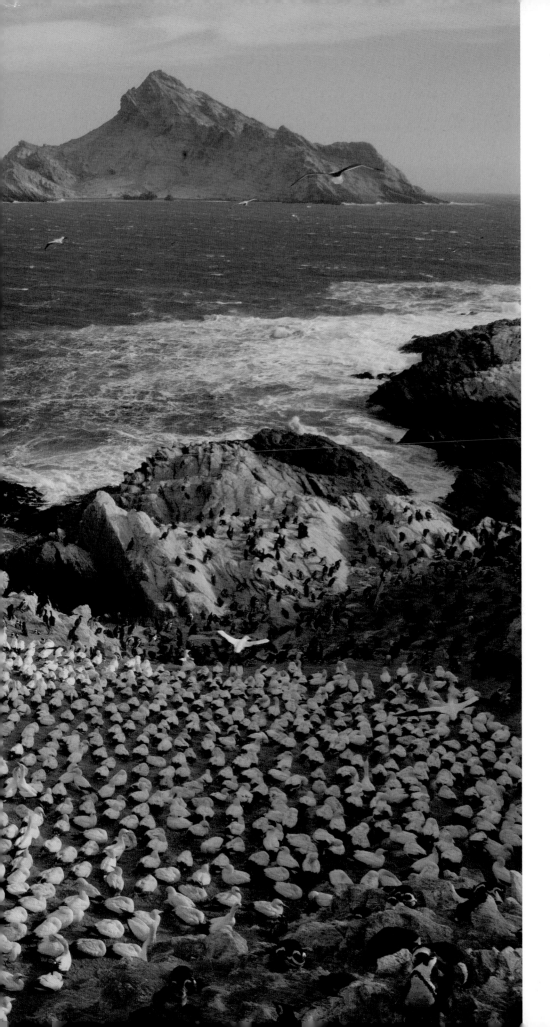

On Patrol • A lone kelp gull soars over Cape gannets and African penguins on Mercury Island, off Namibia's Sperrgebiet. This important nesting site lies within the country's first marine protected area. Namibia, 2012

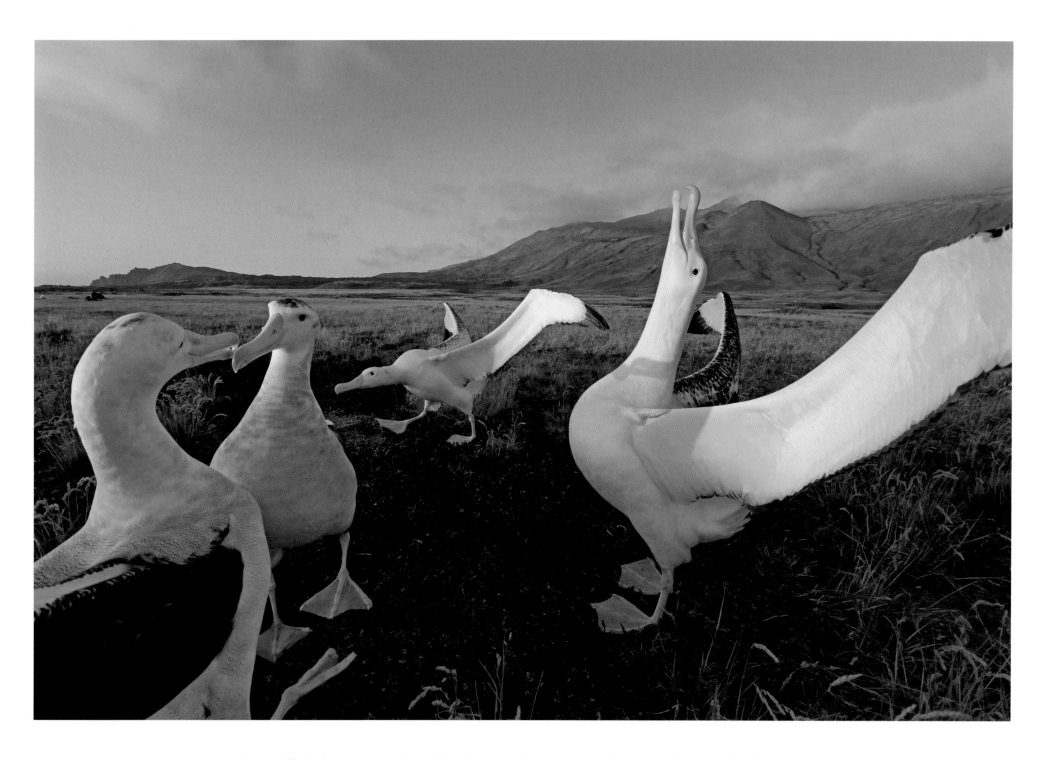

Dance-Off • As the sun sets on Marion Island's western shore, a quartet of wandering albatrosses breaks out in dance. The dancing behavior, typically performed by subadults, helps individuals size up prospective life partners. South Africa, 2017

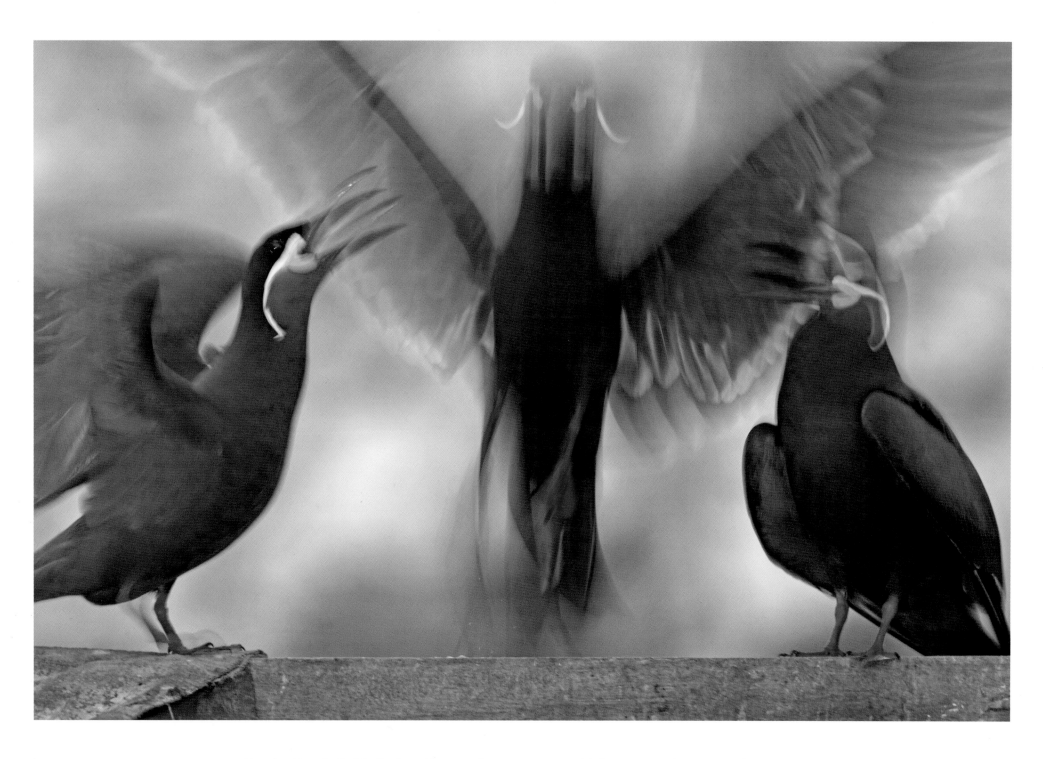

Three's a Crowd • On Isla Guañape Norte, two Inca terns protest a third's attempt to eke out a roosting space between them. With their red beaks and white handlebar mustaches, they are among the most flamboyant seabirds. Peru, 2017

In Your Face • A Cape gannet flies low over Malgas Island, trying to land as close to its partner and nest as possible. If the bird lands too far away, it will have to run through the crowded colony, enduring a gauntlet of stabbing beaks. South Africa, 2010

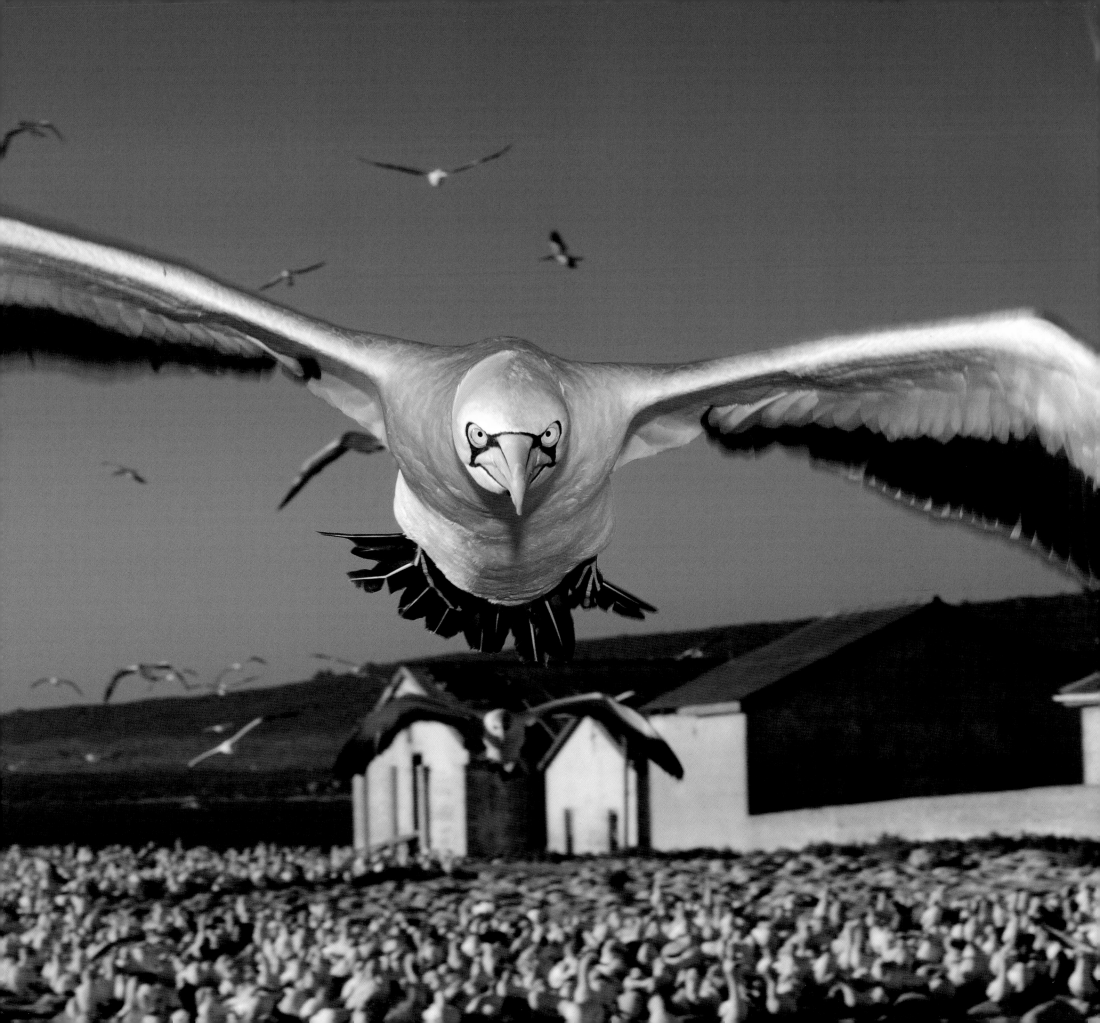

Albatross Nights • Wandering albatrosses lock eyes and display to each other under a star-soaked subantarctic sky. Marion and neighboring Prince Edward Island support the largest breeding population of this vulnerable species. South Africa, 2017

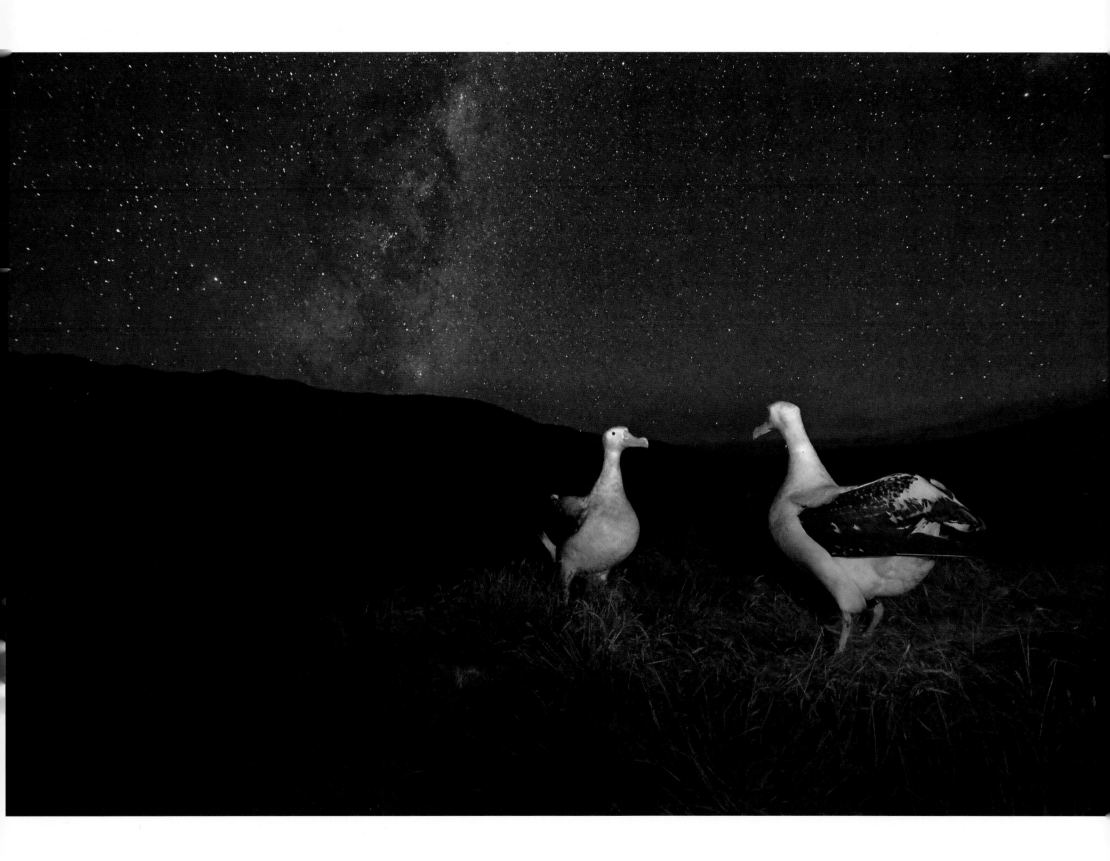

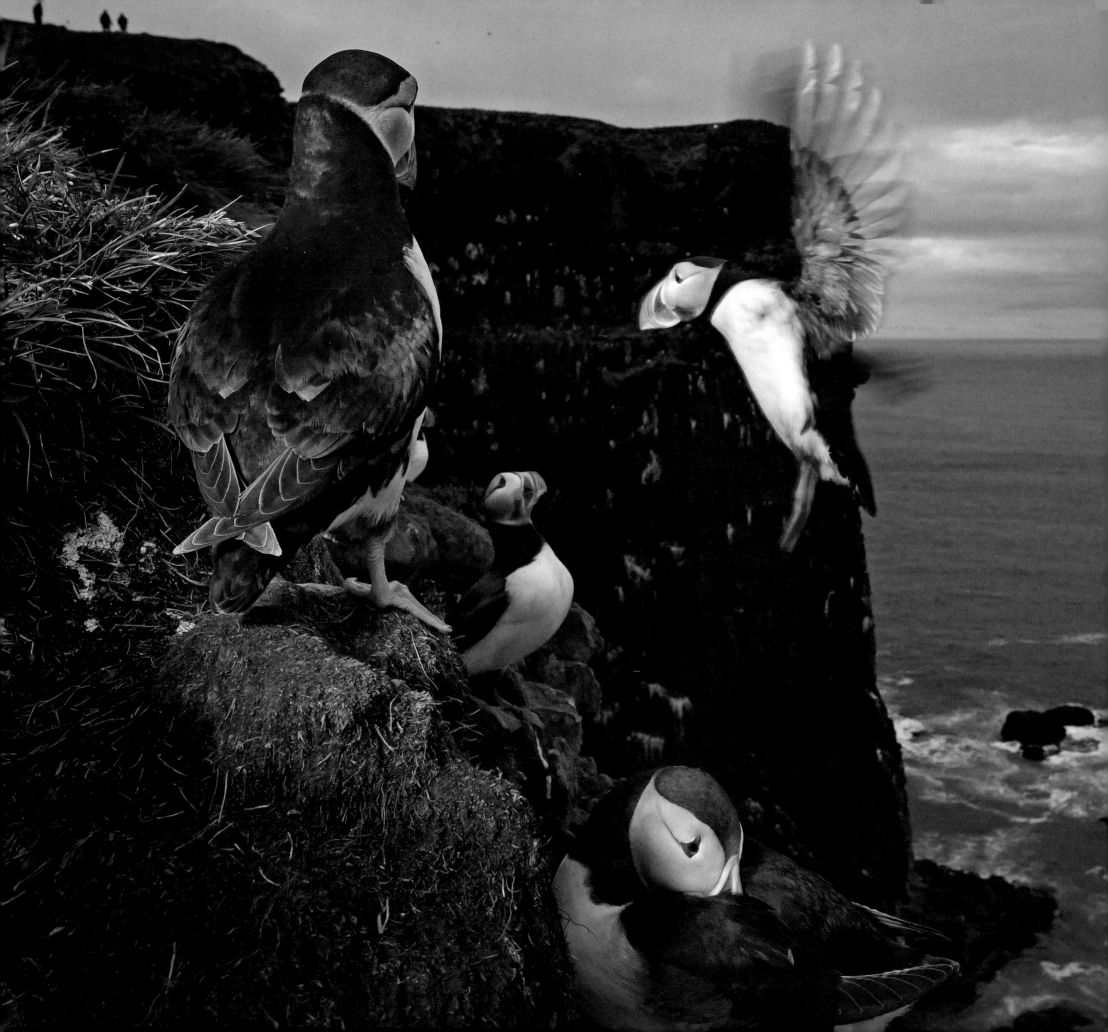

Homecoming • Lit by the midnight sun, an Atlantic puffin returns without fish to its nesting cliff in the Westfjords. As the Atlantic Ocean has warmed in recent years, sand eels, the puffins' principal prey, have moved out of range to the north. Iceland, 2017

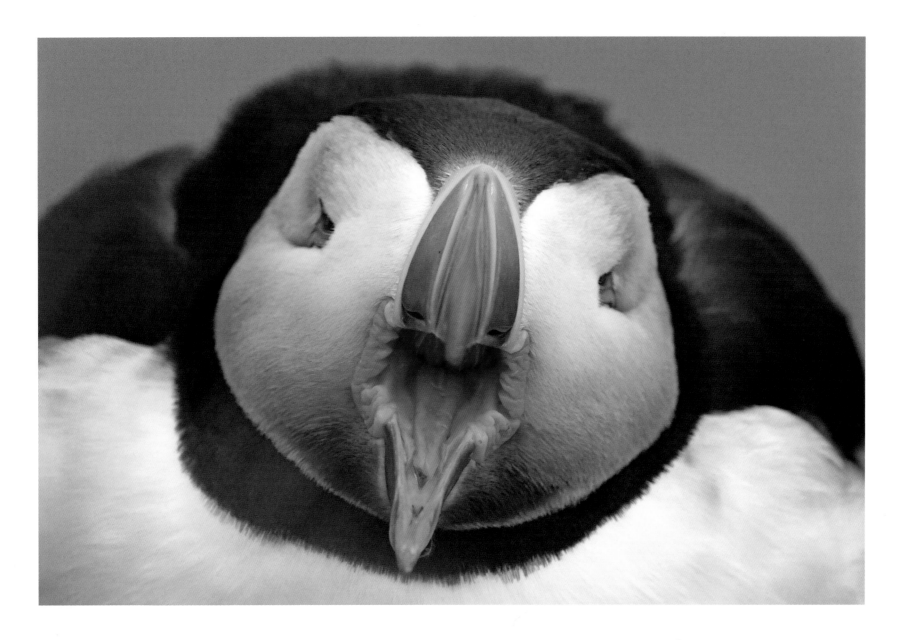

Puffin Protest • An Atlantic puffin gapes widely to display its displeasure with another bird coming too close to its burrow entrance. Iceland, 2017

OPPOSITE

It Takes Two • A pair of bank cormorants hypnotize with their psychedelic eyes. Today, fewer than 1,000 breeding pairs are left in the wild. Namibia, 2012

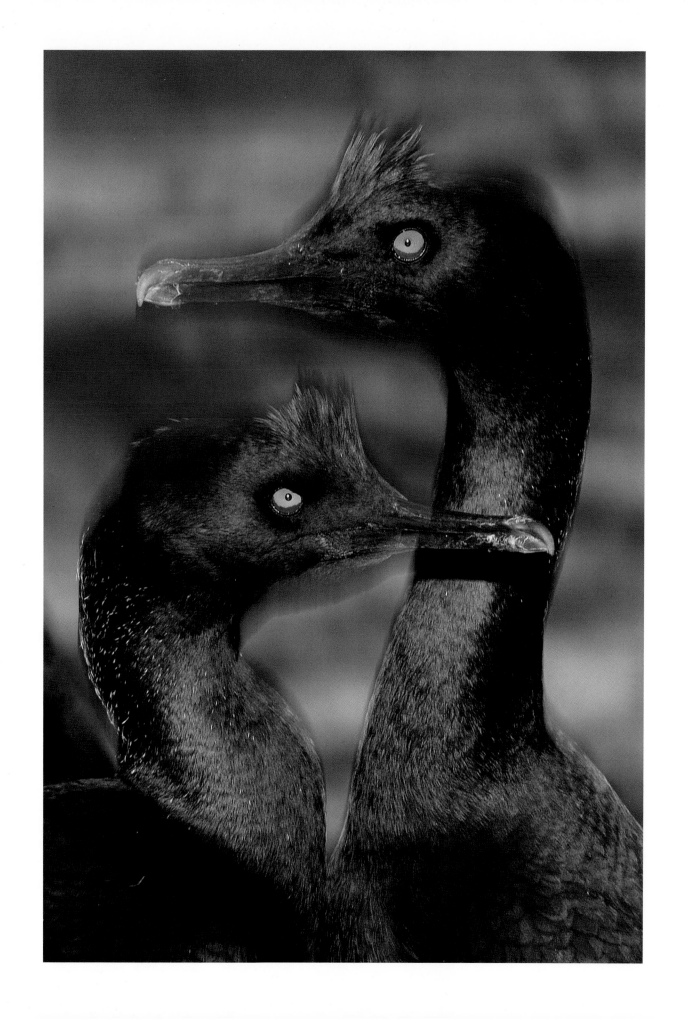

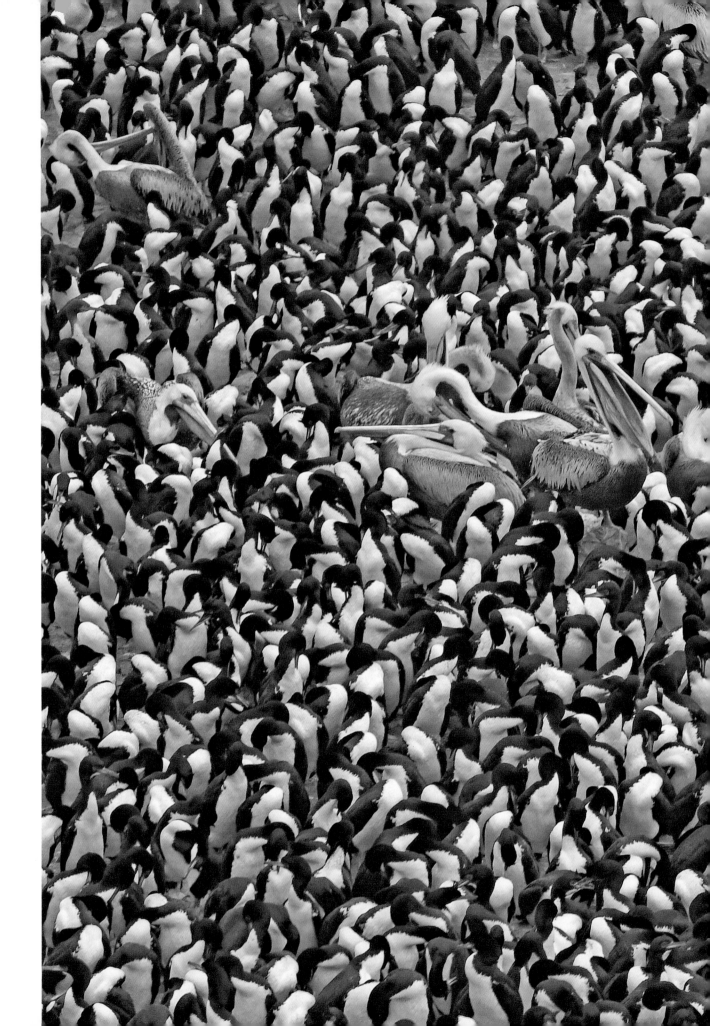

Sea of Birds • Guanay cormorants make room for a few Peruvian pelicans to roost on Isla Guañape Norte, one of the eastern Pacific's most productive guano islands. In slow waves, more than 80,000 birds leave the island every morning to preen offshore. Peru, 2017

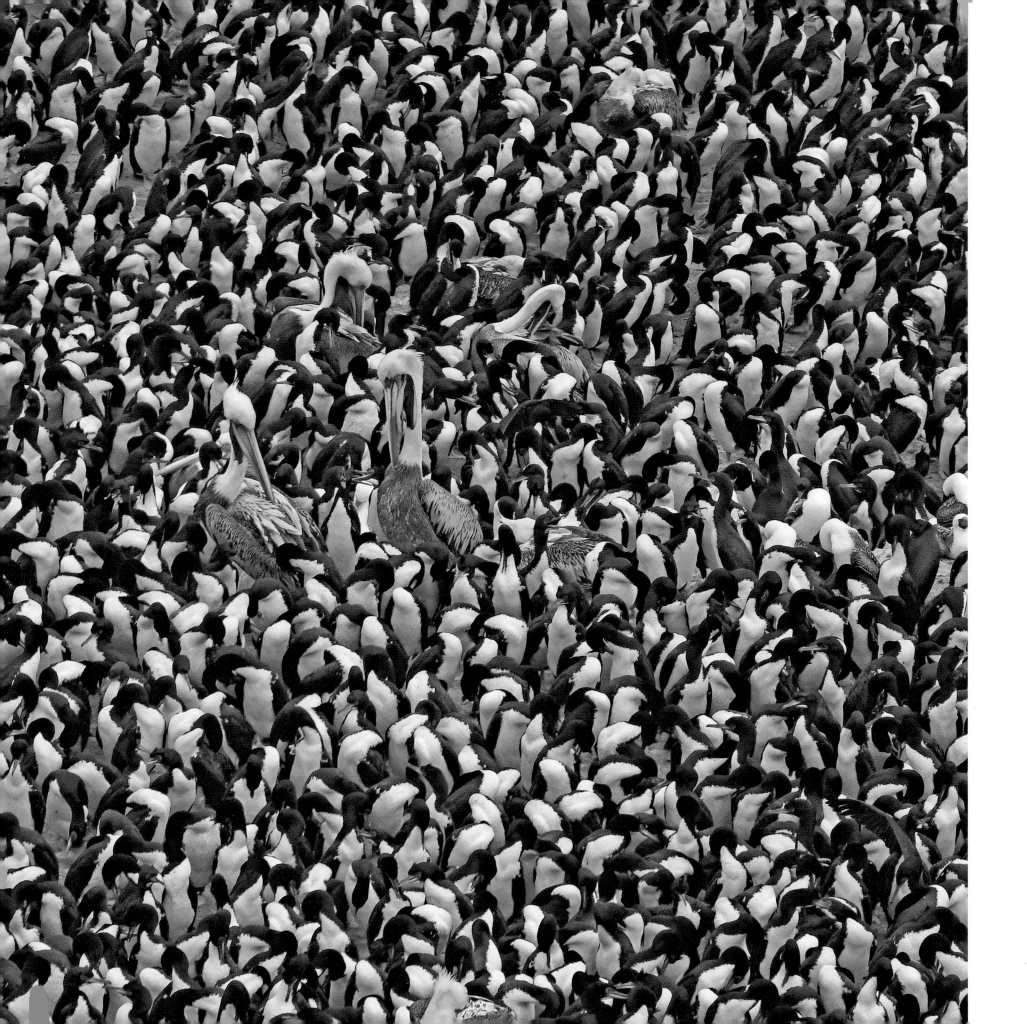

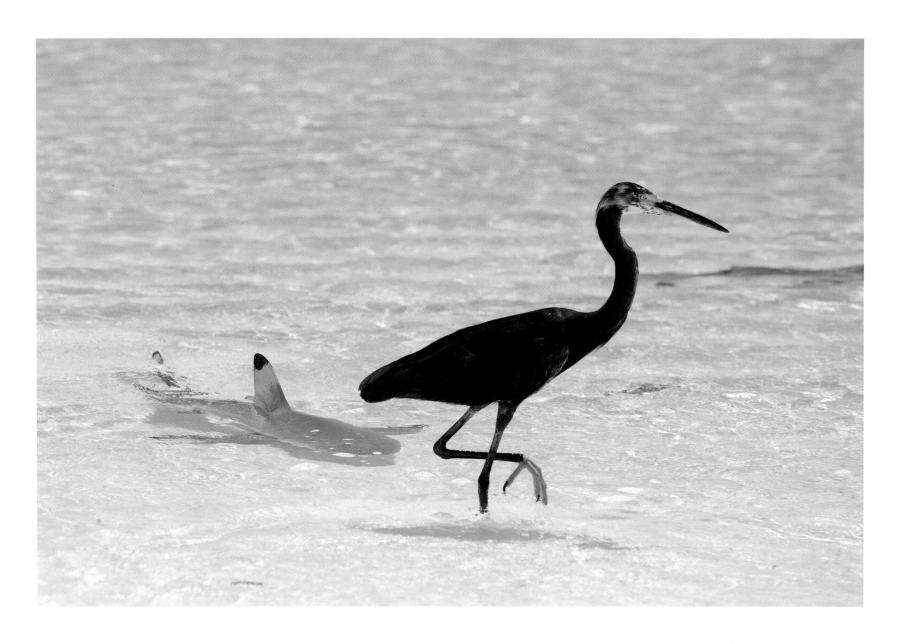

Untroubled Waters • A dimorphic egret and a blacktip reef shark stalk Aldabra's shallows for small fish and crabs. Though the proximity looks dicey, these sharks don't hunt birds. Seychelles, 2008

OPPOSITE

Scoop • Air bubbles escape as a brown pelican plunges beneath the surface to scoop up fish. When expanded, its throat pouch holds approximately three gallons of water. Mexico, 2015

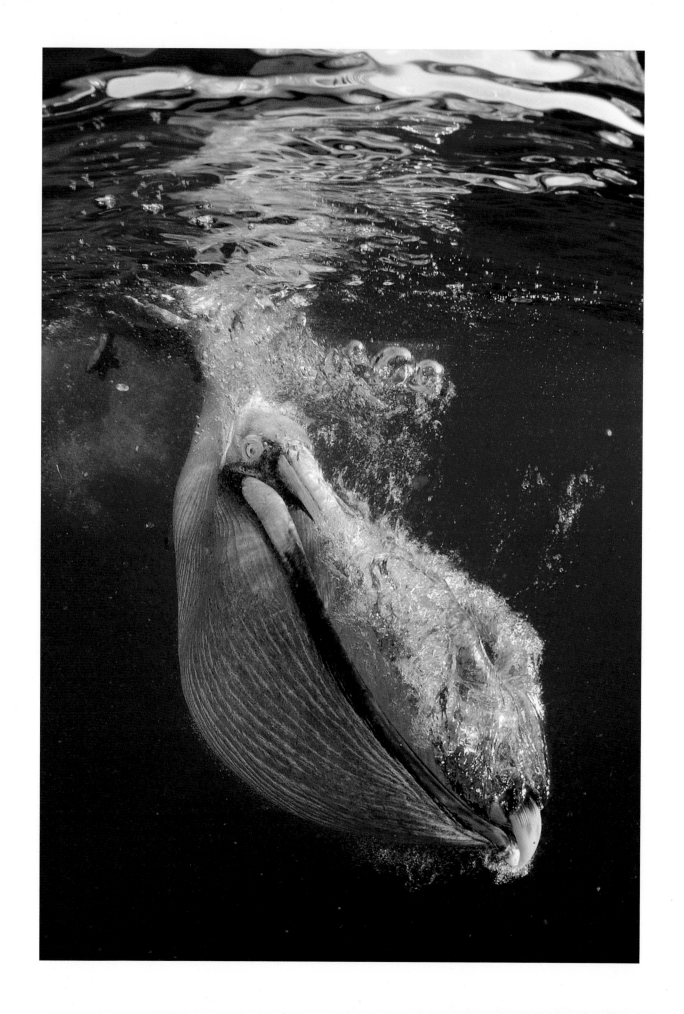

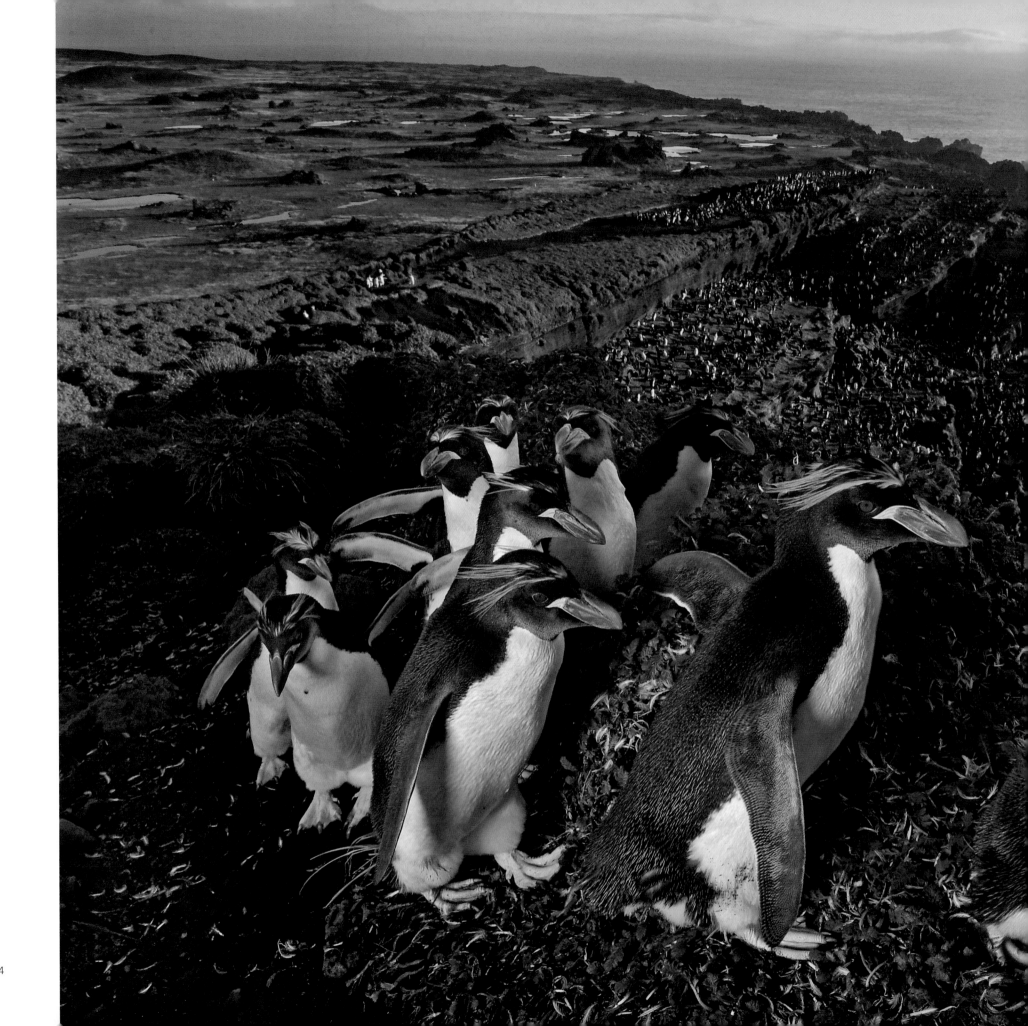

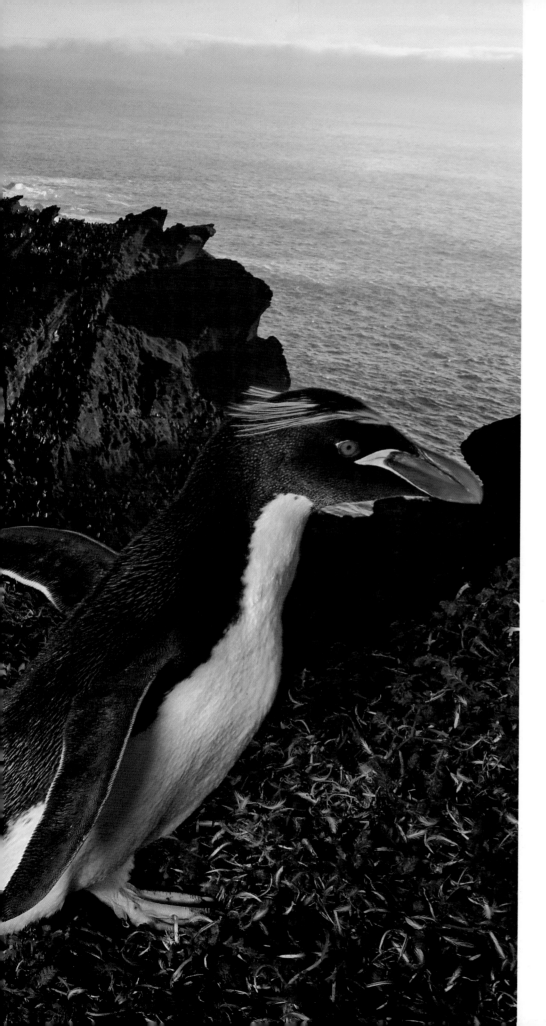

Macaroni March • Fresh from molting, macaroni penguins trudge up the ridge of an old crater on Marion Island. Behind them is "the Amphitheatre," a series of terraces worn down over eons by nesting and molting. South Africa, 2017

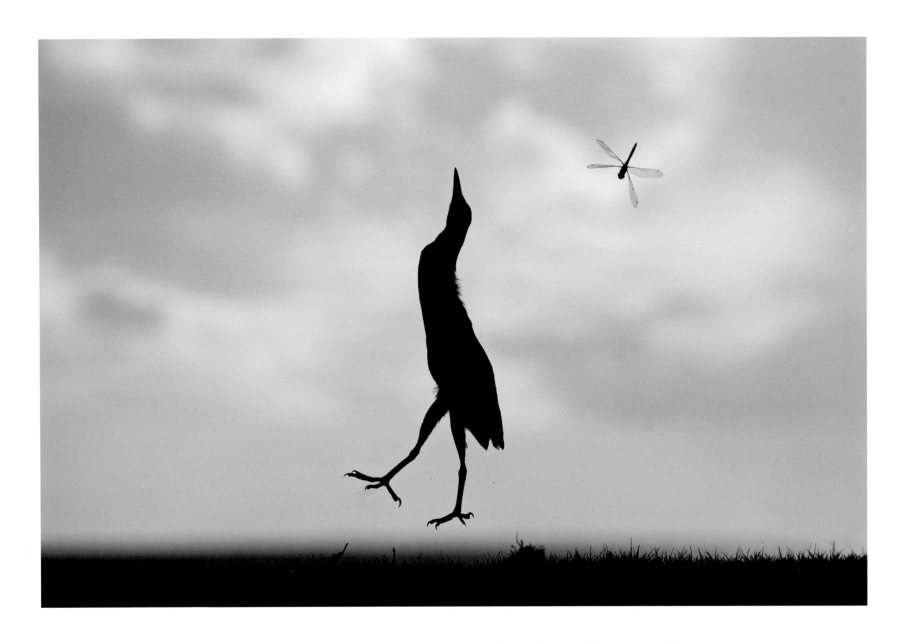

Heron Leap, Dragon Fly • A green-backed heron hunts a dragonfly on Aldabra Atoll. Every year, millions of dragonflies migrate across the Indian Ocean from India to East Africa. Seychelles, 2008

OPPOSITE

Fairy Precarious • A white tern bows its head while perched on a casuarina tree. Also known as fairy terns, they lay a single egg on a bare branch; the chick hatches in the most precarious position imaginable. Seychelles, 2006

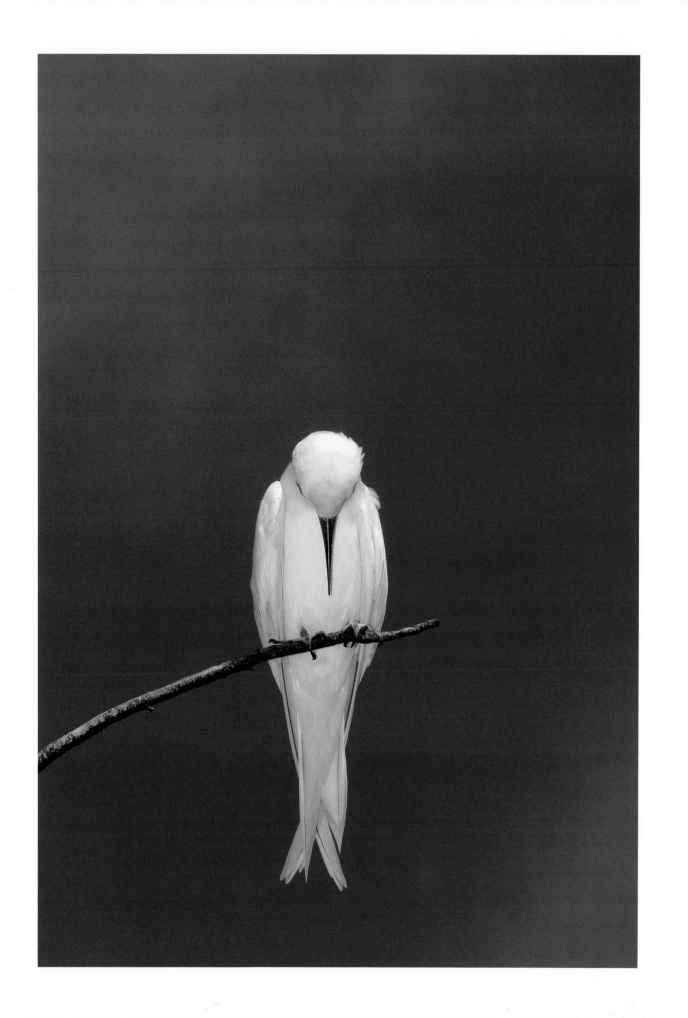

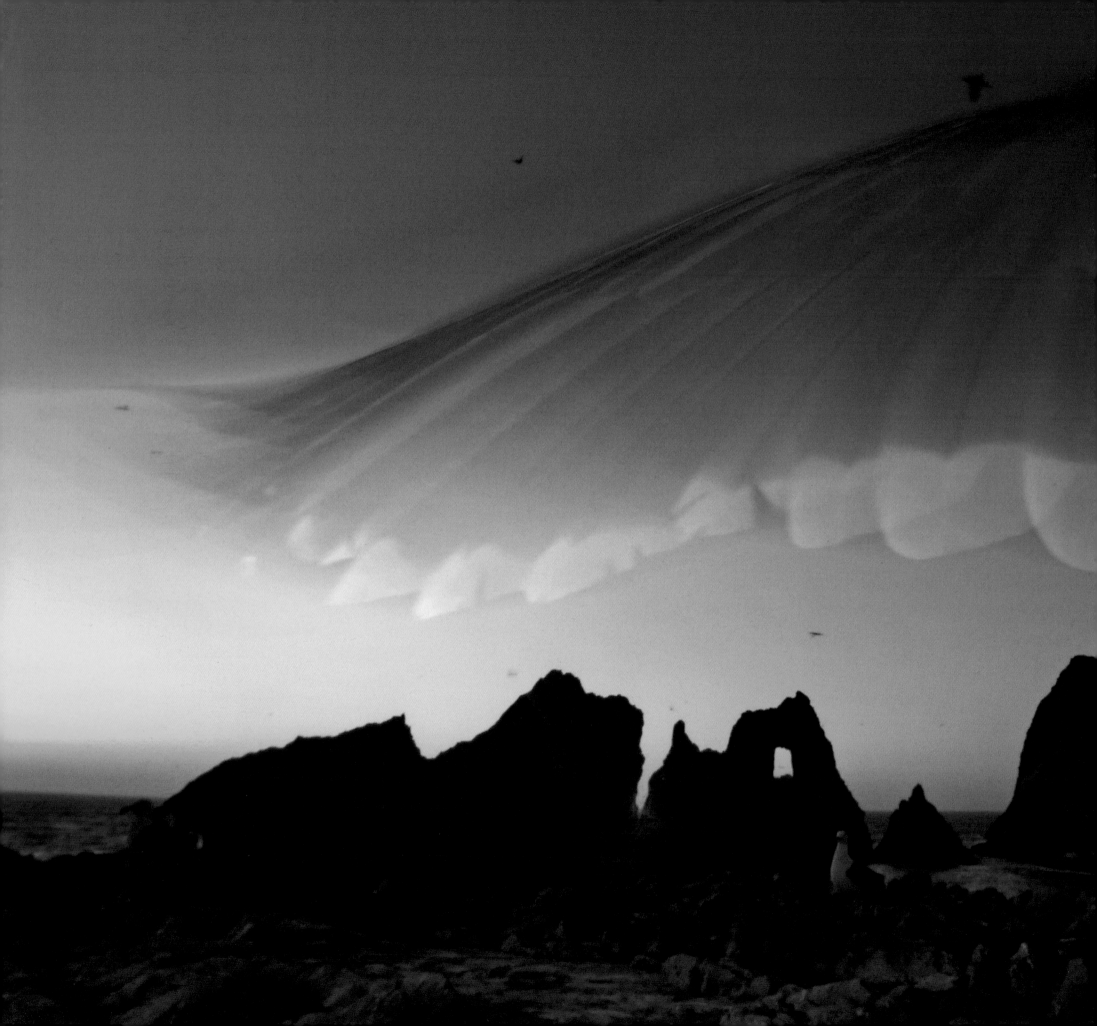

Ghost Gull • A ghostly wing frames the rocky coast of the Farallon Islands just 34 miles west of San Francisco. The islands are a national wildlife refuge and home to 12 species of seabird, including the world's largest single colony of western gulls. U.S.A., 2017

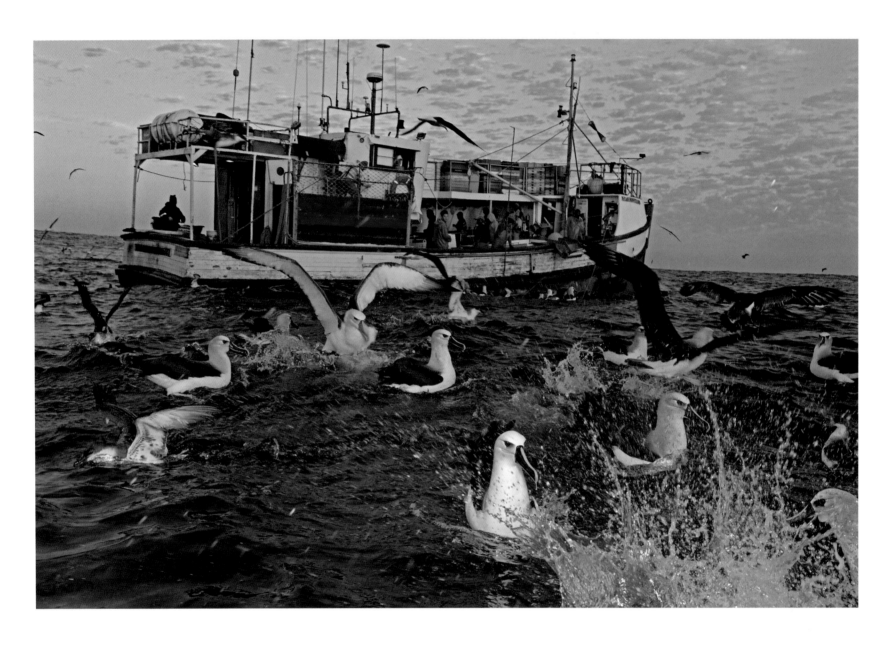

Dangerous Feast • Seventy miles south of Cape Town, albatrosses and shearwaters find plenty to eat. But fishing discards thrown from a longline vessel bring them dangerously close to baited hooks. South Africa, 2017

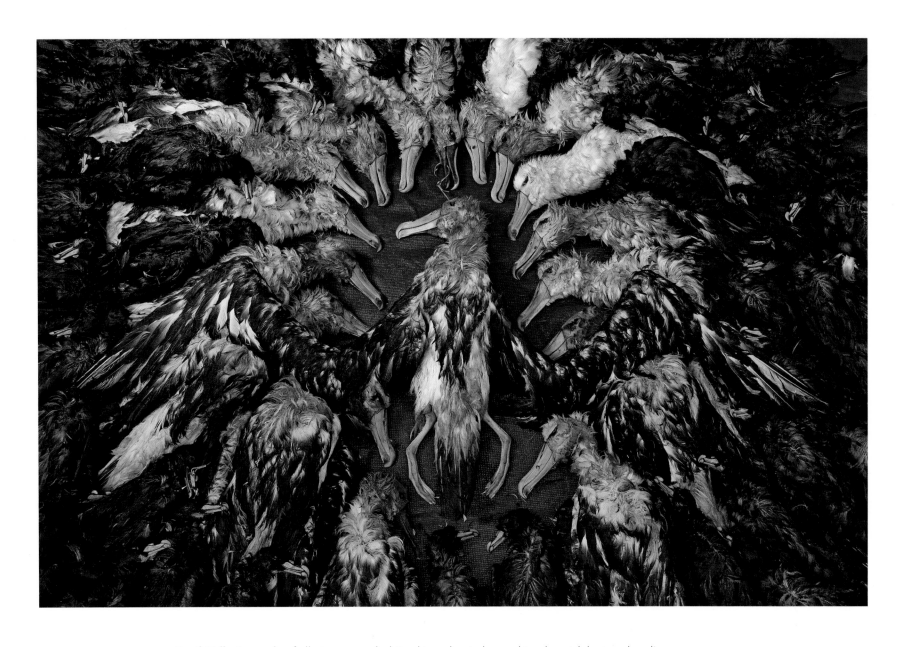

Death Toll • A sample of albatrosses and white-chinned petrels caught as bycatch by tuna longlines. Thanks to sustainable fishing practices, annual bird bycatch in South African waters now numbers only in the hundreds. South Africa, 2017

Zombie Mouse • A scalped gray-headed albatross chick on subantarctic Marion Island gruesomely conveys the threat from invasive species. Mice were introduced to the island 200 years ago by unwitting sealers; today, they flourish with an expanded diet, including live albatross. With no instinctual fear of this new danger, this bird sits passively while mice nibble into its flesh, until it succumbs to a slow death. South Africa, 2017

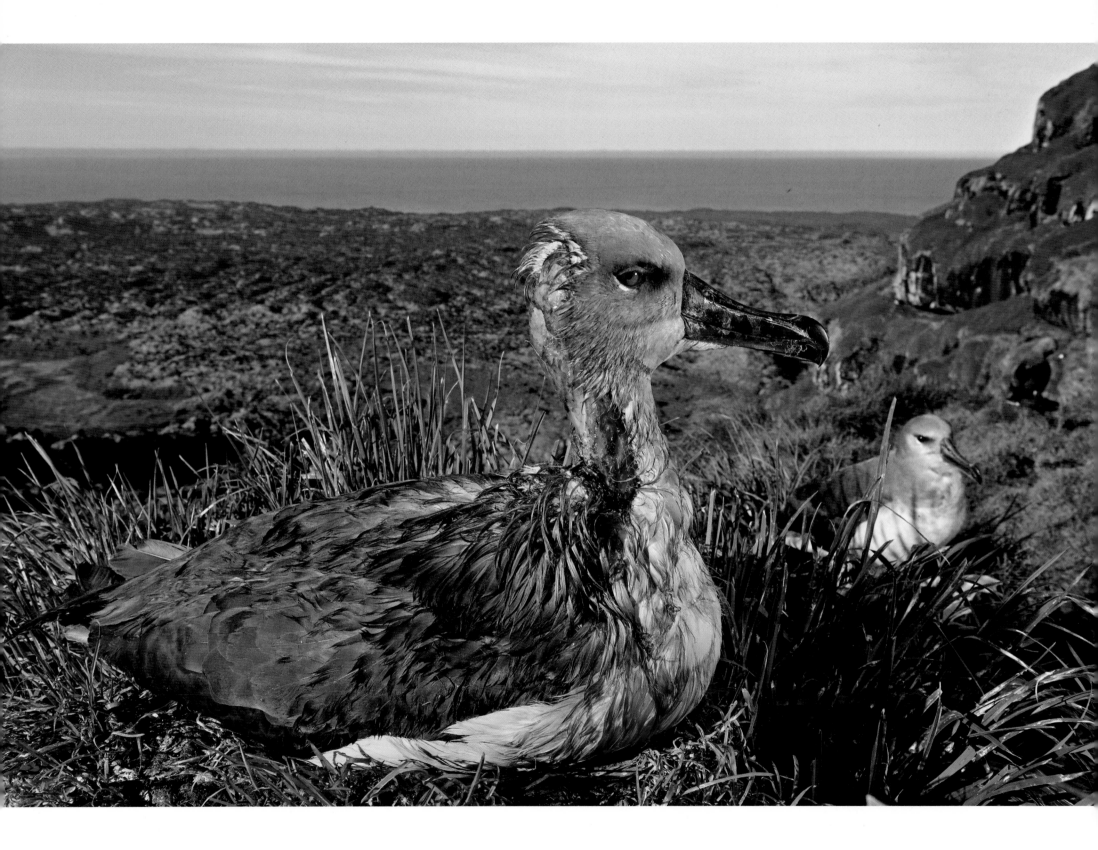

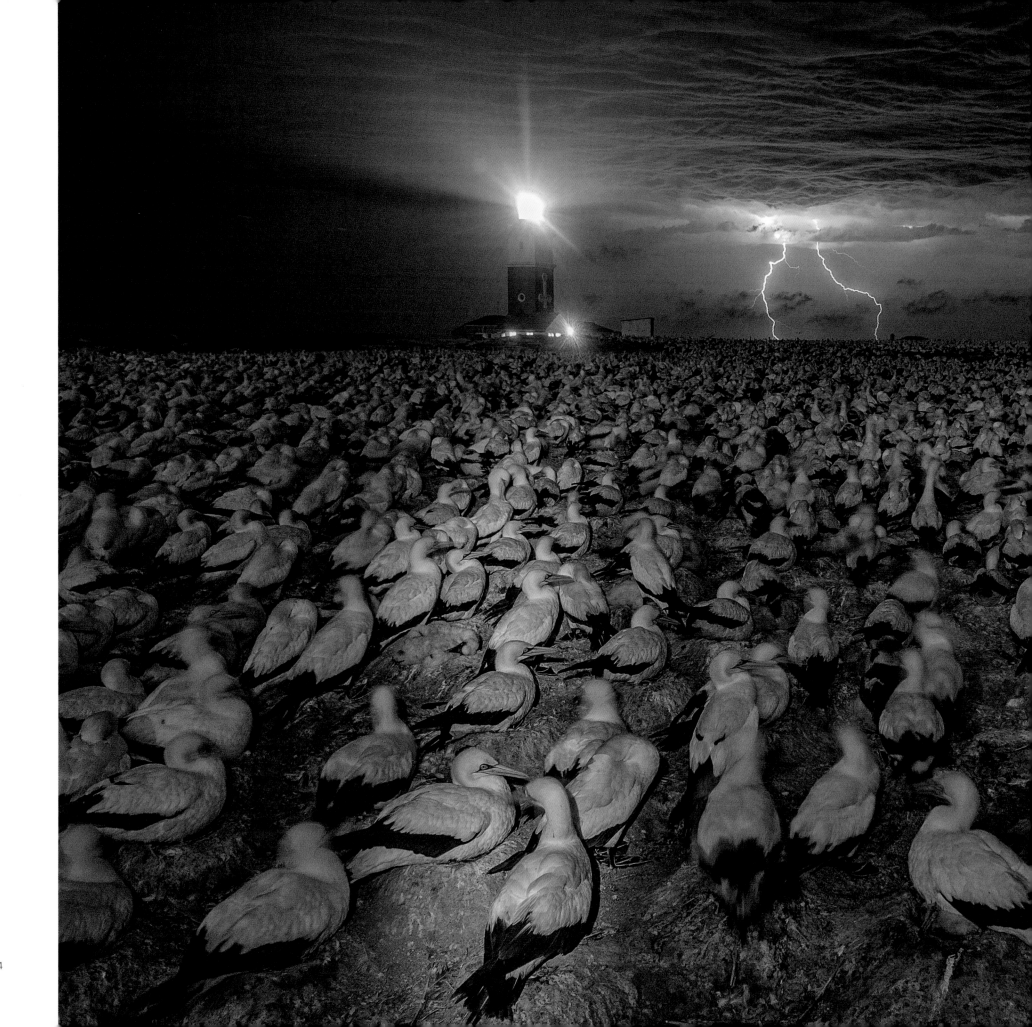

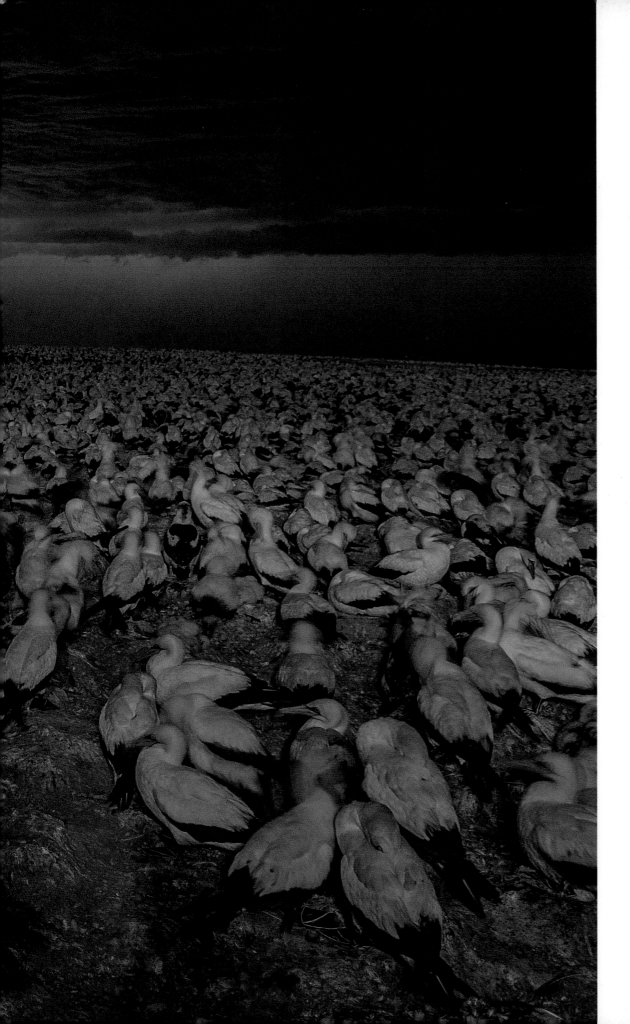

Lightning Birds • Cape gannets on Bird Island sit against the backdrop of a lighthouse and an electric sky. This humble 47-acre outpost in Algoa Bay hosts the largest breeding colony in the world. South Africa, 2006

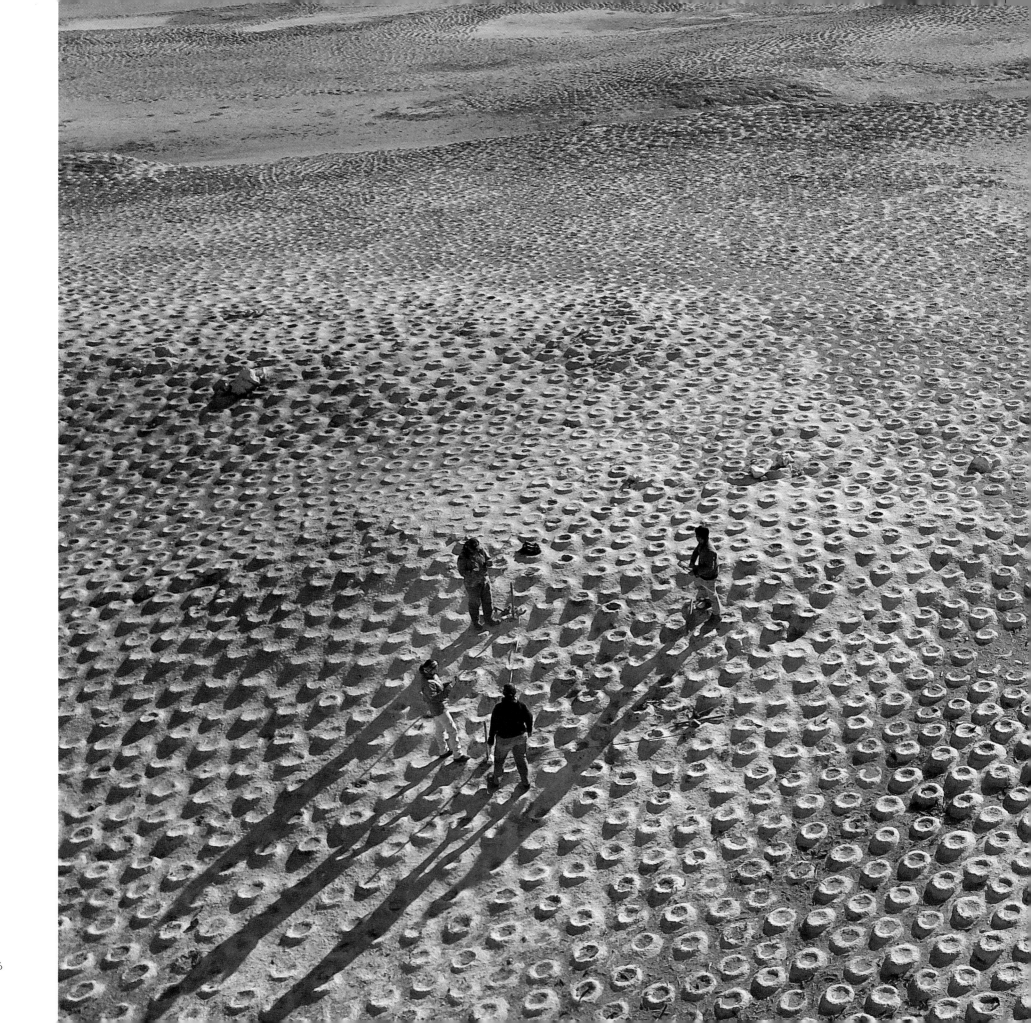

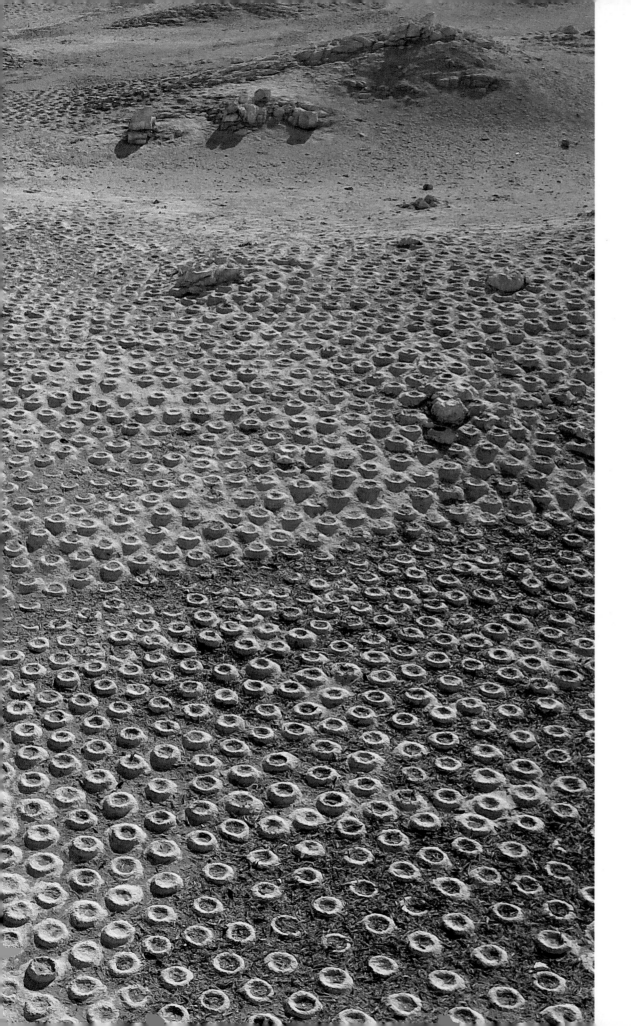

Empty Nesters • Scientists survey tightly packed nests abandoned by guanay cormorants at Punta San Juan. With three or four nests per square yard, these seabirds create some of the densest nesting in the world. Peru, 2017

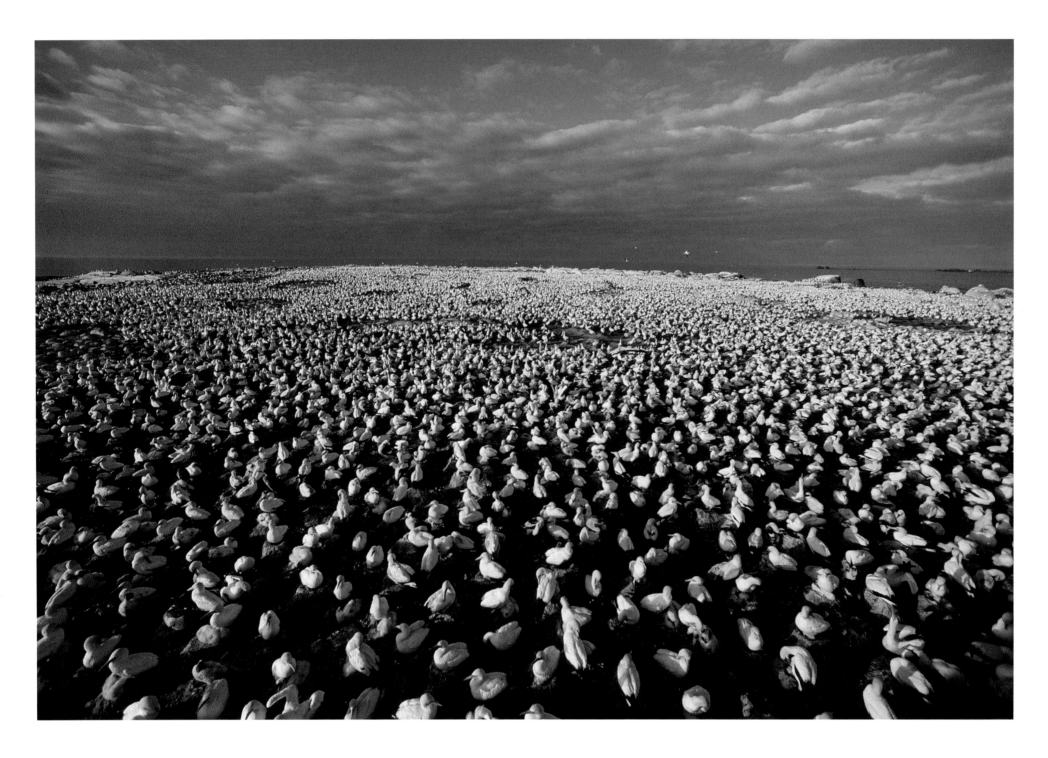

Before • When I first photographed Malgas Island in 2003, nesting Cape gannets blanketed almost the entire island. At the time it was the largest breeding colony in the world, with around 40,000 birds. South Africa, 2003

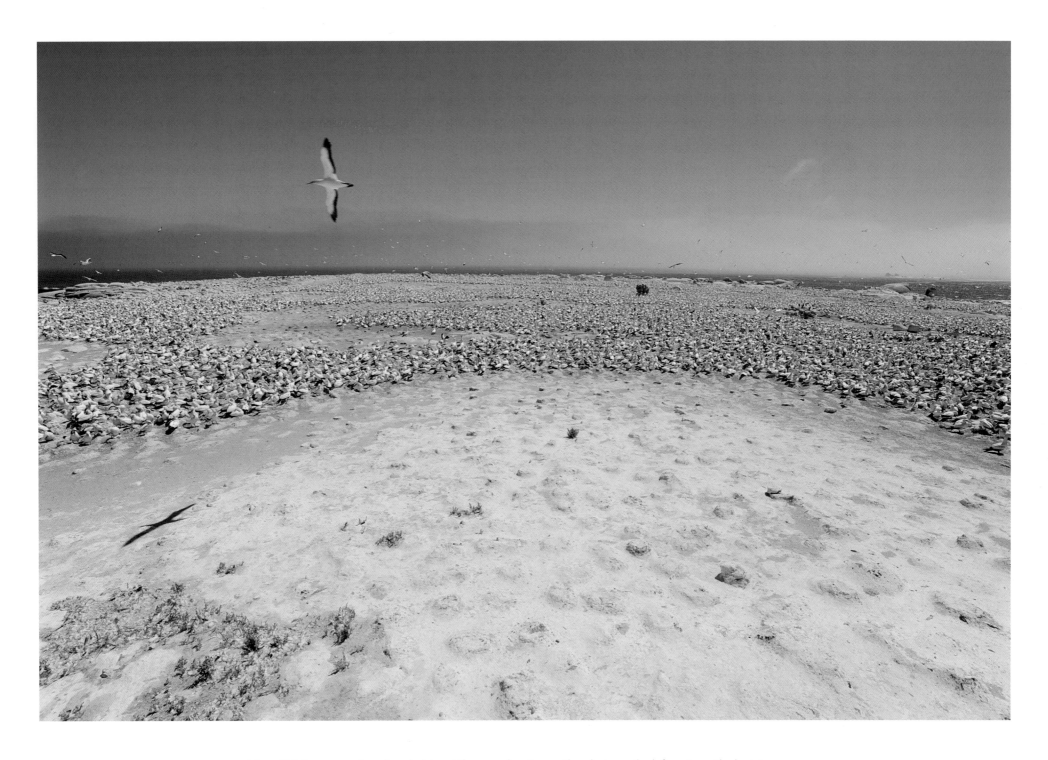

After • This image, made a decade later at the same location as the photo on the left, poignantly depicts the 25 percent decline of the Cape gannet population. Today the number of birds breeding is fewer than 20,000. South Africa, 2012

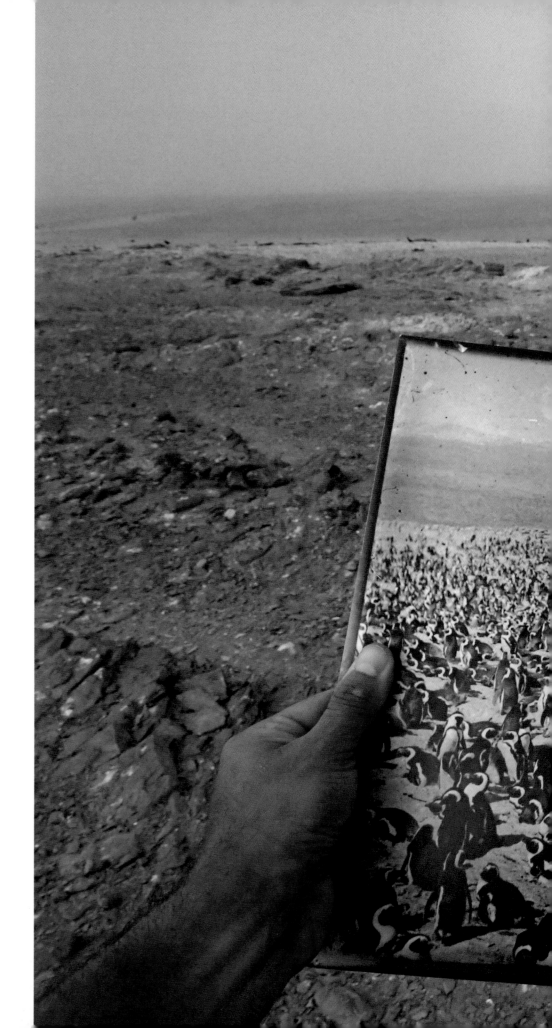

Then & Now • An 1890s photograph of a colony of more than 100,000 African penguins on Halifax Island, located just off the coast of Namibia, is held against a backdrop of the same location in 2012. Today, fewer than 2,000 remain. Decades of unregulated egg and guano collection decimated penguin populations. Namibia, 2012

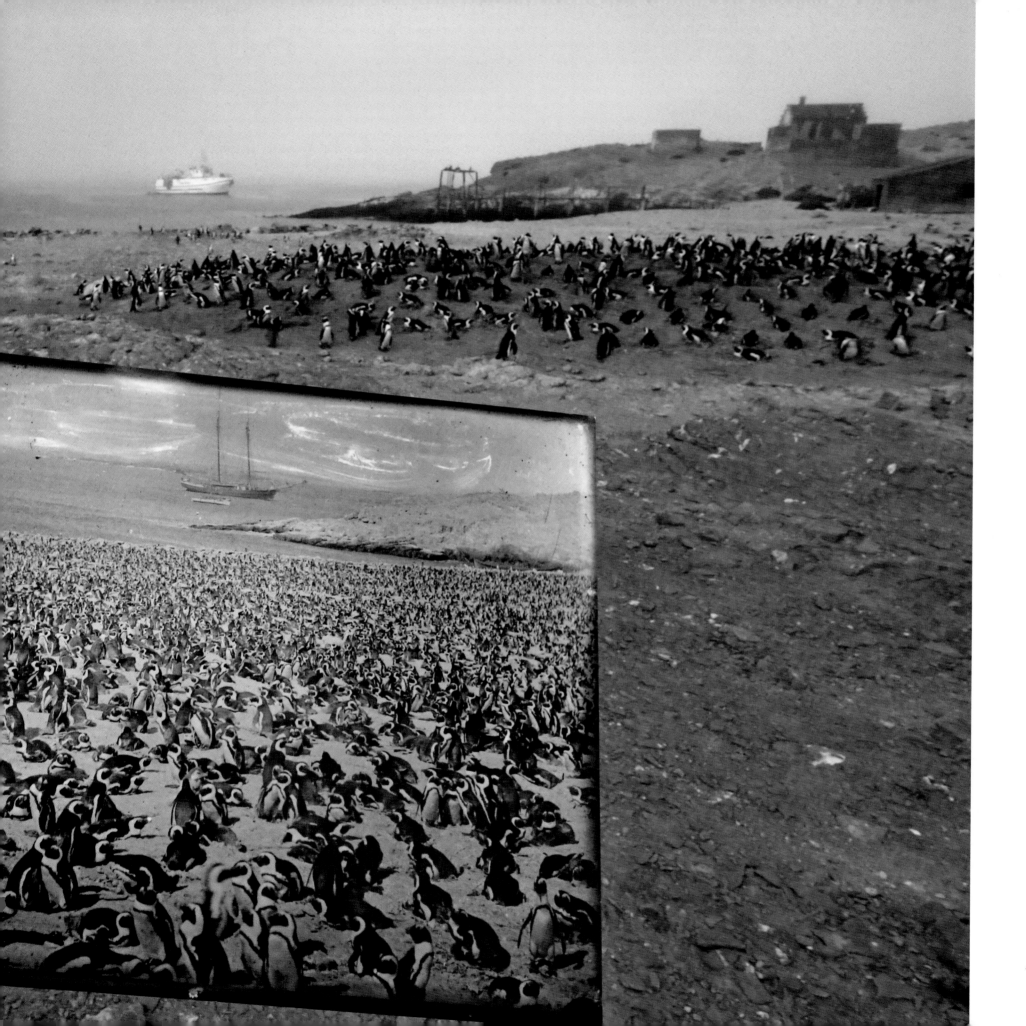

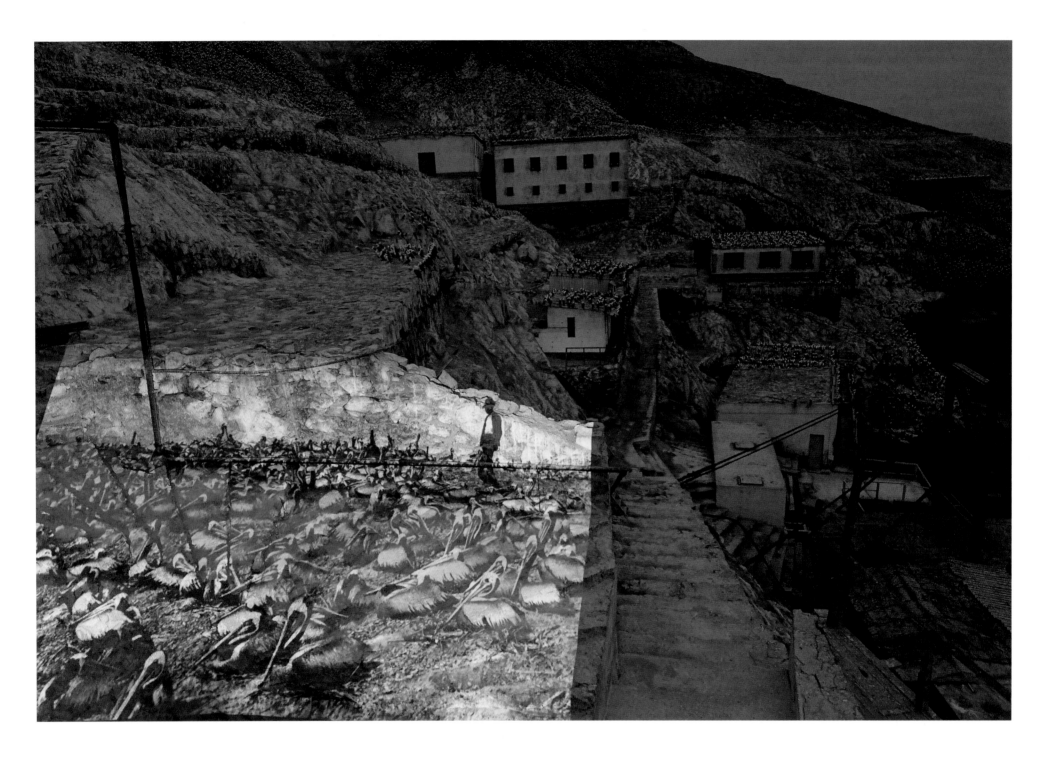

Ghosts of Guano • Guano, the nitrate-rich droppings of seabirds, was a popular fertilizer in the 19th century. Peru's islands were a prime source, and their seabird populations nose-dived due to guano mining. To explore these declines in a novel way, I projected historical photographs onto contemporary scenes of the guano islands. Peru, 2017

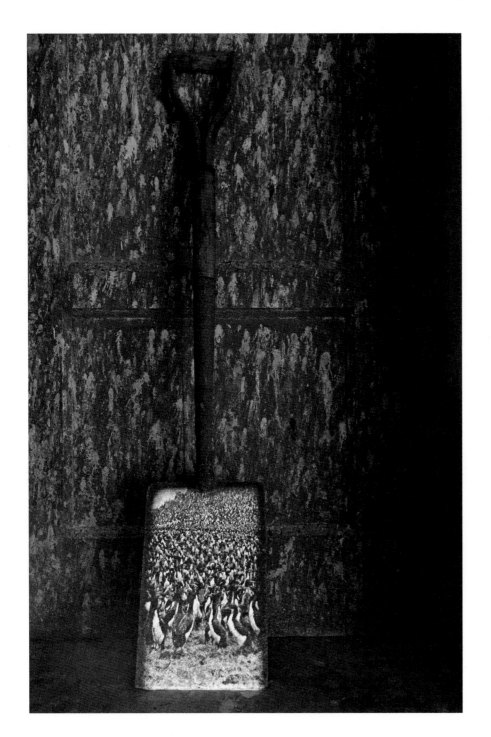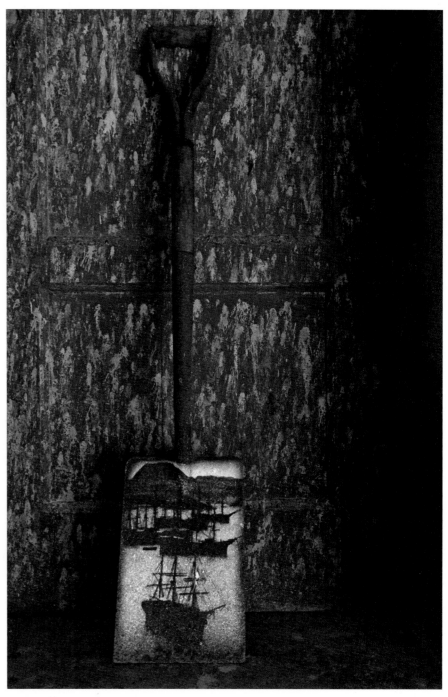

Digging Up the Past • Historical photographs of a dense colony of guanay cormorants *(LEFT)* and guano ships on anchor *(RIGHT)* are projected onto modern mining shovels on Isla Guañape Norte. Today, guano mining is much less frequent, rotates location, and is supervised by conservationists. Peru, 2017

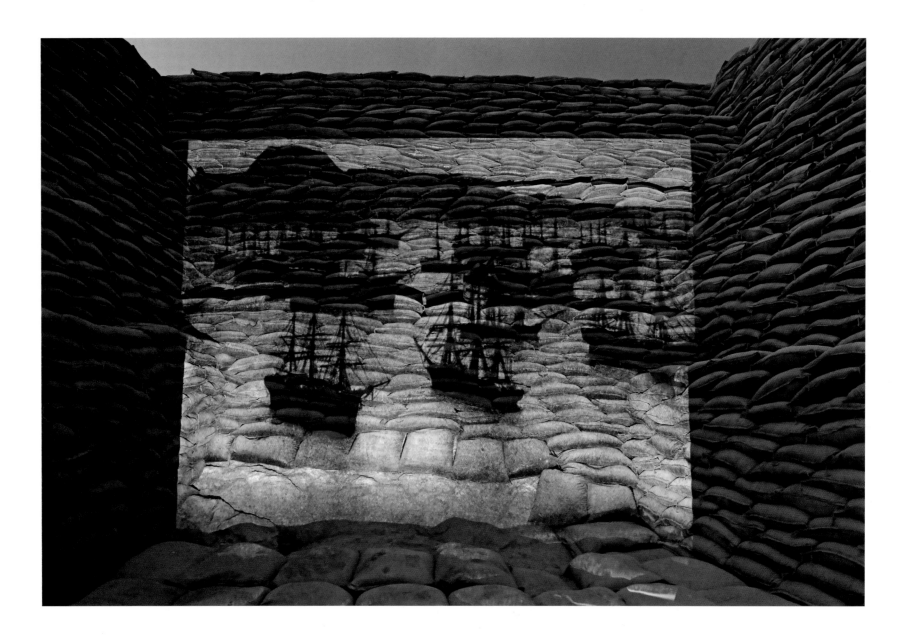

In the Bag • A photograph from the 1890s depicting a fleet of guano ships is projected against a bunker of guano bags ready for shipment on Isla de Asia. Peru, 2017

OPPOSITE

White Gold • A historical photograph of men loading bags of guano onto a ship is projected onto vacated nests of Peruvian boobies, post-breeding season. Peru, 2017

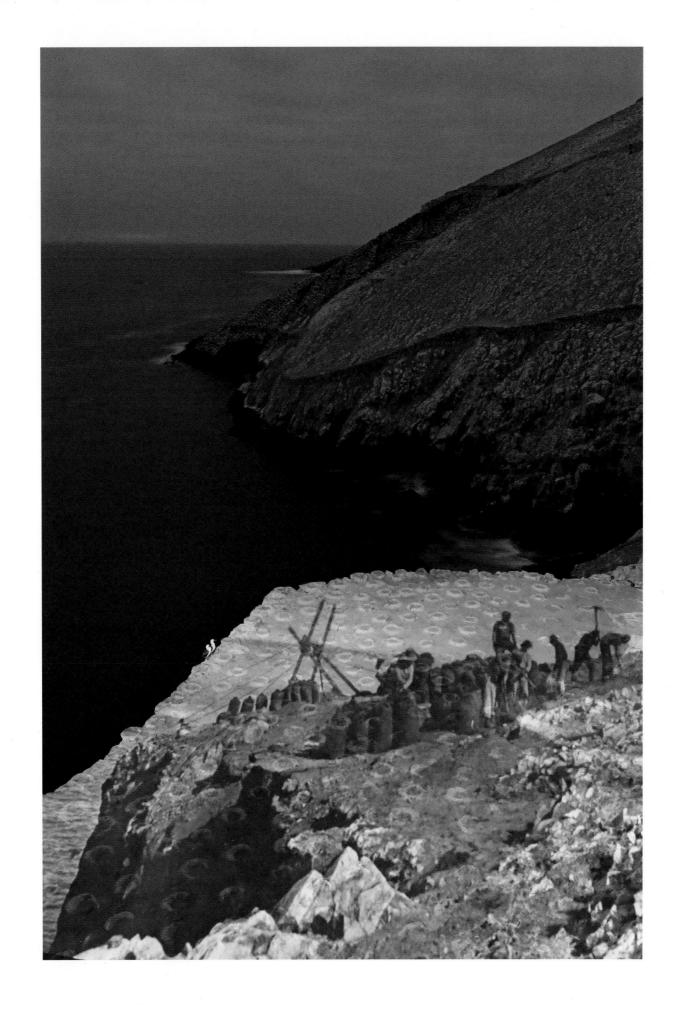

Pelicans of the Past • An archival image of nesting pelicans from 1907 is projected onto a ruined fishermen's chapel on Islas Lobos de Afuera. Back then, up to 200,000 pelicans nested on this remote island. Over the last quarter century, a lack of food due to climate change and overfishing has prevented large numbers of pelicans from successfully nesting here. Peru, 2017

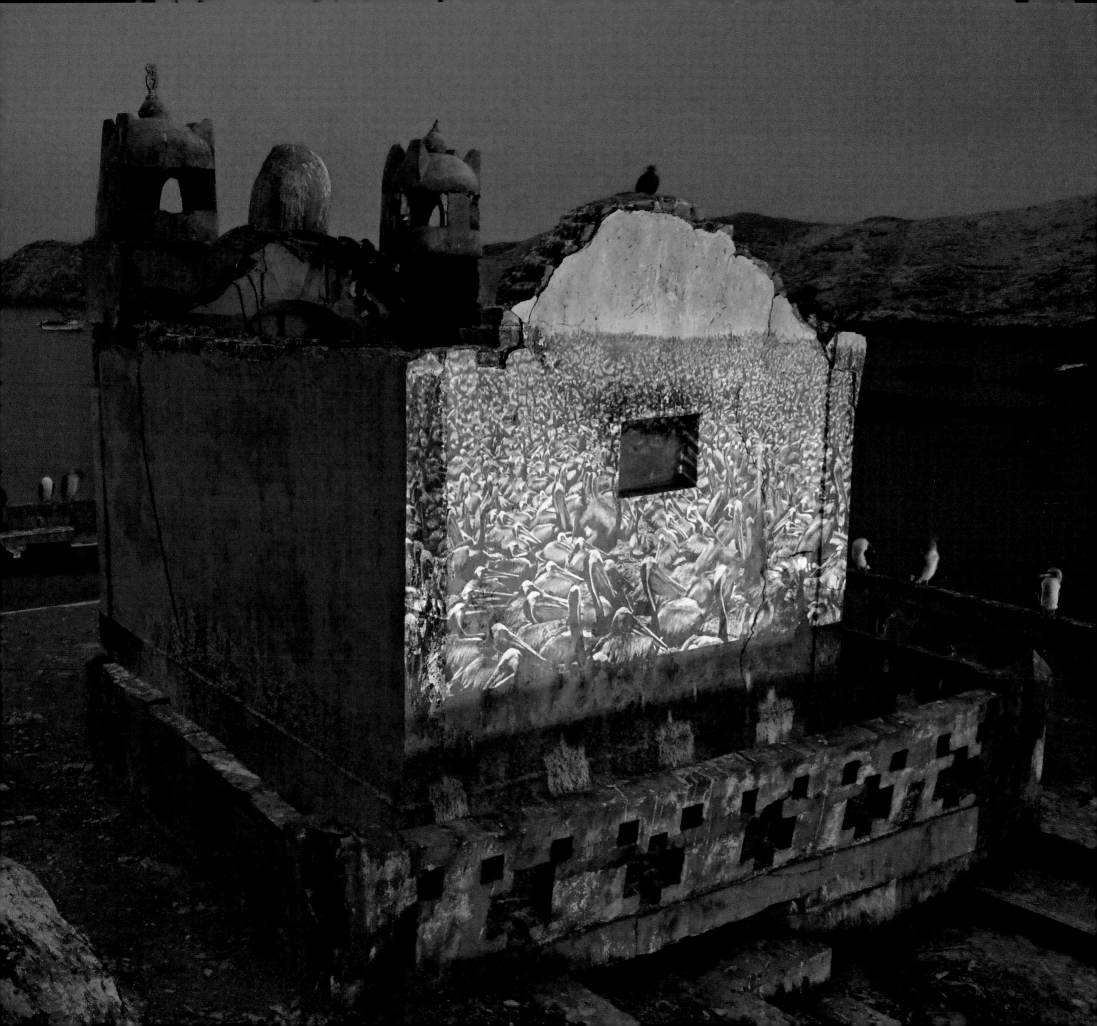

Te Tara Koi Koia
(27 Days of Sheep)

WHEN I FIRST SAW a picture of Te Tara Koi Koia, my jaw dropped. I became determined to visit this spectacular, cone-shaped islet, 570 feet high. Located at the southern edge of the Chatham Islands, 530 miles east of New Zealand, this is the only place in the world where the Chatham albatross nests.

As I discover, a cave high on the island is prime real estate for these seabirds. Protected from erosion by wind and rain, they lay their eggs and raise their chicks on unique, three-foot-tall pedestal nests that look like top hats.

In modern times, more people have been to space than have set foot inside this cave. In addition to its sheer remoteness, the island is not hospitable to humans; accessing the cave is only possible a handful of days a year due to its challenging topography, with no real sheltered place to land. A team of seabird biologists from the Chatham Island Taiko Trust accompanies me to make sure I don't plunge to my death.

There is no cell phone service in the Chathams, and every evening we gather near the radio to listen to the forecast.

After 10 days of too much wind and swell, despair creeps in. To maintain my sanity, I begin photographing sheep; after all I'm staying on a sheep farm and there are 60,000 on the island.

I start off with portraits, then action shots of walking and bleating. On Day 15, I shoot sheep at sunset. Day 19 begins my artistic phase—creating thousands of images of sheep framed by out-of-focus grass. (On a particularly dark day I coin the phrase, "A sheep a day keeps the psychiatrist away.") Days 23 through 26 come and go with no break in the weather, but more photographs of sheep. On Day 27, I am filled with paralyzing anxiety, because the following day is Day 28, my last chance.

That evening, having given up all hope, I kneel prostrate by the radio, willing it to bless me with a weather window. And then, within the static I barely make out the report: "Conditions not great, but maybe . . ."

Of the 698 hours I budgeted, I spend just 24 on Te Tara Koi Koia. When I pitch my tent on its steep rocky slopes that night, I sigh with relief—grateful to be photographing albatrosses instead of sheep.

At the southern edge of New Zealand's Chatham Islands sits Te Tara Koi Koia, also called the Pyramid. It is the only breeding ground of the Chatham albatross.

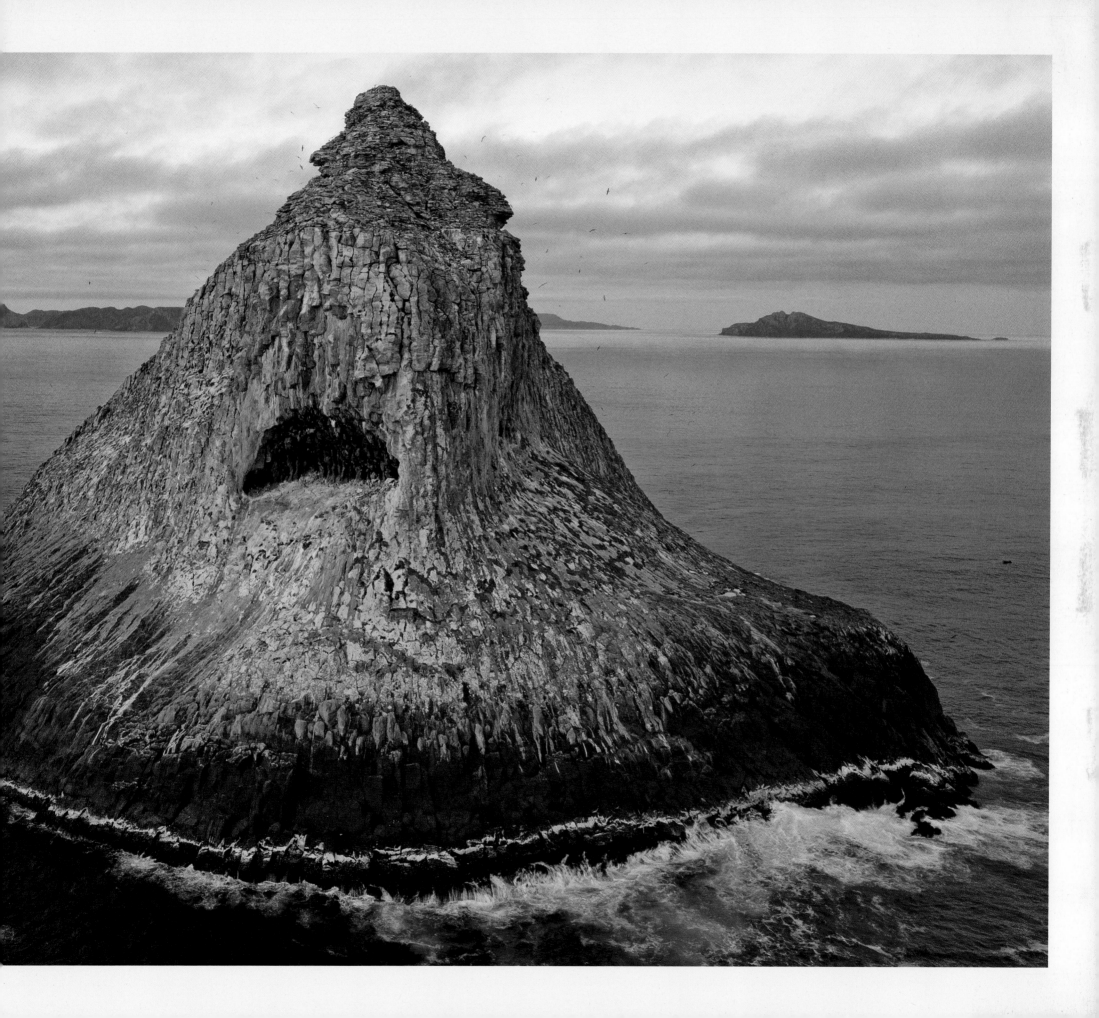

Rock engravings depict albatross chicks sitting on their nests. This modern reproduction was inspired by Moriori petroglyphs found in a cave at Te Whanga Lagoon.

RIGHT: A natural cave is the most sheltered nesting site high up on Te Tara Koi Koia. The unique pedestal nests resemble top hats.

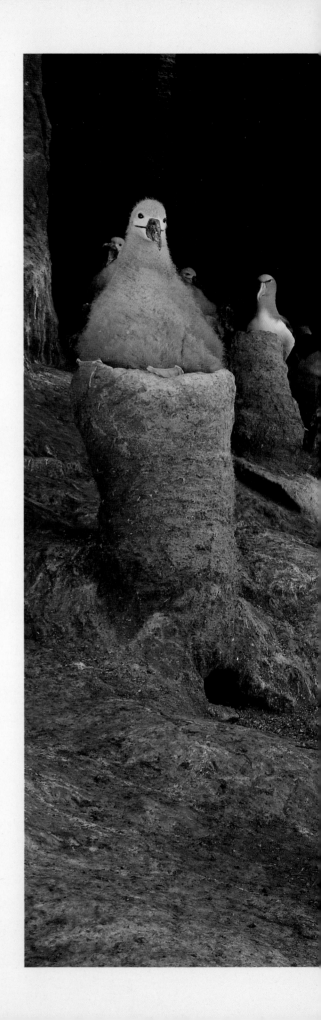

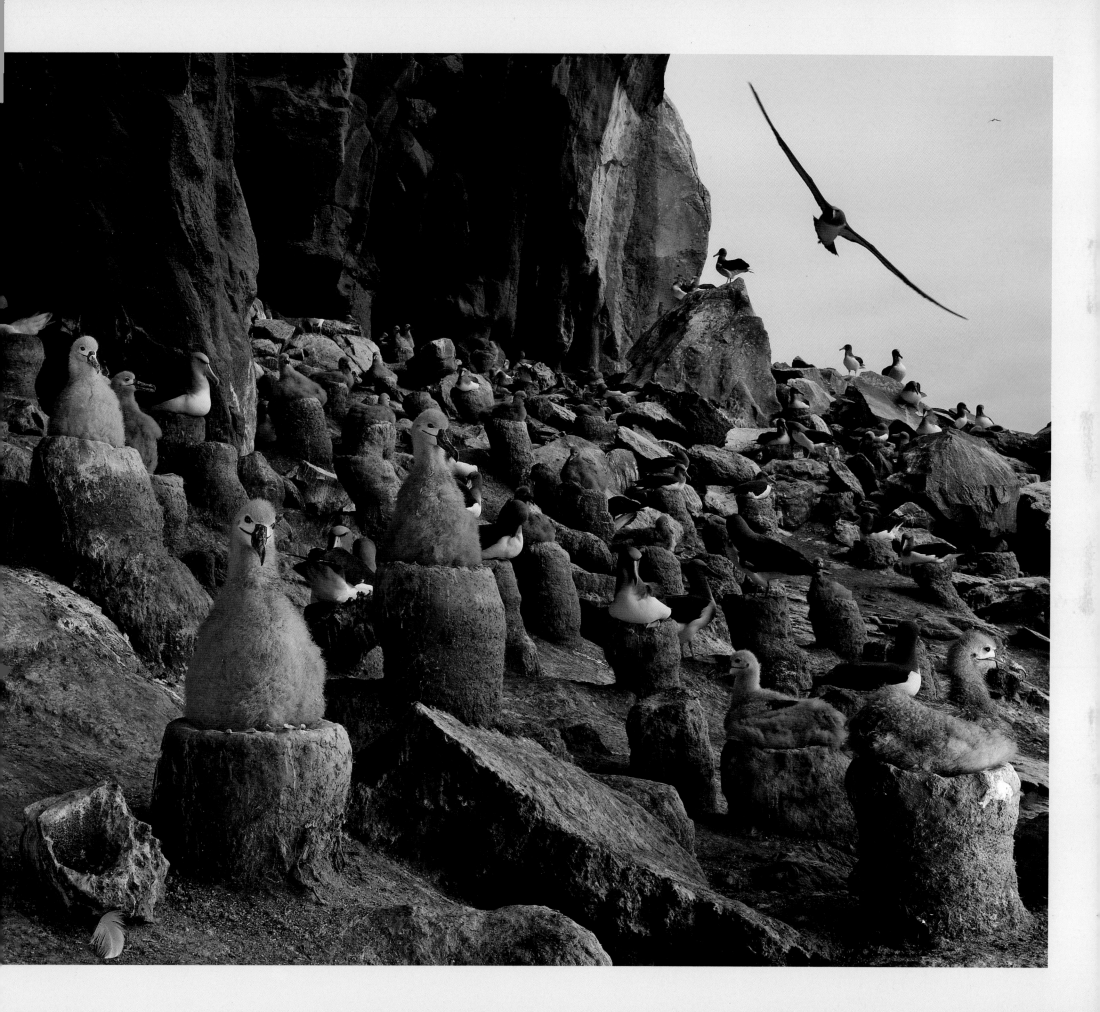

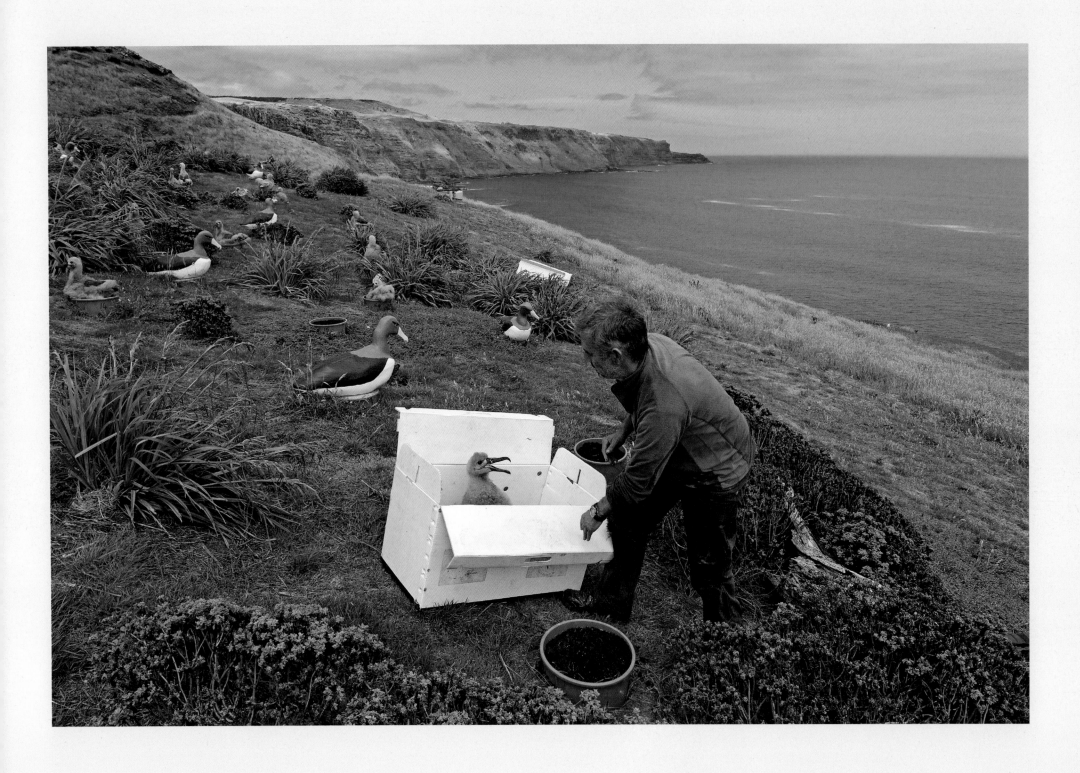

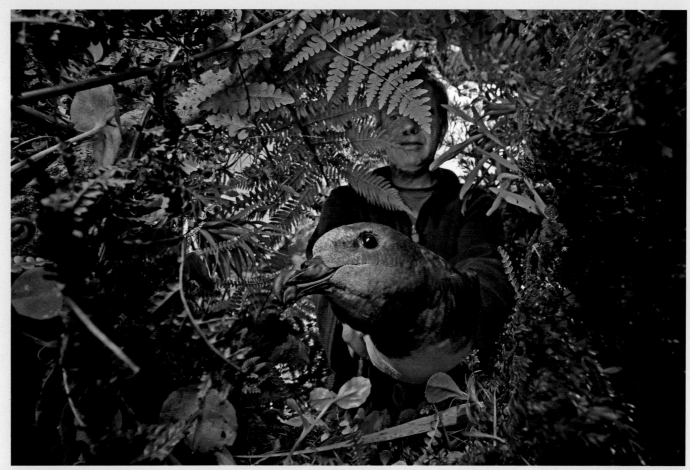

OPPOSITE: Wary of the Chatham albatrosses' reliance on a single breeding ground, the Chatham Island Taiko Trust established another breeding site by relocating some of the chicks from Te Tara Koi Koia.

RIGHT, TOP: Field biologist Dave Boyle returns a taiko, a rare seabird, to an artificial burrow. Thought to have gone extinct more than a hundred years ago, taikos are now protected in a patch of forest surrounded by a predator-proof fence.

RIGHT, BOTTOM: Placed on flowerpot nests among decoy adults on the main island, the relocated albatross chicks are fed fish until they fledge. If all goes as planned, the birds will return in three to five years to lay the foundations for a new colony.

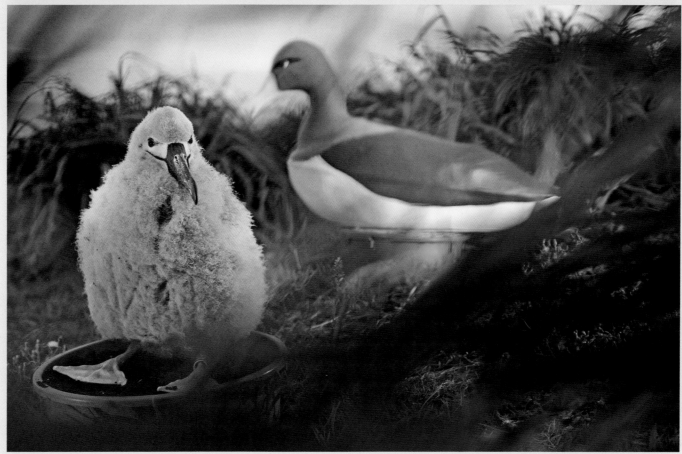

163

Shadows in the Sea

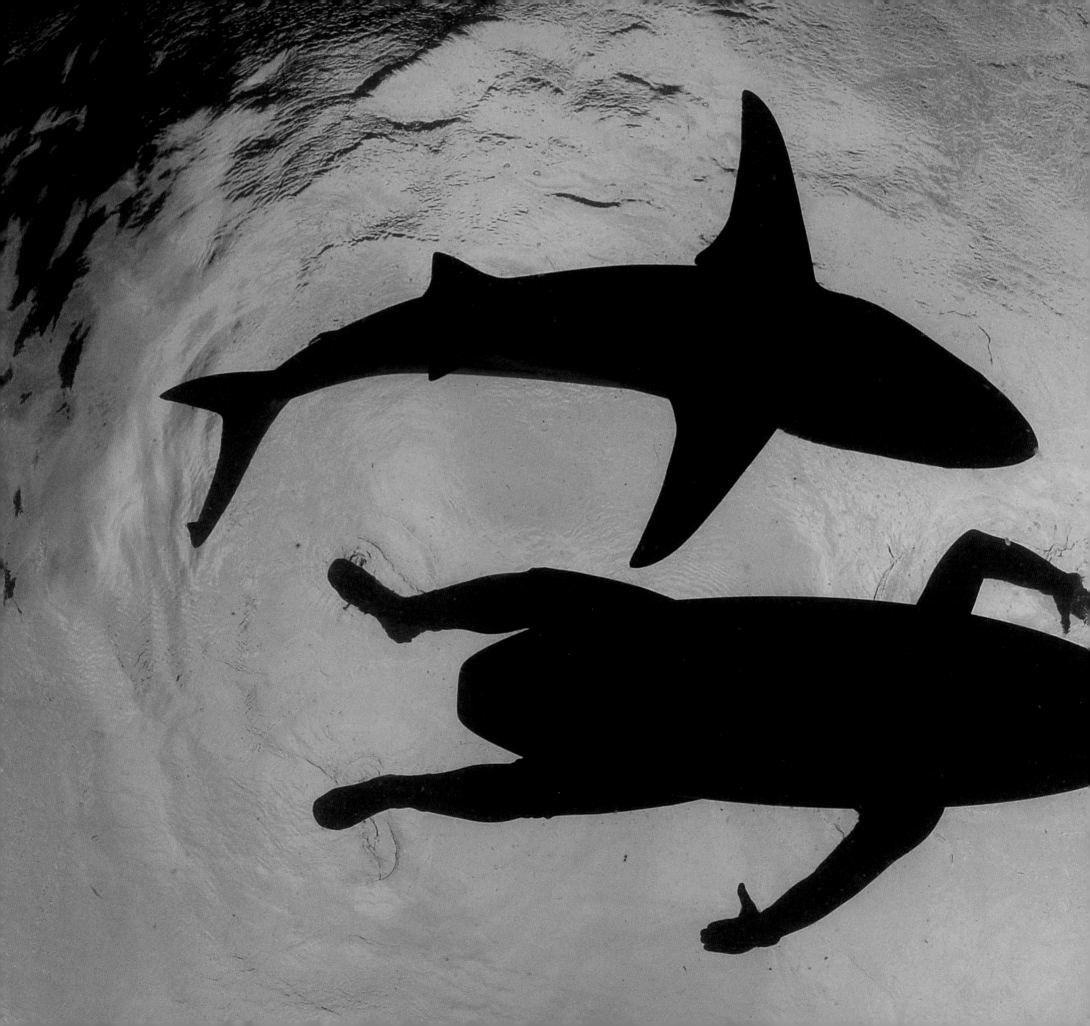

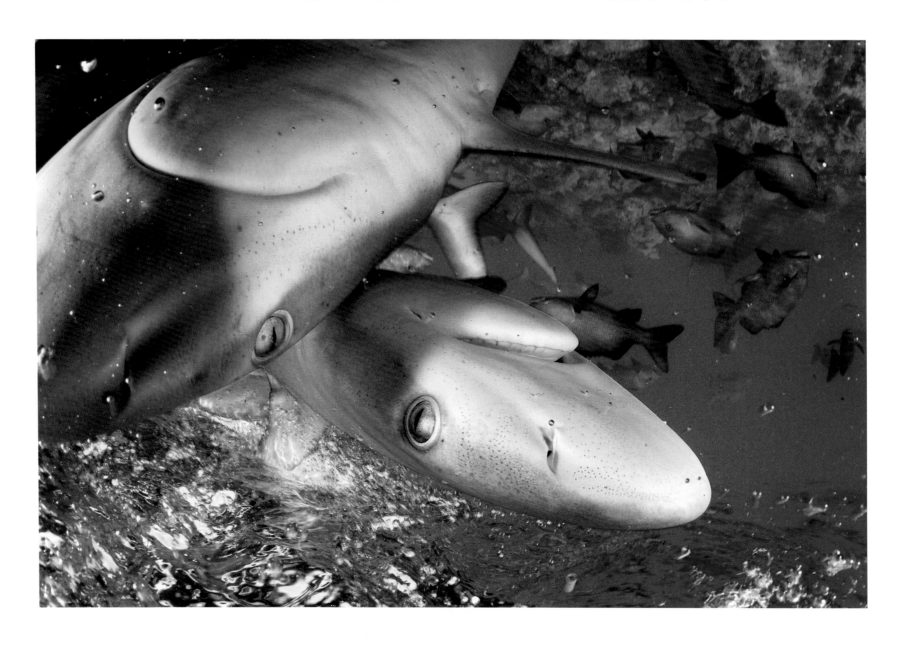

On the Nose • Bold Galápagos sharks investigate my camera inside Bassas da India's vast lagoon.
Mozambique Channel, 2010

PREVIOUS PAGES
Testing the Waters • A surfer tests an electromagnetic shark-deterring surfboard prototype at Aliwal Shoal
near Durban, South Africa, 2005

ON A MISERABLE DAY in the middle of winter, I push my then 60-year-old mother into the icy waters of the Atlantic. Nearby, a 13-foot great white shark senses the commotion and rounds to investigate.

My mother faces the imposing animal, then disappears under the choppy water for what feels like an eternity. She returns to the surface, gasping for breath but smiling; she has always wanted to try cage diving, and I am thrilled that she can finally tag along with me. That said, I prefer encounters like these without steel bars separating me from the wildlife. My mother vehemently disagrees.

The boat engine strains as we motor against the turbulent channel that links Bassas da India's large lagoon to the Indian Ocean. As we enter, the distinctive dorsal and caudal fins of a big tiger shark break the surface.

We arrive at a coral pinnacle just as the sun dips beneath the horizon. Dusk is short-lived in the tropics, and soon we are enveloped in total darkness. After a few sharp successive pulls, the generator hums and the jerry-rigged movie light my team has set up shines through the inky ocean. Like moths to a flame, over 30 Galapagos sharks emerge below the light.

As I gently slip into the water between clumps of curious animals, the droning generator and hissing wind fade. I descend through a serene pyramid of underwater light beams that paint color and texture onto beautiful coral crowns.

The sharks follow me to the reef, waltzing in and out of the light. The most visible and curious are three-foot-long juveniles; the larger, more mature animals loiter along the light boundary. Most reef fish retire safely into coral crevices, and only a lone hawksbill turtle saunters casually through this rave of more than 100 sharks.

After two hours, I exhaust my air supply and make my way back to the boat. Ascending on the fumes of visual elation, I surface just after sucking up the last bit of air in the tank.

I saw my first shark off Egypt's Sinai Peninsula when I was 16 years old. A huge school of barracuda had circled like an overcrowded carousel along the wall of Shark Reef. Weaving in and out of the mass was a trio of blacktips. I tried to get closer, but the current held me back. In my photographs of this not-so-close encounter, the sharks themselves are mere specks, but the seed was planted; I wanted to get closer, and eventually I did. After I made the switch from marine biologist to photographer, sharks became my first photographic muse; I spent more than a decade documenting their infamously complicated relationship with people.

After speaking events, I am often asked about the most dangerous part of my job; most people seem disappointed when the answer is not sharks. Statistically, my most dangerous activities are crossing the road, driving my car, and operating kitchen appliances. Sharks are not as dangerous as people make them out to be, but some are truly formidable predators.

A long time ago, I experienced this firsthand when I inadvertently got between a very determined tiger shark and her meal. I faced her, holding my camera tightly with both hands. She came at me with such speed that my arms were forced up high above my head, leaving my torso exposed. When the shark began chomping her jaws in anticipation, I had less than a second to leap over her and scramble down her back. Back then, I still thought I was invincible.

Encountering wild sharks in their element and witnessing the million-year-old battle between predator and prey is a rare privilege. Their wildness is real, and I now treat each shark encounter with respect and a generous dose of humility.

Sharks resonate in a different way with everyone. To shark fin dealers or fishermen on longlining vessels, they are a means of feeding their families or paying for their children's education. To a surfer whose best friend was tragically killed or to a mother whose child died in a shark accident, they can be deadly beasts and symbols of loss. For scientists, sharks are wells of biological data; for children visiting an aquarium, they represent windows to the wild.

For me, sharks are storytellers that communicate some of the most pressing issues facing our oceans. I take advantage of the fact that very few people are indifferent to them; sharks have an arresting way of commanding our attention, so I try to work with people's fear and turn it into fascination. With the right images and backstory, my hope is to transform sharks from dark, menacing creatures into animals worthy of respect and protection.

Shark Storm • Aldabra's shallow reef flat boils with blacktip sharks as a late afternoon storm rages offshore. The atoll hosts one of the healthiest inshore shark populations in the Indian Ocean. Seychelles, 2008

Saint of the Sea • St. Joseph Atoll was once commercially exploited for fish and coconuts but is now prized for its marine biodiversity and seabird colonies. In 2020, the seas around the island were declared a marine protected area. Seychelles, 2014

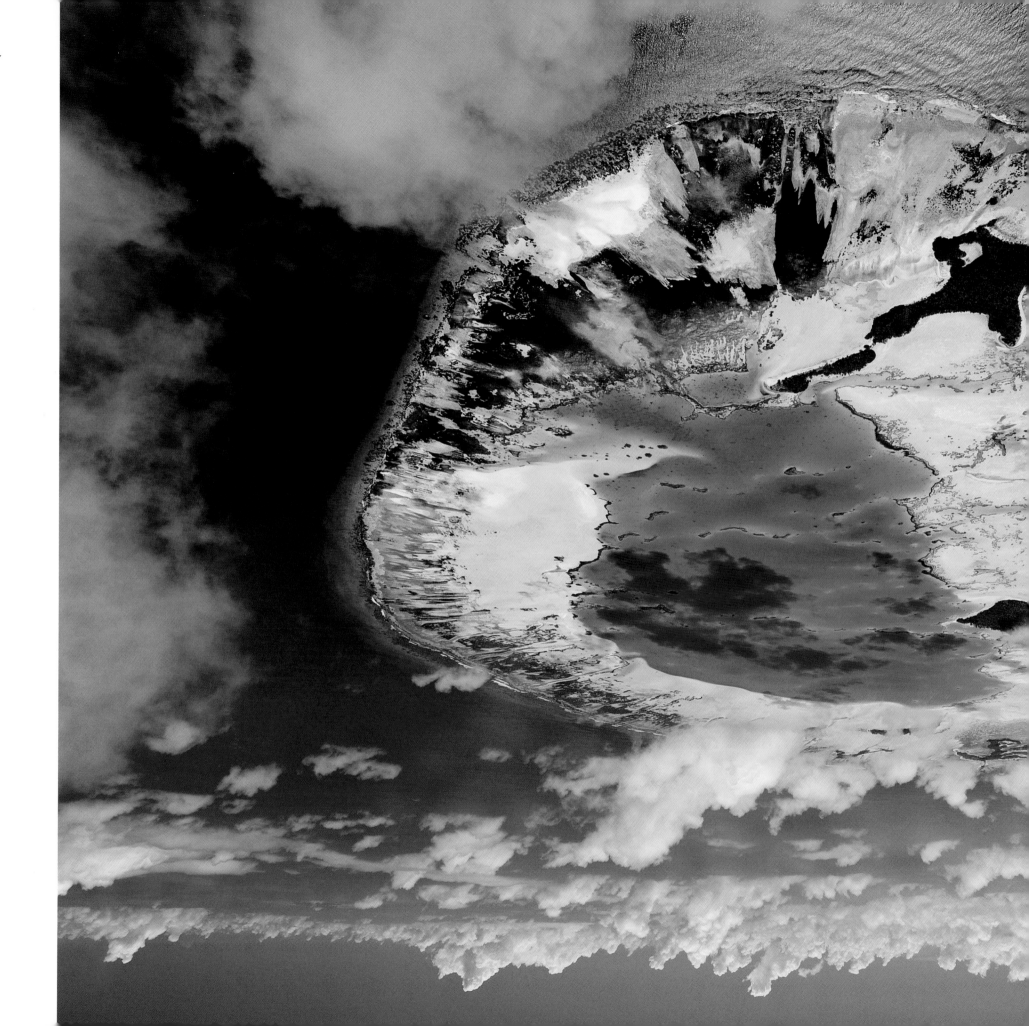

Silvertip Snack • As night falls, a silvertip shark migrates vertically to hunt on coral reefs. Seychelles, 2008

OPPOSITE

Night School • Light shines into the lagoon of Bassas da India, a remote atoll west of Madagascar, revealing a gathering of juvenile Galápagos sharks. Mozambique Channel, 2010

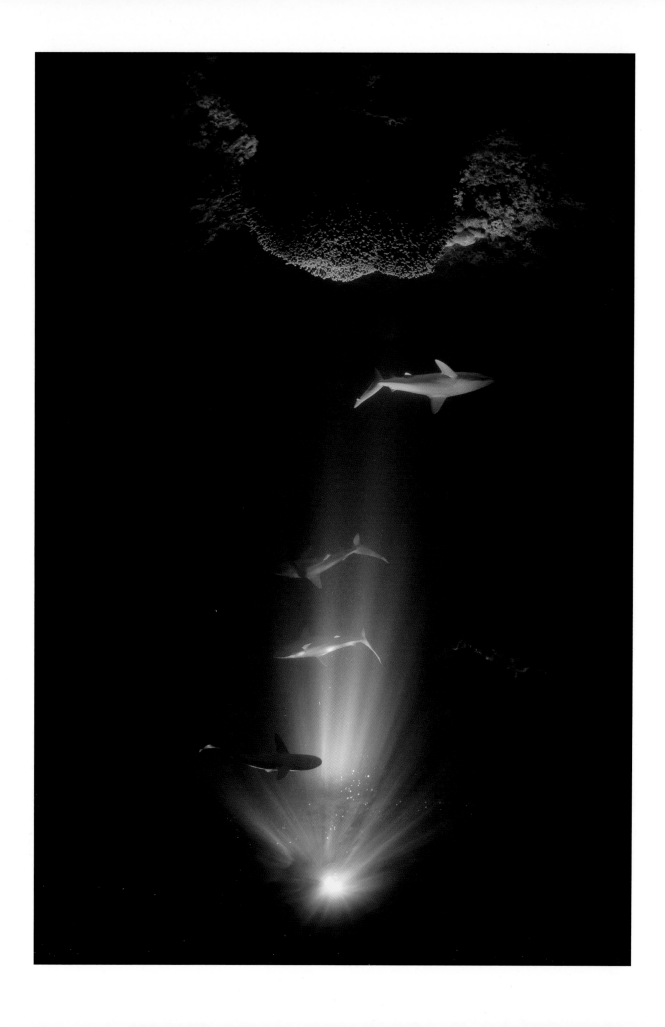

Shy Shark • A pyjama shark assumes the signature defensive position—curling up to cover its eyes and head with its tail. Endemic to southern Africa, this species of catshark is an opportunistic predator feeding on squid, fish, and other invertebrates. South Africa, 2005

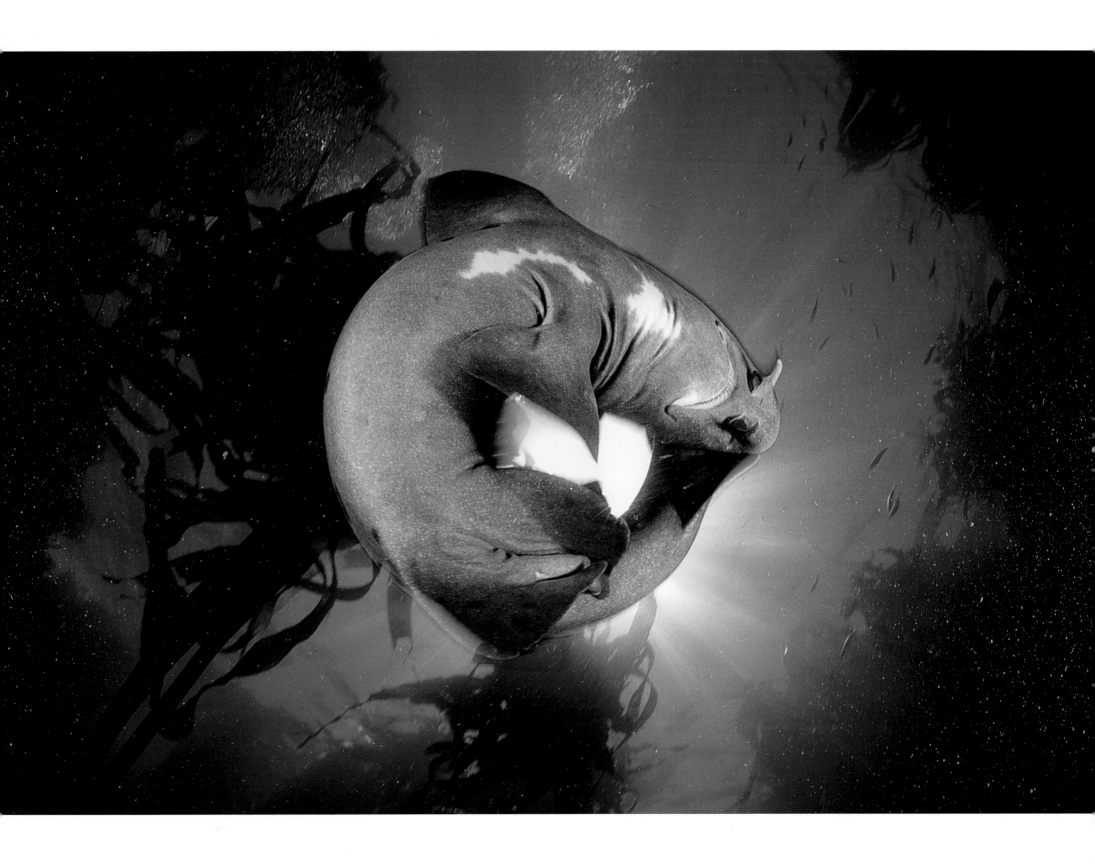

On the Move • A great white shark swims in the Isla Guadalupe Biosphere Reserve, 160 miles off Baja California. As one of two places in the world where these sharks congregate in clear water, this reserve is a magnet for adventurous divers. Mexico, 2013

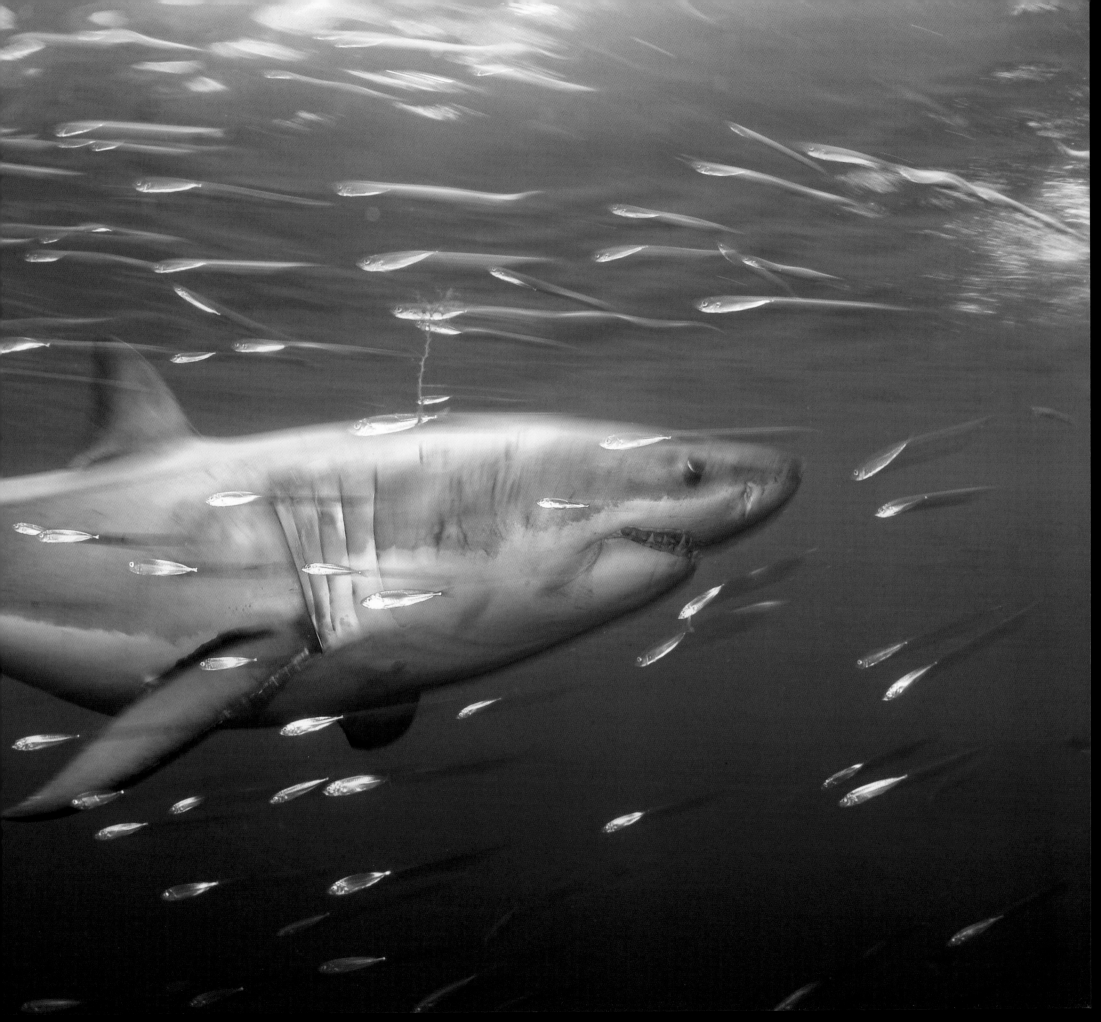

Teeth & Tentacles • Despite their size and formidable reputation, white sharks can be surprisingly curious and calm. This 11-foot female hovers just inches away from the tentacles of a delicate box jellyfish. South Africa, 2002

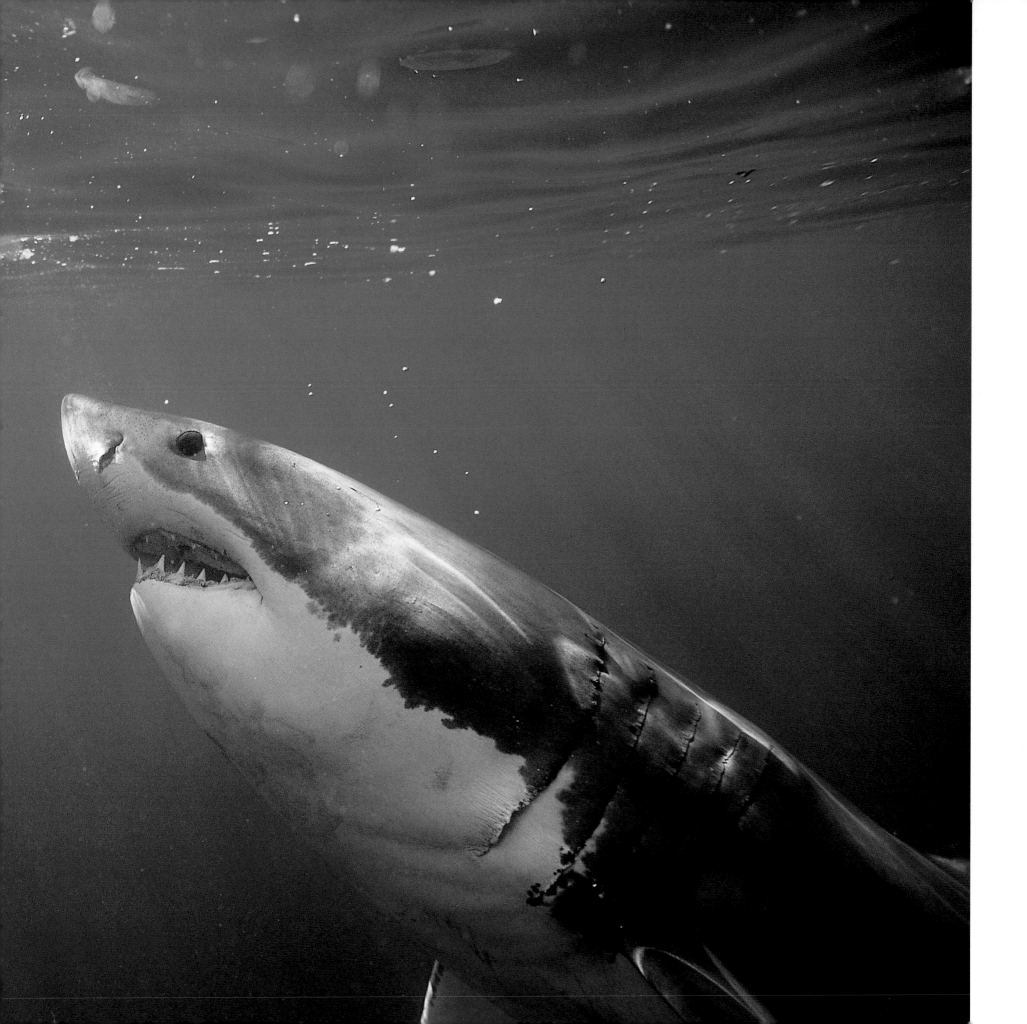

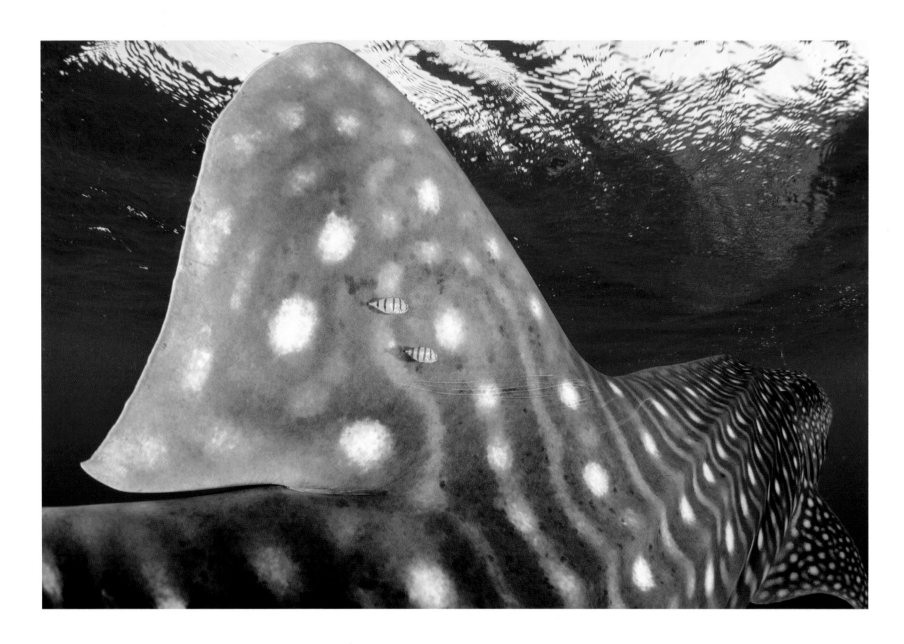

David & Goliath • A whale shark and its entourage of yellow juvenile jacks traverse the western reaches of the Indian Ocean. Attracted by the offer of protection, free meals, and an easy ride, small animals orbit megafauna like large sharks and whales. Djibouti, 2009

OPPOSITE

Scaling Up • At six feet long, these silky sharks are larger than most humans. A filter-feeding whale shark—the largest fish in the world—dwarfs them as they rub against it to scrape parasites off their skin. Galápagos, 2016

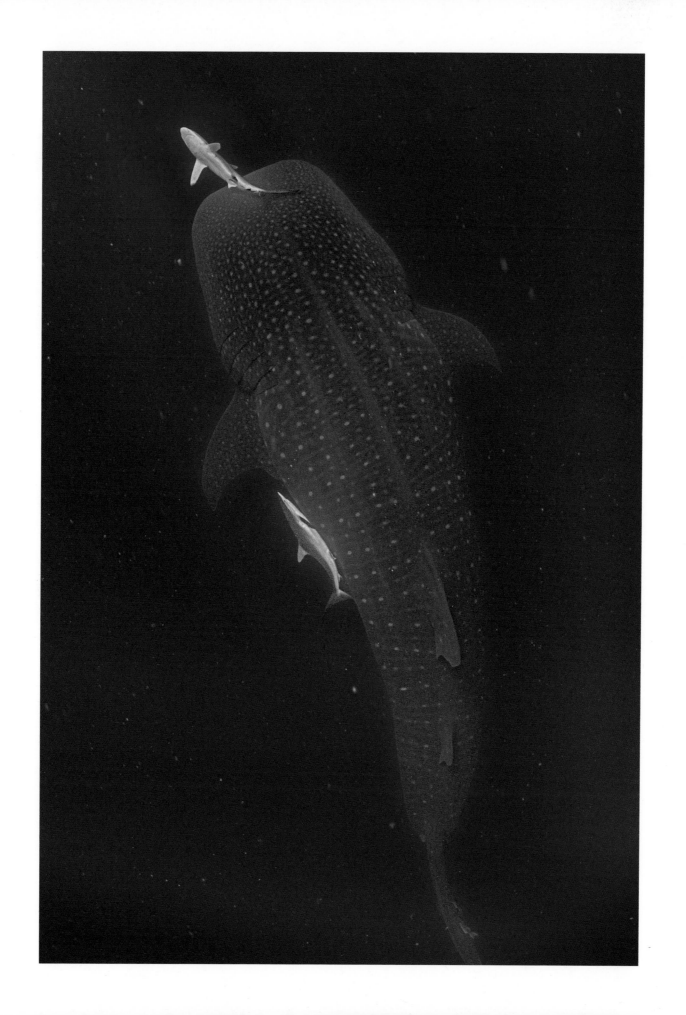

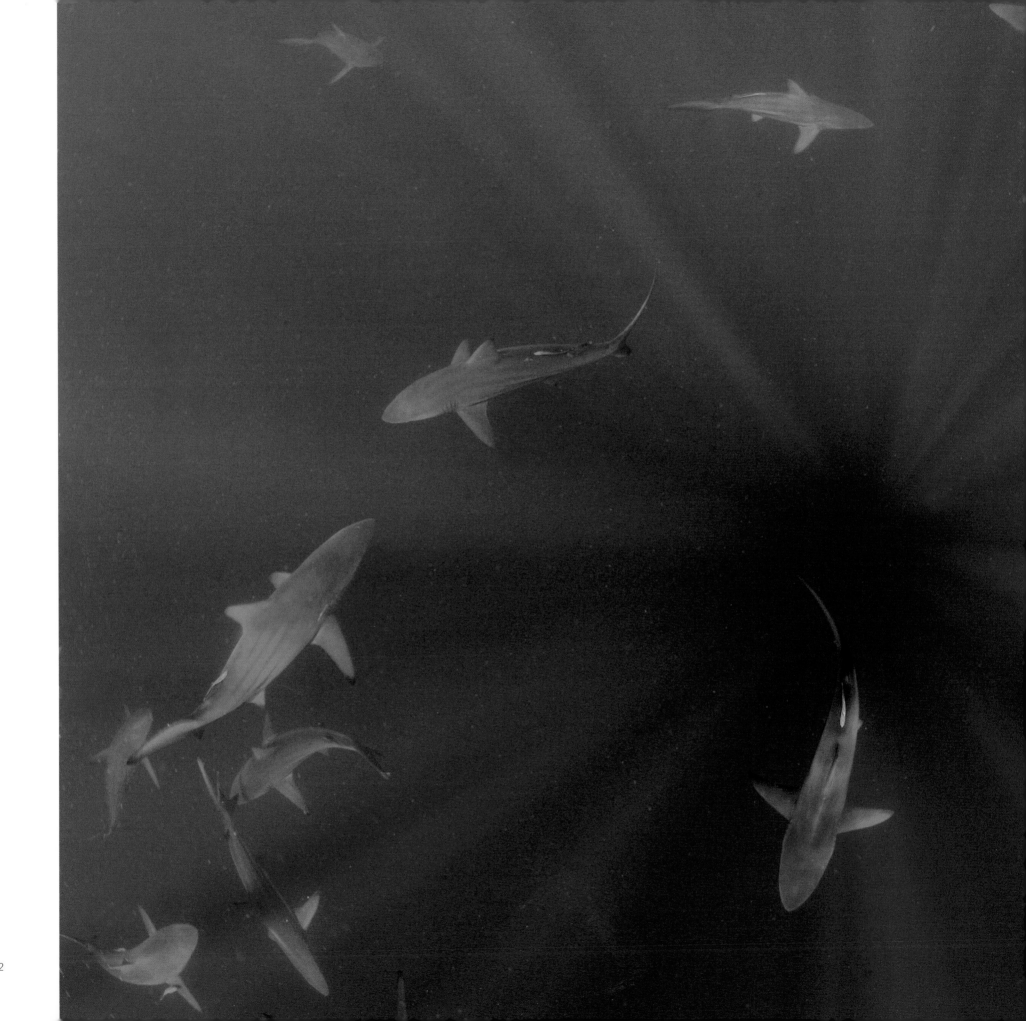

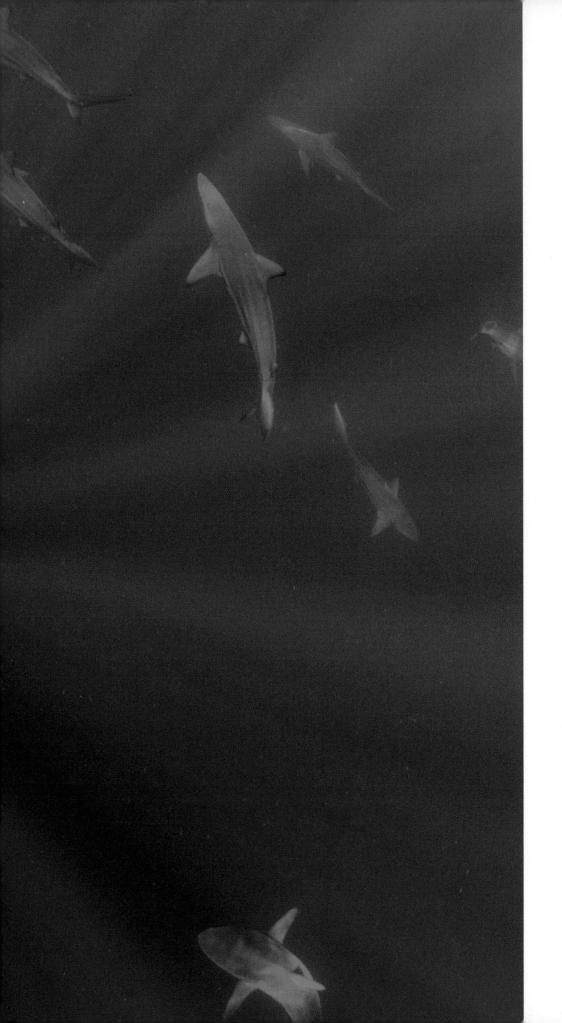

Shiver • A shiver of blacktips circles in the depths of Aliwal Shoal. Healthy numbers of sharks are a good indicator of a robust marine ecosystem. South Africa, 2006

Almost Gone • Globally, sharks have declined dramatically over the past century; some regional studies report declines of more than 90 percent for some species. Oceans without sharks would be like Yellowstone without bears or the Serengeti without lions. South Africa, 2006

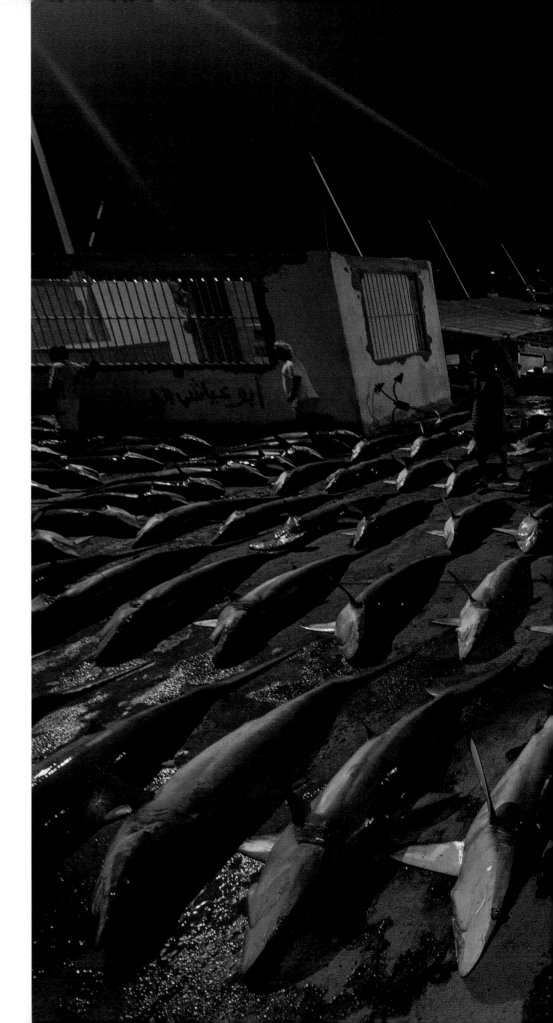

Body Count • A single boat's catch of silky sharks laid out in an orderly grid. The angular puzzle of fins points to the sky, resembling crosses in a military cemetery. Oman, 2012

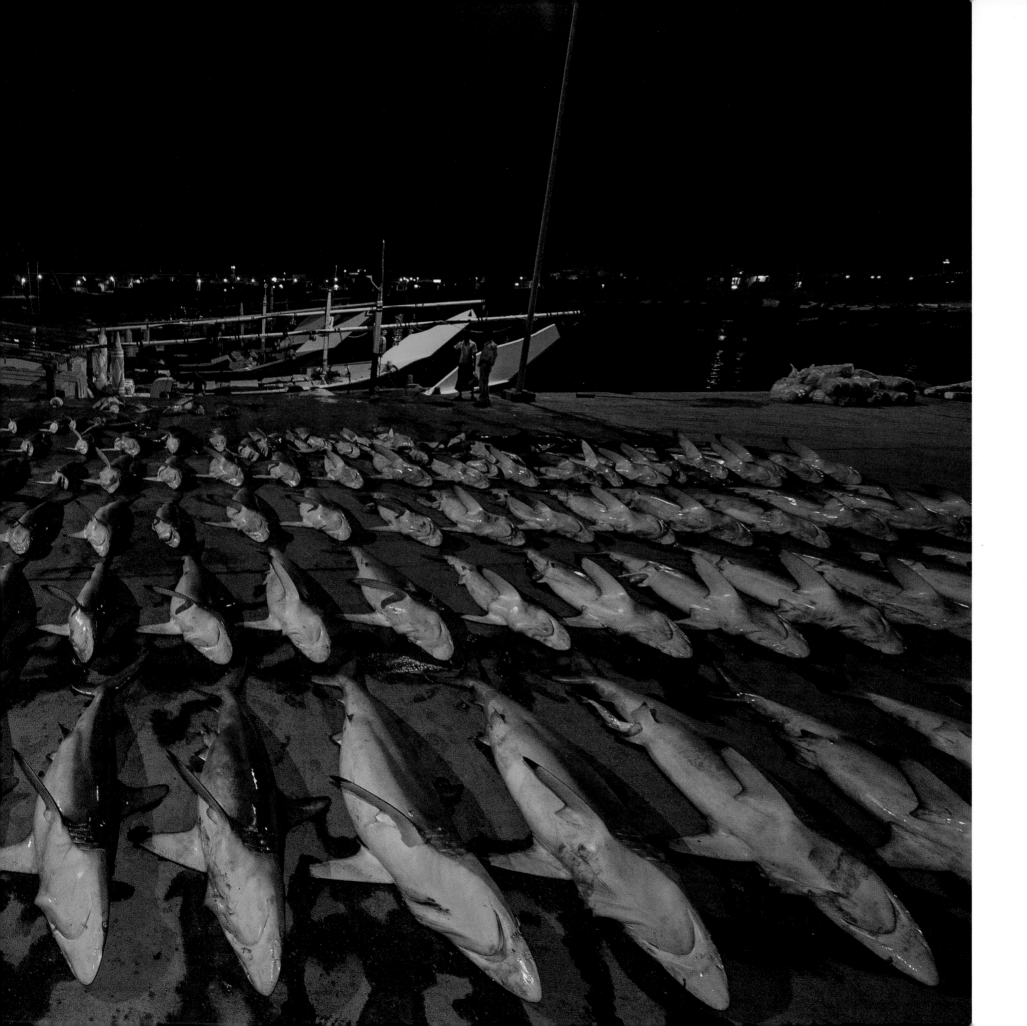

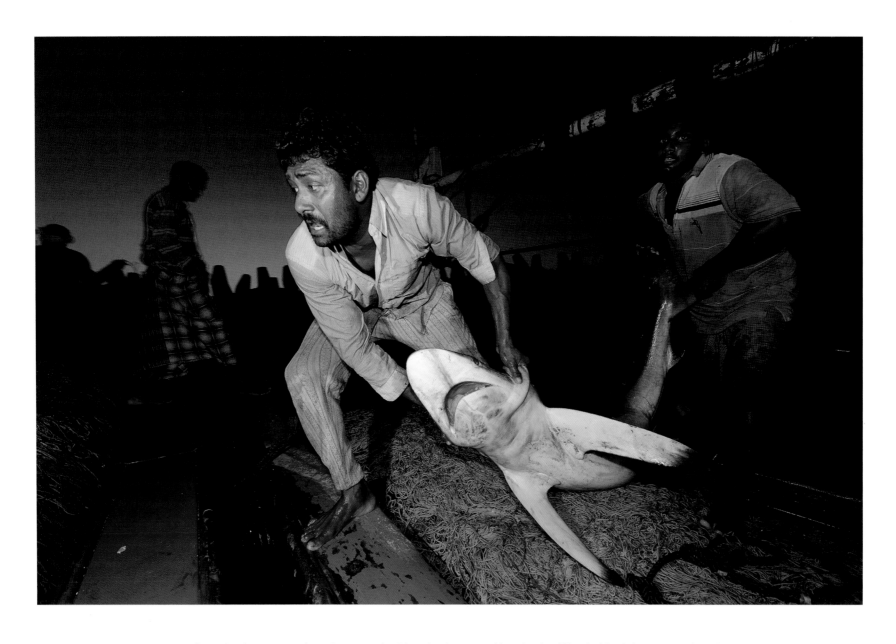

Deadliest Catch • In an Arabian Sea port, this blue shark is one of hundreds off-loaded by fishermen each night.
Oman, 2012

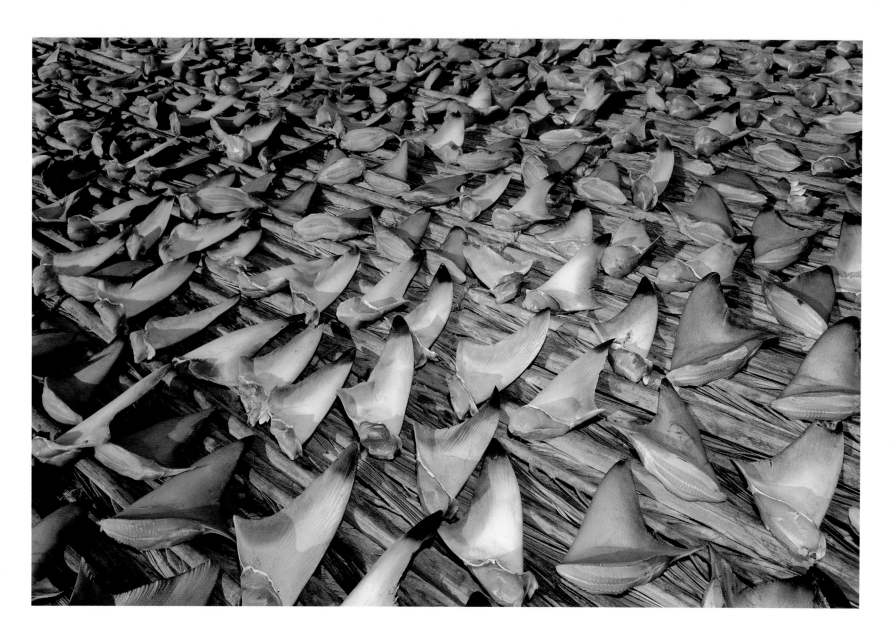

Fins • Shark fins dry in the sun before being packed and shipped to buyers abroad. Most are destined for Hong Kong, which is the largest shark importer in the world. Oman, 2012

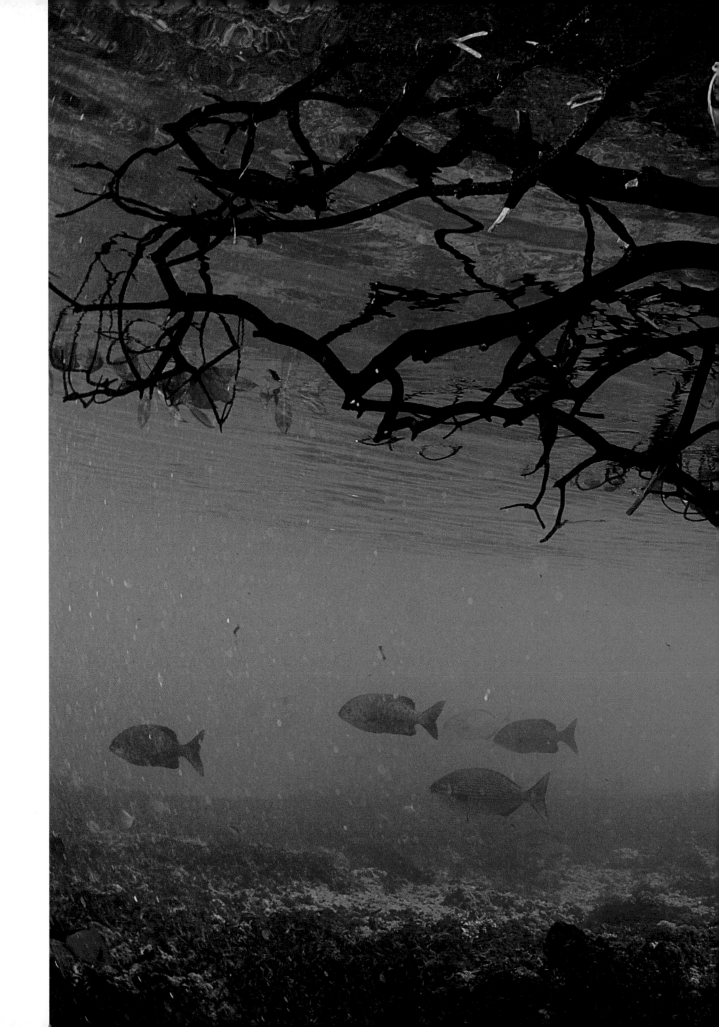

Tree of Life • A blacktip reef shark traverses a mangrove forest as the rising tide submerges low-hanging branches. For many shark species, Aldabra's mangroves serve as both nursery and hunting ground. Seychelles, 2014

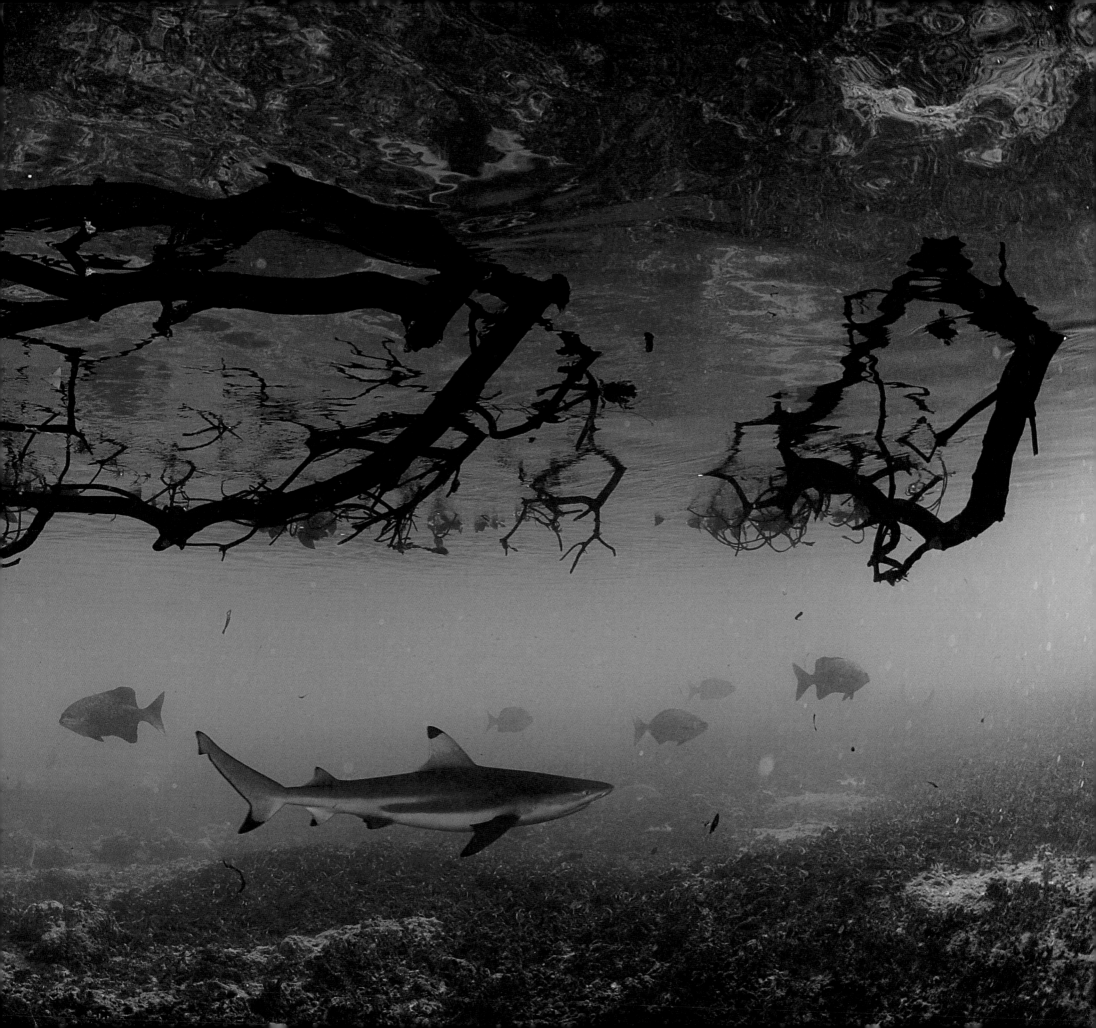

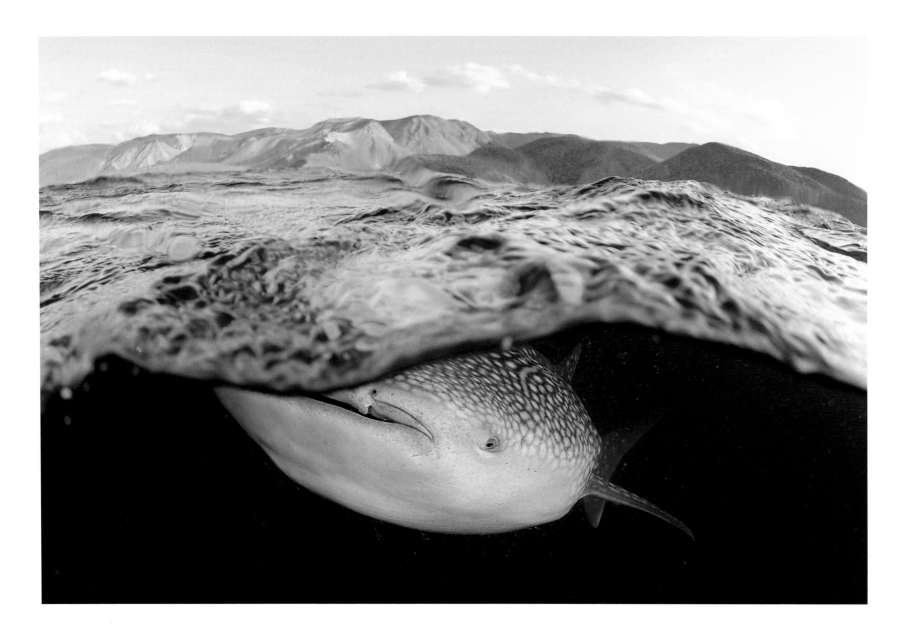

Food Desert • A whale shark feeds on plankton blooms, which are spawned by fierce desert winds and cold-water upwelling. Each winter, great numbers gather in the Gulf of Tadjoura off the Horn of Africa. Djibouti, 2009

OPPOSITE

Visitors From Above • A whale shark hoovers up a patch of plankton just below snorkeling tourists gathered to see these giants. Maldives, 2008

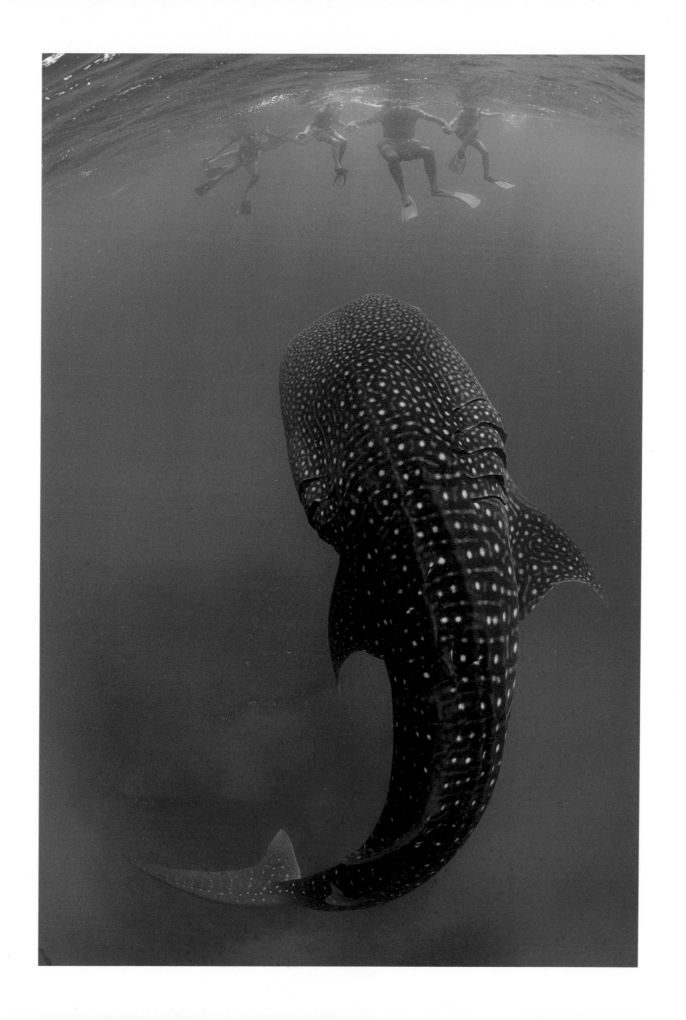

Shark-Set • A quartet of blacktip reef sharks patrols Aldabra's shallow reef flat at sunset. Seychelles, 2014

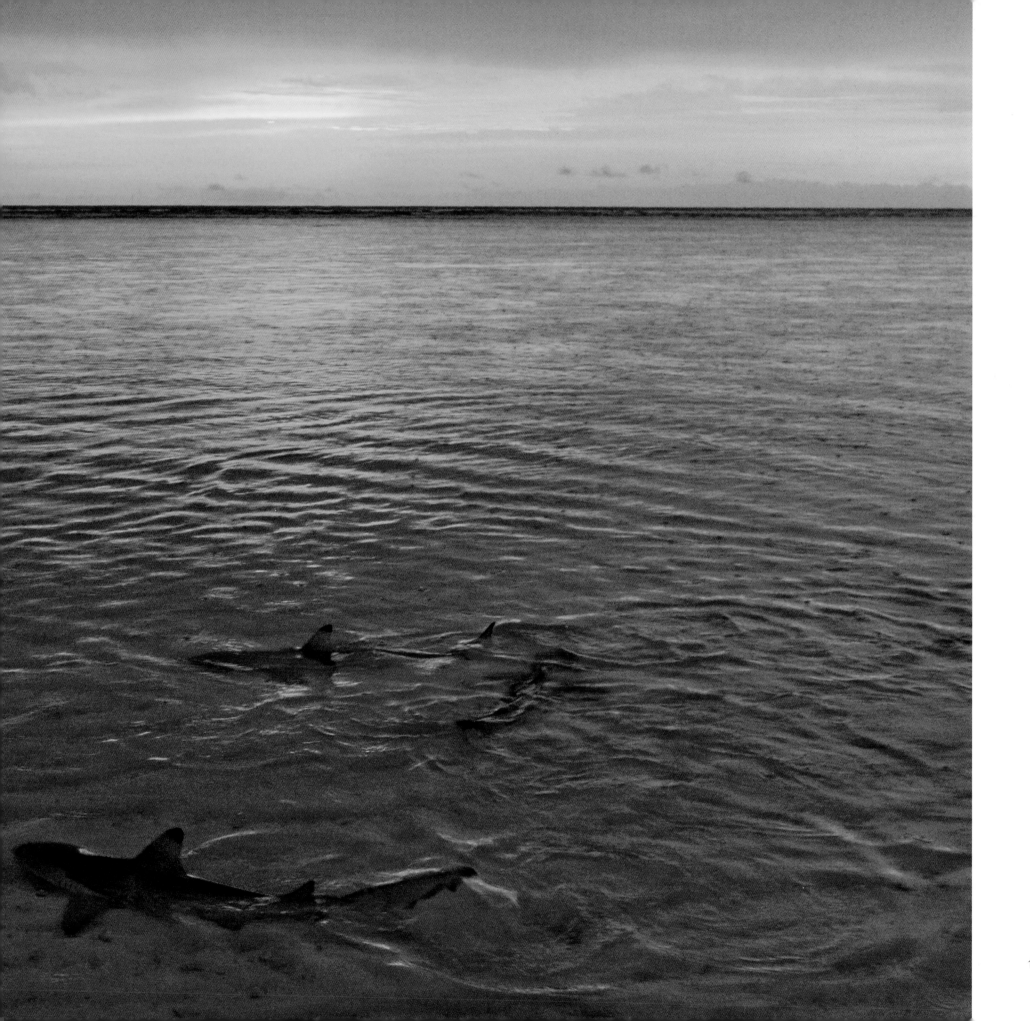

The Kayak and the Shark

IN 2003, Michael Scholl of the White Shark Trust alerted me to large numbers of great whites cruising in shallow water near the tip of South Africa. Tracking the sharks from his boat was easier said than done, as they are either attracted to or repelled by engine vibrations.

I'd recently bought a kayak, and figured it might be a quieter way of tracking the sharks. It was my idea, so I was voted to try it first. With GPS mounted on my vessel, we were able to follow the animals and observe their natural behavior. The first few attempts were a little nerve-racking, but the sharks never showed aggression toward my "yum-yum" yellow craft.

As a start, I decided to make a photograph of a White Shark Trust researcher following a shark across the bay. Instead, a bold female came up from behind just below the surface. I was using slide film and was down to the last few frames. As the dorsal fin broke the surface, the scientist looked back, and I clicked. So instead of the scientist tracking the shark, the shark was now tracking the scientist.

The photograph instantly resonated with the public; 100,000 visitors clicked on the image within the first 24 hours, which was considered viral in 2003. But I wasn't expecting so many people to think it was a fake. Conspiracy theories flourished online, with commenters analyzing everything from the angle of shadows to the ripples from the shark. The picture put me on the map as a photographer. But then it took on a life of its own.

In 2011, Hurricane Irene lashed the Caribbean, bringing massive floods to Puerto Rico; Channel 7 News Miami showed a photograph of a shark swimming up a flooded street. It was an astonishing scene, but then I felt an eyebrow rise. The shark looked very familiar. As it turned out, someone had photoshopped my great white from South Africa into the new storm's aftermath.

In 2012, she appeared again, this time swimming up a submerged highway in New Jersey after Hurricane Sandy. In 2017, she was in Houston after Harvey. As I write this chapter, Hurricane Laura threatens the coast of Louisiana, so I was not surprised when I got a text reading: "Guess who's back?" I clicked on the link, and there she was.

A great white shark closely follows a marine biologist in a kayak.

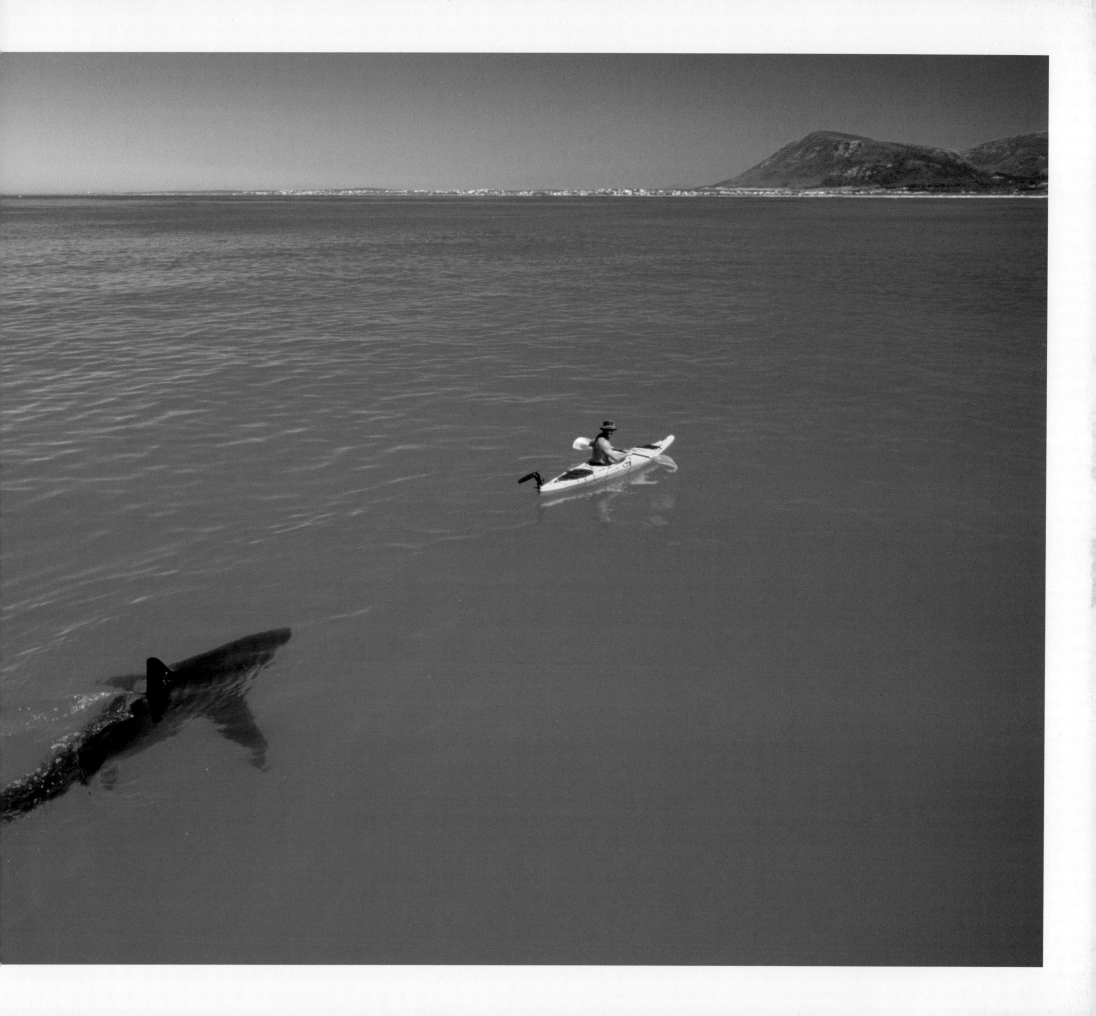

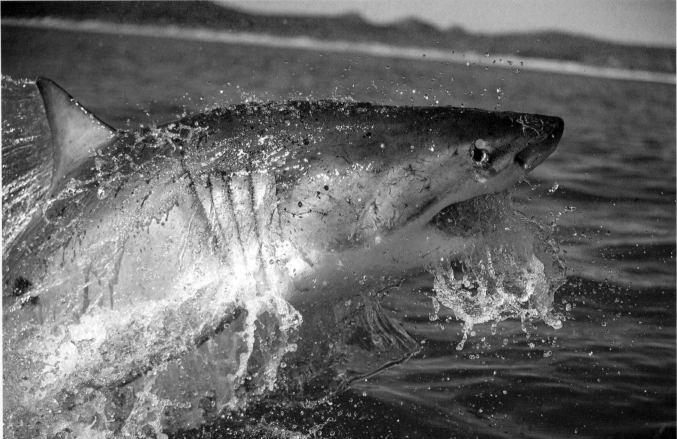

LEFT, TOP: During the summer months along South Africa's southwest coast, white sharks move inshore, presumably to hunt fish or engage in social behavior.

LEFT, BOTTOM: Breaching is part of a great white shark's hunting strategy. When a seal is spotted on the surface, the shark bolts upward from the seabed; the momentum causes it to become temporarily airborne.

OPPOSITE: Unmounted slide film from the roll that produced the iconic white shark/yellow kayak photograph.

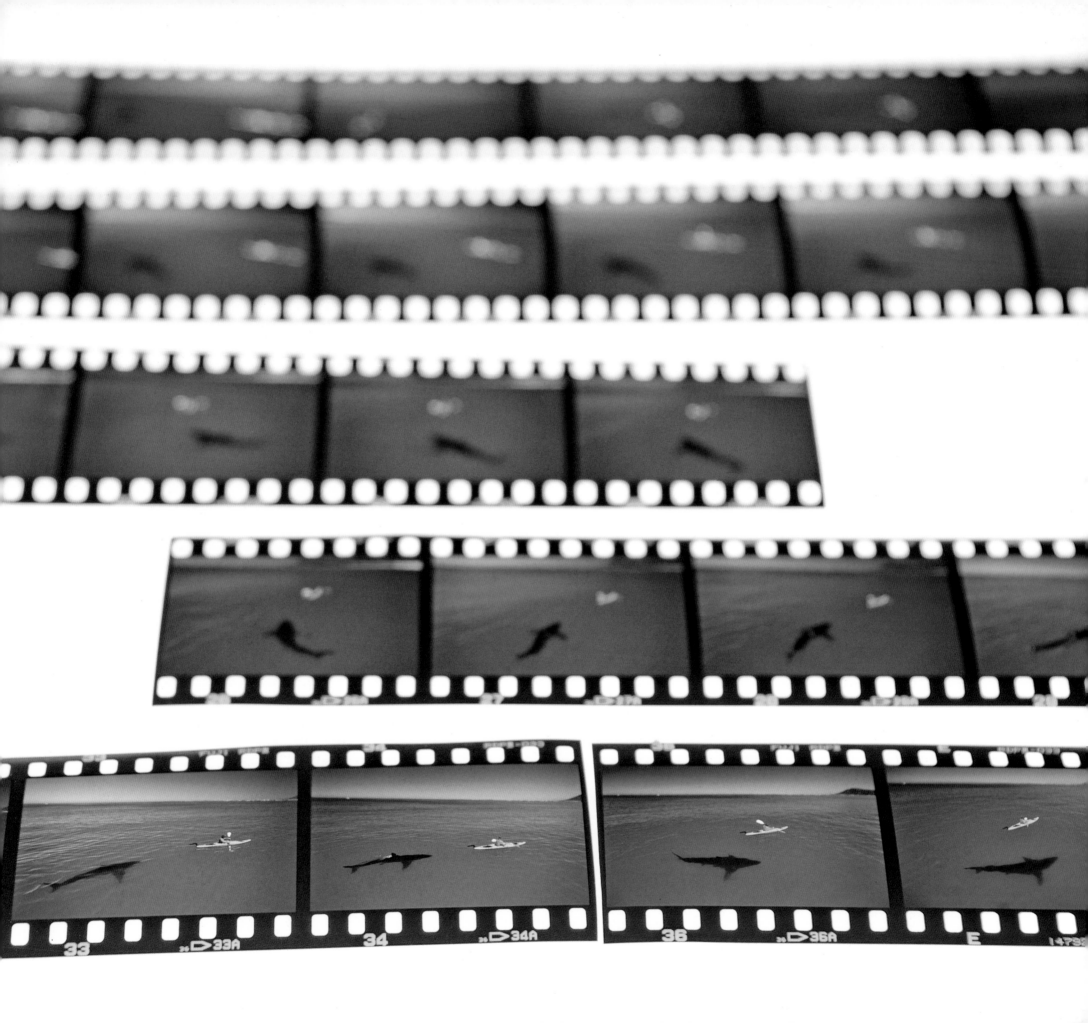

SARDINES

Born to Run

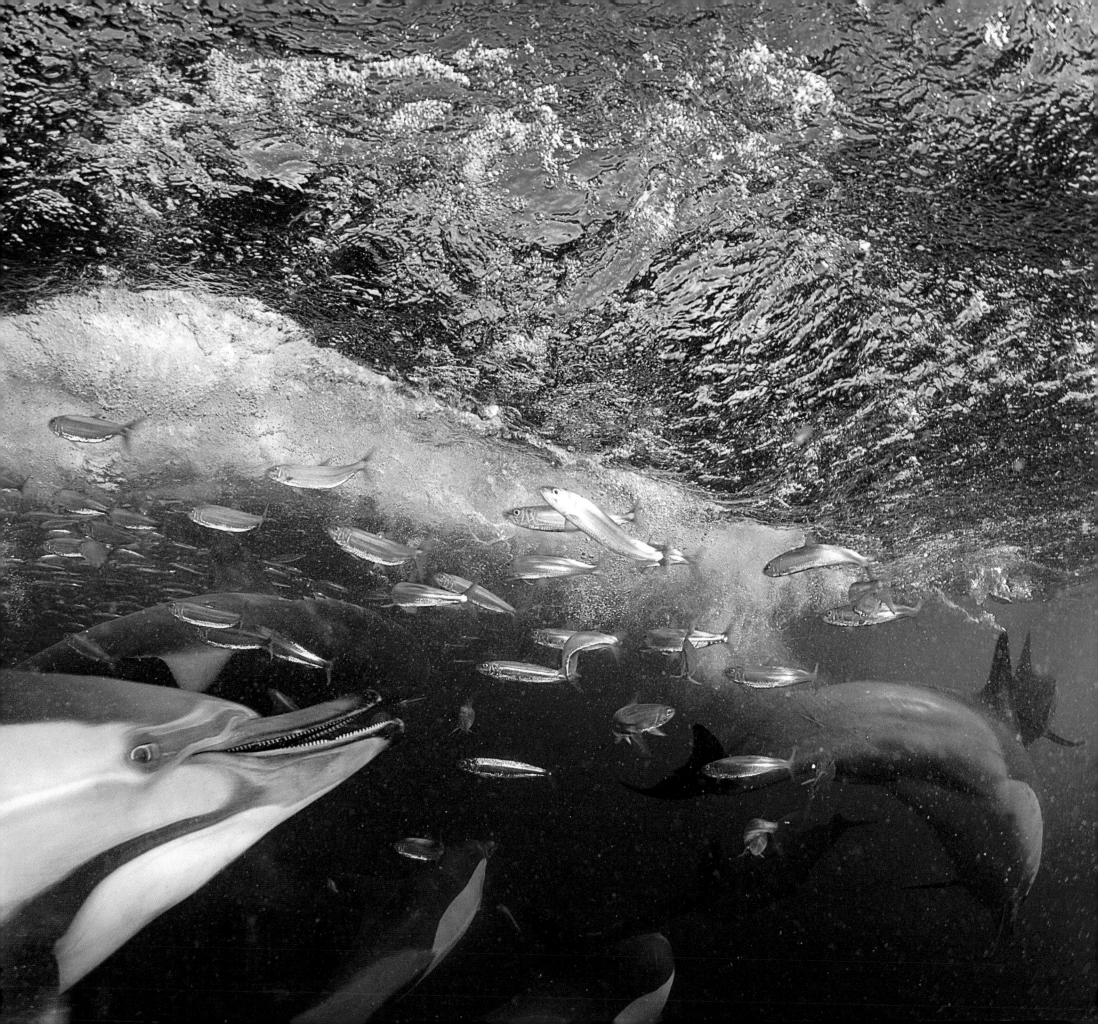

Wild, Wild Country • The Wild Coast in the Eastern Cape is the backdrop for the annual sardine run, a migration of millions of fish. South Africa, 2011

PREVIOUS PAGES

Perfect Predators • A long-beaked common dolphin rushes to grab a sardine while others corral the bait ball of fish to keep it concentrated. South Africa, 2007

I TAKE MY EYES OFF the gigantic disco ball of pulsating fish for just a few seconds. When I look back, the hoard of feasting sharks and dolphins are gone. Something doesn't feel right.

Suddenly I feel like I'm being watched from below. I swim backward, dragging my cumbersome camera and lights, but the sardines are drawn to me like a magnet. I distance myself only a few feet away, when up from the deep roars a 20-ton blubber torpedo. A 50-foot-long Bryde's whale opens wide and effortlessly swallows most of the fish in front of me, leaping out of the water right above my head.

Instinct causes me to curl up into a little ball and brace for impact. A thought flashes of my colleagues on the boat, agonizing over who must tell my parents that a whale crushed their son.

And then, nature gives me a pass. The pressure wave from the whale reentering the water mercifully pushes me out of its path. I ride the chaotic turbulence for the longest 10 seconds of my life before surfacing unscathed, screaming in terrorized gratefulness at my incredible luck.

Back on the boat, the adrenaline causes me to shake uncontrollably as I try to comprehend my near death experience. Once my heart rate lowers, I retreat under a towel to scroll through my pictures. I come across an image that shows the precise moment when the whale reenters the ocean, white water streaming from its mouth.

The funny and disturbing thing is that I have no memory of making this photograph. I likely hit the shutter by accident, but maybe the fear of not getting the shot took priority over keeping my bones intact. The inside joke among photographers at *National Geographic* is that the magazine publishes photographs, not excuses. Being crushed by a whale doesn't cut it.

When it comes to sardines, most people fail to see past the tin can. And yet I have had some of my most adventurous moments photographing these silvery fish.

Sardines are the foundation of the food web in many of the world's oceans. They inhabit the cold waters off South Africa, and once a year, they make an incredible journey. The warm, south-flowing Agulhas Current moves offshore, allowing a tongue of cold water to lick up the eastern flank of the country. With this frigid intrusion, millions of sardines migrate north in an event known as a sardine run.

Common dolphins are the sheepdogs of this phenomenon; they collectively carve smaller schools of fish off the main shoal, which can sometimes be five miles long. The dolphins create a bait ball—a swirling, reflective mass of sardines that they pin against the surface. The fish are trapped and as the predators chip away at them, the survivors become more desperate. I discovered this with great horror when they tried to hide in my armpits or in between my legs.

The hundreds of other guests at this banquet—bronze whaler, dusky, and blacktip sharks—don't see me as a menu item. But they don't give me any special treatment, either, bumping and slamming into me as if I was just another shark.

Underwater, I don't have the luxury of using long telephoto lenses; I use a wide-angle and have to get very close, which means I have to trust the sharks not to make any serious mistakes. I am amazed at how generally tolerant they are of me. Imagine running with a 16-mm wide-angle lens next to a pride of lions as they bring down a zebra; it would be suicide. During one sardine run I watched from just a few feet away as a large bronze whaler shark, jaw agape, burst into a bait ball, effortlessly inhaling sardines. It turned quickly and raced past with a mouth bursting with fish—heads and tails sticking out like clothes from an overstuffed suitcase.

The sardine run is one of the most difficult and most demoralizing events I have ever photographed, because the odds are always stacked against me. It peaks during the winter, when massive Antarctic swells pound the coast; the muddy runoff from rivers turns the ocean into something akin to chocolate milk. Even on rare days when conditions are perfect, locating the sardines can be hard. Launching small boats through the surf on exposed beaches and spending up to eight hours a day chasing these fish in rough seas sometimes makes a desk job look inviting.

I've followed the run for over a decade and only have a handful of good images to show for it. At the end of every season, I swear it's the last one I'll photograph. But time has a way of healing most wounds, and I soon find myself in the grip of sardine fever once again.

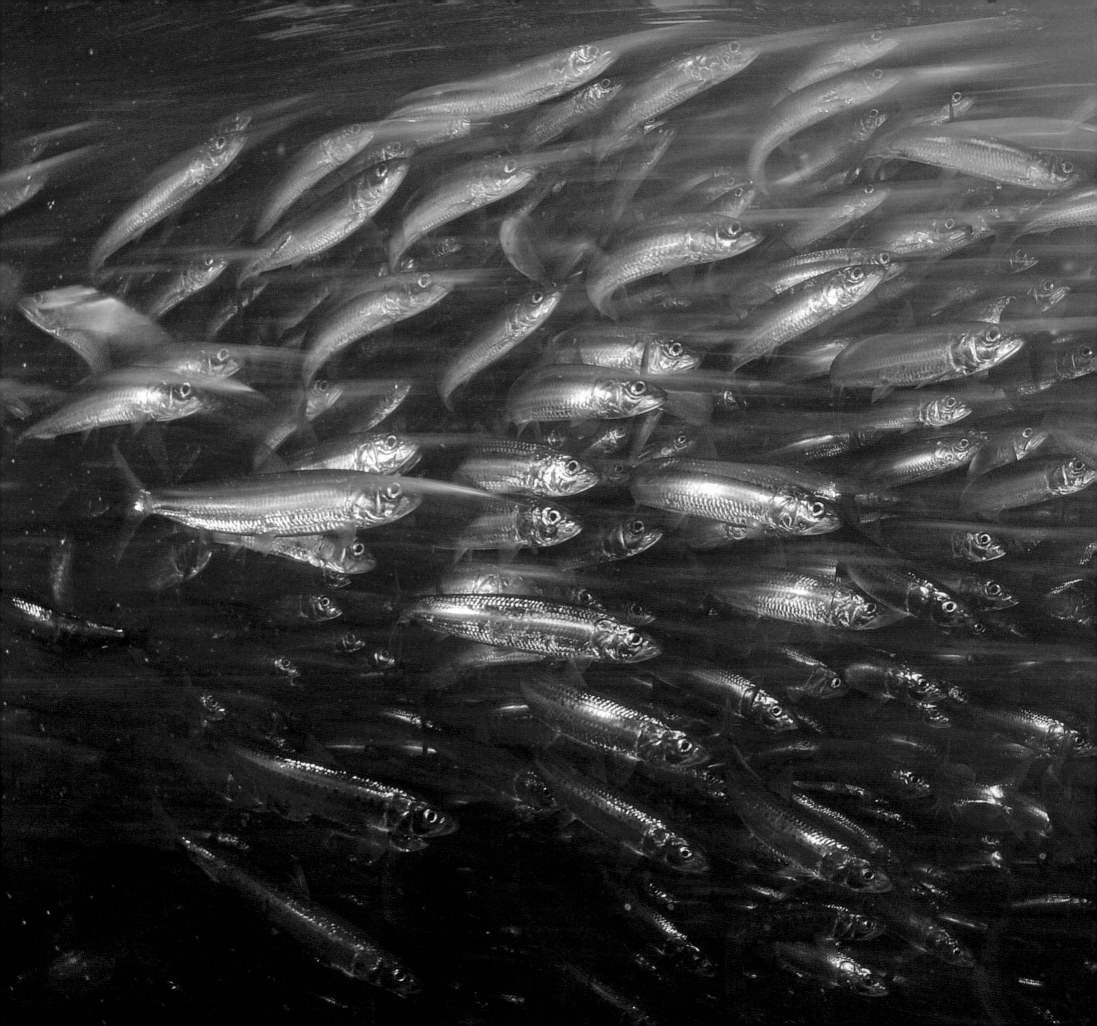

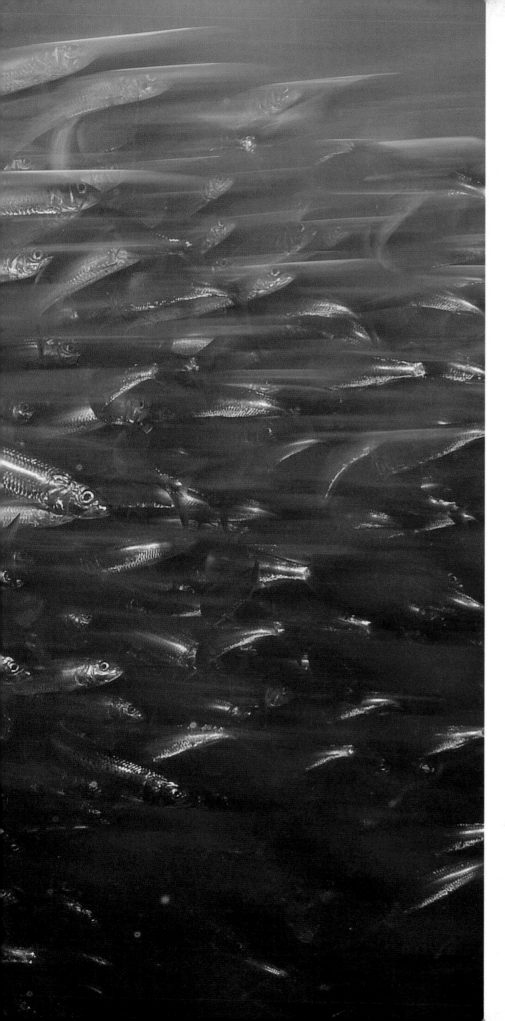

Schooled • Panicked sardines cluster together near the surface, trying to divert the attention of predators. These fish usually inhabit colder water, but make an epic annual migration along the subtropical east coast. South Africa, 2010

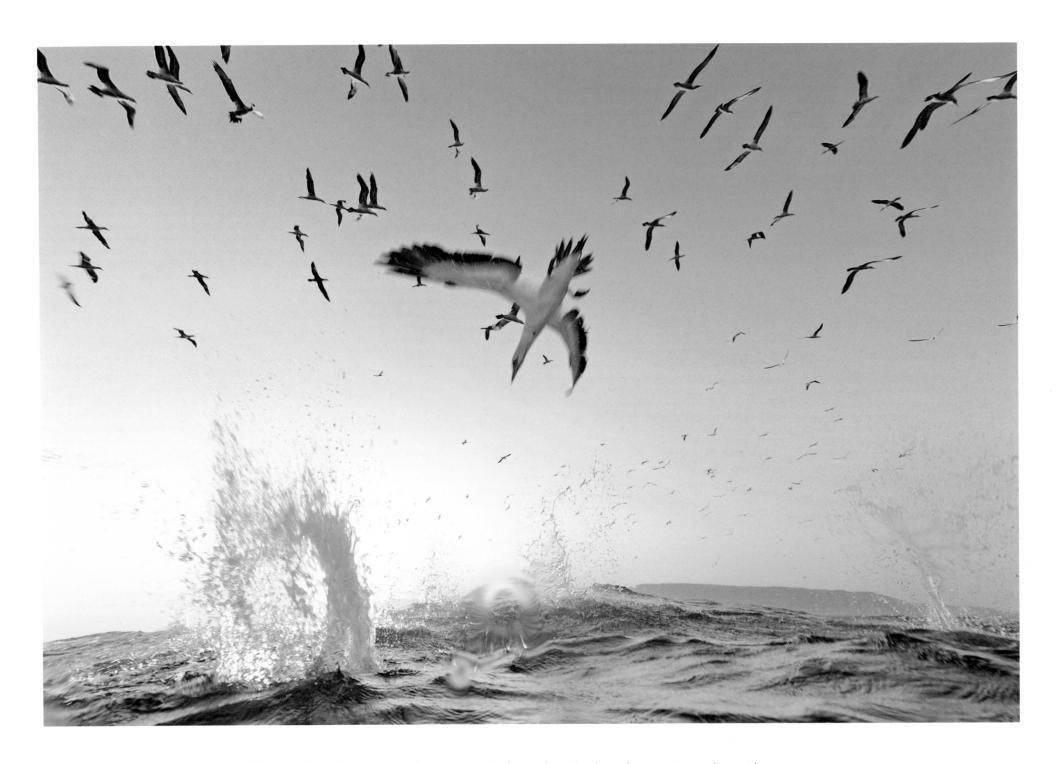

Dive-Bombers • Cape gannets plunge at speeds of more than 60 miles an hour to seize sardines with their razor-sharp beaks. Their momentum and streamlined posture allow them to descend as deep as 30 feet. South Africa, 2010

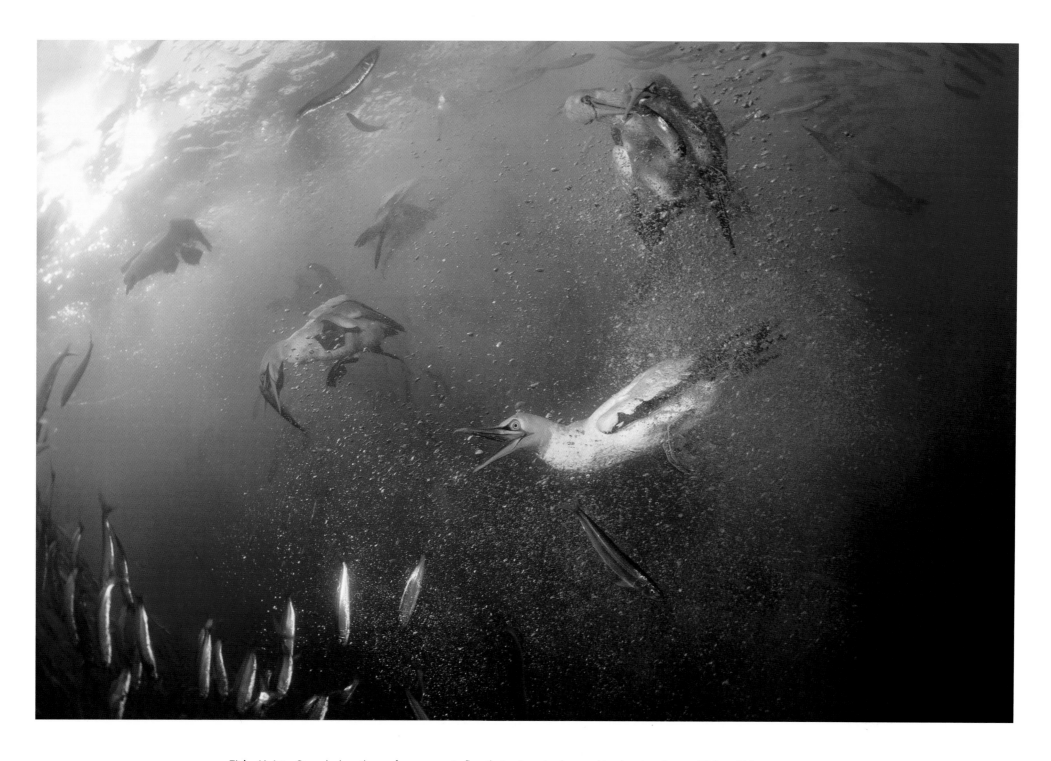

Fishy Heist • Once below the surface, gannets flap their wings to descend to depths of up to 90 feet. This photograph captures the first evidence (top right) of underwater kleptoparasitism among Cape gannets: one bird heisting a fish from another. South Africa, 2010

Sardine Cowboys • A pod of long-beaked common dolphins corrals a sardine dinner. These animals are the true wranglers of the sardine run. In coordination, they carve smaller bait balls from the giant shoals, which they encircle and trap against the ocean's surface. South Africa, 2007

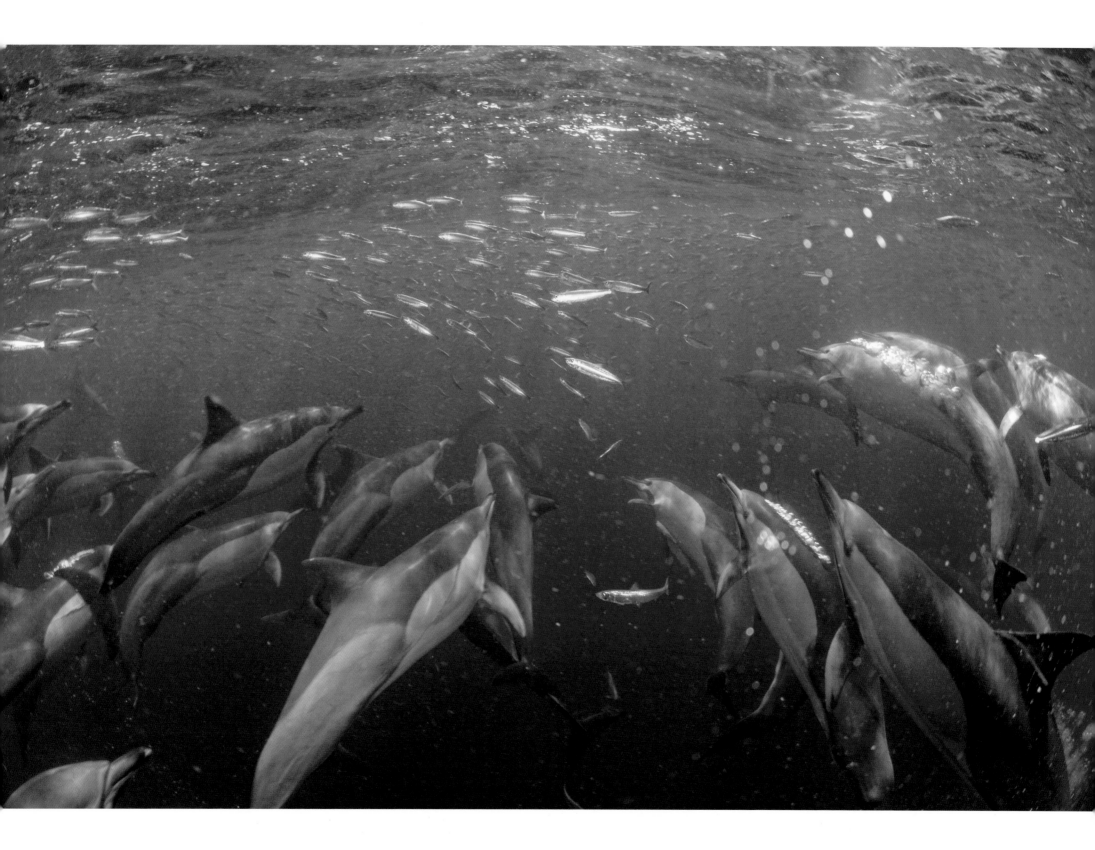

Surf's Up • Long-beaked common dolphins surf off South Africa's Wild Coast. Thousands migrate north annually to feed on vast schools of sardines; the rest of the year they inhabit the shelf region off the southern Cape, where they feed predominantly on squid. South Africa, 2010

The Closer • A Bryde's whale engulfs an entire sardine bait ball, breaches, and crashes back into the water. These 90,000-pound behemoths gulp tons of fish and seawater; prey catches on their baleen plates, while the water streams back out. Bryde's whales consume up to 1,450 pounds of food a day. South Africa, 2007

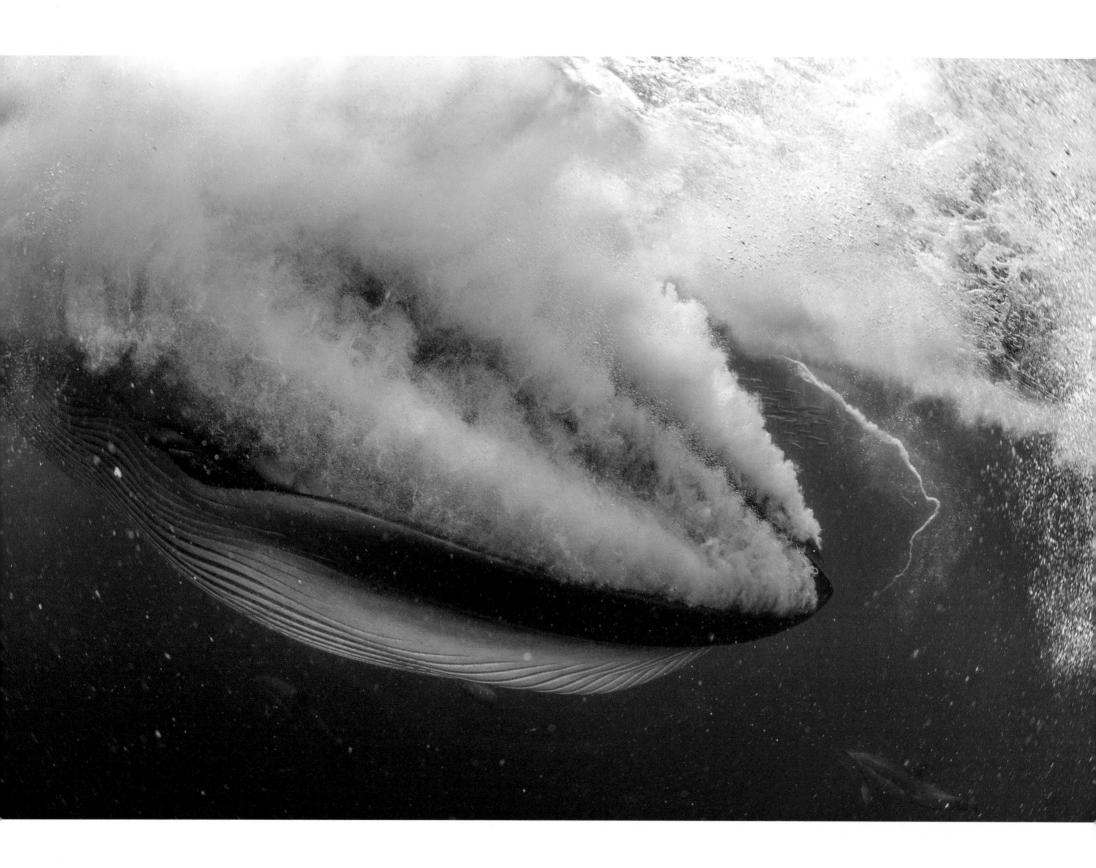

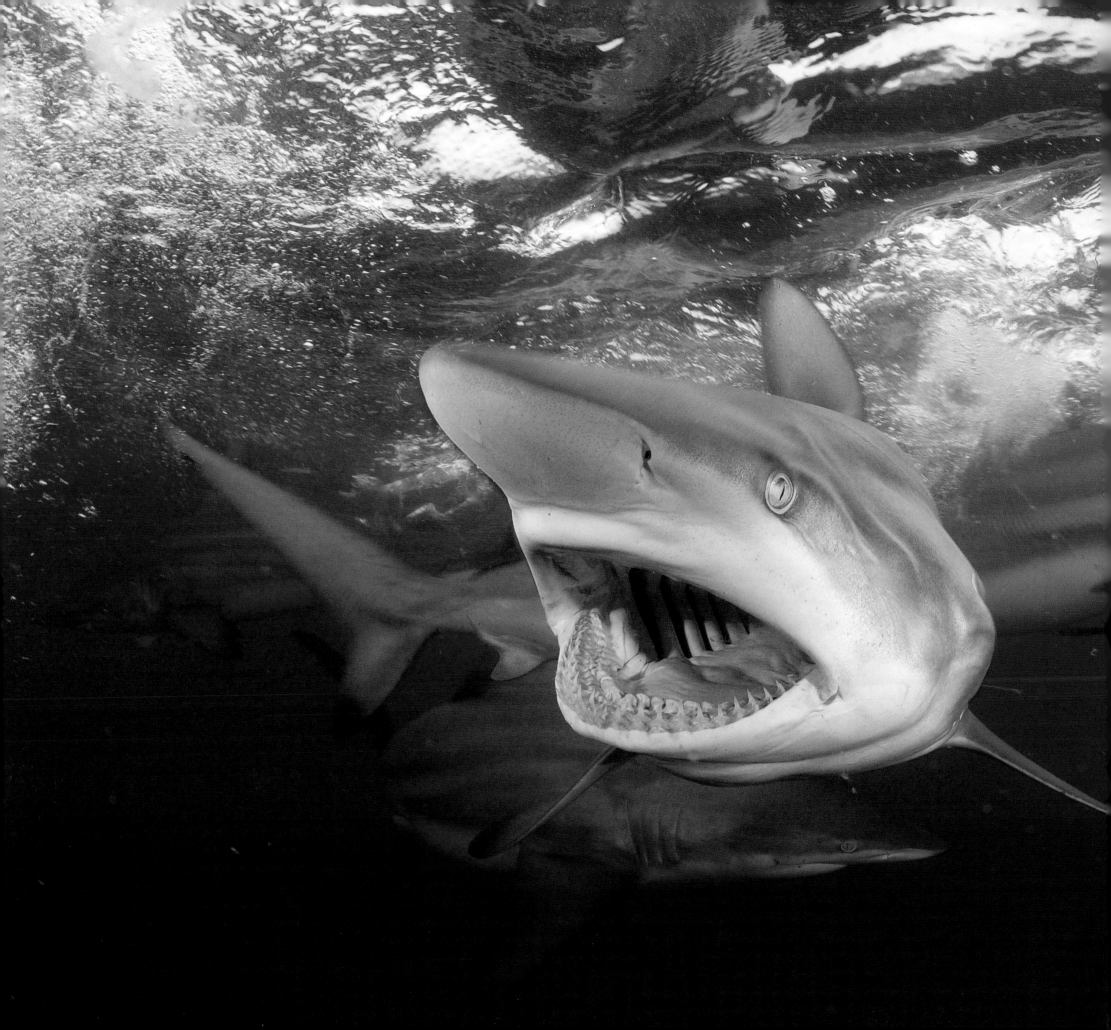

Open for Business • A gaping blacktip shark
shows off rows of narrow slender teeth,
perfectly adapted for a diet of small fish.
Things happened so quickly that I still don't
know if the shark was aggressively gaping
at me or had just swallowed a sardine.
South Africa, 2007

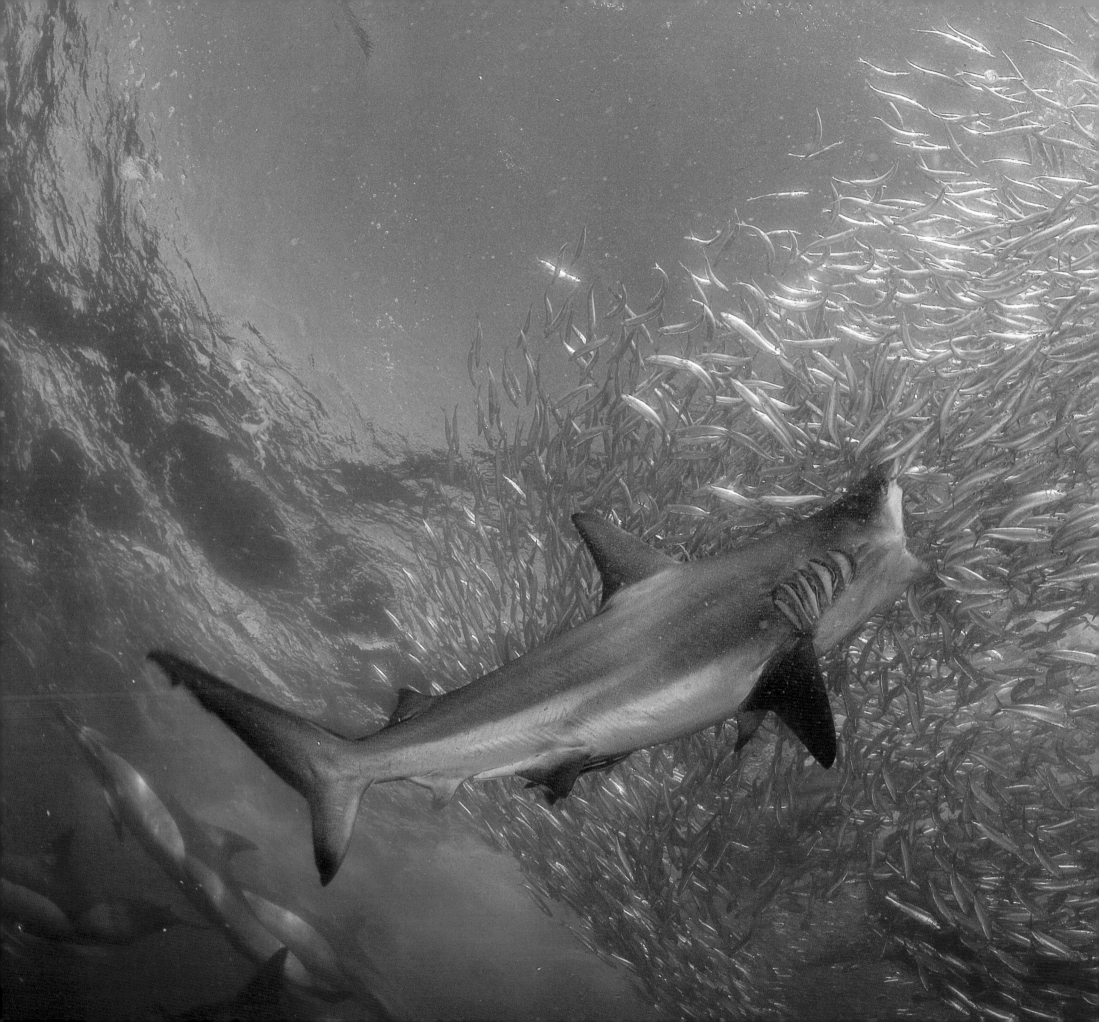

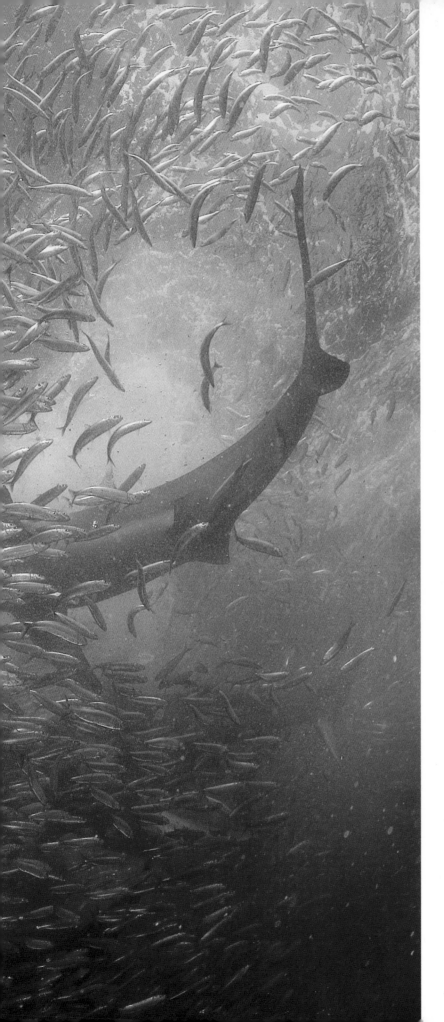

Time of Plenty • A bronze whaler shark
bursts into a bait ball, inhaling sardines
like an industrial vacuum cleaner. This is
the dominant shark species during the
sardine run, and hundreds can be seen
patrolling the margins of the shoals.
South Africa, 2007

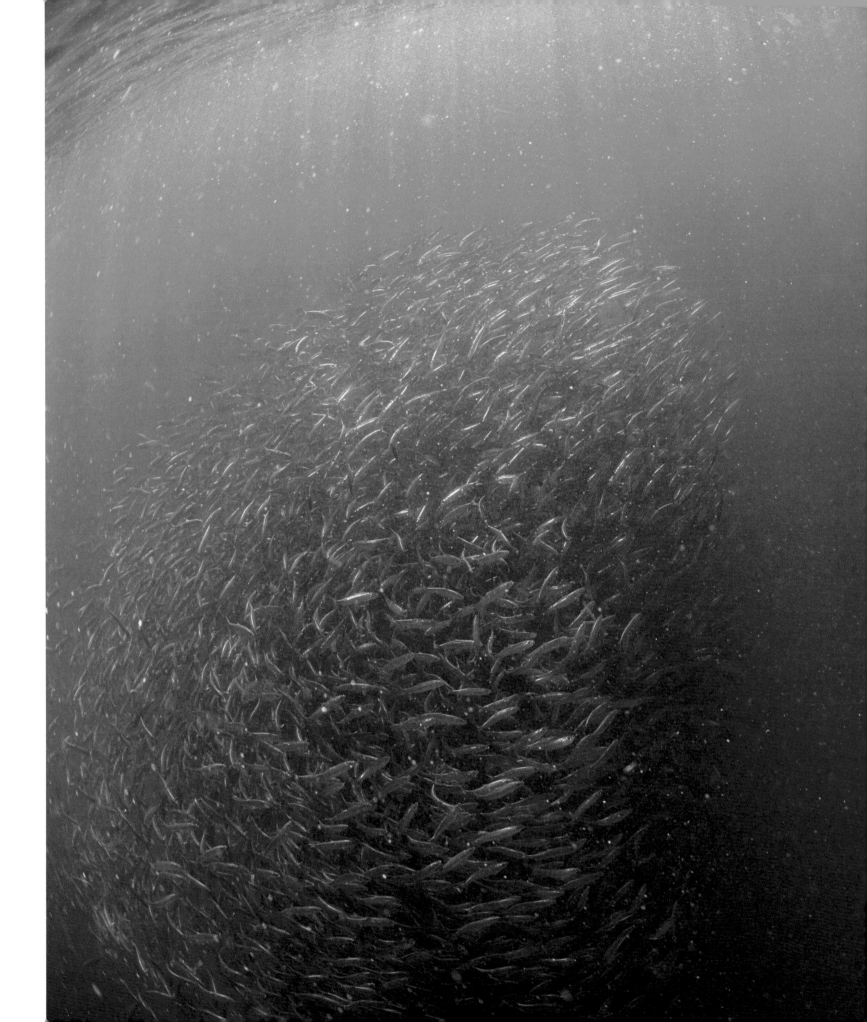

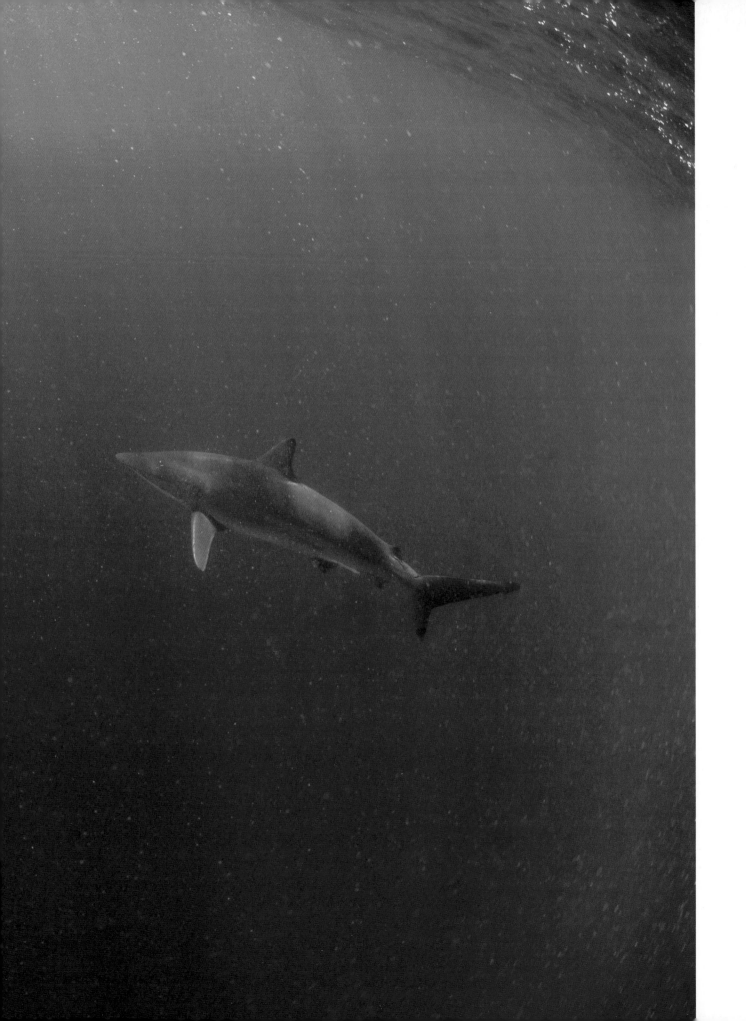

Survivors • Satiated after an hour-long feast, most predators have abandoned what's left of the sardine shoal. A lone shark remains, swimming through shards of sunlight and twinkling fish scales. South Africa, 2007

Surfing Seals

IT WAS LIKE PLAYING chicken with a freight train.

My assistant Steve waited just outside the impact zone to warn of sets of large waves barreling toward me. It seemed like every time I surfaced to catch my breath, he would yell, "Incoming!" I'd fill my lungs and immediately dive again, retreating into the relative safety of deeper water. Waiting for the barrage of waves to pass, I watched Cape fur seals surf past me. They seemed puzzled by my pitiful ineptitude.

I travel more than 250 days a year seeking out unique photographs and stories, and yet I often neglect the wildlife bounty in my own backyard. The seas near my home in South Africa offer some of the best surfing on our planet—but not just for humans. As it happens, a shallow ledge near Cape Town becomes a five-star playground for fur seals when tide and swell are just right. I've watched them surf this wave for years, and always wanted to photograph them—not from the safety of a boat, but underwater, because the real acrobatics were happening beneath the surface.

While big, gnarly waves attracted large numbers of surfing seals, they also increased my chances of serious injury. Waiting for calmer seas meant fewer seals and often, poor visibility. I needed medium-size waves, lots of seals, and clear water. And most important, I needed to be in town. Given my travel schedule, it took a few years for the stars to align.

The seals moved like missiles, so to stay nimble and mobile I ditched the scuba gear in favor of free diving. I'd hold my breath and come up every few minutes for air. My strategy was to swim toward the ledge of breaking waves and repeatedly dive until a squadron of seals surfed over my head.

After fighting waves and making images for the better part of a day, I was exhausted. I retreated to the calm of a kelp-lined channel to review my photographs but was never satisfied. So I returned to the fray. Thousands of images later, and with the light fading, I finally exited the water with a few moments I'm proud to share.

Nothing will ever capture the raw power of the waves and the mischievous energy of the seals—but I like to think that some of my photographs come pretty close.

Cape fur seals play as powerful waves roll across a rocky reef at Duiker Island, South Africa.

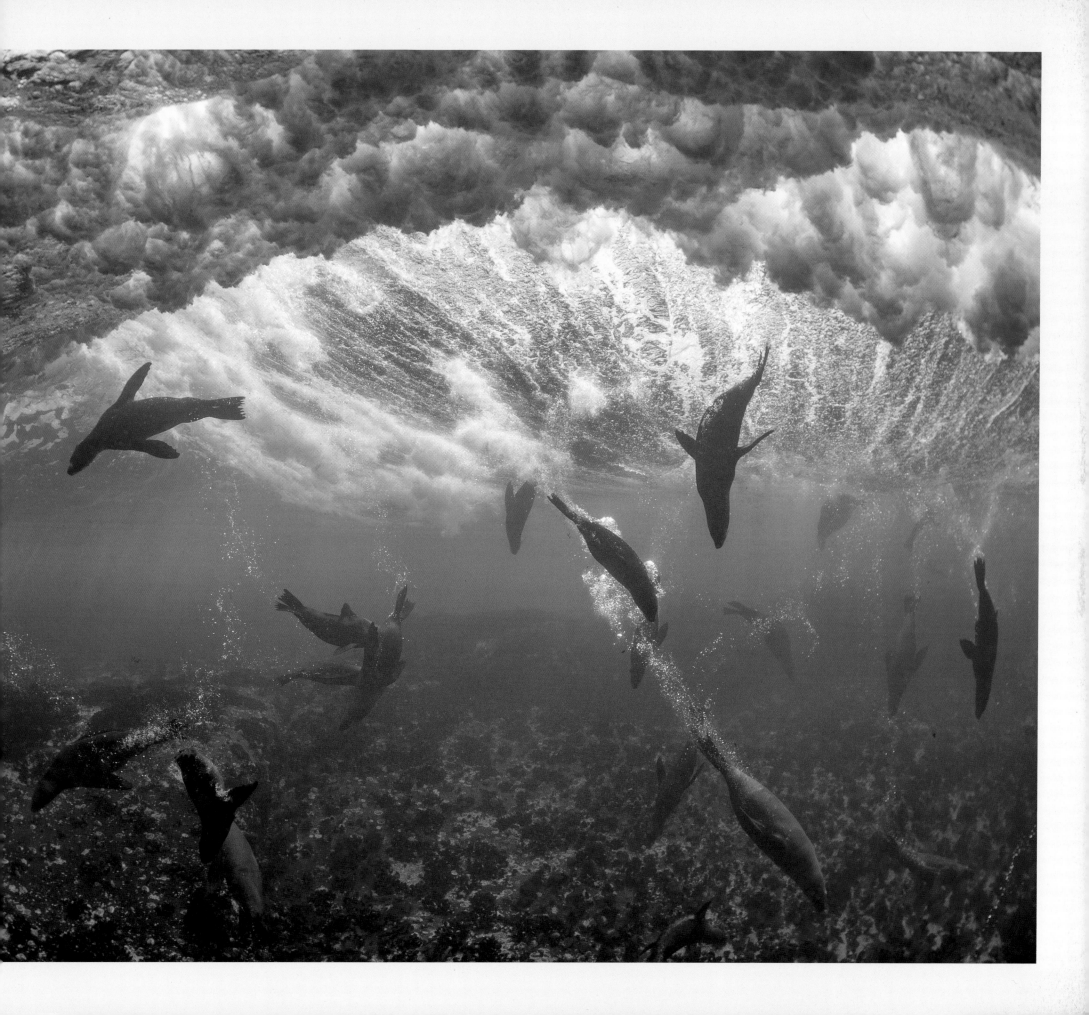

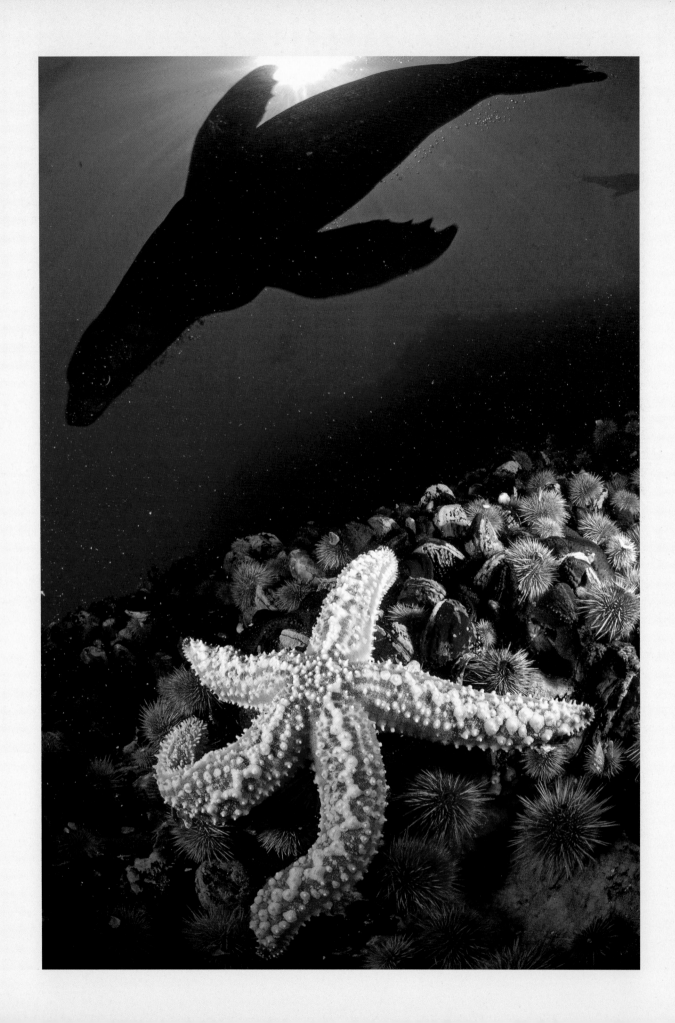

A Cape fur seal curiously lurks in the background as a spiny sea star rests, Zen-like, on a blanket of prickly Cape sea urchins.

OPPOSITE: Just off Dyer Island, a very interactive seal tries to play "pass the seaweed." Not unlike dogs, they will drop an object in front of you and expect you to do something with it.

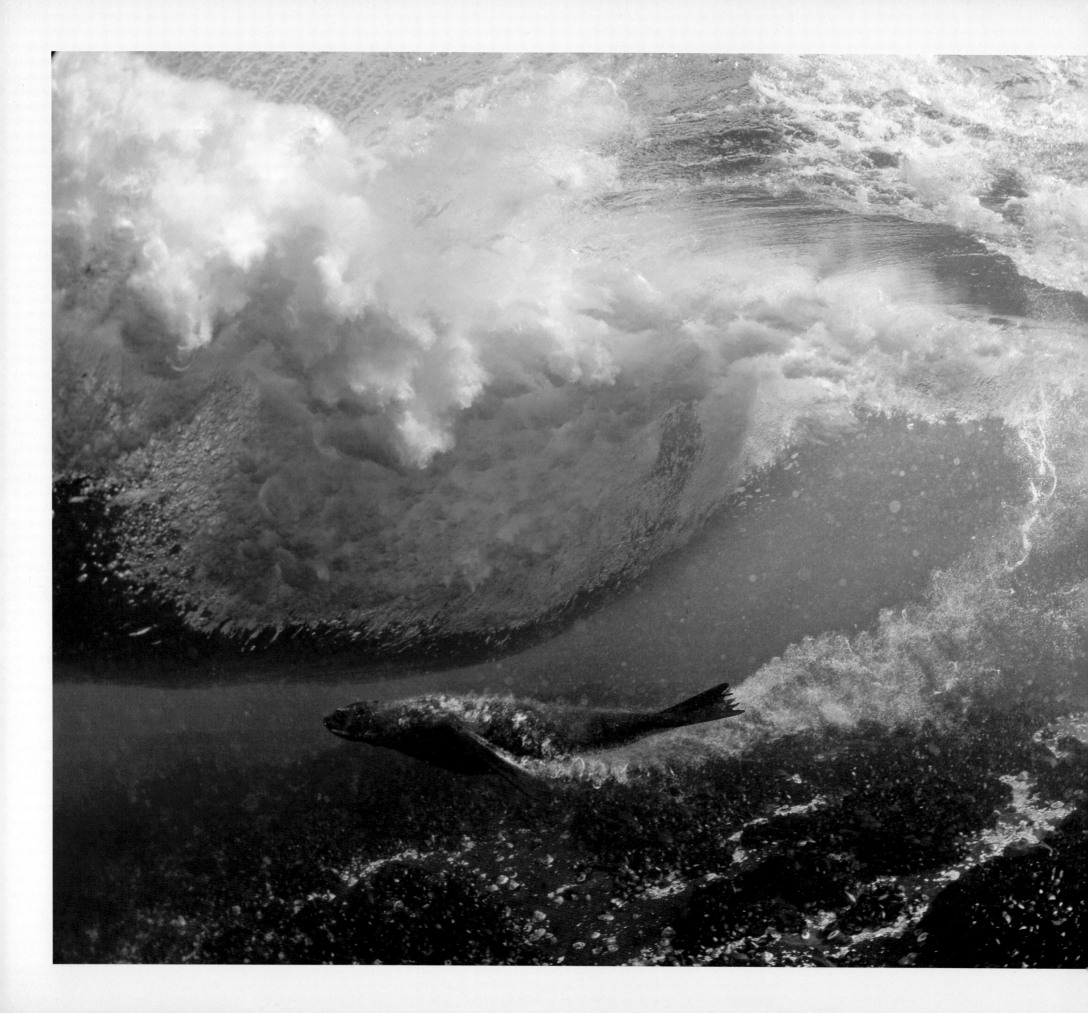

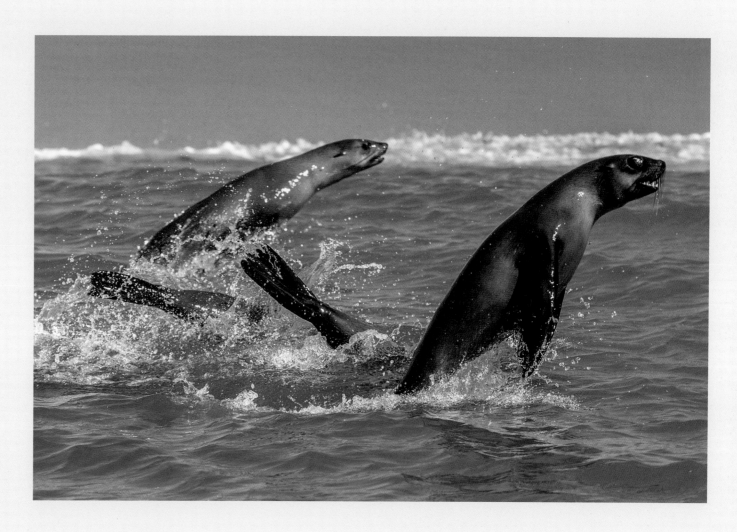

Cape fur seals porpoise through the sea as a strategy to evade white sharks. Porpoising allows for greater speed while still maintaining subsurface vigilance.

LEFT: A Cape fur seal surfs a massive southern swell that collides with Cape Town's shores.

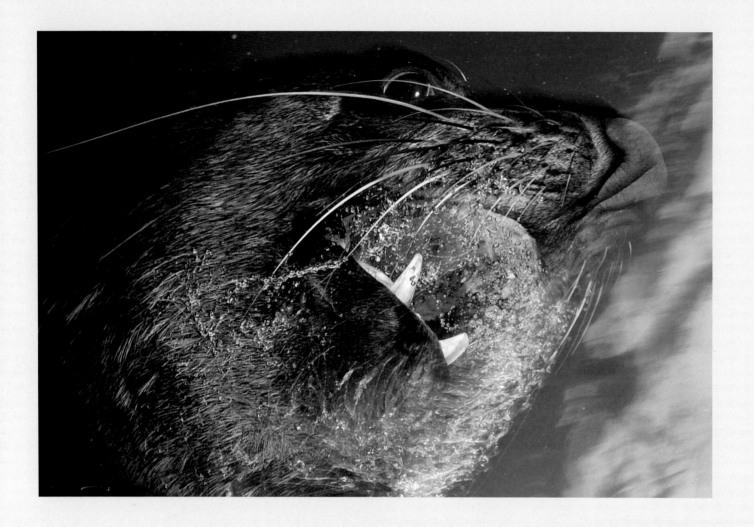

A bull Cape fur seal asserts his dominance by displaying his formidable teeth and vigorously blowing bubbles.

RIGHT: A young Cape fur seal dives alongside a rocky pinnacle, captivated by her reflection in the glass dome of the underwater camera.

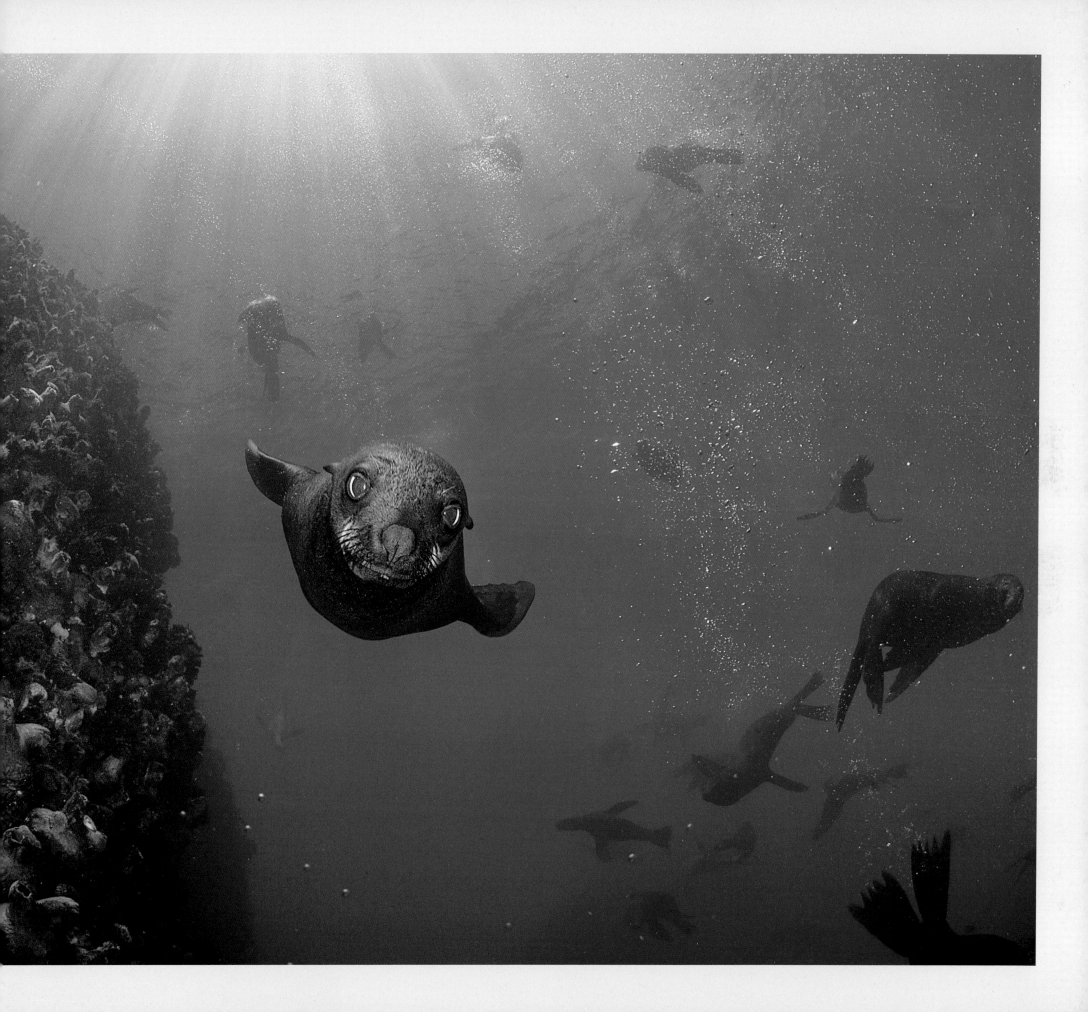

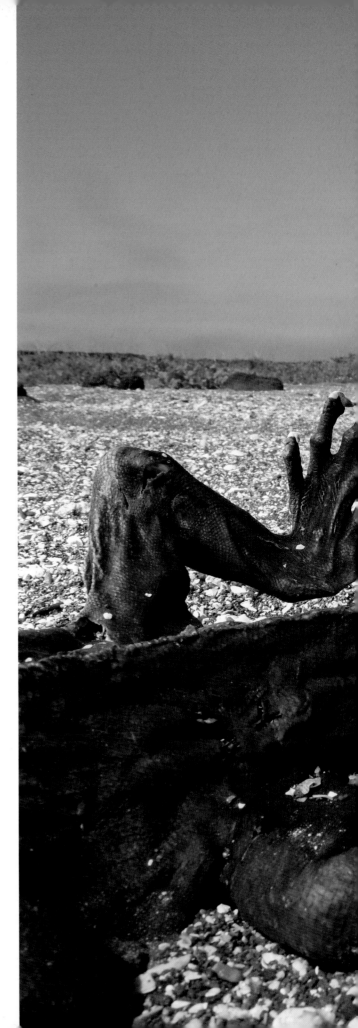

Dragons and Vampires

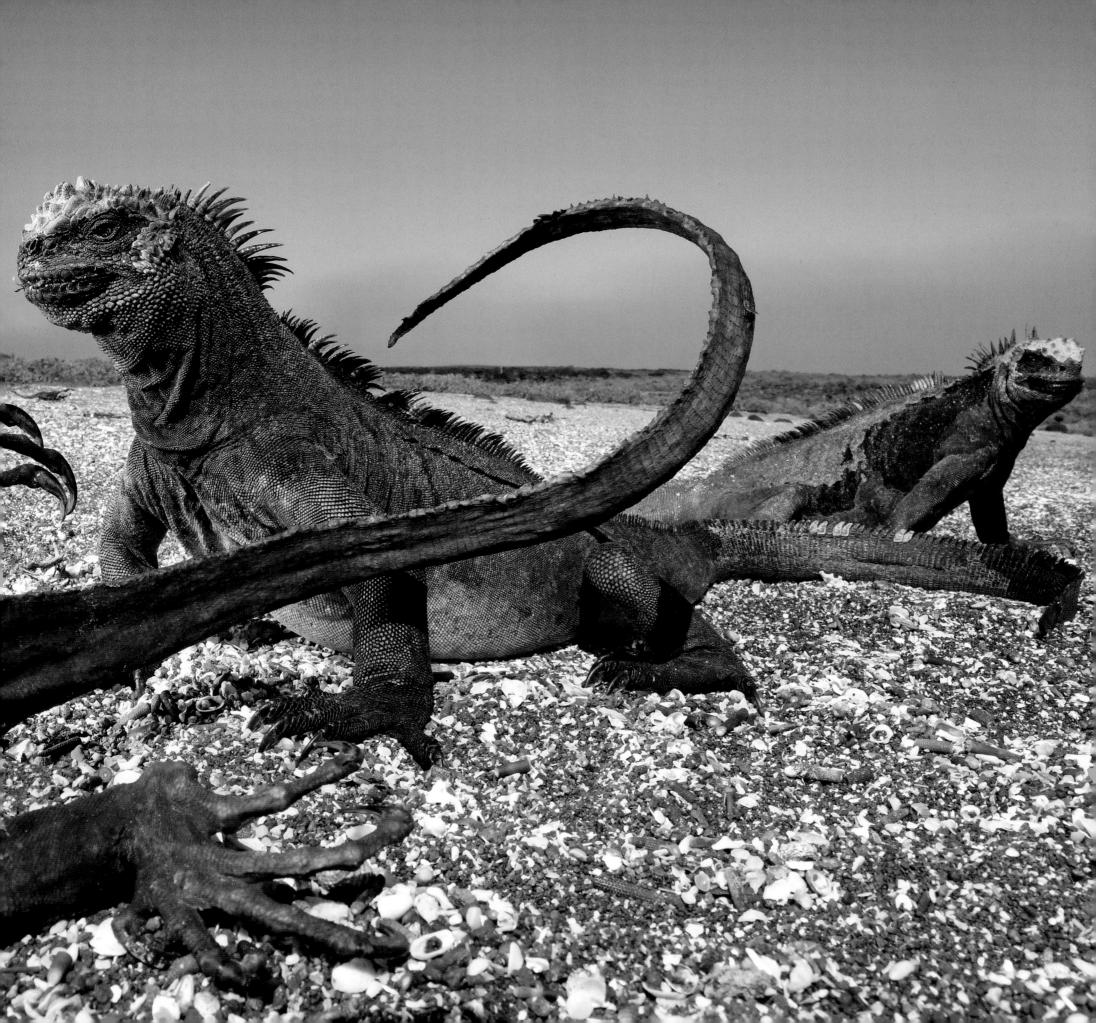

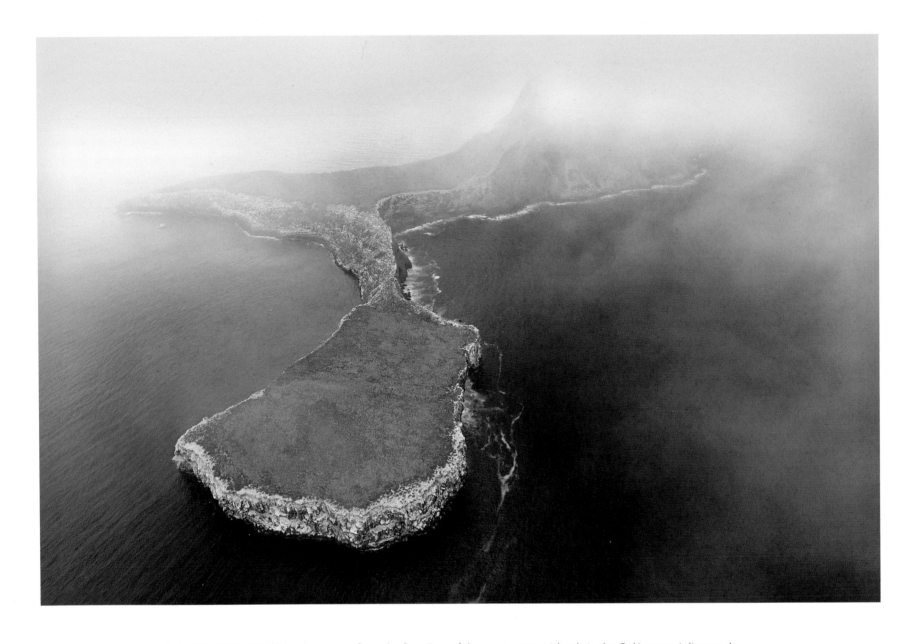

Out of the Mist • Wolf Island emerges from the fog. One of the most remote islands in the Galápagos, it lies north of the Equator. Galápagos, 2016

PREVIOUS PAGES

Life & Death • Two marine iguanas seem unfazed by the presence of one of their mummified brethren (left), who likely died from starvation. Galápagos, 2016

AS A BOY, I loved Godzilla; I was distraught when I learned that this legendary reptilian beast was not real. And so, when I met my first marine iguana 30 years later, it was love at first sight. I knew that these miniature dragons were the closest I would ever get to the mythical movie monster.

Though I find the world's only marine lizard utterly charming and fascinating, the 24-year-old Charles Darwin, who visited the Galápagos Islands 181 years before me, was not as impressed. He described the iguana as "a hideous-looking creature, of a dirty black color, stupid, and sluggish in its movements," referring to them in his journal as "Imps of Darkness."

Darwin was perplexed that these lizards allowed themselves to be caught so easily, rather than flee into the ocean. As an experiment, he took a marine iguana to a deep tidal pool and threw it as far as he could into the water; to his surprise, it immediately returned to the shore. No matter how often he launched the iguana into the sea, it always came back. Darwin concluded that the animals were either stupid or had fewer predators on land. What he didn't understand is that the iguanas' main priority (after hours of grazing on algae in the chilly Pacific Ocean) is to raise their body temperature by basking on the black volcanic rocks.

Although marine iguanas look fierce and invincible, they are in fact incredibly fragile; for them, the difference between life and death can be a matter of a few degrees. And the Galápagos are an epicenter for climatic extremes. In the west, the water can be so cold that green sea turtles escape the ocean to warm up on beaches; at the same time, the air temperature can be so hot that well-insulated sea lions retreat into the ocean to cool down. Additionally, every five to 10 years the stakes get higher during a cyclical, climatic anomaly called El Niño. The oceans warm and rainfall increases, causing a decline in cold-loving seaweeds, the main source of sustenance for marine iguanas.

In response, these reptiles shrink. They are able to absorb parts of their skeleton, which reduces their body length by up to 20 percent. Even their mouths become smaller, making them more efficient at harvesting what little algae remains. Iguanas that shrink the most have a better chance at survival. When the ocean cools, they regrow to their original size.

But if an El Niño lasts long enough, seaweeds die off completely and many iguanas starve. In some years, up to 90 percent of the global population of marine iguanas perishes.

Wolf Island sits at the northern edge of the Galápagos archipelago. Bordered by impossibly steep cliffs, this is a harsh place to survive—even more so during La Niña, El Niño's drier and colder counterpart. Galápagos finches inspired Darwin's theory of evolution, and the sharp-beaked ground variety occur on Wolf Island. They feed on insects and seeds, but both food sources are in short supply during droughts.

To survive tough conditions, the finches take a page from Bram Stoker's *Dracula,* supplementing their regular diet by drinking the blood of Nasca boobies, large seabirds that nest on the island. They peck away at the base of boobies' flight feathers until blood begins to flow and their white plumage is stained red. These little flying vampires lap up blood, quickly attracting the attention of other finches in the area.

On my expeditions I have witnessed up to 10 finches drinking the blood of a single seabird. A booby incubating an egg or sheltering a young chick will simply endure the behavior. However, if not on a nest, the bird soon gets annoyed and flies away. A quick plunge in the ocean washes away the blood and temporarily diverts the finches' attentions elsewhere. Though it may be uncomfortable for boobies and the act looks gruesome, there appears to be no negative long-term impact.

In the Galápagos, tourism forms the backbone of the economy, generating around $200 million (U.S.) in 2019—and although marine iguanas might not win any beauty contests, they are extremely popular with visitors. Tragically, they will also be one of the first animals to go extinct as ocean temperatures continue to increase.

The archipelago's iconic wildlife has successfully adapted to a changing climate for millions of years, but the exponentially increasing rate of change is challenging even for the most resilient species. Whether or not these real-life dragons and thirsty vampires survive the next century depends on how humans respond to climate change.

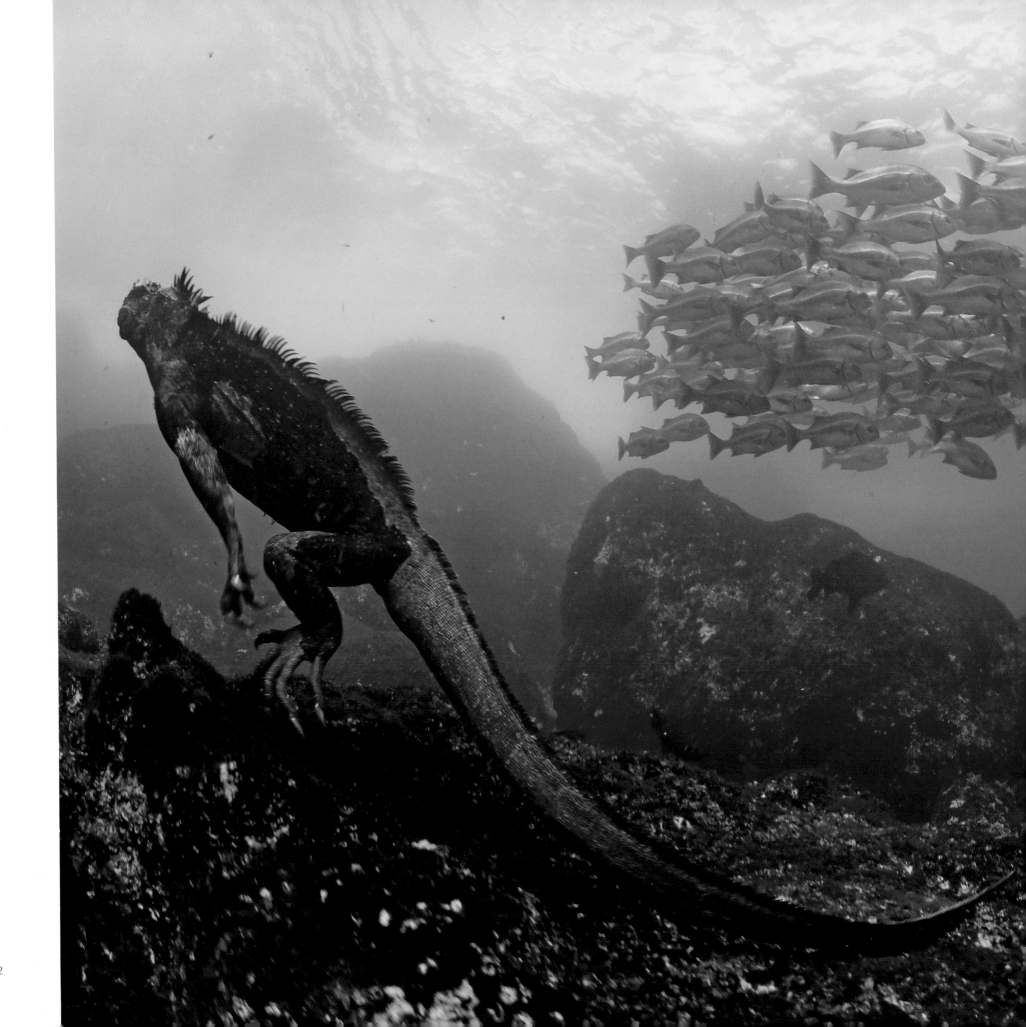

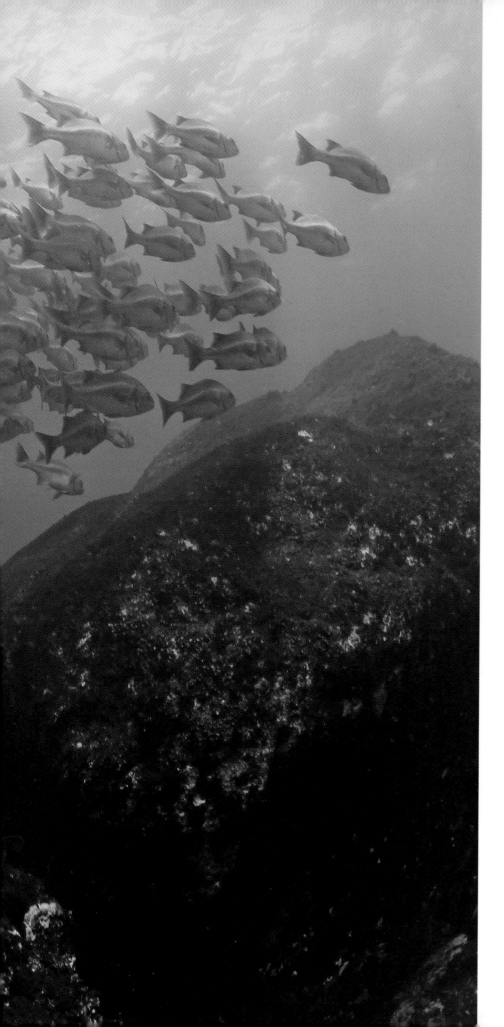

Ocean Godzilla • Larger marine iguanas dive to 30 feet or more to graze on nutritious algae. They can forage in the cold waters for about an hour before needing to return to land to warm up. Galápagos, 2016

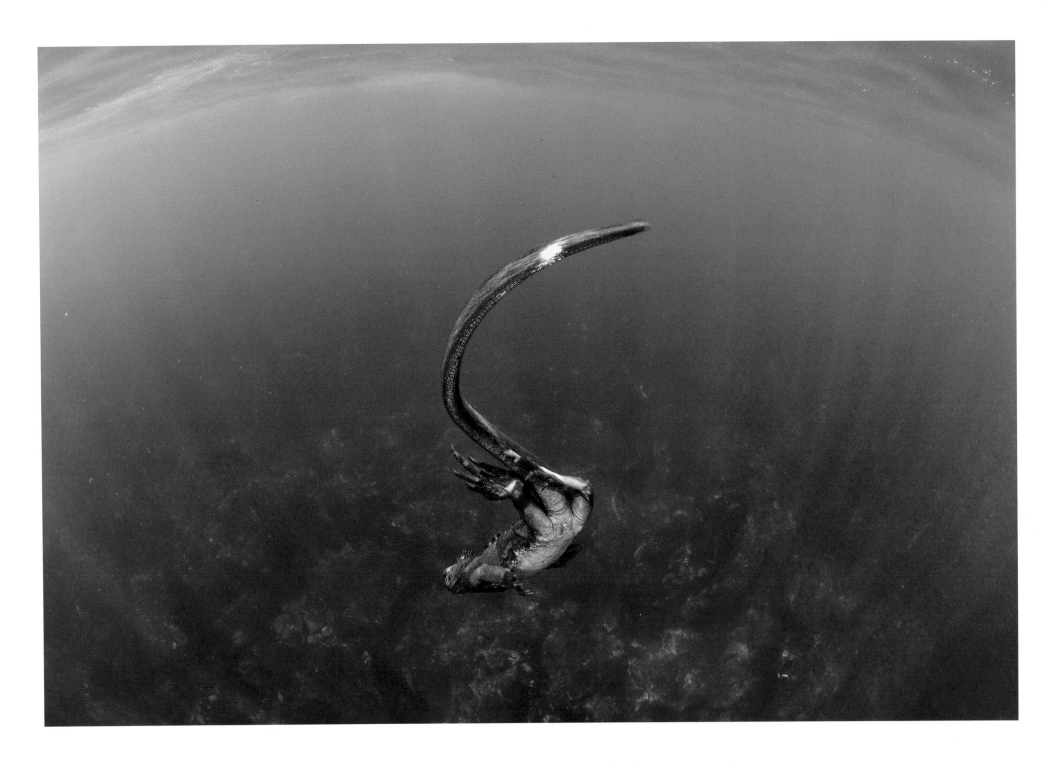

Sea Grazer • A marine iguana dives to the seabed in search of seaweed. When food is scarce, the lizards can shrink their overall size by as much as 20 percent; they bounce back when food becomes more plentiful.
Galápagos, 2016

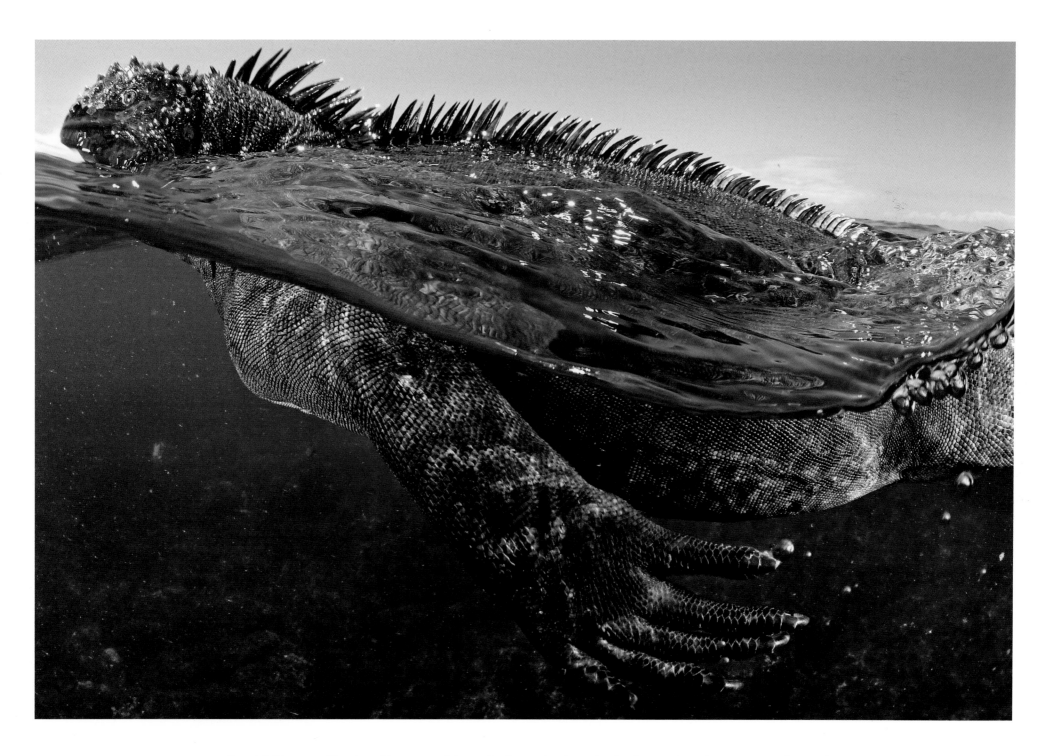

Darwin's Dragons • The short, blunt nose of the marine iguana is adapted to feeding on algae that grow on rocks. Excess salt from the algae is expelled through a special gland connected to the nostrils. Galápagos, 2016

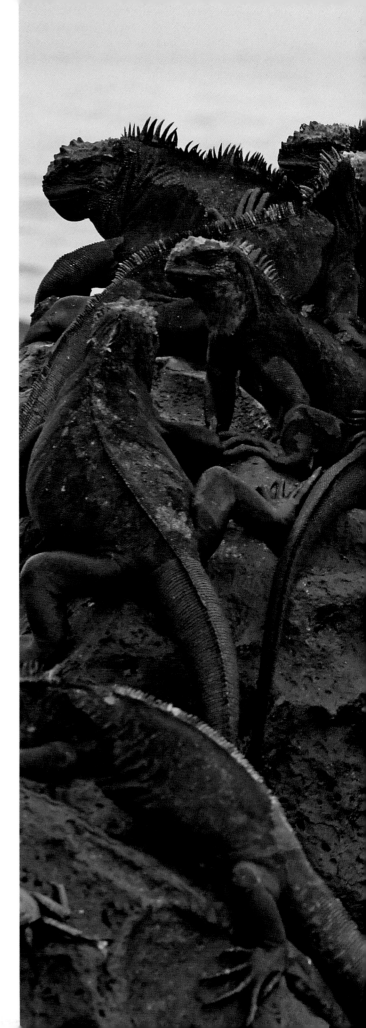

One of a Kind • Marine iguanas crowd together on lava rocks to warm up after foraging at sea. The world's only oceangoing lizard and the red Sally Lightfoot crab are both grazers that depend on cold-water seaweeds for survival. If sea temperatures continue to warm, these Galápagos icons could become the first to disappear. Galápagos, 2016

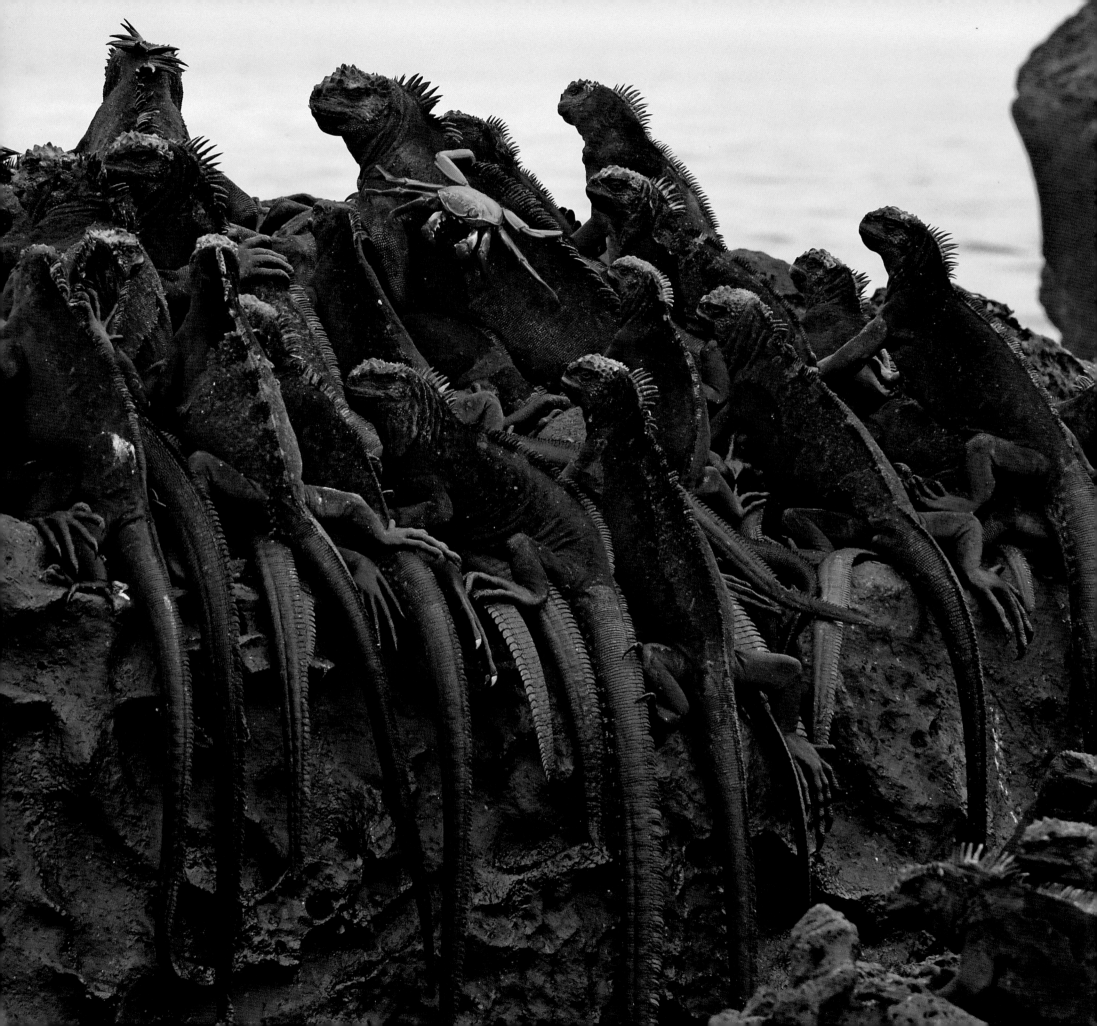

The Dead Zone • Dead marine iguanas collected along the rocky shores of Isla Fernandina form a grisly tableau. Scientists predict higher death rates as climate change warms the oceans. Galápagos, 2016

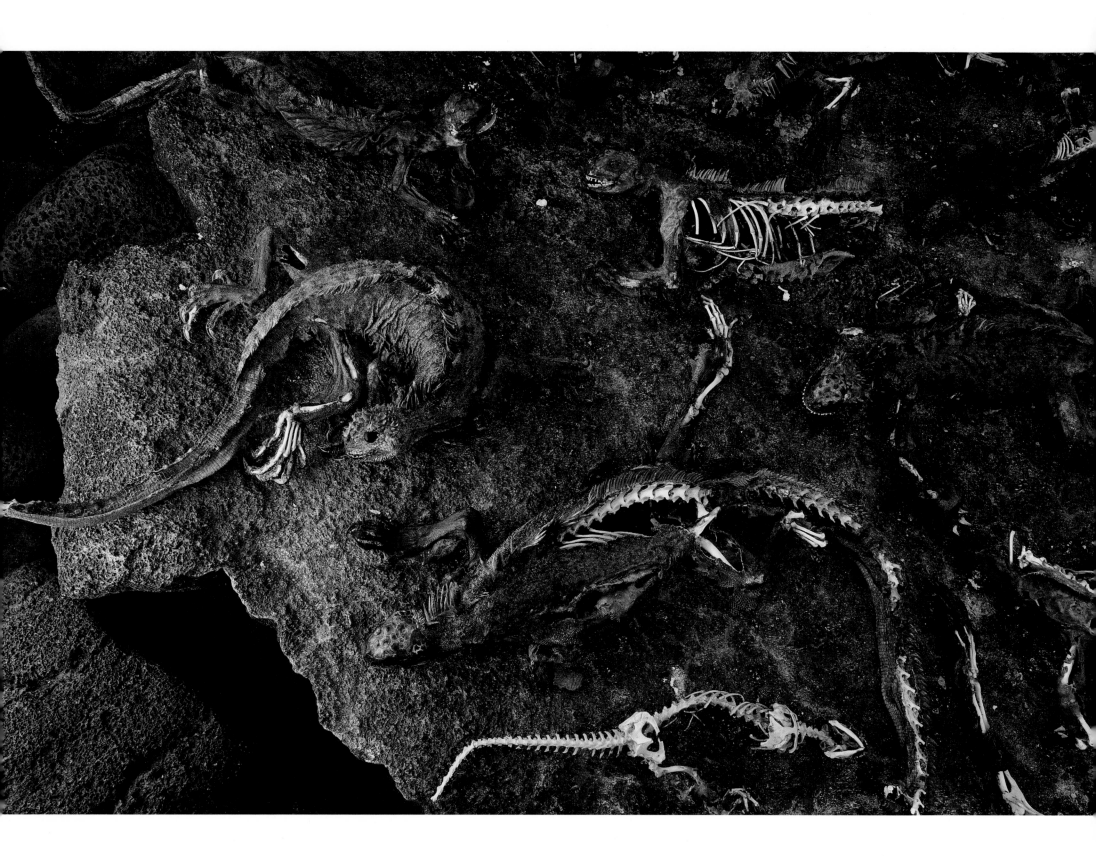

Sea King • Like Neptune on his throne, a marine iguana sits on an algae-cloaked rock as a procession of yellowtail surgeonfish graze in the background. Marine iguanas can hold their breath and stay submerged for more than 30 minutes. Galápagos, 2016

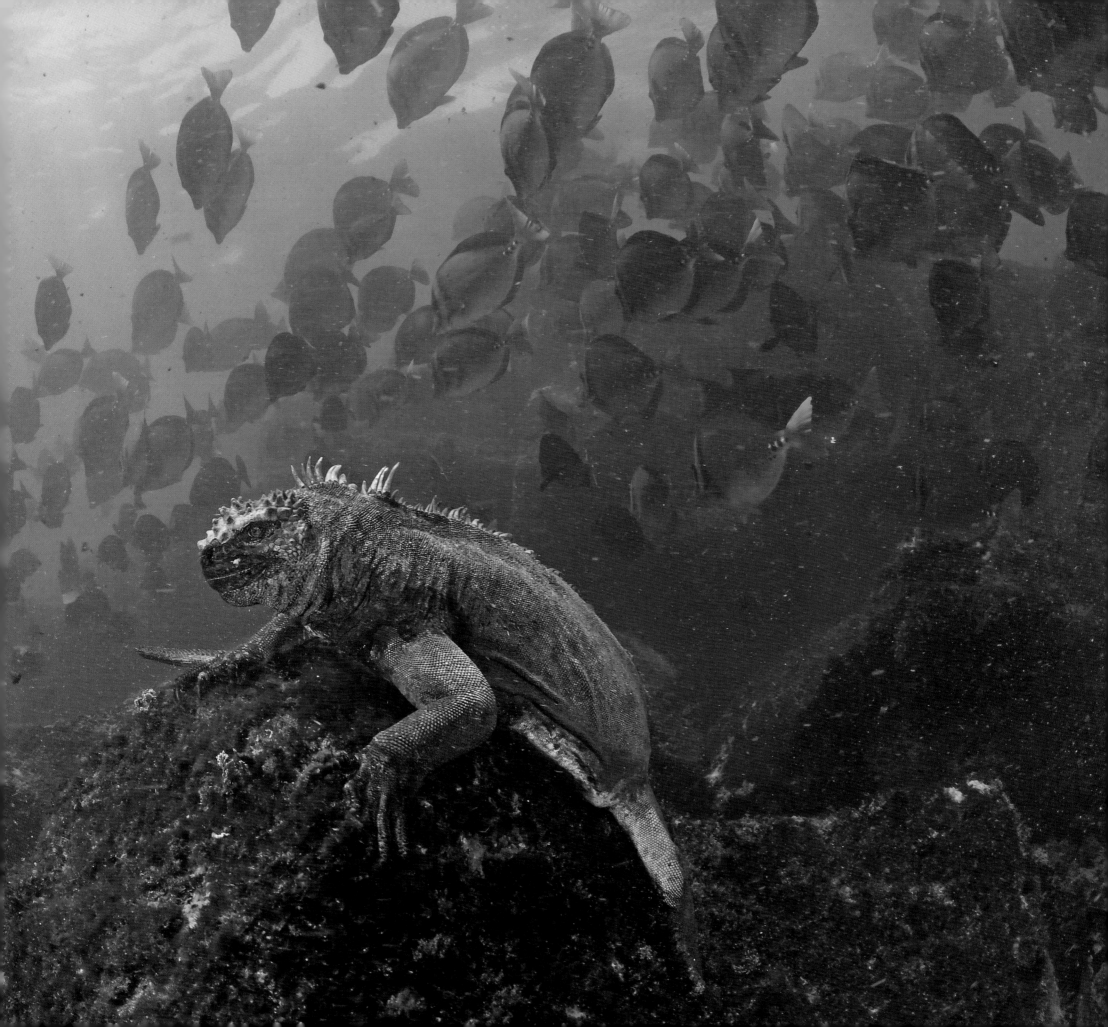

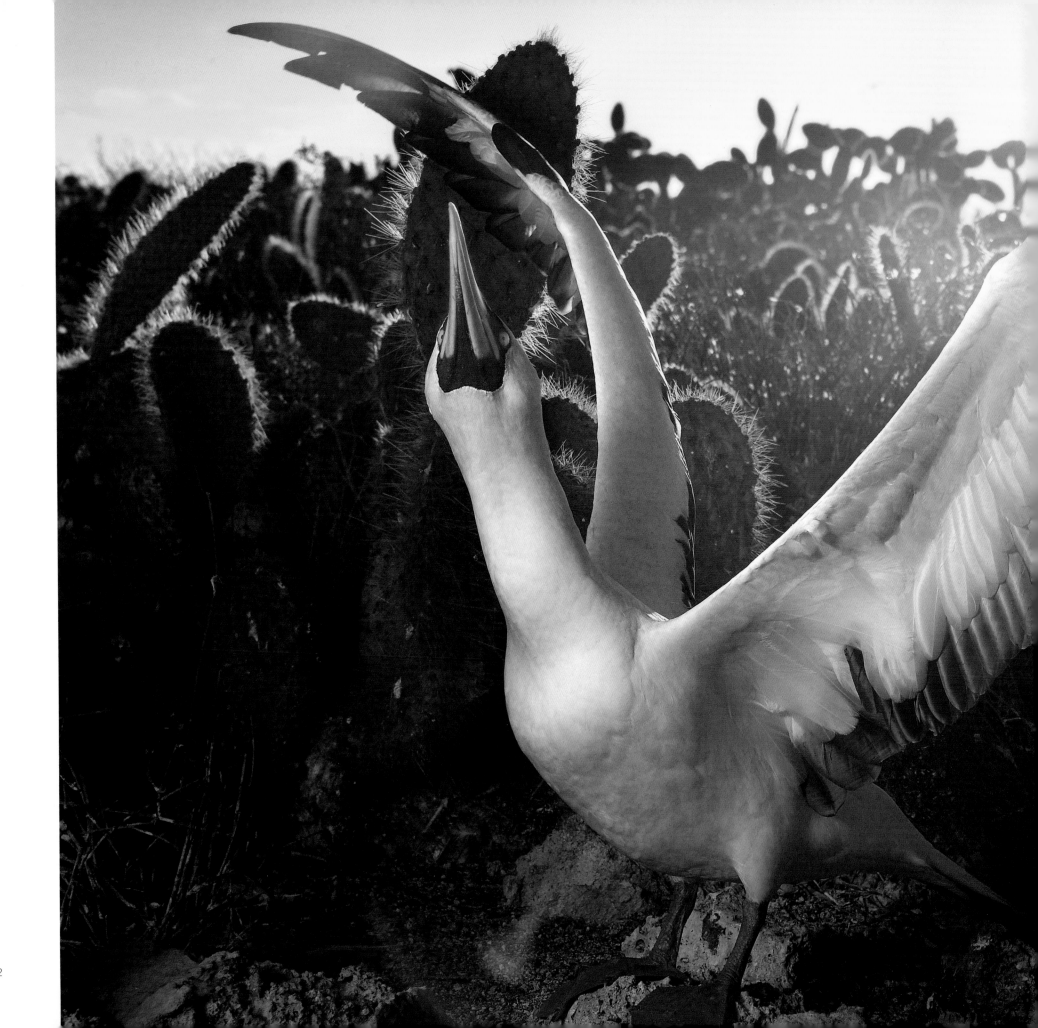

Sunset Beach • After hunting fish, a Nazca booby returns to its nest near a thicket of *Opuntia* cacti on Wolf Island. Climate change will trigger changes in its diet, which may decrease reproduction and depress populations. Galápagos, 2016

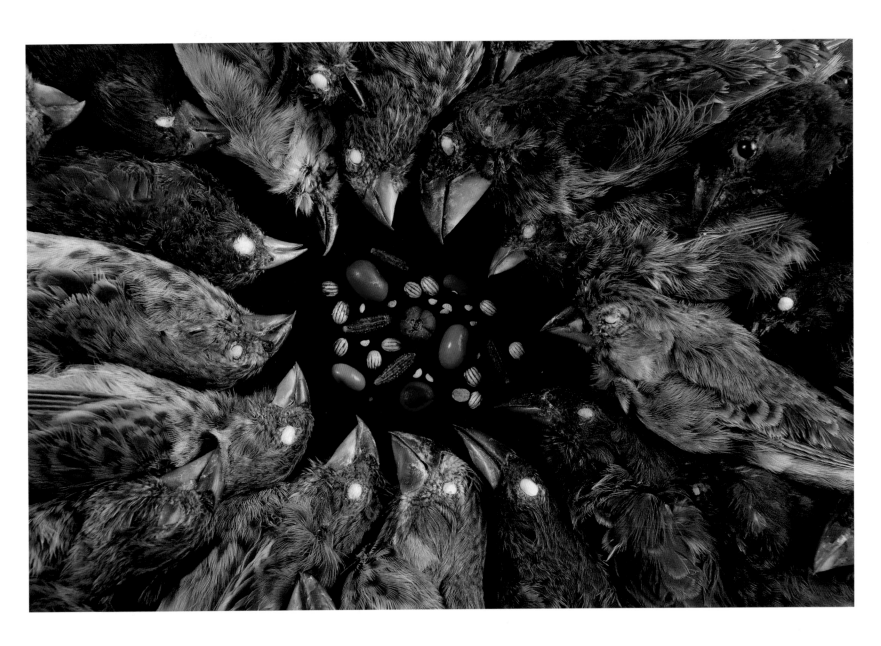

Darwin's Finches • A variety of finches from different islands are arranged around an assortment of local seeds at the Charles Darwin Research Station. The size, width, and shape of their beaks evolved to exploit the seeds available in each of their respective habitats. Galápagos, 2016

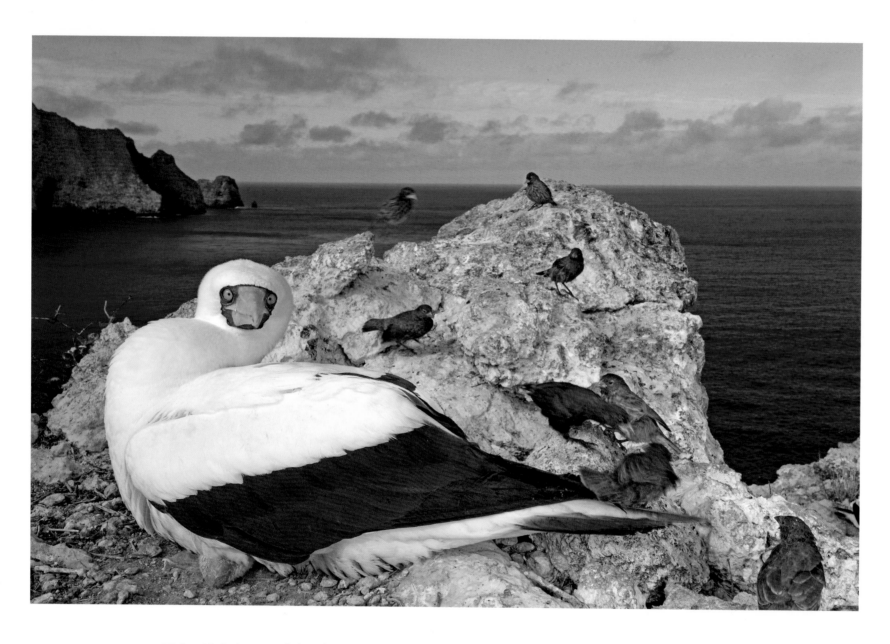

Bird on Bird • A group of sharp-beaked ground finches, also called vampire finches, mob a nesting Nazca booby. Wolf is one of only two islands in the world where finches drink seabird blood. Galápagos, 2016

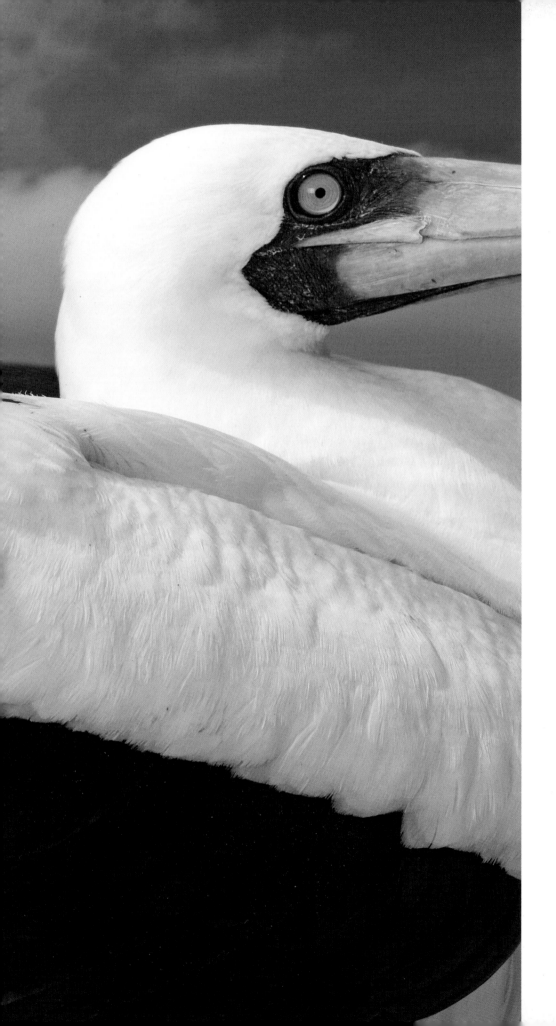

Blood Thirsty • Finches on Wolf Island have a tougher time procuring a meal than land birds elsewhere. When seeds and insects cannot be found, sharp-beaked ground finches become vampires; they peck at the base of Nazca booby flight feathers to feed on their blood. Galápagos, 2016

Crabzilla

THEY COME LIKE THIEVES in the night and eat everything. They will steal your cameras, shoes, or water bottles. When they scuttle and scrape across the corrugated roof, it sounds like nails on a chalkboard. Some nights are so bad that to get any sleep, I have to get up and relocate them from the roof to the ground.

Coconut crabs—also called robber crabs—are the behemoths of the crustacean world. Lifting items up to 60 pounds, this jackrabbit-size animal is the largest terrestrial arthropod in the world. They are opportunists, eating everything from seeds to seabirds. There is even a theory that coconut crabs might have devoured pioneering aviator Amelia Earhart's body after she supposedly crash-landed on the remote island of Nikumaroro.

In a macabre twist, the crabs themselves are very tasty, and humans ate them to extinction across most of the western Indian Ocean. However, one population found a safe haven on Aldabra, a remote atoll in the Seychelles. Aldabra is the antithesis of a honeymoon destination; the coralline rock of the atoll protrudes like razor blades and will destroy

brand-new hiking boots in a matter of weeks (one barefoot misstep could cost you a toe). But the harsh, uninviting environment keeps people away and ultimately saved this coconut crab population from extinction.

One night, my assistant Otto and I accompany a scientist on her mission to census and measure coconut crabs. We walk through the ruins of an old settlement when the beam of my flashlight catches a large crab sitting just outside a doorway. Its eerie shadow, cast onto the dilapidated wall, reminds me of a horror movie. In an instant I know I have to make a photograph inspired by the 1950s-vintage movie posters for films like *Attack of the Crab Monsters* or *The Deadly Mantis*.

I place my tripod next to the crab. It seems unfazed by my presence, so I start building the scene. We set up lights to illuminate the inside of the building and to create the crab's shadow on the outer wall. Otto crouches in the doorway and in that moment, a second crab walks into frame. I ask Otto to turn on his headlamp, and my modern take on a classic horror movie poster is complete.

A torch projects the shadow of a coconut crab onto a decaying limestone wall on Aldabra Atoll. Weighing up to nine pounds with a leg span of three feet, they are the largest terrestrial crabs in the world.

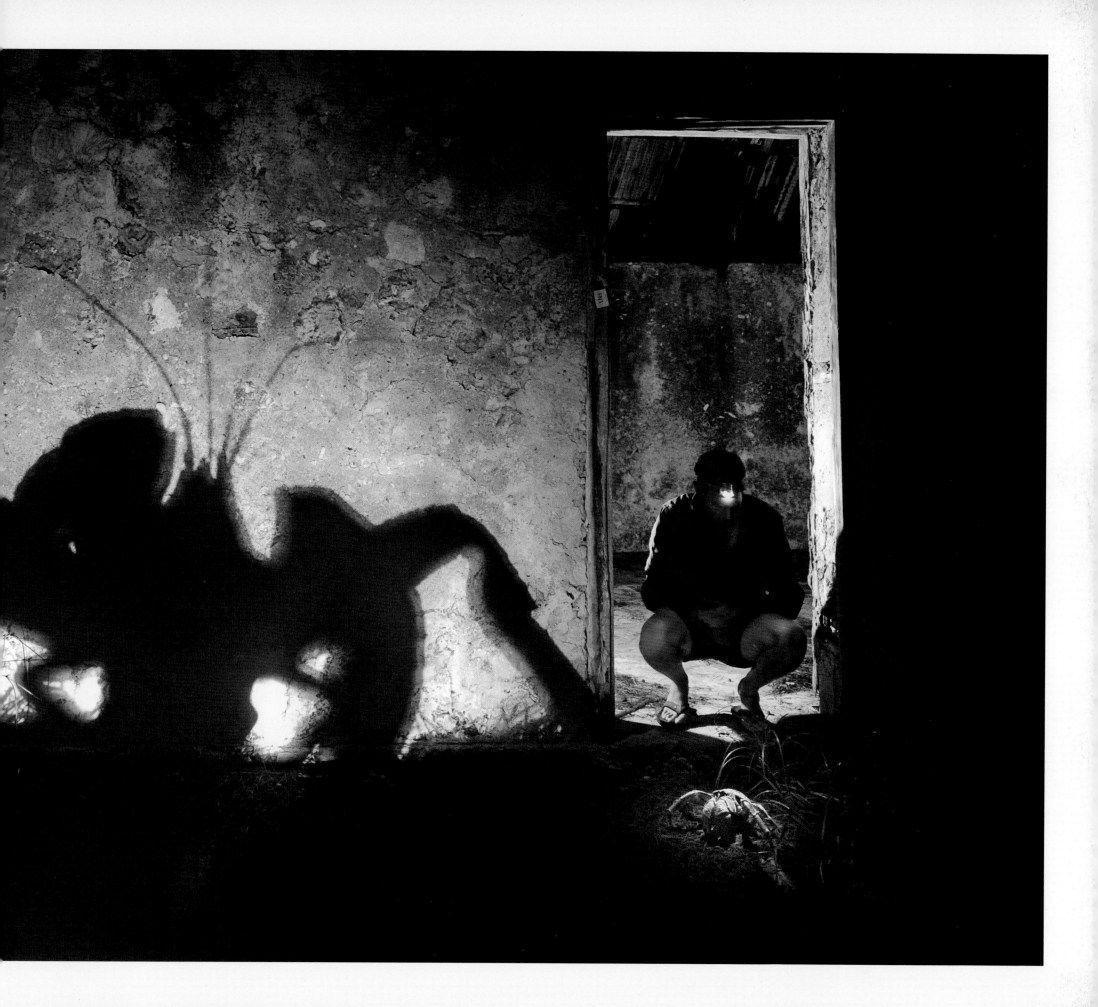

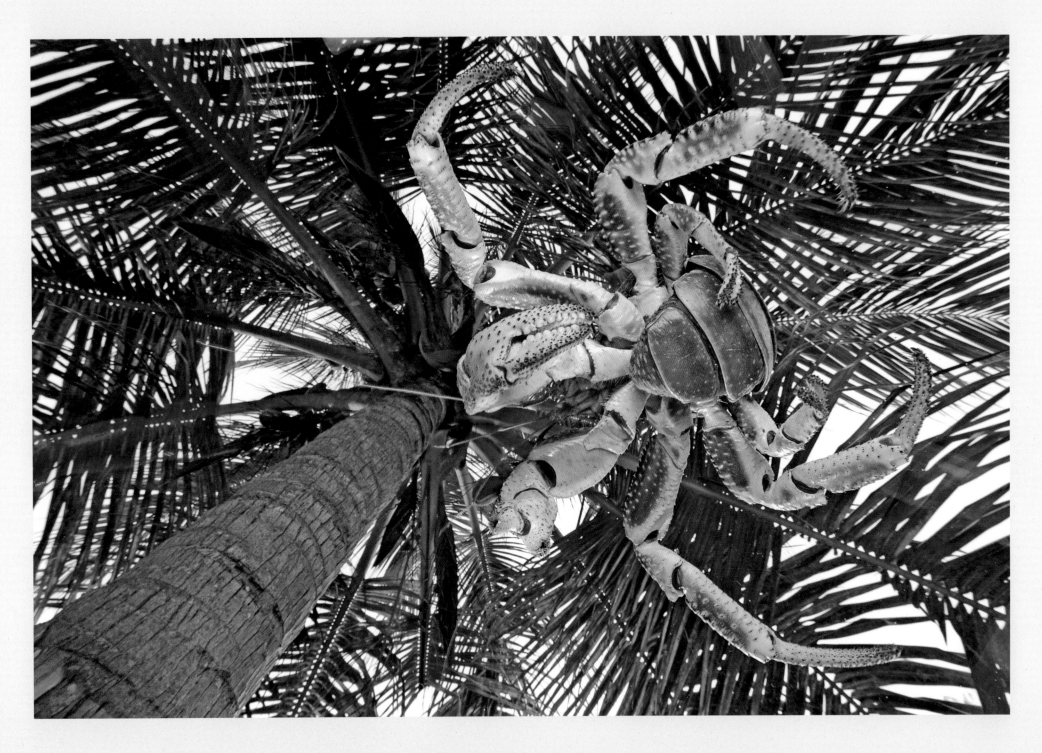

A coconut crab walks across a sheet of glass installed beneath a coconut palm. These animals are scavengers that subsist mainly on fallen coconuts, but they also hunt and eat large seabirds. They can lift items up to 60 pounds, and the crushing power of their claws nearly rivals that of a lion's bite.

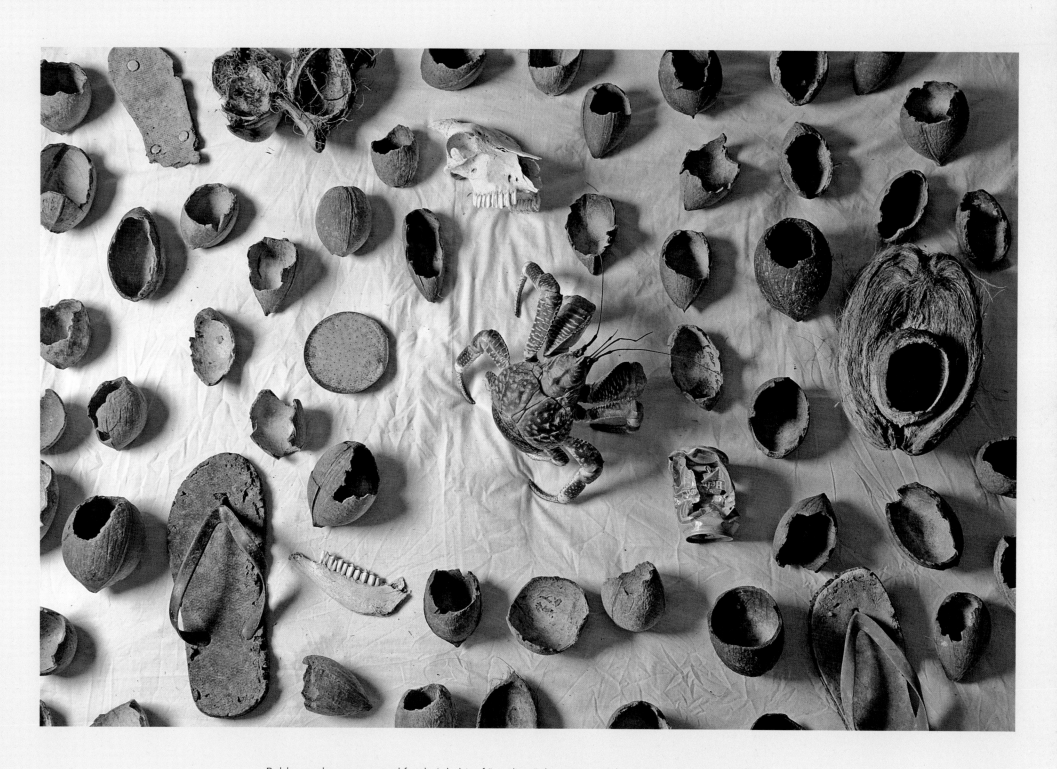

Robber crabs were named for their habit of "stealing," dragging novel items into their burrows. The items in this photograph, including a showerhead, flip-flops, and a goat skull, were found within the vicinity of this crab's home. The white background is a bedsheet from the Aldabra Research Station.

Time of Death • A spearfisherman with a freshly killed longfin tuna off Aliwal Shoal. While this image is graphic, it portrays a fishing method that is far more selective than longlines, trawls, or gill nets.
South Africa, 2008

Ocean Minded

WHEN I SPEAK about my work, I am often asked about the scariest part. The answer is definitely sharks—but not for the reasons most people think.

What frightens me most is a scenario in which I am not able to find sharks to photograph. This is unfortunately a rational fear; overfishing has all but eliminated these predators from parts of the world.

But my consternation is not limited to sharks. I am equally afraid to find no sea turtles, seahorses, or giant clams. The scariest part of my job is the fear of an empty ocean.

As a boy, I dreamed about seas full of life. In my nocturnal excursions I explored otherworldly places where manta rays blocked out the sun and seals played in giant kelp forests. I have spent most of my life looking for real places that are as magical as those in my dreams. Every year I have to travel farther to find these remote jewels.

I remember snorkeling in my teens. The water was clear and the coral pristine; every day

I met the same hawksbill turtle along the reef. Decades later, I returned to the same spot—but saw no signs of coral or turtles.

Despite having seen the degradation of our oceans in my lifetime, I believe it is not too late for a turnaround. I have witnessed the resilience of marine ecosystems; the ability of species to recover is astounding. I nurture my inner optimist and choose to invest in hope, rather than despair. As long as there are fish in the sea, I will keep documenting the stories they are trying to tell us.

However, helping to protect the ocean is not the exclusive domain of photographers or biologists; it's everyone's responsibility. The decisions you make about seafood you eat, things you buy, and what you throw away all make an impact. Never underestimate your power as an individual and as part of a community.

Environmentalist David Suzuki said it best: "In a world of more than seven billion people, each of us is a drop in the bucket. But with enough drops, we can fill any bucket."

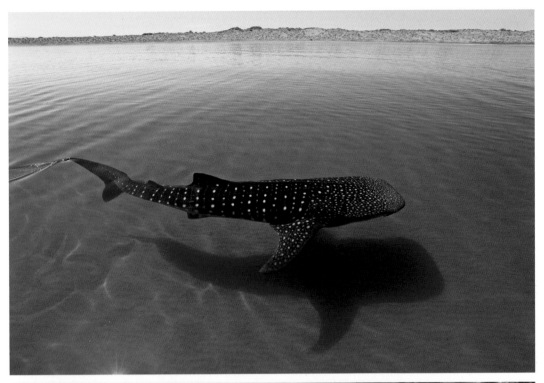

Climate Change

I'D EXPECTED the water to be cold and murky, but am instead immersed in warmth. I'm thrilled by the crystal clear visibility, but grow frustrated when the marine life I'm here to photograph is absent. There are no signs of leaping mobula rays, schooling hammerhead sharks, or fishing cormorants. Cold and green is the ocean's badge of productivity; blue and warm doesn't nourish the array of life that normally thrives off the coast of Baja California.

Truth be told, the climate has been out of whack in almost every story I've worked on for *National Geographic* over the past decade. Predictable cycles that have held strong for centuries are being severely altered; salmon spawning disruptions, disease outbreaks in sea stars, and favorable conditions for invasive species are just some of the negative impacts I've seen. As we burn fossil fuels, carbon dioxide levels continue to rise, which creates a disruptive ripple effect reaching every corner of the planet. The oceans heat up first and fastest; as a result, many marine species and ecosystems are threatened. A sustained increase in the maximum annual temperature of just one degree Celsius may be enough for most coral reef systems to go extinct as soon as 2050.

TAKE ACTION: Go online to measure your carbon footprint. Fly and drive less. Bike and walk more. Reduce the amount of meat in your diet. Vote for politicians who understand the ongoing threat of climate change. Plan for smaller families. Consume less.

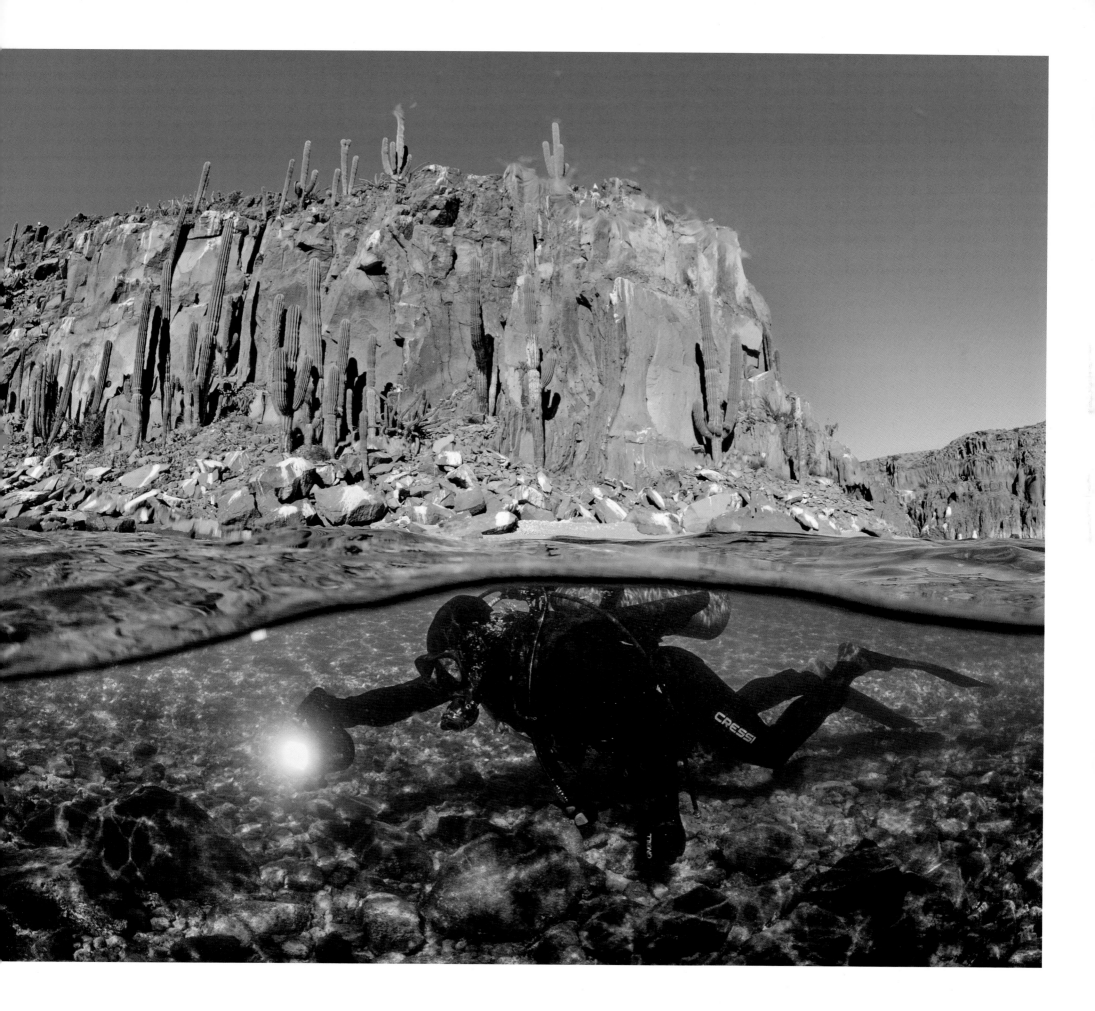

Plastic Ocean

I WAS IN THE RIGHT PLACE at the right time to prevent this plastic bag from being swallowed by a whale shark. It was a small act, but I hope it made a difference.

Filter-feeding marine animals, seabirds, and the very fish we consume inadvertently ingest large amounts of plastics. Most of what they ingest are microplastics: plankton-size pieces commingled with actual plankton. Most countries don't have the infrastructure to recycle plastics; as a result, most enter the waste stream and often end up in our oceans.

TAKE ACTION: Reduce the amount of plastic you use (especially single-use items like bottles, straws, and bags). Support food companies that prioritize the reduction of plastic packaging, or apparel companies that use natural materials or reclaimed polyester-based items.

Ghost Nets

ALMOST EVERY OUTCROP is draped with an abandoned gill net; turtles, sharks, and many species of reef fish lie around me, trapped. Most are dead, but I detect some movement. A surgeonfish struggles fiercely to escape; I take out my knife and cut it free.

Ghost nets are fishing gear left or lost in the ocean. They take up to 30 years to degrade, and continue to catch and kill animals as long as they are underwater. Ghost nets frequently wash up on beaches, especially after storms. If they are not collected, they can wash back to sea. Fortunately, conservation groups are beginning to conduct underwater cleanups to remove them; doing our part individually will exponentially advance the global efforts on this front.

TAKE ACTION: Organize beach cleanups and support artists or businesses that make sculptures, sunglasses, carpets, or skateboards out of discarded fishing gear.

Fossil Fueled

AS I WATCH the tanker navigate the passage between the island and the mainland, my stomach drops. It's not a question of if but when one of them will cause an oil spill and threaten this vital Cape gannet colony.

Although the number of large spills may have decreased since the 1970s, they are catastrophic when they happen. The 2010 Deepwater Horizon spill in the Gulf of Mexico was the third largest in history; its impacts are still being felt today.

Offshore gas is considered less risky. But the seismic exploration needed to establish offshore drilling is detrimental; these surveys generate some of the loudest sounds in the ocean. They continue for weeks and can be heard within a hundred-mile radius. These sounds have been linked to hearing loss in whales and dolphins, which interferes with vital communication and feeding efforts. Seismic testing is thought to be a probable cause for cetaceans beaching themselves in large numbers.

I use fossil fuels every time I photograph a story. I get into cars, planes, or ships; even my cameras are made from hydrocarbons. But bearing witness to shipwrecks and seabirds covered in oil has made me more mindful when it comes to my own impact. I do what I can to minimize my complicity, while still trying to tell conservation stories that make a difference.

TAKE ACTION: Buy local whenever possible. Support companies that are reducing their carbon footprint. Support legislation that champions renewable energy like solar and wind.

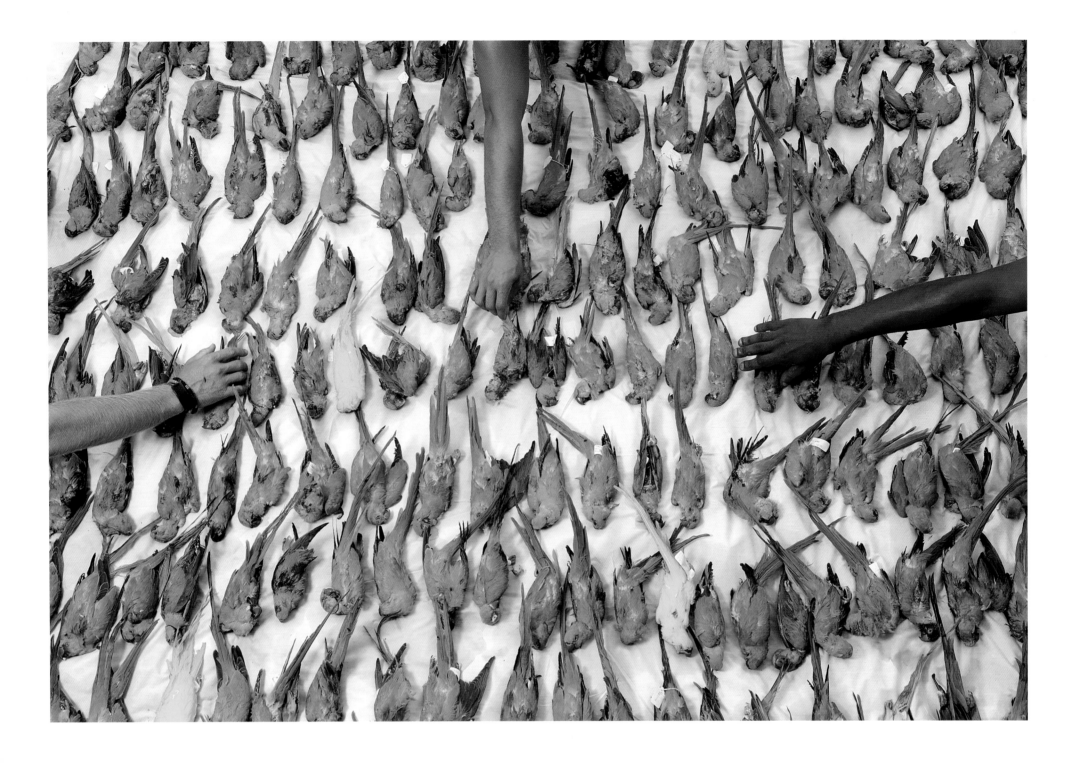

Alien Invasion

OCEANIC ISLANDS are some of my favorite ecosystems, home to animals and plants that occur nowhere else on Earth. They are uniquely vulnerable; half of all animal extinctions of the past 400 years occurred on islands.

In 1996, two pet parakeets escaped from their cage in the Seychelles. They multiplied to over 500 and threatened the national bird, the black parrot. It took hundreds of thousands of dollars and eight years to eradicate the parakeets. Invasive species are also a real threat in the ocean. The algae *Caulerpa* in the Mediterranean and lionfish in the Atlantic are the most notorious; both species escaped from aquariums and are threatening native plants and animals.

TAKE ACTION: Don't release unwanted or exotic pets or plants into the wild; if you see invasive species, report them.

Sea Medicines

I AM EXPLORING one of the most pristine reefs in the Indian Ocean, with not a single bleached or broken coral colony anywhere in sight.

Often a surprise to many, the ocean is a generous pharmacy; when I plumb its depths, I'm surrounded by some of the cornerstones of modern medicine. Sponges, sea squirts, cone shells, and other tropical marine life contain compounds used to treat cancer, heart disease, and other human ailments. (Fortunately, these compounds are now being synthetically replicated, making wild harvests unnecessary.)

In Traditional Chinese Medicine (TCM), however, the original animal and plant ingredients continue to be the only sources for remedies. Seahorses have been part of the Chinese pharmacopeia for around 600 years, and are primarily used to treat respiratory and sexual disorders. Over 16 million seahorses are consumed in Asia annually, and all species are classified as vulnerable or endangered. Hong Kong is the world's largest importer; the majority are sourced from fisheries in Thailand, the Philippines, Australia, and India, where most are caught accidentally as bycatch. All the top export countries currently have seahorse trade bans in place, meaning that many of the seahorses for sale today are illegal.

TAKE ACTION: If you are a user of TCM, look for more sustainable ingredients that don't exploit endangered species. Avoid buying any dried seahorses (or other animals) in curio shops.

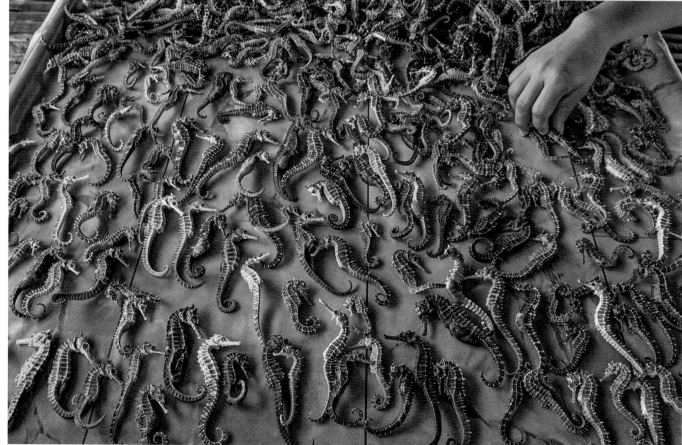

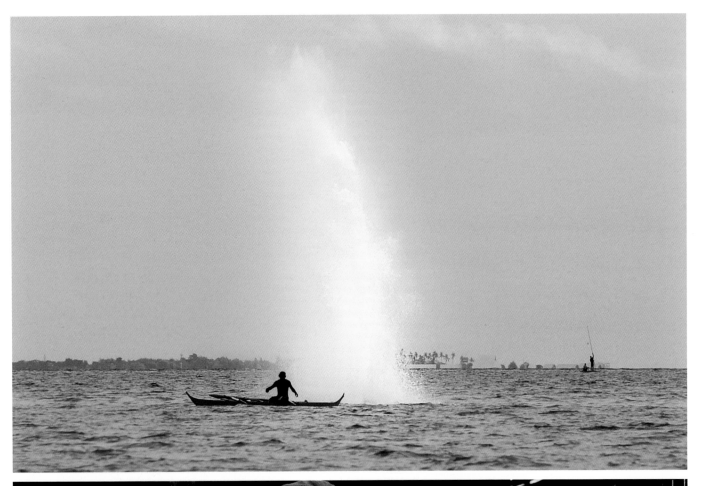

Blast Fishing

THE EXPLOSION took both his hands, but every morning he walks down to the shore to search for egg ribbons of nudibranchs. He collects them with his toes.

He had been a boat-based fisherman, but then catches declined. (In parts of the Philippines, I have seen fishermen come home after a full day's work with little else than a few small fish.) This man needed more than he could catch to feed his family, so in desperation he turned to blast fishing. That was when the bottle bomb filled with fertilizer exploded prematurely.

Blast, or dynamite, fishing is one of the most destructive methods in use today. Fishermen throw homemade explosives onto coral reefs and let the blast do the rest. Dead fish float to the surface, where they are easily collected. This unselective killing takes everything from the smallest seahorse to the largest grouper.

Blast fishing not only removes all the fish from the ecosystem, but it also destroys the ecosystem itself. The explosion reduces coral reefs to rubble within a hundred-foot radius. It is easy to vilify those that turn to this and other illegal methods, but most do so out of desperation; impoverished people often don't have the resources to conserve their ecosystems when basic needs are not being met.

TAKE ACTION: Support conservation projects that focus not only on wildlife, but also on the communities of people who depend on them.

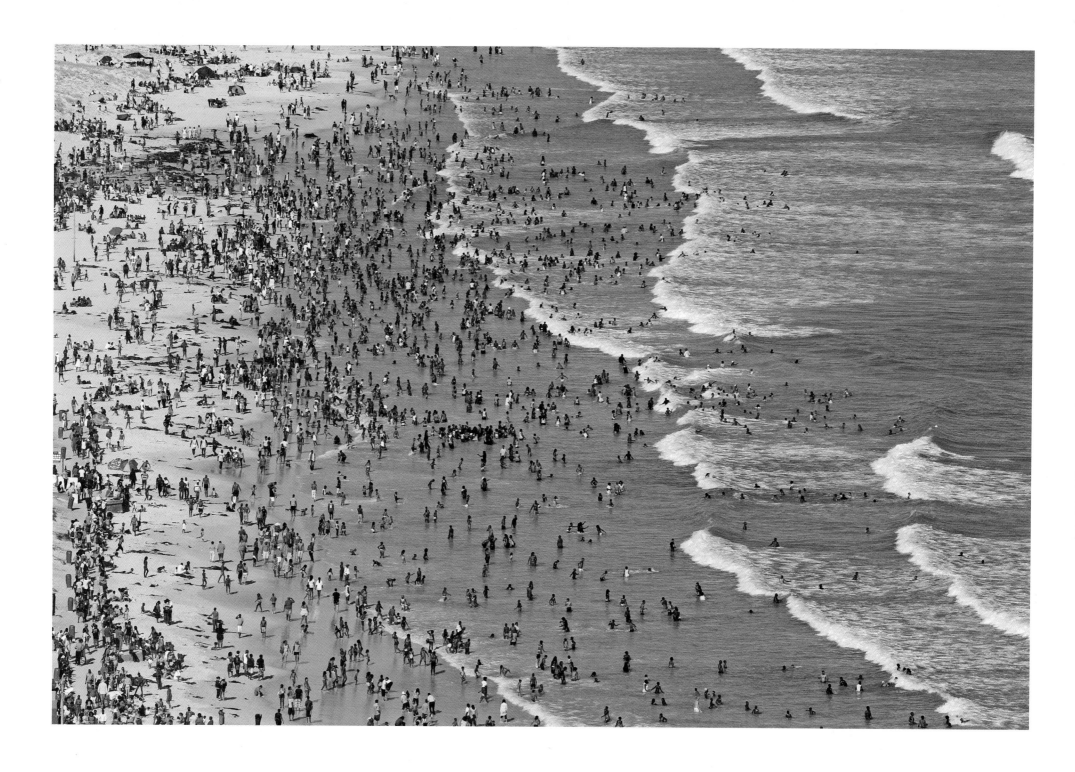

Coastal Gridlock

FORTY PERCENT of the world's population lives within 60 miles of a coast. Photographing the festive crowds above Muizenberg Beach near Cape Town on New Year's Day really brought this statistic to life for me.

Coastlines were the first to be colonized, developed, and exploited; wilderness was dislocated by concrete and asphalt. Today, very few truly wild coastal places are left. Namibia's Skeleton Coast, Canada's Great Bear Rainforest, and Chile's Patagonia are three of the few remaining strongholds. Here prides of lions still roam beaches, wolves rub shoulders with killer whales, and pumas hunt Magellanic penguins.

TAKE ACTION: Get to know the ocean and its inhabitants personally. Explore beaches and tide pools. Go whale- and turtle-watching. Learn to snorkel or scuba dive.

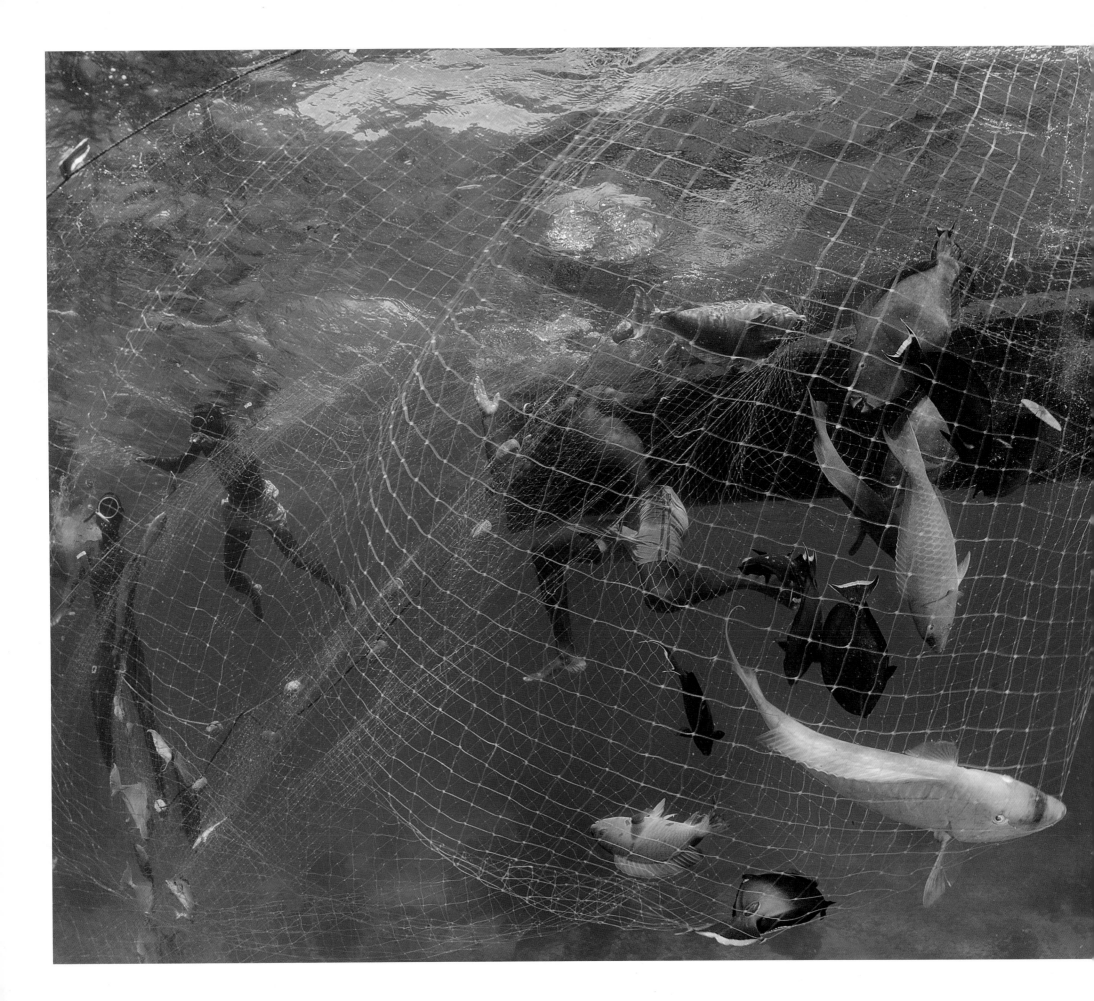

Seas of Plenty

HALF A DOZEN fishermen surround me. I follow as they hold their breath and dive to the seabed to remove beautifully colored reef fish from their nets.

Normally the sight of dying fish makes me sad, but today is different. In 2003, the fishing communities on northern Mozambique's Vamizi Island partnered with conservation groups to ban all fishing off one of its shorelines. Over the years, fish populations recovered inside this sanctuary and soon began spilling over into the fishing areas. This spillover effect rewarded fishermen with good catches.

In the icy waters off British Columbia, I watch from below as Wally Bolton, a halibut fisherman, pulls up his catch. Most days he departs from the small village of Hartley Bay in a small aluminum skiff and uses a hand-cranked longline to fish for halibut. His low-impact methods ensure bountiful and sustainable catches; in a period of weeks, a commercial longliner could clean out the fishing grounds that have sustained local communities for generations.

TAKE ACTION: Know where your seafood comes from and how it was caught. Use scientifically supported apps like Seafood Watch before choosing your seafood at a fish counter or restaurant.

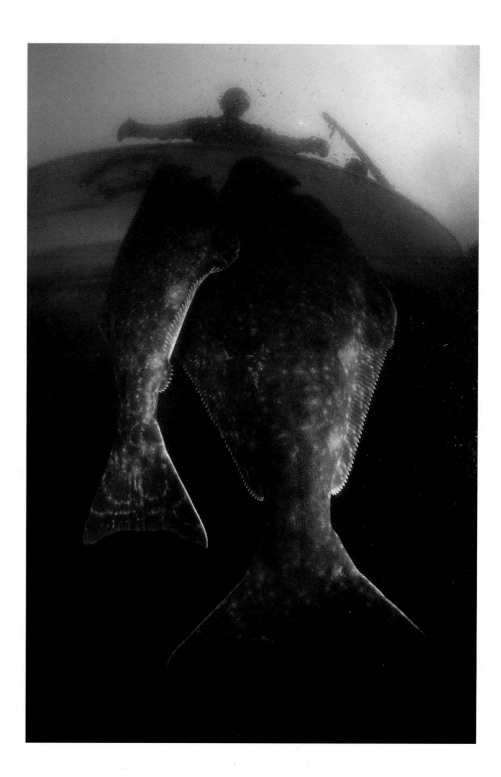

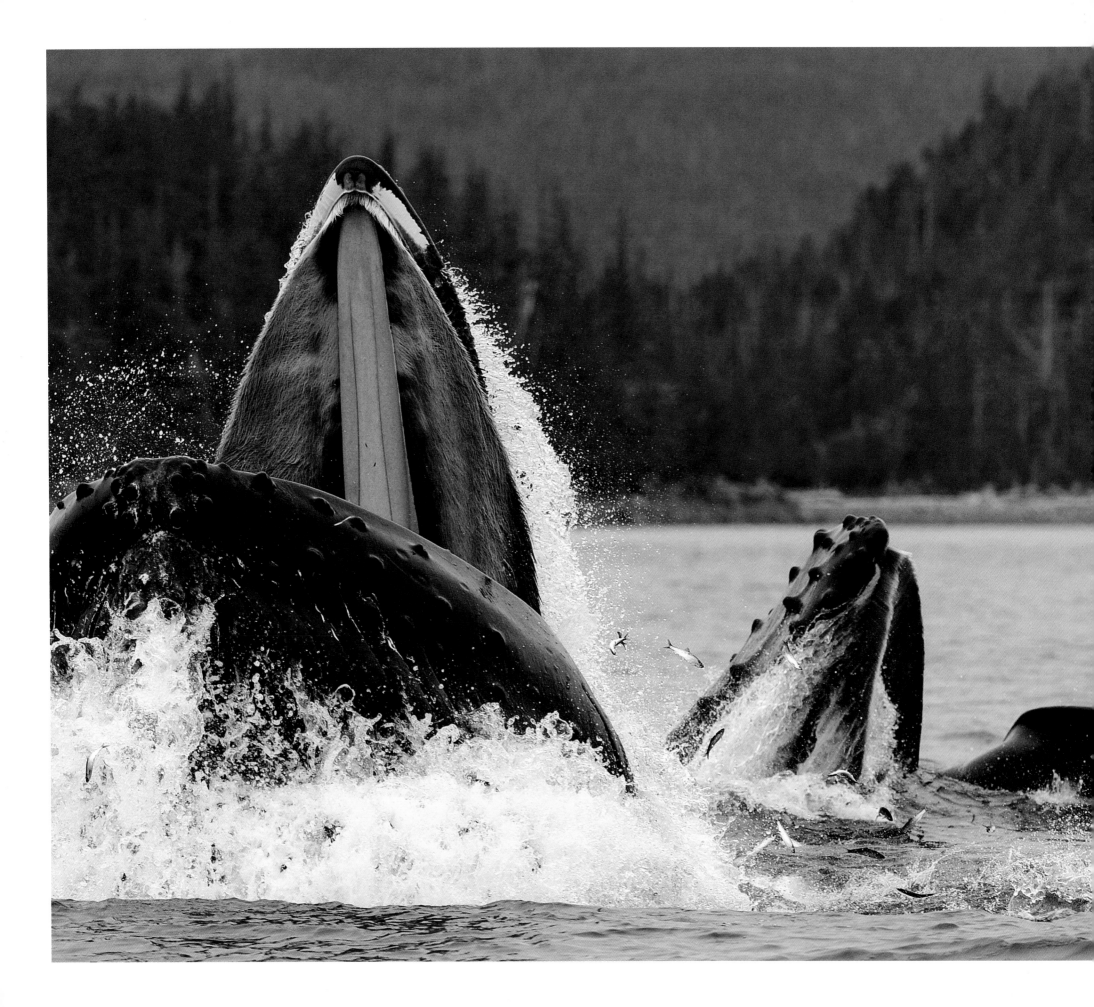

Call It a Comeback

A CURIOUS wide-eyed young elephant seal swims up to me. Just as I am about to slowly back away, he gently secures my arm with his mouth as if to say, "Don't go yet!"

A century ago, any interaction between a human and a northern elephant seal would have been bloody. Hunted for their blubber, which was turned into lamp oil and lubricants, elephant seals came dangerously close to extinction; by 1890, fewer than 200 individuals survived. A ban on hunting in the early part of the 20th century triggered a slow but gradual recovery.

Whale song reverberates through the hull of the boat. I feverishly scan the sea around me. Seconds later the water boils with herring leaping for their lives, followed by five humpbacks, mouths agape, erupting out of the water.

After near obliteration by hunting in the 19th and 20th centuries, a moratorium on commercial whaling helped the species recover to more than 100,000 individuals. The same is true for the smalltooth sawfish I photographed in the Everglades. Fishing and habitat loss reduced the species' once vast range to small pockets of southwestern Florida. Thanks to the Endangered Species Act and net bans, the smalltooth sawfish is making a comeback.

TAKE ACTION: Volunteer your services or donate to a local conservation organization focused on endangered species.

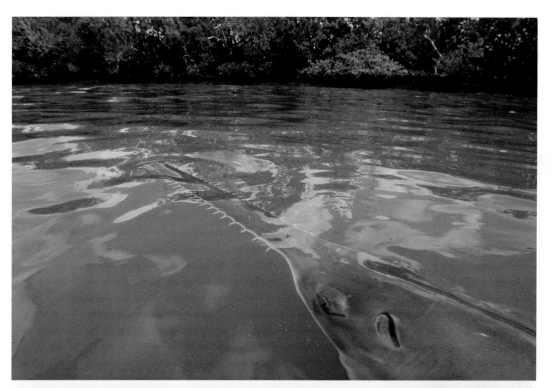

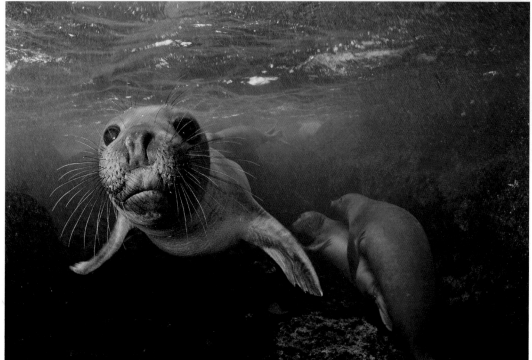

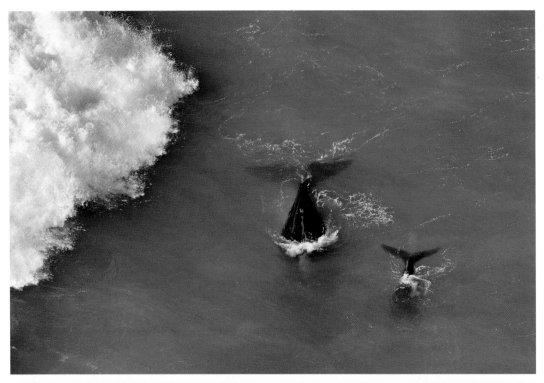

Ocean Sanctuaries

I HAVE NEVER BEEN so outnumbered. All I see are flashes of silver as a pulsating school of thousands of trevallies embraces me. The fins of the uppermost fish break the ocean's surface while the deepest scrape their bellies on the sandy seabed 80 feet below.

The waters off Cabo Pulmo, a sleepy village along Mexico's Baja California Peninsula, were not always so full of life. Overfishing was rife until local fishermen convinced the authorities to create a marine reserve in 1995. After only a decade of protection, scientists measured the largest recovery of fish ever recorded. Today, Cabo Pulmo is considered the most successful marine reserve in the world, and others, especially no-take reserves where fishing is prohibited, are also making significant contributions to ocean conservation.

The De Hoop Marine Protected Area along the southern tip of Africa is a critical sanctuary for southern right whales. One of the newest preserves is the D'Arros and St. Joseph Atoll Marine Protected Area, where hawksbill turtles, reef manta rays, and reef sharks thrive. With this proclamation, the Seychelles now has protected 30 percent of its territorial waters.

TAKE ACTION: If you are passionate about the ocean, share that enthusiasm and love with as many people as possible. Take photographs, tell stories, and post on social media. Become the eyes and ears for people not able to experience the marine realm firsthand.

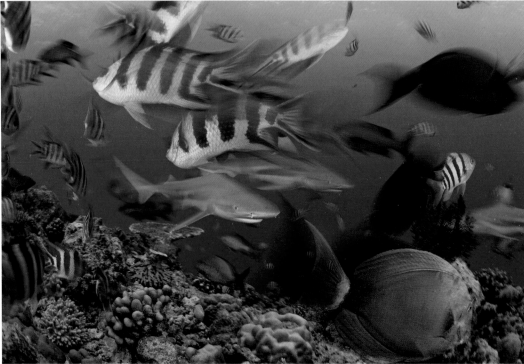

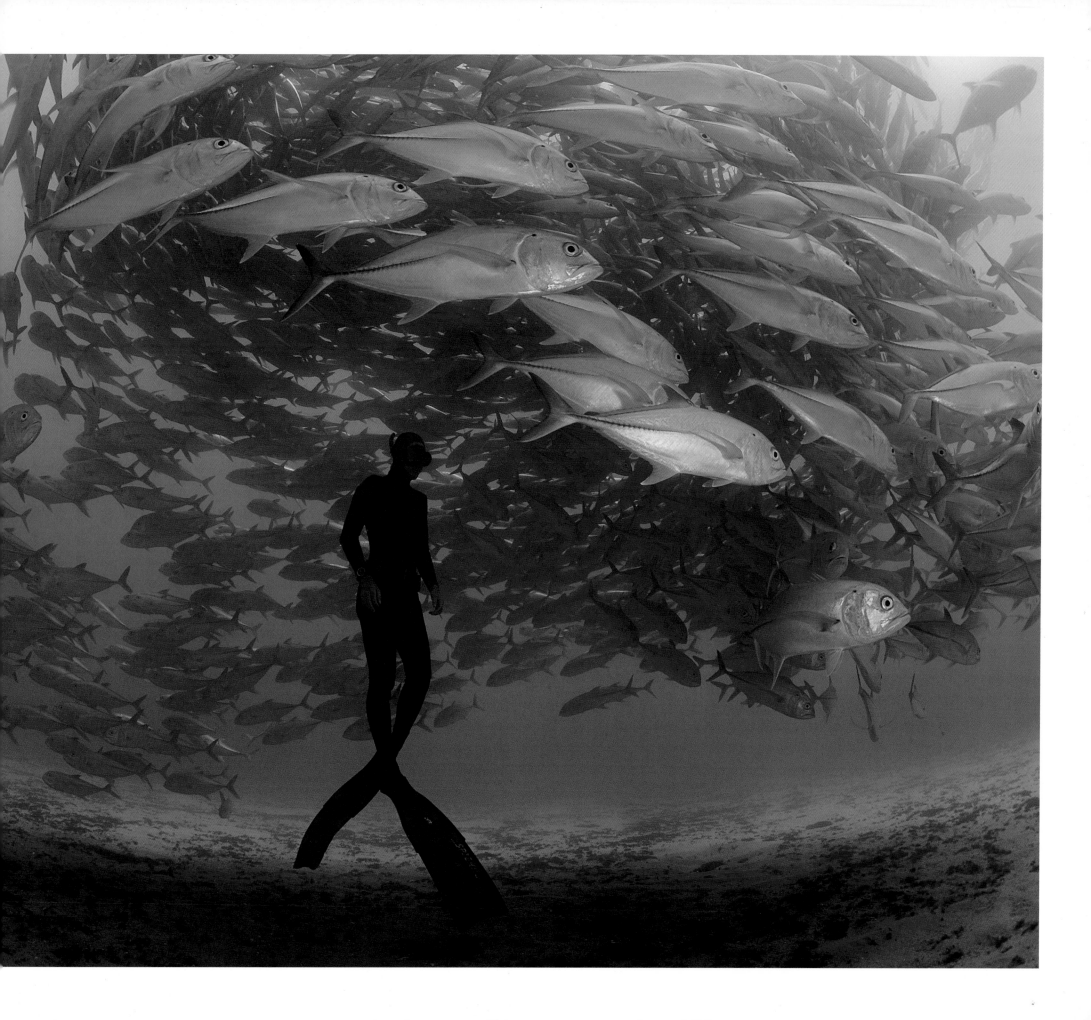

To Sunnye, who makes life more beautiful and enjoyable in every way imaginable, and to my parents, who supported my unconventional career choice and always encouraged me to follow my dreams.

ACKNOWLEDGMENTS

The Save Our Seas Foundation has generously supported my conservation photography for more than 15 years. A heartfelt thank-you to the founder, former CEOs Dr. Chris Clarke and Michael Scholl, and current CEO Dr. James Lea.

Kathy Moran, my photo editor at *National Geographic* magazine, introduced me to the magical world of visual storytelling and helped me succeed beyond my wildest dreams. Every time I travel to edges of the world on assignment, I am comforted knowing she always has my back.

Dr. Otto Whitehead and Steve Benjamin, talented videographers in their own right, have been my long-suffering field assistants. Their contributions in helping me create challenging images and tell complex stories in difficult conditions cannot be overstated.

Professor George Branch—my visionary Ph.D. supervisor at the University of Cape Town—more than 20 years ago showed me that science and photography are not mutually exclusive, and that popular storytelling can be every bit as important as scientific publishing.

National Geographic has been my home for 15 years. I wish to thank everyone at NGP and NGS, both past and present. Gary Knell, Susan Goldberg, David Brindley, Emmet Smith, Michael Tribble, Sarah Leen, and Whitney Johnson for allowing me to tell stories that champion conservation causes. Thank you for your trust and faith in me. Kaitlin Yarnall introduced me to so many fascinating and like-minded souls, and her support and guidance were key in me achieving my dream of becoming a National Geographic Explorer. Beth Foster turned my dream projects into reality and was instrumental to my National Geographic Fellowship. Tom O'Brien advised on technology and built equipment that survived hostile elements and (most) wildlife encounters. In my early days at National Geographic, photographers Paul Nicklen, Tim Laman, Brian Skerry, David Doubilet, and Christian Ziegler helped me navigate what can be a daunting place for a newcomer.

Sarah Borchert at *Africa Geographic* and Roz Kidman Cox and Sophie Stafford at *BBC Wildlife* magazine were among the first to take a chance on me and publish my early work.

Michael Scholl of White Shark Trust introduced me to my first great white shark in 1999, and worked with me to make the now infamous white shark kayak image.

Mark and Gail Addison introduced me to South Africa's iconic sardine run and provided me with a home away from home along South Africa's east coast.

Guy Stevens invited me to experience the world's largest manta ray feeding aggregation in the Maldives, which became my first story for *National Geographic* magazine in 2008. In its wake the Manta Trust was born and blossomed.

Fellow photographer and conservationist Hussain Aga Khan generously supported and participated in many of my expeditions through his organization Focused On Nature.

The Paul M. Angell Family Foundation supported storytelling projects, including those focused on the seabird crisis, sea turtle conservation, and climate change in the Galápagos Islands.

This book was produced in partnership with the wonderful team of creative and hardworking people at National Geographic Books: Lisa Thomas, Hilary Black, Melissa Farris, Moriah Petty, Adrian Coakley, Mike Lappin, and Judith Klein. David Griffin's timeless design allows my photographs to breathe and shine. Sunnye Collins skillfully edited and shaped early versions of the text, and Kathy Moran was an essential guide when it came time for me to choose just two hundred images out of more than a thousand favorites.

Sunnye Collins has been my partner in crime for a decade, and I would not be where I am today without her. A gifted writer, editor, and podcaster in her own right, she is my sounding board and litmus test, my travel companion and confidant. Without her, there would be no Hugo, Blue, and Luna, which bring so much furry canine joy into my life. Our mountain hideaway that heals and replenishes me after long and taxing assignments would also not exist without her creativity, care, and sacrifice.

My parents encouraged my love for the ocean and adventure from a very young age. They took me diving, sailing, rafting, and rock climbing. They introduced me to wild places and wild creatures. I always felt safe taking risks because I knew, no matter what, there would always be a safe and loving place to return home to.

Although I might be the one that looks through the viewfinder and presses the shutter, the photographs in this book are all born of a collaborative process. Unfortunately, acknowledging everyone who guided, advised, and supported me over the years would require a completely separate book. Please instead visit *www.thomaspeschak.com* for the complete acknowledgments.

WILD SEAS

Since 1888, the National Geographic Society has funded more than 14,000 research, conservation, education, and storytelling projects around the world. National Geographic Partners distributes a portion of the funds it receives from your purchase to National Geographic Society to support programs including the conservation of animals and their habitats.

Get closer to National Geographic Explorers and photographers, and connect with our global community. Join us today at nationalgeographic.com/join

For rights or permissions inquiries, please contact National Geographic Books Subsidiary Rights: bookrights@natgeo.com

Additional photo credits: 32, Steve Benjamin; 35 (top left), Klaus Peter Peschak; 39, Otto Whitehead; 43, Otto Whitehead.

Library of Congress Cataloging-in-Publication Data
Names: Peschak, Thomas P., author.
Title: Wild seas / Thomas Peschak.
Description: Washington, D.C. : National Geographic, [2021] | Summary: "Conservationist and National Geographic photographer Thomas Peschak shares more than 200 of his images and the stories behind them"--Provided by publisher.
Identifiers: LCCN 2021003326 | ISBN 9781426221934 (hardcover)
Subjects: LCSH: Marine animals--Conservation. | Marine habitat conservation.
Classification: LCC QL122.2 .P455 2021 | DDC 333.95/616--dc23
LC record available at https://lccn.loc.gov/2021003326

Printed in Malaysia

21/QRM/1

FOLLOWING PAGE

In the dead of night, a young whale shark feeds on tiny zooplankton attracted to the lights of a small fishing boat. Djibouti, 2009

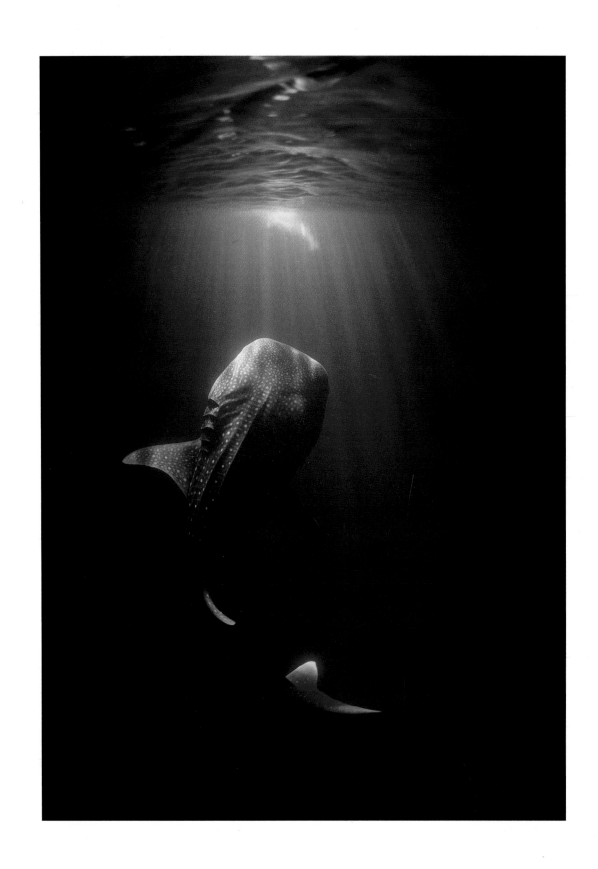